THE KEY TO THE BRESCIA CASKET:
TYPOLOGY AND THE EARLY
CHRISTIAN IMAGINATION

Collection des Études Augustiniennes

Série Antiquité - 165

Christianity and Judaism in Antiquity Series

Gregory E. Sterling, *Series Editor*

VOLUME 14

*The University of Notre Dame Press gratefully acknowledges
the generous support of Jack and Joan Conroy of Naples, Florida,
in the publication of titles in this series.*

Catherine Brown TKACZ

THE KEY TO THE BRESCIA CASKET: TYPOLOGY AND THE EARLY CHRISTIAN IMAGINATION

University of Notre Dame Press
Institut d'Études Augustiniennes
PARIS
2002

A record of the Library of
Congress Cataloging-in-Publication Data is available
upon request from the Library of Congress.

ISBN: 0-268-01231-8

Christianity and Judaism in
Antiquity Series (CJAS)

The Christianity and Judaism in Antiquity Program at the University of Notre Dame came into existence during the afterglow of the Second Vatican Council. The doctoral program combines the distinct academic disciplines of the Hebrew Bible, Judaism, the New Testament, and the Early Church in an effort to explore the religion of the ancient Hebrews, the diverse forms of Second Temple Judaism, and its offspring into religions of Rabbinic Judaism and the multiple incarnations of early Christianity. While the scope of the program thus extends from the late Bronze and Early Iron Ages to the late antique world, the fulcrum lies in the Second Temple and Early Christian periods. Each religion is explored in its own right, although the program cultivates a History-of-Religions approach that examines their reciprocally illuminating interrelationships and their place in the larger context of the ancient world.

During the 1970s a monograph series was launched to reflect and promote the orientation of the program. Initially known as Studies in Judaism and Christianity in Antiquity, the series was published under the auspices of the Center of the Study of Judaism and Christianity in Antiquity. Six volumes appeared from 1975 to 1986. In 1988 the series name became Christianity and Judaism in Antiquity as the editorship passed to Charles Kannengiesser, who oversaw the release of nine volumes. Professor Kannengiesser's departure from Notre Dame necessitated the appointment of a new editor. At the same time, the historic connection between the series and the CJA doctoral program was strengthened by the appointment of all CJA faculty to the editorial board. Throughout these institutional permutations, the purpose of the series has continued to be the promotion of research into the origins of Judaism and Christianity with the hope that a better grasp of the common ancestry and relationship of the two world's religions will illuminate not only the ancient world but the modern world as well.

Gregory Sterling
Series Editor

For my mother

Ruth Mosher Brown

PREFACE

The enigma of the meaning of the Brescia Casket first captured my attention when I had the good fortune to be at Dumbarton Oaks working as Project Manager and Assistant Editor of the *Oxford Dictionary of Byzantium* Project. The casket figured in some of the entries I was writing. Its visual unity argued for a coherent program underlying it, and the puzzle of what that was tantalized me. The unity of the top register on the right side (see Chapters 5-6) was treated in a conference presentation in 1988, and the role of a popular prayer, the *Commendatio animae*, in the selection of most of the Old Testament figures on the casket (see Chapter 4) in a presentation the next year, by which time I was working for the National Endowment for the Humanities. It became clear that the entire program of the casket could be explained, and that this would require a book. My husband encouraged me enthusiastically, and also practically, by providing a "spouse sabbatical" for me to complete the research and writing. It was a great satisfaction when the Institut d'Études Augustiniennes and the University of Notre Dame Press accepted the book manuscript in 1995.

Many scholars have thoughtfully advised me. Richard Brilliant of Columbia University, Richard K. Emmerson, now Executive Director of the Medieval Academy of America, and Gary K. Vikan, Director of the Walters Art Gallery, have read and critiqued portions of the book. John J. Contreni of Purdue University, who heard my initial presentation in 1988, Timothy C. Graham, of Cambridge and Western Michigan University, Thomas P. Halton of the Catholic University of America, Jeffrey Burton Russell of the University of California at Santa Barbara, and Fredric W. Schlatter, S.J., of Gonzaga University have read and critiqued the entire manuscript. During the years between the acceptance of the book for publication and the recent completion of its copublication agreement, it was necessary to update the bibliography and otherwise revise the work; most graciously, Jeffrey Russell reread the entire revised version of the manuscript as well. Any errors or infelicities are therefore entirely my own. My dear husband Michael W. Tkacz has from the start helped me with sound advice, welcome encouragement, and practical aid of all sorts, including preparing the map. Thanks to the kind offices of Dr. Renata Stradiotti, Director of the Civici Musei d'Arte e Storia di Brescia, I was able to study the Brescia Casket itself and the Museo's records. Irene Vaslef, Director of the Byzantine Library at Dumbarton Oaks, and Natalia Teteriatnikov, Director of the Princeton Index of Christian Art at Dumbarton Oaks, have, with

their staffs, helped make my research trips both pleasant and productive. Bruce Miller of the Library of Theology and Philosophy at the Catholic University of America, Martha Steele of the Getty Center for the History of Art, and Brigitte Kueppers, head of Special Collections at the University of California at Los Angeles, have enabled me to use these resources efficiently. Many colleagues, in particular, Guinevere L. Griest, Maben D. Herring, Douglas Kries, and Russell M. Wyland, have in friendship interested themselves in this project. The conversation and prayers of the community of the Dominican House of Studies in Washington, D.C., have been a cherished support.

The Samuel H. Kress Foundation generously supported the illustration of this volume. Their grant made possible the full illustration of the Table of Identifications, including the digitized detail shots of every individual representation on the Casket as well as the schematic drawings. Any three-dimensional monument, from sarcophagus to cathedral, with a complex iconographic program can be made more accessible to readers through such electronically produced illustrations. Philip C. Aldrich of New Horizons Computer Learning Center, Spokane, Washington, prepared these schematic drawings on three-dimensional computer-aided design (3D CAD) and transferred them to a standard drawing program, Corel Draw. The detail shots throughout the Table of Identifications were produced by optically scanning the photographs and using Adobe PhotoShop to produce individual files in tagged image file format (TIFF). Hirmer Verlag graciously allowed these multiple shots to be reproduced without additional fees.

<div align="right">

Catherine Brown Tkacz
Spokane, Washington

</div>

TABLE OF CONTENTS

LIST OF ILLUSTRATIONS

In addition to the illustrations listed here, see the Table of Identifications for exhaustive and systematic illustration of the individual representations on the Brescia Casket. For detail figures of individual representations and registers placed throughout this book, consult the index.

INTRODUCTION

In the early centuries of the Christian Church, the members of this new religion were learning how to relate their faith's founding revelations, recorded in what came to be called the New Testament, to the centuries-old tradition of the Jewish faith, recorded in the Pentateuch and the other Jewish scriptures, soon called by the Christians the Old Testament. Hebrew scriptures and teaching had held that the prophesies concerning the Messiah would be fulfilled, and Jesus Christ in repeated instances correlated his teachings to those of Judaic tradition and prophecy. Further, Judaic tradition held that the lives of certain figures, such as Moses and Jacob, expressed patterns that would be repeated and surpassed by the Messiah. In this light, Jesus pointed to parallels between himself and Jewish tradition, as when he offered the people the sign of Jonah. The apostle Paul continued this practice, teaching that Christ was the new Adam, for instance.

The intellectual and pastoral work of the early Church included identifying and explicating the various Old Testament figures who had provided a mirror to the future, a reflection in advance of the face of Christ. Such correlation is called typology, with the Old Testament figures serving as types or patterns of Christ. Thus Jonah, with his three days in the belly of the whale, was a type of Christ's three days in the tomb. Reflection upon and discussion of such correlations recurred in the writings of the early Church and attracted the popular imagination. The stories of Old Testament characters who had long been popular in their own right, such as Daniel in the Lions' Den and the Three Hebrews in the Fiery Furnace, gained new appeal as foreshadowings of newly revealed Christian truths. Daniel, his arms spread wide in the traditional pose of prayer, flanked by two quiescent lions, prefigured Christ, his arms spread on the Cross, but no more harmed by death than Daniel was harmed by the lions; for Daniel, sealed in the lions' den, emerged unharmed, just as Christ, sealed in the tomb, was wondrously resurrected.

Typology was drawn on for sermons and liturgical texts, it was touched upon in popular prayers, and, at least sometimes, it informed the visual arts as well. Indeed, it would be surprising if the newly christianized imagination ignored typology. Nevertheless, the question of just how much and how often it played a role in Early Christian art has often been assumed to have the answer, "Very little, and rarely." Was Early Christian depiction of types rare, however, or is the rarity the modern recognition of types *in the ways they are used in the Early Christian period*? The fully worked-out patterns of typology recorded in

illustrated manuscripts from the middle ages are universally recognized, but then it would be impossible to ignore the role of types in the systematic juxtapositions of the late medieval *Biblia Pauperum* with their schematic illustrated pages and explanatory glosses written as part of the design (Fig. 10). In these, the events of Christ's passion are set directly beside Old Testament types which had prefigured them. Look for this formulaic layout with its clarifying inscriptions in Early Christian art and you will not find it, but are types present in other formats?

The Brescia Casket presents evidence that they are. The panoply of biblical scenes carved on that Early Christian ivory box presents a fascinating experiment: the use of types not just to parallel, but actually to complete and enhance the depiction of Christ's passion, and then to exemplify human responses to the passion. In short, the entire program of the casket is typological. With regard to the casket itself, this discovery solves the riddle of its enigmatic images, often deemed unrelated. More broadly, this finding indicates a sophistication and richness in the use of typology to inform Early Christian art, and this in turn implies that other early artworks previously considered to be only loosely coordinated in their imagery might fruitfully be reconsidered with an eye for other typological experiments.

For centuries, the Brescia Casket has been a tantalizing mystery, drawing scholars to search to understand what its rich collection of images was meant to convey. For this reason alone, a full explanation of its meaning is valuable. Beyond this, if it can be shown that the casket's design is typological, this will open the door to reconsidering the role of typology in Early Christian art as a whole.

CHAPTER ONE:

THE BRESCIA CASKET

The Brescia Casket (Figs. 1-8) is a late fourth-century[1] Early Christian box—probably a reliquary, although its exact use is unknown—most likely made in Northern Italy[2] and notable as "the most beautiful of Christian iv-

1. The putative date of the Brescia Casket has gradually moved from the late third or early fourth century to the 380s or even later. Nineteenth- and early twentieth-century scholars considered it Constantinian; e.g., Davin, "Capella greca," 312; Pérate, *Archéologie chrétienne*, 343; Stuhlfauth, *Altchristliche Elfenbeinplastik*, 198. Though Delbrueck (*Probleme der Lipsanothek*, 67-78) also accepted the Constantinian date, the evidence on which he based this was shown by Toynbee (review of Delbrueck, 239) and others to be incomplete. Rarely has a fifth-century date been suggested: E. B. Smith, *Early Christian Iconography and Ivory Carvers*, 115; Diehl, *Art chrétien primitif*, 30; and Morey, *Early Christian Art*[2], 136-37. Once the casket has been assigned to the "fifth or sixth century" (Maskell, *Ivories*, 143).

With few exceptions scholars since the 1920s have progressively advanced the date from possibly middle fourth (Wulff, "Geschichte der altchristlichen Kunst," 220; Dalton, *East Christian Art*, 208), to second third of the fourth (Grabar, *Early Christian Art*, 274), to 360s (Grabar, *Art de la fin de l'Antiquité*, 1:509, and id. *Christian Iconography*, 137; Carrà, *Ivories*, 60), to 370s or later (Kollwitz, *Lipsanothek von Brescia*, 64-68), to the 380s (Soper, "Italo-Gallic School," 174-77, Soper, "Brescia Casket," 278) to third quarter of the fourth (Volbach, *Early Christian Art*, 27; (Syndicus, *Early Christian Art*, 105, Volbach, *Elfenbeinarbeiten*[3], 77). Scholarship in the last decade has consistently argued for a late fourth-century dating: Kessler, "Acts of the Apostles on Early Christian Ivories," 109, considers the casket to be one of a group of ivories carved "during the years around 400"; Watson ("Program of the Brescia Casket," 291, 293) proposed assigning the casket to "the age of Ambrose," specifically "in or shortly after 386"; Milburn (*Early Christian Art*, 239) reiterates the date of "near 380" and Anthony Cutler tentatively deems it late fourth century; "Lipsanothek," *ODB* 2:1233. Late fourth century, perhaps around 386 is suggested most recently; *Area di Santa Giulia*, 66.

2. A Northern Italian provenance is likely, on stylistic and iconographic grounds; in addition, the present study will show that a variety of pertinent and public texts, mainly sermons, were preached initially in Northern Italy, thus demonstrating that the ideas for the typology informing the casket were available there. For reviews of arguments for a North Italian origin and the refutation of earlier views placing its manufacture in Constantinople, Antioch, and Asia Minor, see Kollwitz, *Lipsanothek von Brescia*, 47-63; Soper, review of Kollwitz, 433; Volbach, *Elfenbeinarbeiten*[3], 77-78; and Watson, "Program of the Brescia Casket," 283. Several metal reliquaries have similar dimensions and as-

ories."[3] Also known as the Lipsanothek (i.e., reliquary) of Brescia,[4] this artwork measures roughly 32 cm. long by 22 cm. wide by 25 cm. high.[5] A wealth

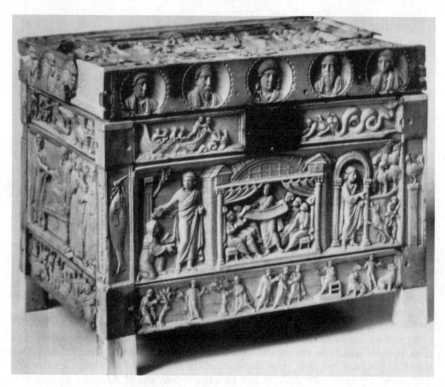

FIGURE 1. Brescia Casket. Ivory, late fourth century.

pects of decoration; see Buschhausen, *Spätrömischen Metallscrinia und frühchristlichen Reliquiare*, vol. 1, passim. A Milanese workshop is suggested; *Area di Santa Giulia*, 66.

3. The assessment of the casket as "le plus beau des ivoires chrétiens" was shared by Pérate, *Archéologie chrétienne*, 341, and Henri Leclercq, "Brescia (archéologie)," *DACL* 2.1:1150.

4. Federico Odorici, who published the casket in 1845, called it the Brescia reliquary ("la Lipsanotheca bresciana") and described the registers ("le tavolette bresciane") which comprise the casket ("una cassetta"). Thus he established the basic vocabulary that has been used in describing this monument throughout the history of scholarship on it. See *Antichitá cristiane di Brescia*, two parts (Brescia 1845, 1853; reprint Milan 1858), 66, 67. Note that some German scholars have misspelled Odorici's name as Oderici; his name is clearly Odorici on the volume just cited, however; Stuhlfauth, *Altchristliche Elfenbeinplastik*, 50 and Kraus, *Christlichen Kunst*, 1:503.

5. Roughly 12.5" x 9" by 10". The first published report of the measurements was by Federico Odorici in 1845: "Componevano queste una cassetta della lunghezza di 315

of Christian images adorn it. Included are thirty-three scenes comprising two series of New Testament and Old Testament representations. The "refinement and elegance" of these carvings has been frequently discussed by scholars; André Grabar accorded it "pride of place" among ivory carvings, noting its "finely executed reliefs" and the artist's "perfect realization" of Jesus as a youth of ideal beauty, graced with a "grave serenity."[6] Beyond its esthetic qualities, the casket is interesting for its history and the mystery of its decoration.[7]

HISTORY OF THE BRESCIA CASKET

The Brescia Casket is now, and may always have been at Brescia in northern Italy, fifty-two miles southeast of Milan (see map). Its designer may well have been the patron who commissioned its manufacture, or it could have been the actual craftsman or another artist who supervised the carver.[8] In the fourth century, Brescia gained its own bishop, suffragan to Milan.[9] A women's Benedictine monastery of San Salvatore was founded in Brescia in 753 by Ansa, wife of Desiderio of Brescia, Lombard duke of Istria.[10] The relics of S. Giulia were brought to the monastery in 762/3, and the convent's name was doubled to San Salvatore e Santa Giulia.[11] Already by 760 documents show that the convent had extensive treasures in precious materials.[12] Thus the ivory casket

millimetri larga ne' fianchi 218, alta 210"; *Antichità cristiane di Brescis*, 67. Ettore Modigliani, who restored the casket (see below), gives its measurements as 31.8 cm. long by 22.3 cm. wide by 25 cm. high; "Ripristino della Lipsanotheca," 102 n. 1. For a discussion of the measurements, see Watson, "Program of the Brescia Casket," n. 10.

6. Kessler, "Acts of the Apostles on Early Christian Ivories," 110. See also, e.g., Wolfgang Fritz Volbach, *Early Christian Art*, 27; Grabar, *Early Christian Art*, 273-74. Soper asserted that the casket is "in its time unique for the richness and iconographic importance of its carved decoration" and is struck by its "remarkably wide repertory of scenes from the Old and New Testaments"; Soper, "Brescia Casket," 278. Scholarly consensus continues to find the Brescia Casket "unsurpassed for excellence of design and craftsmanship in ivory"; Milburn, *Early Christian Art*, 239.

7. "[D]espite an abundance of resourceful and often astute exegesis, its date, use, provenance and meaning remain among the most formidable and enduring enigmas in the study of early Christian art"; McGrath, "Maccabees on the Brescia Casket," 257.

8. Henry Maguire's reasoning about the designers of Early Christian floor mosaics is generally pertinent to early art; *Earth and Ocean*, 14-15.

9. In 342 Brescia's first known bishop took part in the Council of Sardica. A later bishop, St. Filastrus (d. 397) wrote a book on heresies which Augustine used, as did the next bishop of Brescia, St. Gaudentius; E. P. Colbert, "Brescia," *NCE* 2:786-87.

10. Panazza, *Musei di Brescia*, 47, 45, 57.

11. *Area di Santa Giulia*, 11-12.

12. *Area di Santa Giulia*, 65. Among the most precious treasures now, and perhaps then as well, are the Brescia Casket, the fifth-century Boethius Diptych, a sixth-century Gospel book on purple vellum and the eighth-century Cross of Desiderius; ibid., 66, and *Brescia, Cittá di S. Giulia*, pl. 17.

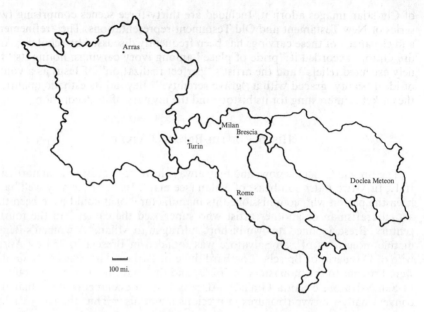

100 mi.

with its silver lock[13] could have been in the monastery from its founding, per-
haps a gift from its patroness. In the nineteenth century after the unified king-
dom of Italy had been created, the church was suppressed in 1798, and the
casket passed to the Biblioteca Queriniana, named after Cardinal Querini.[14]
On August 25, 1882, the deconsecrated church of S. Giulia was renamed the
Museo dell'Etá Cristiana, later simply the Museo Cristiano, and the elegant iv-
ory work was returned to the building in which it had previously passed so
many years.[15] Originally constructed as a box, the casket was dismantled after
it had been taken from the church, its legs stored, and the sides and top ar-
ranged to form a cross (Fig. 2). This was done—"most imprudently"—to dis-
play all the parts on a single surface, so that visitors might view the carvings
easily.[16] Unfortunately, none of the five surfaces—top, front, sides, back—was

13. For the metal of the lock, see Volbach, *Elfenbeinarbeiten*[3], 77.

14. *Area di Santa Giulia*, 14. Later the constitutional monarchy was proclaimed on
March 14, 1861; A. Gambasin, "Italy," *NCE* 7:767-69. The basilica of S. Salvatore and
the churches of S. Giulia and of S. Maria in Solario were taken over by the Comune di
Brescia; Panazza, *Musei di Brescia*, 45.

15. Panazza, *Musei di Brescia*, 47, 45, 57. Note that studies earlier than Panazza ap-
parently refer to the Biblioteca Queriniana and the Museo Cristiano as the Museo Quer-
iniana, or civic museum of Brescia, and identify the casket as being there; Stuhlfauth,
Altchristliche Elfenbeinplastik, 39-40; C. M. Kaufmann, *Handbuch der christlichen Arch-
äologie*, 555 and n. 2.

16. Odorici, *Antichità cristiane di Brescis*, 67. The date of the reassembly as a cross is
unknown ("in epoca imprecisata"); Panazza, *Musei di Brescia*, 57.

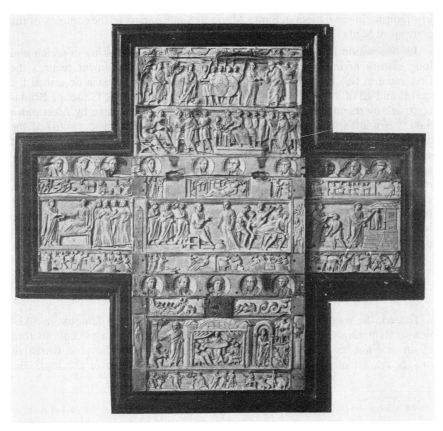

FIGURE 2. The Brescia Casket, when formerly assembled as a cross.

kept in proper relation to the others in the cross-arrangement: the back was placed where the front had been, between the left and right sides, and the front was put in the bottom position in the cross's upright. Moreover, while the casket was in the form of a cross, the ivory strips which edge the sides were not displayed, presumably to provide the cross with shorter arms. Probably during this time occurred the loss of two bust medallions from the sides. In 1928 under the direction of Ettore Modigliani, a cabinet maker named Luigi Alberizzi returned the artwork to its original form, and Modigliani's full report records the research done to restore the five surfaces to their correct relation to each other.[17] The casket is currently displayed in a climate-controlled case under

17. Panazza, *Musei di Brescia*, 57 identifies Alberizzi as a cabinet-maker. Modigliani himself describes the restoration in fascinating detail: tabs ("animae") on the ends of the narrow registers fit into slots (e.g., "incavi") in the pilasters. When the casket had been put into the shape of a cross, the tabs on the two sides had been cut off, but their measurements (one is a half centimeter higher than the other) and other physical clues clarify

low lighting in the Chiesa di Santa Maria in Solario, part of the complex of the convent of Santa Giulia.[18]

Its decoration has tantalized scholars for centuries, resulting in a rich and long history of interpretation. An eighteenth-century document records the first voice in this history; an official of the Museum at Brescia described the casket and all of its images.[19] In the early nineteenth century, Giuseppe Brunati, struck by the artistry of the ivory registers, had them drawn by Alessandro Sala.[20] Brunati's work was reported by Federico Odorici, who published the casket in 1845. *Antichitá cristiane di Brescia* included Odorici's drawings of each face and his detailed description, suggesting an identification of each image. He published a revised version of this volume (with no change, however, in the date on the title page) with quotations from letters from several scholars, commenting on the proposed identifications. Odorici quoted in full a letter from the Secretary of the Institute of France, the archaeologist Désiré Raoul-Rochette (1789-1854), who readily concurred that this discovery might be the most important in Early Christian art to date:

> The Christian monument you have made known to me is certainly one of the most precious that we could have discovered, and I don't know if there even exists anywhere a collection of depictions that has the same importance for the number and newness of its subjects, its style, and its antiquity.[21]

Indeed, the wealth of depictions on the Brescia Casket is famous: in addition to its panoply of thirty-three biblical scenes, fifteen bust medallions (out of an original seventeen) adorn the edges of the cover, and nine Christian images are set along the borders of the sides, vertically over the legs. The

which belongs on the left and which on the right. Evidently the lock on the casket is original, although the hinges are replacements made of solid silver artificially oxidized to eliminate the danger of rust; "Ripristino della Lipsanotheca."

18. For a three-dimensional plate showing the entire complex, see *Brescia, Cittá di S. Giulia*, 6-7.

19. Kollwitz, *Lipsanothek von Brescia*, provides a transcription of the manuscript and explains that, when the casket was taken apart and reassembled as a cross, the manuscript was fastened to the back of the cross so that eventually the ivory could be restored to its original form; p. 7; transcription pp. 7-9. The transcription was provided to Kollwitz by the museum, which evidently gave him no catalog information on the manuscript.

20. Odorici, *Antichità cristiane di Brescia*, 69.

21. Omitted are the extensive italics appearing in Odorici's study and presumably in the original letter. Raoul Rochette is not listed in the Library of Congress's computerized Name Authority File, but details of his biography are evident in *The National Union Catalogue of Pre-1956 Imprints*, which lists dozens of works by Rochette (vol. 499:383-86). He was the conservator of the Cabinet des médailles antiques of the Bibliothèque Royale, later the Bibliothèque Nationale. His numerous publications primarily concern ancient, classical and Early Christian art. Odorici describes him as the celebrated secretary of the "Instituto di Francia," evidently the Institut National de France des Sciences et Arts; Odorici, *Antichità cristiane di Brescia*, 66, 68-69; *NUC* 499:384-85.

thirty-three scenes form two series: 1) scenes from the New Testament (the Gospels and Acts); they are carved on panels about 4" high, two panels on the lid and one as the central register on each of the four sides; and 2) scenes from the Old Testament (Genesis, Exodus, 1 Kings, 3 Kings,[22] Jonah, Daniel);[23] these are carved on panels roughly 1.5" high, which form the top and bottom registers on each of the four sides. In short, the lid is entirely New Testament and the sides all emphasize New Testament scenes. On each vertical face the New Testament images are central, framed above and below by Old Testament scenes, and the area devoted to the New Testament is greater than the area devoted to the Old. (If the Old Testament registers were 2" high, the area for Old and New would be equal.) Visually, the greater importance of the New Testament images is obvious.

The minor series are 1) the medallion portraits of Christ, the disciples, and St. Paul[24] that decorate the outside edges of the lid of the casket; and 2) the symbols edging each section. On the lid, a single horizontal band runs across the top; six birds are carved here, separated by five designs with draperies. On every other face of the casket the images run vertically at the edges, flanking the New Testament register.

Many of the very early identifications of the images on the casket have proven correct, and subsequent scholarship has been concerned with challenging, refining, and completing these identifications,[25] and relating the casket to other

22. First through Four Kings in the Septuagint and Vulgate are entitled First and Second Samuel and First and Second Kings in the Protestant Bible.

23. Most scholars agree that all these scenes are from the Old Testament, but some would identify a few scenes as either New Testament or extra-biblical. For instance, the feast scene on the back of the casket is considered to be the Wedding at Cana by Henri Leclercq, "Brescia," *DACL*, vol. 2.1, fig. 1626 (but cf. col. 1155) and by Volbach, *Elfenbeinarbeiten*³, 77-78, and the central scene on the upper right side was once, in the eighteenth century, construed as the souls in Purgatory; see Kollwitz, *Lipsanothek von Brescia*, 7-9, for a transcription of the document; cf. Odorici, *Antichità cristiane di Brescia*, 68-69.

24. The remaining three portraits are variously interpreted as evangelists, church fathers, prophets, or other saints. Watson (1981, p. 290) interprets the medallions to include saints Gervasius, Protasius, and possibly Felix and Nabor.

25. For instance, after a few false starts, the bottom register on the right side was recognized in the nineteenth century as a series of Jacob scenes, but the precise events took longer to be defined. The register depicts the meeting of Jacob and Rachel at the well, then Jacob wrestling with the angel, and finally Jacob's ladder—but with Jacob, not the angel, ascending it. Initially, Odorici reports (1845, pp. 86-87), someone construed the scene at the well as depicting Moses. The two wrestling figures were originally taken to represent Laban and Jacob meeting, presumably about to embrace (see Kollwitz, *Lipsanothek von Brescia*, 9). Later Odorici (1845, pp. 68, 86-87) and still later Kraus (*Christlichen Kunst*, 503) construed this scene as Jacob and Esau. Notably, until now J.O. Westwood has been the sole voice correctly to identify the figure ascending the ladder as Jacob; see his *Fictile Ivories in the South Kensington Museum*, 35. Other commentators either designate the scene only as "Jacob's ladder" or simply "the ladder," or else identi-

monuments of Christian art, especially funerary art and ivorywork. Quite early on scholars observed that the casket has Old Testament registers and New Testament registers, but the question of whether some of the Old Testament registers contain non-biblical scenes and images has remained open. A central and abiding issue has been whether the images on the Brescia Casket comprise a coherent program, and, if they do, what it is. Richard Delbrueck (1952), to be discussed in Chapter Four, suggested a liturgical basis for the selection of images; Carolyn Josslyn Watson, "Program of the Brescia Casket," suggested that Ambrose designed the casket, drawing on his own writings to commemorate "a conflict between the bishop and the Arian imperial court at Milan in Lent of 386." Both of these interpretations, while offering valuable insights, fall short of proving a complete explanation.

In Watson's study, particularly provocative and plausible are her discussions of two images and of the identity of the designer. The depiction of Christ teaching in the Synagogue she relates to Ambrose's *Commentary on the Gospel of Luke,* in which the bishop finds in the event evidence of the divinity of Christ. Watson is also the first to observe that the reclining Jonah on the back is "by far the largest Old Testament figure on the casket," and she infers he may therefore be "especially significant." (She does not remark on the fact that the placement of the hinges on the back of the casket dictates the size of the three scenes in the top register.) She quotes Ambrose's report that, on Holy Thursday 386, just as he was preaching on Jonah under the gourd, word came that the Arian emperor was rescinding restraints on orthodox Christians. She does not address, though, why the event most clearly linked with the event the casket is supposed to memorialize is on its back, not in some more prominent position, such as the front. Turning to the identity of the casket's designer, she reasons from the possibility that Ambrose may have "composed inscriptions for the Biblical scenes on the walls of his basilica" that he might also have designed the program for the casket, a fascinating suggestion.

Other aspects of Watson's argument, however, are weak. Her thesis that the casket stresses the divinity of Christ is at odds with the repeated suggestions that images of Christ on the casket point to Ambrose. For instance, she construes the New Testament register on the front as "direct[ing] believers to look to the bishop for instruction, penance, and protection." Again, she holds that one reason why it was unnecessary to show the crucifixion on the casket was because Ambrose had not been martyred. Such interpretations unintentionally impute vainglory to the bishop, in contrast to her consistent presentation of him as the exemplary pastor. Other arguments are forced. The miracles depicted on the casket's sides are said to show Christ's divinity particularly well because Christ wrought them independently, unprompted by anyone's faith. Not only is that false (see below), but it ignores the miracle on the front in which faith is focal, as Ambrose notes and as Watson herself discusses. Simi-

fy the figure as the angel—without explaining why the angel looks like, not just one of the two wrestling figues, but also the figure who meets Rachel at the well.

larly, the grounds for finding Sapphira (on the back of the casket) to represent the Arian dowager Empress Justina are tenuous: Ambrose likened Justina to Herodias and Jezebel, so he could also have likened her to another "biblical evildoer." The study is an admirable attempt to ground the program of the casket in the Early Christian milieu which produced it. Yet linking it with one particular person and event, Ambrose and his conflict with the Arians, proves untenable.[26]

Outside such studies as those of Delbrueck and Watson, a common conclusion has been that the only trait in common among the images and events depicted on the sides of the casket is that they are all biblical, that except for the separation of Old Testament from New Testament scenes in distinct panels, the sides of the casket have no program of decoration.[27] Lurking here is the implication that the audience for this art was content without a program. This reduces the ivory carvings to the intellectual standard of the sort of children's wallpaper that randomly depicts nursery rhymes: there need be no rationale for selection or order, for the audience will hardly expect one.[28] Given the failure to date of "all attempts at interpretation in programmatic terms," however, and the presence of enigmatic scenes on the casket, about the best that could be reasonably concluded has been that perhaps "the imagery was, in part, misunderstood and here misrepresented."[29] The present study will argue that the Brescia Casket has a coherent program, readily intelligible in its major statements and richly nuanced. While the case for this thesis will include recovering the interpretive strategies and focal Christian concerns of the fourth century, this case must begin with the visual facts of the artwork itself.

26. Watson, "Program of the Brescia Casket": Synagogue scene, 285; reclining Jonah, 291-92; Ambrose as designer, 293; quotation about New Testament register on the front, 286; Ambrose not martyred, 292; miracles, 288; hemorrhissa, 285; Sapphira and Justina, 292.

27. E.g., see Grabar's final assessment of the Brescia Casket as a series of unrelated images; *Art de la fin de l'antiquité*, 1:509, discussed below in Chapter Three. Thomas F. Mathews characterizes the long-prevalent view of much Early Christian art (a view he counters) as showing "no effort to connect one image to another to create a larger programmatic whole. To borrow a musical term, we might call them 'staccato' images, a word that refers both to the brevity of a note and its separation from other notes"; *Clash of Gods*, 13, with a sound critique of other terms, in n. 18 on p. 184. In this book Mathews offers a cogent argument against the longheld view that all Early Christian art was patterned on imperial models. Unfortunately he mixes brilliant argument (e.g. 75-77, 92, 95, 142-43) with shallow concessions to trendiness (e.g. 48-49, 98, 128) and memorable turns of phrase (e.g. 95, 177) with flippancy (e.g. 92, 97). "Staccato images" is one of his useful coinings. See also the reviews of Mathews by Kleinbauer, Schlatter, and Brown.

28. Interestingly, the presence or absence of meaning is also debated regarding third-century pagan sarcophagi, and it has been necessary to assert of them also, "The images are [not] wall-paper"; Kampen, review of Koortbojian.

29. Tronzo, *Via Latina Catacomb*, 77.

The Visual Facts

Logic requires that any interpretation of a work of art must account for its visual facts: for the casket, this entails its images, their arrangement, evident parallels and patterns of design, and even, to some extent, proportion. (The dimensions of the casket and of its Old and New Testament registers are given above.) In the case of an image that is innovative—and the casket has several—other artworks will be cited in order to demonstrate the newness of what is on the casket. Because many of the images on the casket depict specific biblical passages, the details and sequence of the images will be compared to the details and sequence of the passages, for this discloses part of the pattern of the casket's design.

The following description records my identifications of the various images; where necessary, notes here and throughout the book call attention to crucial points of disagreement with other scholars. Beyond that, the reader can consult the Table of Identifications at the end of this volume. So complex is the history of interpretation of the casket, that, as an aid to understanding it, this table presents the various identifications of the sixty-one separate images which have been suggested, starting with the anonymous document of the eighteenth century and including books and articles devoted to the Brescia Casket as well as scholarly works which consider the casket along with other works of art. The table follows the physical arrangement of the casket, face by face, register by register, image by image. For each image, every proposed identification is listed. Under a given image, each identification is listed in the order in which it was proposed, with its adherents cited in chronological order, the earliest first. The present author's identifications are found in the body of this volume, not in the Table.

The specific images are as follows.

The Cover. On the lid (Fig. 3) under the narrow band of birds, five scenes in two registers depict events leading up to but not including the Passion of Christ. Pilate's washing of his hands is recorded only in the Gospel of Matthew (27:24), but otherwise all the Gospel accounts are relevant to the depictions on the lid (Matt. 26-27, Mark 14-15, Luke 22-23, John 18). Notably, as discussed in detail in Chapter Three, the five historically ordered scenes comprise the longest narrative sequence of the events of the Passion depicted through the early fifth century.

In the upper register, in the left, is Jesus in the Garden of Gethsemane, represented by two trees flanking him. The arrest of Jesus by five soldiers comes next. That is, the designer of the casket chose not to use the betrayal, even though Judas's kiss was one of the first events of the Passion narrative to be depicted.[30] Instead of showing Jesus passively accepting betrayal, the artist pre-

30. Judas's betrayal is depicted on, for instance, several fourth-century sarcophagi, the ciborium at San Marco in Venice, an early-sixth-century mosaic at Sant' Apollinare Nuovo in Ravenna, an ivory diptych (ca. 870) made in North Italy, and the late-twelfth-

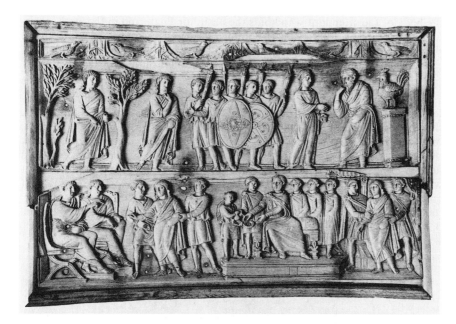

FIGURE 3. The lid of the Brescia Casket.

sents Christ actively making himself known to the soldiers by pointing to himself.[31] The third scene in the top register is the denial of Peter. He is being addressed by the woman servant; behind him, on a pedestal, is the cock, whose crow stung him with the realization of his denial of Christ. Here, too, the artist has not taken the usual course. The usual scene, which survives in scores of Early Christian examples, especially on sarcophagi, is "the annunciation of the denial" in which Christ foretells it to Peter. To create a chronological sequence of scenes of the Passion narrative, the artist has innovatively adapted the earlier depiction of the annunciation of the denial in order to portray the denial itself.[32] The lower register is evenly divided between two judgment scenes: at the left, a seated Caiaphas points at Jesus, who is held at the forearms by two guards who flank him; at the right, a seated Pilate, backed by four attendants and a serving boy with pitcher and basin, washes his hands, signaling this as the moment when he asserts, "I am innocent of the blood of this just man" (Matt. 27:24), while at the right stands Jesus, held as before by two guards. A vertical line through the center of the lid is indicated in the lower register by

century bronze door of the cathedral at Benevento; Henri Leclercq, "Judas Iscariote," *DACL* 8.1:255-79, figs. 6394-99, and Schiller, *Iconography*, 2:51-56 and figs. 158, 274-78.

31. Schiller, *Iconography*, 2:52.

32. S. A. Callisen discovered this adaptation; "Iconography of the Cock on the Column," 161, 175. See also Millet, *Iconographie de l'Évangile*, 345, and Stommel, *Ikonographie der konstantinischen Sarkophagplastik*, 128.

the body of the attendant who holds the basin for Pilate and in the upper register by the central soldier of the five in the Garden, who holds a prominent oval shield, the device of which, a four-pointed star, has a strong vertical axis. In each register, the outer figures face toward the center of the register.

The Front. On the front of the casket (Fig. 4), the top Old Testament register comprises a balanced pair of Jonah scenes flanking the lock. On the left, the prophet is precipitated into the sea-monster (Jon. 2:1), from whose coils, on the right, he emerges (Jon. 2:11). Not only are these scenes the same size, but in each one Jonah is placed near the center of the register, the creature's head is toward the center and his tail toward the edge, and the bulk of the boat with its six occupants in the first scene is balanced by the creature's maze of coils in the other. Three quarters of the length of the first scene is spanned by the boat, the point of its stern set in the outer corner of the depiction. The same portion of the second scene is spanned by the body of the serpentine monster, whose raised tail is set in the outer corner.

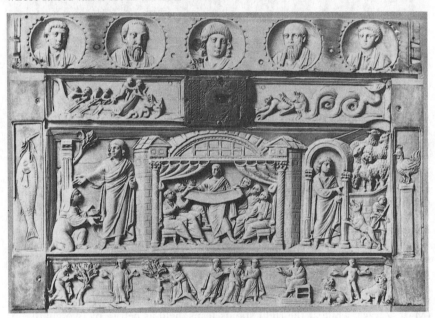

FIGURE 4. Front of the Brescia Casket.

With a balanced outer half and a dynamic inner half, this pair of complementary scenes is designed to draw the eye to the inside of the register, and then down. In the first scene, the outer half has strong horizontal and parallel diagonals, pointing to the inner half of the scene. The heads of the four seated men in the boat—the steersman holding the horizontal rudder and the three rowers with their parallel oars—form a horizontal line, matched in the right-hand scene by the level of the top of the whale's two coils and its tail. In each

coil the downward curl balances the diagonals of the oars. The inner half of the first scene depicts two men casting Jonah over the prow of the boat into the monster's gullet. The knees of the man on the left are both bent, showing that he has just run up to eject Jonah, who appears to be diving into the whale: the prophet's legs are separated, flailing, and his arms and head are already inside the monster. A strong downward diagonal is established by the hurrying man's head, which impinges on the upper border of the panel, and especially by Jonah's body. This diagonal points to the head of Christ in the New Testament register below. In the righthand scene, the inner portion is filled with the head and gaping jaws of the sea-monster and the emerging body of the prophet as he is vomited forth, arms extended, with head and torso visible. Again Jonah's body establishes a downward diagonal from the tip of the monster's upper jaw through Jonah's back, shoulder and extended arm. And again this diagonal points to the head of Christ.[33]

The central register—one of the three on the casket to use architectural dividers[34]—depicts on the left, Jesus's healing of the woman with the flux of blood; in the center, Jesus preaching in the synagogue; and, on the right, Jesus the Good Shepherd.[35] The story of Jesus healing the woman with the flux of blood is recorded *within* the account of Jairus's daughter (Matt. 9:18-26, Mark 5:22-34, Luke 8:40-56). Christ is on his way to the ruler's house when the woman touches the hem of his garment. In the account in Matthew, Jesus turns to her, encouraging her, and as he speaks she is healed (vv. 20-22). This is the instant portrayed on the casket's front (compare the representation of this event on a tree sarcophagus now at Arles, Fig. 11).

Passing over the central scene for a moment, consider the casket's unusual presentation of the Good Shepherd: it depicts John 10:1-16 specifically, a point rarely recognized and never explained.[36] Moreover, the Brescia Casket appears to be the first depiction of this passage, which is otherwise not por-

33. I am grateful to Timothy C. Graham for calling my attention to the diagonals which point to Christ. For discussion of the significance of there being seven men in the boat, see Nordström, "Jewish Legends in Byzantine Art," 502, and Narkiss, "Sign of Jonah," 63. The seven figures in the synagogue and in the furnace share this meaning.

34. The architectural features of two registers form one of the artist's means of making the two visually analogous, as befits their content, while the pillar in the third case is his means of establishing a strong center line vertically for the entire panel, something this artist does for each face of the casket. For the contrasting view that the use of architectural dividers on the casket is "unsystematic" and shows a lack of conscientiousness on the part of the decorator, see Watson, "Program of the Brescia Casket," 284.

35. Osker Wulff considers the Brescia Casket's pairing of the scenes of Jesus's preaching and of the Good Shepherd to be traditional ("im traditioneller Zusammenstellung"); "Geschichte der altchristlichen Kunst," 220. To support this, however, he cites only four sarcophagi; 306. That is, he demonstrates precedent rather than tradition.

36. Maskell, *Ivories*, 144. Watson, "Program of the Brescia Casket," 285 cites the correct scriptural reference, but neither scholar explains the pertinence of the source and Watson does little more than note that the scene is not "usual" in that the shepherd confronts the wolf.

trayed until the eleventh century.[37] A variety of scriptures from Old and New
Testament support the symbol of Christ as the Good Shepherd; these include
the 23rd Psalm, Isaiah 40:11 (famous now from Handel's setting), John 10:1-
16 and Luke 15:3-7.[38] Often the Shepherd is depicted in Early Christian art
with a sheep slung over his shoulder;[39] often he stands or sits in the midst of
the sheep in an unenclosed pastoral setting, as in the lunette mosaic in the
Mausoleum of Galla Placidia and the apse mosaic in S. Apollinare in Classe,
both in Ravenna.[40] On the casket, however, the artist has included several de-
tails from Jesus's self-description in John 10:1-16, a passage which foresha-
dows the passion by speaking of how the Good Shepherd is the one who will
lay down his life for his sheep. The distinctive depiction on the casket places
the flock inside a protective enclosure with an arch as entrance. Christ stands
within the arch. This depicts his repeated statement that he is the door itself
(vv. 1,7,9) as well as his assertion that he enters by the door, the action which
identifies him as the true shepherd in charge of the sheep (v. 2). He is shown
warding off the wolf, from which the hireling is shown fleeing (vv. 12-13).[41]

37. Scanning the two drawersful of cards on "Shepherd: Good" in the Princeton In-
dex of Christian Art (hereafter ICA) confirms that most depictions show him flanked by
sheep or with a sheep on his shoulders. The Index categorizes the scene on the Brescia
Casket as "Christ: declaring Himself Good Shepherd" (John 10:11-16) and includes in
this category eight other examples, eleventh- through fourteenth-century, e.g., a thir-
teenth-century lectionary from Sainte Chapelle showing a shepherd warding off a wolf
and other predators, with the flock nearby; Paris, B.N. lat. 17326, fol. 99. For "Christ:
Parable, Good Shepherd" (Luke 15:3-7, Matt. 18:12-13) eleven depictions are identified,
again eleventh- through fourteenth-century.

38. Scriptures pertinent to the symbol of Christ as the Good Shepherd include Pss.
23:1 and 80:1; Isa. 40:11; Jer. 31:10, 43:12, 49:19, 50:44, 51:23; Ez. 34:23; Zec. 11:16,
13:7; quoted in Matt. 26:31 and Mark 14:27; John 10:1-16, Luke 15:3-7; Heb. 13:20; 1
Peter 2:25 and 5:4.

39. On the image, see Alexander P. Kazhdan et al., "Good Shepherd," *ODB* 2:860;
for its meaning, see also Dulaey, "Brebis perdue dans l'Église ancienne." The sheep over
Jesus's shoulder can recall the retrieval of the one lost sheep in Luke 15:3-7. The methods
of carrying described in Isa. 40:11 are different. On the popularity of this symbol in the
century before Constantine, see Syndicus, *Early Christian Art*, 21-23. At the baptistery in
Dura Europos (232) above the font was the Good Shepherd with twelve sheep; ibid. 14.

40. Christine Smith, *Ravenna*, color plates on pp. 20 and 97. Also Wilpert and Schu-
macher, *Römischen Mosaiken*, pl. 73.

41. The earliest description identified the animal that is jumping up as a wolf (see
Kollwitz, *Lipsanothek von Brescia*, 8), and most scholars have construed it thus. Odorici
(1845, p. 83), however, interpreted it as a faithful dog to whom Jesus was entrusting the
flock. A few other scholars, most of them recent, also consider the animal a dog: Henri
Leclercq, "Brescia," *DACL* 2.1:1154 and fig. 1625; Watson, "Program of the Brescia
Casket," 285; Milburn, *Early Christian Art*, 239. See also Table of Identifications. As
the scene on the casket matches the details of John 10:1-16 so well, it seems best to con-
strue the animal in the foreground as the harrying wolf the Good Shepherd defends the
flock from (vv. 12-13).

The central scene depicts Christ teaching. All scholars agree on this. Depictions of Christ as teacher recur in the late third and early fourth century, and he is often shown holding a papyrus roll, as in the catacombs.[42] But these scenes have only a generic likeness to the fully developed depiction on the Brescia Casket. The distinctiveness of the scene on the casket has led to a variety of specific interpretations of it. Several scholars have seen it as Christ teaching his apostles,[43] but Delbrueck is correct that the faces in the scene do not match the bust portraits on the casket,[44] which rules out this interpretation. The casket's strong focus on the Passion narrative surely influenced those critics who construed the scene as occurring during Holy Week or after Christ's ascension.[45] But the event which best fits the depiction of the casket is Christ preaching in the Synagogue at Nazareth and reading from Isaiah an utterance which he fulfils: "The Spirit of the Lord is upon me."[46] Tellingly, the artist has cap-

42. See Syndicus, *Early Christian Art*, 26. On sixteen sarcophagi from the fourth through sixth centuries, Christ is depicted, often seated, holding a roll or book, flanked by four to twelve apostles (ICA); for instance, Christ holds a roll, but so do five of the apostles, on the sixth-century sarcophagus at the Cathedral of Notre Dame in Clermont-Ferrand. Other examples are the fourth-century sarcophagus 46213 at the Musée Lapidaire at Arles, a fifth- or sixth-century relief, No. 5423, in the Ottoman Museum in Constantinople, and a sixth-century sarcophagus at the Church of Aphrodise at Béziers. Two ivory carvings have slight similarities: Christ holds a roll in his left hand on pyxis no. 563 (3rd-6th cent.) in the Staatliche Museen in Berlin; seated on a throne, he reads from a book on a lectern to twelve seated men within a synagogue of elaborate architecture on the ninth- or tenth-century plaque in the Musée Historique in Orléans. The general arrangement of exalted teacher with a gathering of disciples is derived from antique depictions of philosophers, often at a sigma table; Sybel cited by Wulff, "Geschichte der altchristlichen Kunst," 197-98.

43. Westwood, *Fictile Ivories in the South Kensington Museum*, 36; Sybel, *Christlike Antike*, 246; Kohlwitz, *Lipsanothek von Brescia*, 19-20; Gerke, "Plastik in der Theodosianisch-Honorarianische Zeit," 139-40; Weigand, review of Kollwitz (1935) 431; Soper, "Italo-Gallic School," 177; Volbach, *Early Christian Art*, 328; and Bourguet, *Early Christian Art*, 176.

44. Delbrueck, *Probleme der Lipsanothek*, 24-26. This visual fact precludes the interpretations of Schultze and Stuhlfauth as well; see next note.

45. Christ preaching in the Temple in Jerusalem during Holy Week: eighteenth-century anonymous, see Kollwitz, *Lipsanothek von Brescia*, 8; and Odorici, *Antichità cristiane di Brescia*, 44. Resurrected Christ preaching to the apostles: Schultze (1895) 279 and Stuhlfauth, *Altchristliche Elfenbeinplastik*, 44. The elaborate architectural setting seems to have indicated no less than the Temple in Jerusalem to the eighteenth-century anonymous and Odorici, and probably to the scholars who took the scene as the boy Jesus preaching before the Doctors; Kraus, *Christlichen Kunst*, 503 #19, Natanson, *Early Christian Ivories*, 24, and Panazza, *Musei di Brescia*, 57.

46. Luke 4:16-21, Mark 6:2, Matt. 13:54. This is the view of Venturi, *Storia dell'arte italiana*, 1:459; Leclercq, "Brescia," *DACL* 2.1:1154; Delbrueck, *Probleme der Lipsanothek*, 24-26; Toynbee, review of Delbrueck, 240; Watson, "Program of the Brescia Casket," 285; and Milburn, *Early Christian Art*, 239. Delbrueck suggests that the opening words from Isaiah may have originally been painted on the scroll on the casket. Also pertinent are the other synoptic accounts of Christ teaching and preaching in synago-

tured a detail specific to this event: "And the eyes of all in the synagogue were fixed on him" (Luke 4:20).

Several elements of the design combine to make Christ in this scene serenely focal on this face of the casket. He stands in the midst of the seated congregation, and the artist has aligned Christ's upright body with the lock and with his own bust portrait above and with Susanna (and one of the elders) below. In this way the figure of Christ establishes a center axis for the front of the casket. The pointing diagonals formed by the body of Jonah in each of the scenes depicted in the upper register also help focus the viewer's eyes on Christ. Two further traits of Jesus's position are notable: his arm placement and the way he holds the scroll.

Of all the surviving Early Christian depictions of Christ standing, this is the one in which his arms are raised the highest. Both are at elbow height. Though his hands are not as high as those of Susanna and Daniel, both orant in the Old Testament register below, Christ's hands are as high as those of some of the figures in the fiery furnace, depicted on the right side of the casket. The visual fact of Christ's stance matters because the casket was carved decades before the first depiction of the crucifixion (see Chapter Three), and as yet Christ was very rarely shown with his arms extended. The artist of the casket introduced a modest innovation by showing Christ in a stance recalling the cruciform position, i.e., with his arms spread.

They are spread because he has opened the scroll of scriptures wide. The artist deftly depicts that Christ taught with authority, which every Gospel account says impressed the people. On the casket this is conveyed by the way Christ holds the scroll and by the design of the scene. Christ holds the scroll, not of his own need: he gazes above it, not reading it. Rather, he displays it to others, opening it in a double sense. He explained it so that its meaning was opened, and he is shown holding its written surface turned toward the viewers, including those who see the casket. Fittingly, the scene is designed to focus on Christ, not the scroll. Its curved lower edge complements the curved roof of the synagogue, defining a lateral oval whose center is Christ's face. The design further strengthens the focus on his face by means of his audience: the heads of the six men who flank him, three on each side, form two ascending lines that meet at the head of Christ, at whom the men are gazing. Thus in the central scene of the central panel of the front, Christ's face is the center. This scene of Christ teaching, eloquently depicts the idea that the Hebrew scriptures, the Christian Old Testament, are opened and understandable when one focuses on Christ.

The artist has added an element to the scene which is puzzling: a pair of floor-length curtains that hang from a rail that spans the breadth of the synagogue. Each curtain has been gathered and fastened to the side, revealing the scene within. Neither the Gospel accounts nor the focussing lines the artist constructs within the scene require this veil. Yet the designer of the casket has added it, and we should not hastily dismiss it as purely decorative.[47]

gues, for they relate that he spoke with authority and impressed the people: Matt. 4:13 with 7:28, Mark 1:21-22, Luke 4:31-32.

47. Delbrueck is one of the few critics who even mention the curtain: "ein zweiteiliger Vorhang, nach den Seiten gerafft." He describes the scene and its architecture carefully and refers the curtain to manuscript images indebted to the ancient theatre; *Probleme*

Seven figures people this scene: six listeners and Jesus. The use of the number seven here may be related to its use in the first Jonah scene. In each scene, the focal figure—Jonah or Christ—is with six others to form a group of seven. Perhaps in the scene of Christ the Teacher the number again indicates that all of humanity is intended, this time as the recipient of his saving word. Moreover, the focal figures of Jonah and Christ are central in the carvings of their respective registers: Christ is the central figure in the middle scene on the front New Testament register, and the two Jonah figures are the centermost figures in the top Old Testament register; further, the strong diagonals of Jonah's torso as he is swallowed and of his arms as he emerges point to Christ in the register below. Finally, each scene on the casket that depicts seven people appears to be a scene literally or typologically depicting Christ with a body of people he ministers to or dramatically saves.

The central register as a whole is spanned by a complete arch. It rises through the spine and hand of the kneeling hemorrhissa on the left, through the extended arm and shoulders of Jesus into and through the arched vault of the synagogue and on to the figure of Christ in the right-hand scene, whose arm is extended to the right, warding off the wolf whose body carries the eye down to the ground. This arch is not perfect, and the synagogue's outer walls are neither exactly symmetrical nor precisely centered in the register, but harmony and completeness are conveyed. This panel was well designed to be front and center, which befits the content of this central register, for the artist shows his audience Christ the healer, Christ the teacher, and Christ the Good Shepherd; generous power, benign authority, and protective beneficence shown in direct contact with his people.

The bottom register of the front depicts Susanna (Dan. 13) and Daniel in the Lions' Den (Dan. 6 and 14). First Susanna is shown orant in the garden, an eager elder behind each of the trees that flank her, each elder depicted striding toward her, leaning forward with arms outstretched in his desire to capture her; then Susanna is depicted again, held by the elders before a seated Daniel whose hands are raised in gestures of speech; this is the moment when she, condemned on false testimony and being led to execution, is divinely vindicated when Daniel declares her innocence, saying, "I am clean of the blood of this person." On the right of this register stands Daniel orant between two lions who are rather sedate compared to the two elders, for the lions are sitting, their bodies oriented away from Daniel; only by turning their heads over their shoulders to face him do they indicate danger. The obvious symmetry here is of two serenely orant figures, Susanna and Daniel, standing between those figures which menace them.[48] It appears the artist is deliberately contrasting the

der Lipsanothek, 25-26. Soper considers the curtain possibly added to clarify that the figures are indoors; "Brescia Casket," 284. Without mentioning the curtain, Watson ("Program of the Brescia Casket," 285) describes the setting as "stage-like." The same sort of curtains, including rod and tie-back arrangement, is frequently depicted in late antique art; Weitzmann, *Late Antique and Early Book Illumination*, 11-12, figs. IV-V, pl. 3.

48. These two orant figures, tranquil though menaced, appear together elsewhere in art: they constitute the entire decoration of a wooden comb, carved before 700, now pre-

elders to the lions, for the men, who should have restrained themselves, failed even to try to do so, while the ravenous, starved beasts, who could not have restrained themselves, were made docile by God.

The symbols bracketing the central register are, on the left, a fish, caught and hung, and, on the right, a cock on a pedestal, like the one on the lid in the scene of Peter's denial. While fish are frequently depicted in Early Christian art, the hanging fish of the Brescia Casket is unusual, perhaps unique.

The Right Side. On the right side of the casket (Fig. 5), the top register depicts the call of Moses (Moses and the Burning Bush, Exod. 3:1-6), the Three Hebrews in the fiery furnace (Dan. 3), and Moses receiving the Law (Exod. 24:12-18).[49] This register is discussed in detail in Chapter Six. As William Tronzo has noted, the latter depiction is unusual in that the Law is not being delivered from heaven into the hands of Moses, but lies on the ground before Moses.[50] The pillars which separate the three scenes indicate the walls of the fiery furnace. In it in an unusual depiction the holy trio is shown twice: bound, in the background, and, in the foreground, arms outstretched in prayer and in the company of the angel who is "like unto the Son of Man." The flames are knee-high, as are the flames around the Three Hebrews in a contemporary work in Constantinople.[51]

The figures of Moses in the outer scenes are arranged symmetrically, which recalls two traditions of depictions of Moses. Moses and Abraham appear as a balanced pair framing a central medallion on numerous fourth- and fifth-century sarcophagi: Moses reaching up to receive the law from the hand of God is balanced by Abraham, his arm raised to sacrifice Isaac, but halted by the hand of God.[52] Also, the precise pairing found on the Brescia Casket, i.e. Moses and

served in Berlin, Staatliche Museen, no. 1.3263. In the center of the obverse of the comb Daniel is orant between two lions; on the reverse, Susanna appears in the same position with the elders depicted as two lions; Wulff, *Altchristliche und mittelalterliche byzantinische und italienische Bildwerke*, 1:288, pl. 9-10. On depictions of Susanna in the catacombs and on sarcophagi, see Kathryn A. Smith, "Susanna in Early Christian Art."

49. Below, in Chapter Five, a far more detailed analysis of the visual facts of the central scene is provided; also see Chapter Six for more details of the Moses scenes.

50. Tronzo, *Via Latina Catacomb* 77.

51. Klaus Wessel, "Jünglinge im Feuerofen," *RBK* 3:670, describing a "Schrenkenplatte" of ca. 400.

52. Of the nine instances cited here, four are in the Vatican's Museo Cristiano, and one each in the Cimiterio di S. Sebastiano and the Cimiterio SS. Marco e Marcelliano; for plates and description, see Deichmann, *Repertorium der christlich-antiken Sarkophage*, vol. 1: 33-39, 43-45, 116-19, 252-53, and vol. 2: pl. 12, 13 (twice), 15, 45, and 94. See also the Two Brothers Sarcophagus and a Roman sarcophagus of ca. 340, now at Syracuse, Museo Archeologico Nazionale; Beckwith, *Early Christian and Byzantine Art*, 27, 29, and Grabar, *Early Christian Art*, 243. This symmetry is also on Sarcophagus 3 of the Musée Lapidaire at Arles; Benoît, *Sarcophages paléochrétiens d'Arles*, no. 44 on p. 47 and pls. XVI.1, XVIII.1. See also H. Leclercq, "Moïse," DACL 11.2:1655-86.

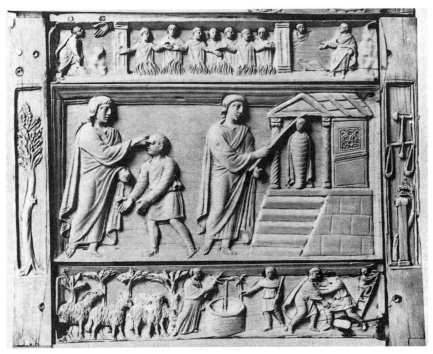

FIGURE 5. Right side of the Brescia Casket.

the Burning Bush and Moses receiving the Law, occurs elsewhere so often that Kurt Weitzmann deemed it traditional.[53] On the Brescia Casket these two scenes are depicted symmetrically so that in each one Moses faces the center of the register, gazing at the symbol for God–the hand of God and the face of God in a cloud–which are put in the inner top corner of these scenes. Thus an arch, albeit a vertically compressed–i.e., flattened–one, spans this register, too, running through the figure of Moses to the symbol of God, straight across the top of the fiery furnace, and down through the symbol of God and the other figure of Moses. This further links the two theophanies to Moses already associated by symmetry.

53. He compares the pairs of scenes–Moses and the burning bush and Moses receiving the law–in the frescoes at Dura Europos (244/45-56) and the sixth-century mosaics at Mt. Sinai, where they fill the same positions, "right and left above a central niche, in the synagogue above the Torah shrine, and in the Christian Church above the apse. This parallel in the programmatic layout in the central part of a cult room can hardly be explained as a chance duplication but points to a common tradition." He also finds the pairing in the two major manuscripts of the *Christian Topography* of Cosmas Indicopleustes; Weitzmann and Kessler, *Frescoes of the Dura Synagogue*, 35 with nn. on p. 38. For excellent plates of the Sinai mosaics, see Weitzmann, "Crusader Icons on Mount Sinai," 15 (on date) and pls. 126-27 (color) and 182-86b (black and white).

Because the vertical compression here allows only a suggestion of the beautiful arch on the front of the casket, a comment on the proportions of the casket is in order, for these proportions cause the compression. In addition, they affect the depiction of three scenes on the sides of the casket. Never, however, have the proportions of the registers on the front and back of the casket been compared to those of the registers on the sides. Specifically, the central, New Testament register on the front and back measure approximately 10 cm. high by 31 cm. long, and the Old Testament registers on the right and left sides measure approximately 4.5 cm. high by 22.5 cm long. To be proportionate to the central front New Testament register, an Old Testament register of only 4.5 cm. in height would be only some 16 cm. wide, whereas the side registers are nearly half again as wide. As a result, any visual patterning of a side Old Testament register after the front (or back) New Testament register must involve considerable vertical compression, or horizontal stretching. The design difficulties resulting for the artist are much greater when it is recognized that several of the Old Testament biblical events (such as those involving Moses) that are depicted in horizontally stretched spaces on the Brescia Casket, are characteristically depicted elsewhere in Early Christian art in upright rectangles, not horizontal ones.

This vertical compression also helps explain anomalies in two of the scenes on the sides of the casket. On the right side, in the depiction of the Three Hebrews, the figures in the fire seem to be too short for their breadth, which is exaggerated in their orant positions. This apparent shortness has misled some scholars, who have thus considered the figures to represent the Band of Korah, depicted in the instant when they had begun to be swallowed by the earth.[54] Also on the right side, in the depiction of Moses receiving the Law, Mount Sinai is behind Moses. That is, Sinai is opposite the face of God, not under it, an anomaly scholarship has ignored. Presumably the artist considered it essential to include both the face of God and the mountain, but as the vertical compression of the scene would have made it difficult to represent both intelligibly if together, he separated the two. Most Early Christian depictions of Moses receiving the Law, as well as the one at Dura Europos, are higher than they are wide, whereas the scene on the Brescia Casket is much wider than it is high; displacing Sinai also allowed the artist of the casket to use the unusually broad space created for this scene by vertical compression. The third scene affected by vertical compression is David confronting Goliath, which will be discussed below.

Returning, then, to the right side of the casket and the top Old Testament register, note that this register and the central front one are the only two on the casket with architectural dividers which simultaneously separate three scenes and also define the setting of the central scene. Also, each of these two registers is spanned by an arch. Finally, each has seven figures in the middle scene. Any interpretation of the casket should account for these visual parallels.

The central register on the right side is filled by two miracles: Jesus healing a blind man and the raising of Lazarus. In each case, Jesus is to our left in the

54. For a discussion of the much-debated identification of this scene, see Chapter Five.

scene and is much taller than the man he miraculously aids. The blind man lifts his arms halfway towards Jesus in supplication as the Lord lays a finger of his right hand on a blind eye (as in John 9). In the raising of Lazarus, Christ touches Lazarus's head with a rod,[55] the once-dead man stands, wrapped in cerements, at the entrance to an elaborate tomb, its architecture borrowing its roof and pillars from the Synagogue on the casket's front.[56] The pairing of the scenes is not haphazard, or a chance selection of any two miracles. Just as the Good Shepherd on the front of the casket depicts John 10 specifically, so the right side of the casket represents the particular account of John 11. That Gospel records that some onlookers mocked Jesus, for *if he could heal a blind man*, could he not have prevented this man's death (John 11:37)? Jesus then proceeded to call Lazarus forth with a loud voice, and the dead man comes from the tomb, wrapped in winding cloths (vv. 43-44). On the casket, these two scenes appear in narrative order (Figs. 4-5). In short, on the Brescia Casket the onlookers' mocking reference to the healing of a blind man is transformed into praise of the Lord who not only heals but also resurrects his people.

It is worth noting that several other Early Christian works may express the same praising reference to John 11 by depicting both the resurrection of Lazarus and the healing of the blind man. While this is unlikely on works where the two subjects simply appear separately among many depictions,[57] elsewhere the pair of scenes are linked visually. For instance, they are sometimes placed diagonally across from each other[58] or form a pair flanking a central figure.[59] On some frieze sarcophagi and a reliquary the two scenes are side by side.[60]

55. Grounding her discussion in patristic commentary, Martine Dulaey explains the rod in Early Christian art as a symbol of God's efficacious power; "Symbole de la baguette dans l'art paléochrétien."

56. Soper, "Brescia Casket."

57. For seven sarcophagi showing both scenes but not side by side, see Deichmann, *Repertorium der Christlich-Antiken Sarkophage*, 1:18-19 and vol. 2, pl. 7 no. 21; 1:22 and vol. 2, pl. 8 no. 25a; 1:37-39 and vol. 2, pl. 13 no. 42; 1:252-53 and vol. 2, pl. 94 no. 625 (Deichmann differs from my identification, but Dinkler identifies the scenes as I do); 1:271-72 and vol. 2, pl. 102 no. 674—see also Bourquet, *Early Christian Art*, 7 for black and white photograph; 1:317-18 and vol. 2, pl. 122 no. 771, and 1:383 and vol. 2, pl. 146 no. 919.

58. Diagonal placement is found on a fifth-century ivory diptych and a fourth-century bronze casket; diptych, Victoria and Albert Museum, A47, 47a-1926: Longhurst, *Catalogue of Carvings in Ivory*, 30-31; reliquary, Budapest, Magyar Nemzeti Múzeum, Inv. Nr. 64/1903-19, 20, 21, 23, 24: Buschhausen, *Spätrömischen Metallscrinia und frühchristlichen Reliquiare*, vol. 1, no. A 65, A Tafel 69.

59. This occurs on a sarcophagus (Deichmann, *Repertorium der Christlich-Antiken Sarkophage* 1:13-14 and vol. 2, pl. 5) and on an ivory book cover from Murano, in Ravenna, the National Museum; Morey, *Early Christian Art*², pl. 93 and p. 275.

60. Two of the fourth-century sarcophagi are at the Museo Nazionale Romano: no. 770 has the two scenes in the far right of its bottom register, and no. 772 has them in the far left of that register; see Deichmann, *Repertorium der Christlich-Antiken Sarkophage* 1:316-18 and vol. 2, pls. 121 and 122. The third sarcophagus is also in Rome, at the Cem-

One side of a fifth-century ivory comb is devoted to the pair of scenes; on the other side is Christ on a donkey.[61] Similarly, on the Brescia Casket the juxtaposition of the two scenes is emphasized by the fact that together they fill the register.

The bottom register on the casket's right side has a trio of Jacob scenes. The left half of the register is filled with the flock of sheep which Rachel tends at the well, which is at the center of the register. Immediately to the right of the well, Jacob stands, facing Rachel (Gen. 29:1-12) and holding a rod in his hand.[62] Crowded beside Jacob is the scene of his struggle with the angel, who is reaching for Jacob's leg and is just about to shrivel his thigh with a touch (Gen. 32:24-32). On the far right is the ladder Jacob dreamed of and commemorated with an altar at the spot, which he named Bethel (Gen. 28:11-19). Here, however, it is Jacob, not the angel who climbs the ladder.[63] This point should be explained, for "[d]epartures from the scriptural version of events are always significant; they are red flags signalling the intervention of some special concern beyond the obvious storytelling interest."[64] The three scenes are not in historical order, either, as they depict Genesis 29, then 32, then 28—again, a departure from the scriptural account. Formally one notes a strong vertical center-line in the design of this side of the casket, too, indicated by the well, the figure of Jesus calling forth Lazarus, the overlapped figures in the furnace, and the central apostle on the edge of the lid.

The symbols flanking the central register are a tree and, on the right, scales over a pillar with a vine, or a grave stele.[65]

The Back. Jonah, Susanna, and Daniel—who each appear twice on the front of the casket, their appearances filling the Old Testament registers there—each appear once, together filling one register, on the back (Fig. 6). (The top register, like the corresponding edge of the lid above it, has undecorated areas occu-

etery of S. Lucina, and dates from the second half of the fourth century; ibid. 1:33-34 and vol. 2, pl. 12 no. 39. See also the fourth-century metal reliquary at Bonn, Rheinisches Landesmuseum, Inv. Nr. 1697; Buschhausen, *Spätrömischen Metallscrinia und frühchristlichen Reliquiare*, no. A54 and A Tafeln 62-63.

61. The comb, found at Antinoë, is now at the Coptic Museum in Cairo; Beckwith, *Early Christian and Byzantine Art*, 70, pl. 54A-B.

62. Rachel and Jacob here form a "quite obvious" parallel with the depiction in the Via Latina catacomb, a scene identified as Jesus and the Samaritan woman meeting at Jacob's well (John 4:6); Bargebuhr, *"New" Catacomb*, 79 and Taf. 42.

63. Westwood, *Fictile Ivories in the South Kensington Museum*, was evidently the first (and perhaps only other besides the present author) to note that it is Jacob, not the angel of the biblical account, on the ladder; see also John H. Lowden and Catherine Brown Tkacz, "Jacob's Ladder," *ODB* 2:1030. The scene can be construed as spiritual ascent and as a type of the Crucifixion; see Chapter Three, under "Jacob."

64. Mathews, *Clash of Gods*, 54-55; for the vivid example of Pharaoh dressed as a Roman emperor when drowning in the Red Sea, see p. 76. He also notes (p. 68) that the specific moment the artist has chosen to depict for any given biblical event is important.

65. Stuhlfauth (*Altchristliche Elfenbeinplastik*, 41) and Watson ("Program of the Brescia Casket," 289-90) term it a grave stele.

pied by the hinges.) On the left in the top register is the vindicated Susanna (cf. Dan. 13:63), orant, between two trees, just as she is on the front lower register. Then Jonah is shown asleep under the gourd, and finally, Daniel is depicted poisoning the dragon (Dan. 14:27), a scene Gary K. Vikan has described as "highly unusual in Early Christian art."[66]

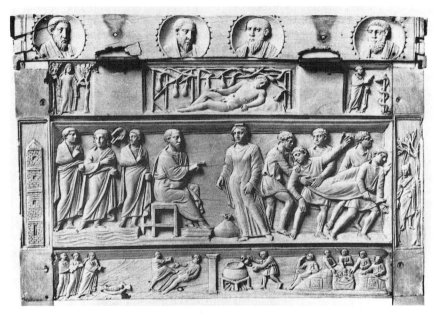

Figure 6. Back of the Brescia Casket.

The central register depicts the Transfiguration and the only New Testament scene on the casket which is not from the Gospels: Peter with Sapphira and Ananias. The Transfiguration is recorded in the synoptic Gospels (Matt. 17:1-9, Mark 9:2-9, Luke 9:28-36). The casket shows Christ flanked by Moses and Elijah, with the cloud of the glory of God depicted as wavy lines beneath their feet. (Bear in mind that in a carving, especially of small figures, it would be impossible to show an enveloping cloud without obscuring the figures within it.) The hand of God deftly denotes the presence of God in the specific manner required by the account: the hand, representing the voice of God which spoke during the Transfiguration, indicates Jesus, as God announces Jesus to be his beloved son and admonishes the disciples to listen to Jesus. In the Gos-

66. In Weitzmann, *Age of Spirituality*, no. 421, p. 470. Vikan was commenting on a late fifth-/early sixth-century ivory pyxis at Dumbarton Oaks. Leclercq catalogs monuments with this scene: a gilded cup in the British Museum, a glass cup, sarcophagi at Arles, Narbonne, Lyon, Mantua, and Algiers (originally from Numidia): "Daniel," *DACL* 4.1:223-24, 229-31, 240-41, 243, and fig. 3587. For additional references concerning Daniel, see Chapter Three, note 63.

pel accounts Peter and John are the witnesses to the Transfiguration; by not depicting them, the designer of the Casket has put the Christian viewer of the carving in the role of witness.

The register's other scene, depicting Acts 5:1-11, is also depicted in very much the same way on several Early Christian sarcophagi.[67] Peter is seated, pointing at Sapphira as her husband's body is borne out. Peter's leg and arm positions match those of the high priest on the left on the lid and also those of Daniel on the front; Peter's chair is also like Daniel's. These similarities are fitting, for Peter is here acting as a judge. In the New Testament account, Ananias is dead and wound in burial clothes, but on the casket he seems to gesture with his full arm and, though his eyes are closed, his face is oriented toward Sapphira. In Acts, about three hours elapse after his burial before she arrives, but on the casket his death and her judgment are simultaneous. In Acts, Peter tells her that he hears the return of the men who buried her husband and he prophesies that they will carry her out, too. The artist has devised an effective way to depict the account, for the image on the casket shows Ananias's surprise and death, but also the fact that the young men carried him out, which signals Peter's prophesy. Ananias's burial clothes were omitted to give the scene immediacy. Had the young men been shown returning, empty handed, nothing would have identified them as the ones who had carried out Ananias.

The bottom register is devoted to three sequential Moses scenes depicting events recounted in both Exodus and in Acts, in Stephen's homily before he is stoned. With the Passion registers of the cover, this Moses register is among the earliest narrative sequences in Early Christian art.[68] The finding of the infant Moses (Exod. 1:15-2:10, Acts 7:17-21) is succeeded by Moses as a young man killing the Egyptian (Exod. 2:11-15, Acts 77:22-25), and finally, Moses feasting in the house of Jethro (Exod. 2:16-20, Acts 7:29).[69] The first scene has three women, evidently Pharaoh's daughter and her maids (2:5), pointing to the swaddled Moses lying in the basket made of bulrushes. Behind and above it delicately carved lines indicate the Nile from which the basket was drawn. The next scene shows Moses pointing his right hand at and thrusting his right foot at a man who is falling down. This must be the Egyptian whom Moses saw beating a Hebrew, and therefore struck and killed. The third scene, obviously a feast, is shown by its place in this Moses register rather than by its details to be Moses in the house of Jethro. After Moses had killed the Egyptian, he fled into Midian, met Jethro's seven daughters at the well, was invited into Jethro's house to eat bread (2:20) and eventually married Jethro's daughter Zipporah.

67. Kessler, "Acts of the Apostles on Early Christian Ivories," 90-91.

68. Watson, "Program of the Brescia Casket," 284.

69. Grabar (p. 287) and Watson ("Program of the Brescia Casket," n. 30 on pp. 295-96) interpret the scene as the feast in the House of Jethro (Exod. 2:20). Westwood, *Fictile Ivories in the South Kensington Museum*, 37, suggests it may be Moses feasting his brethren. Another interpretation of it is as the feast of the quail (Num. 11:31-33). Leclercq ("Brescia," *DACL* 2: fig. 1626), following Volbach, identified the scene as the wedding at Cana, but this would put a New Testament scene in the series of registers otherwise reserved for Old Testament images, a point Watson also makes.

The details of the scene on the casket do not match the details in Exodus. The artist seems to have "plugged in" a standard feast scene to represent the feast in Jethro's house. Certainly the group of five figures seated at a crescent-shaped table is familiar from banqueting scenes on the walls of the catacombs.[70] Bread and another dish are on the table, and a servant is dipping a vessel into a cauldron over a fire; the flames are similar to the flames in the fiery furnace on the casket. This precludes the cauldron being a wine jar, so the scene cannot be an unusual depiction of the wedding at Cana, as some have thought (see Table of Identifications). The pillar that divides the register in the center serves to show that the feast occurs inside.

It is interesting that the back is the only one of the casket's five faces with a gap serving as part of the implicit vertical center-line of the surface. The bottom register's pillar is emphatic, and the top register's less-strong indication of the center is the bend in the reclining Jonah's knees and the vertical of the gourds hanging from their vine above him. In the center register, however, a blank area is in the center, separating Peter, who is judging, from Sapphira, the bag of money she had lied about at her feet. Behind Peter is the scene of the glorious Transfiguration; behind Sapphira is the corpse of her dishonest husband. The artist seems to be indicating that here is a gap indeed, a profound separation. The artist has also constructed an opposition between Susanna triumphant, in the upper left, and Sapphira, in the right half of the center register: Susanna's right foot and leg are slightly forward and her head is turned a little to her left; Sapphira's stance is the reverse of this. Susanna's arms are raised, palms open and outward in prayer; Sapphira's hands are down.

The corner posts show a tower on the left and, on the right, Judas hanging himself (Matt. 27:3-4, Acts. 1:16-18). Significantly, this is the only appearance of Judas on the casket. He is omitted from the Passion narrative on the lid, although he could have been included in the scene of the arrest, giving the treacherous kiss (e.g. Matt. 26:47-49). Now when he does appear, it is not even in a New Testament panel, but off in a post decoration, the only human to be depicted in an edge panel, and on the back of the casket at that. His placement at the far right of the back of the casket puts him just around the corner from its left end. On another ivory casket a similar depiction of Judas hanging is also placed to the left, with the earliest depiction of Christ on the cross to the right (Fig. 9).[71]

The Left Side. The left side of the casket (Fig. 7) shows, in the top register, David with the stone ready in his sling, and Goliath (1 Kings 17 = Prot. 1 Sam. 17). This scene appears elsewhere "exclusively on sculptures of Gaul and north Italy."[72] The artist indicates the giant's great height by placing him diagonally

70. Milburn, *Early Christian Art* (1988), for instance, discusses such scenes on the walls of the Catacomb of Calistus and the Catacomb of Priscilla; pp. 34-35, figs. 19-20. See also Achelis, "Totenmahle," 81-107.

71. Judas is depicted hanging in the Rabula Gospels, the Stuttgart Psalter, the Syriac Rabula Codex, and on the ciborium at San Marco in Venice; Leclercq, "Judas Iscariote," *DACL* 4:270 and figs. 6399 and 6402; Morey, *Early Christian Art2*, 105, 107; and Schiller, *Iconography*, 2:77 and fig. 323.

72. Soper, "Italo-Gallic School," 177.

in the register. As discussed above, the vertical compression of the Old Testament registers on the sides affects this depiction. Evidently the artist put the giant on the slant because the boy David already spanned the height of the register. Beyond this, the slanting of Goliath is a way of keeping the giant's head no higher than the future king's, and also adumbrates Goliath's imminent toppling, once the stone depicted in David's sling will have struck the warrior's brow. The slanting of Goliath also recalls the position of the slain Egyptian on the back of the casket.

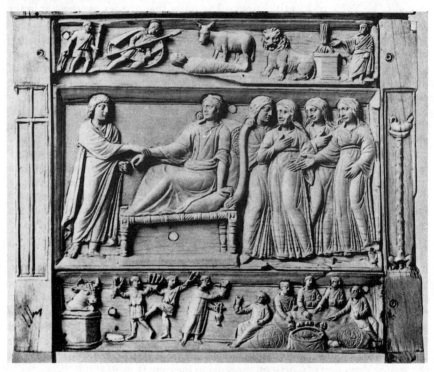

FIGURE 7. Left side of the Brescia Casket.

The next, two-part scene depicts a subject unique in Early Christian art: the disobedient prophet killed by a lion (3 Kings 13:24-28) and the earlier punishment, by that prophet, of the disobedient Jeroboam (3 Kings 12:26-13:4 and 13:32-34). The artist of the casket evidently created each part of this depiction, otherwise not known until centuries later.[73] On the right of the register is Jero-

73. Jeroboam and the unnamed prophet are so rarely depicted that no entry for Jeroboam (or Kings/Rois/Königen) is in *DACL, DMA,* or *RBK.* Réau cites only four depictions of them, the earliest being that on the casket; the others are from the thirteenth, seventeenth, and eighteenth centuries; Réau, *Iconographie de l'art chrétien,* 2.1:300-01. Cf. John H. Lowden, "Kings, Books of," *ODB* 2:1129-30. The Princeton Index identifies

boam. As in the bottom register on this side, worship of a golden calf is involved in the biblical account being depicted, although the calf itself is not represented here.[74] Jeroboam built an altar and raised up a golden calf at Bethel. (3 Kings 12:26-30). In the very place where Jacob had his dream of the ladder (depicted on the opposite end of the casket) and built his altar, now Jeroboam has erected a golden calf and prepares to offer incense to it at the altar.[75] Rebuked by the Man of God, Jeroboam stretched forth his hand across his altar and ordered that the prophet be seized, at which Jeroboam's hand was withered so that he could not draw it back to himself (13:4). The moment depicted here is not just idolatry, but angry rejection of God's word. Jeroboam is portrayed in the precise moment of his sin and its punishment: the smoke of the incense is rising from the altar and his arm is extended across it. On the casket, Jeroboam is in fact pointing across the altar toward the prophet, but the prophet is depicted in a later event—his own death.

Shortly after the prophet obediently confronts Jeroboam, and, at his request, prays for his healing, which God grants (13:6), the prophet himself goes against the word of God (8-22). A lion then kills him on the road, and the lion and the ass that the prophet had been riding stand by the body (vv. 24-25). To indicate that the prophet is dead, the artist depicted him in cerements. To show that this was divinely arranged, scripture records that "the lion had not eaten of the dead body, nor hurt the ass" (v. 28) which waited by the body. This accounts for the demeanor of the ass and the seated lion, who, like the lions which flank Daniel on the front of the casket, are restrained providentially.

Notably, each man in this two-part scene is shown in a way recalling both his disobedience and also his punishment. The two halves of this narrative scene would not be intelligible separately. We would not be sure it is Jeroboam at the altar if the dead prophet, identified unmistakably by the lion and ass, were not nearby. In the same way, on the back of the casket, Ananias would be unrecognizable if Sapphira were not present with the bag of money. That scene from Acts is constructed so that the focal moment, centered on the register, is Peter confronting Sapphira; on the left end, again the two-part scene from 3 Kings is designed so that the focal moment is centered: the dead prophet, wrapped in cerements, is thus immediately above Jairus's daughter, rising from death, and this heightens the contrast of his providential death and her miraculous restoration to life.

21 depictions of Jeroboam other than that on the Brescia Casket: the earliest are two ninth-century manuscripts, e.g., the *Sacra parallela* of John of Damascus, Paris, B.N. gr. 923, fol. 311 (ICA). Only twelve depictions of the Man of God out of Judah are recorded in the ICA; except for the Brescia Casket, all are from the tenth through fourteenth centuries.

74. Moses Aberbach and Leivy Smolar discuss Exod. 32 and 1 Kings 12:28ff. While their underlying interest is historico-critical and thus their conclusions are not relevant to the Brescia Casket, nevertheless their analysis of the similarities between the two passages is useful; "Aaron, Jeroboam, and the Golden Calves," 129-40, esp. 132.

75. See also Jerome, *Tractatus de Psalmo 76*.9 (CCL 78, pp. 70-71), for a discussion of the golden calf at Bethel.

The New Testament register is devoted to the raising of Jairus's daughter; the miracle is recorded in all the synoptic gospels (Matt. 9:23-26, Mark 5:35-43, Luke 8:49-56), but the account of Matthew has the best "fit" with the depiction. Each account is unambiguous that when Jesus arrived at Jairus's house, the people were mourning: the daughter had in fact died. Unlike Lazarus on the right side of the casket, Jairus's daughter is not yet wrapped in the cerements which identify a corpse; instead the women with sorrowing faces, beating their breasts, are evidence that the woman Christ is raising had truly died. The mourners also serve as does the healing of the blind man on the opposite side of the casket, namely as a reminder that Jesus was mocked before he raised the dead. The synoptic Gospels all note that the people in the house scorned Jesus (Matt. 9:24, Mark 5:40, Luke 8:53).[76] When Jesus takes Jairus's daughter by the hand, the Gospel relates, she rises (Matt. 9:25, Mark 5:41-42, Luke 8:54-55); this is the moment portrayed on the casket. As in the scene from Acts on the back and the scene from 3 Kings just above, in this scene also the artist has placed the earlier moment to the right. Just as the corpse of Ananias is depicted to the right of Sapphira and Jeroboam is depicted to the right of the corpse of the Man of God, so here the mourners are shown mocking Christ to the right of the resurrection miracle. This arrangement makes Jairus's daughter central and focal in the register.

The bottom register shows the Israelites dancing and feasting before the golden calf, depicted as a head. On the left end of the scene is the idol with two Hebrews dancing before it (Exod. 32:1-4). On the right the feasting before the Golden Calf (Exod. 32:5-6, 19-20) is indicated by a typical banquet, again with five people at a crescent-shaped table as in the bottom register on the back. Fish and bread are already on the table, and the center of the register shows a standing man holding both a pitcher and a hoisted goblet and, facing him, a seated man at the table lifting his goblet for a refill. Although most scholars have construed this as two scenes, the dancing and the feasting, the dancers both look toward the table and thus clarify that this is one scene.

The symbols flanking the central register are the cross and a tall lampstand with a bird-shaped lamp atop it.[77] Characteristically, the casket's sole depiction of an actual cross is as a standard of victory with no pain of sacrifice shown. This sign of the resurrected Christ is placed immediately beside the New Testament scene of a resurrection miracle.

The Bust Portraits. The remaining images are the series of medallion portraits on the four edges of the lid. Scholarly consensus identifies the central front figure as Christ, a logical identification confirmed by similarities to the various depictions of Christ on the casket. Further, commentators generally agree that the portrait of Christ is flanked by portraits of Peter and Paul. Be-

76. Watson notes that the mourners' expressions are derisive; "Program of the Brescia Casket," 289.

77. For identifications of the right-hand symbol as a lamp, see Stuhlfauth, *Altchristliche Elfenbeinplastik*, 41, and Milburn, *Early Christian Art* (1988) 240.

yond that, most critics indicate that the other portraits probably are of apostles and evangelists; rarely does a scholar suggest which each is likely to be.[78]

Examining the visual facts of the Brescia Casket has shown that it has a number of novel depictions, as far as can be judged from comparison with extant works of Early Christian art. Several events depicted are common in Early Christian art, and they are depicted on the casket in a well-established image; among these are the trio of Jonah scenes, Daniel in the Lions' Den, and Christ before Pilate. Other events shown, however, are depicted on the casket differently from what one would expect, and the innovations appear to be deliberate: to create a historical passion sequence, the designer has modified the usual Annunciation of the Denial to Peter into the moment when Peter realizes he has denied his Lord; the Good Shepherd appears on the casket, but not in his usual stance with a sheep across his shoulders or in the midst of a calm flock; the designer has deliberately selected details from John 10:1-6 to portray, evidently for the first time, Christ's assertion, "I am the Good Shepherd." While depictions of the raising of Lazarus and of the healing of a blind man are frequent in Early Christian art, the Brescia Casket provides a rare instance of the two scenes juxtaposed, in narrative linking of the two miracles in the eleventh chapter of the Gospel of John. The two-part scene of the disobedience of the prophet and of Jeroboam from 3 Kings is apparently the first depiction of these events, and the distinctive depiction of the Three Hebrews has no visual parallel in Early Christian art. And other elements are unique to the Brescia Casket.

In addition to being highly original, the design of the casket as a whole, when referred to the biblical events it depicts, has more constants than have been acknowledged. The scenes are in fact drawn from a very few books of the Bible. The New Testament scenes all derive, not surprisingly, from the Gospels and from the Acts of the Apostles; the Acts also record, in Stephen's preaching, the events from Exodus depicted on the casket's back. The Old Testament scenes are from just six books: Genesis, Exodus, First Kings, Third Kings, Jonah, and Daniel. Moreover, each of the eight Old Testament registers on the casket contains two or more scenes, or a two-part scene, from a single biblical book, and in seven of eight Old Testament registers a pair of scenes depicts the same figure. And the Passion sequence on the lid is not alone on the casket in being chronologically ordered: in all cases but one, the Old Testament scenes are also ordered chronologically, left to right. This is true of the two Jonah scenes in the upper register of the front, the two Susanna scenes in the lower register of that face, the two Moses scenes in the upper register of the right side, the first two of three Jacob scenes in the lower register of that face, the two scenes from the Book of Daniel in the upper register of the back, the three Moses scenes in the lower register of that face, and the two parts of the Exodus scene in the lower register of the left side. The only exception is the lower register on the right side in which the last Jacob scene is out of chronological order. If the casket has a program, there should be a reason for the anomalous order of that one register.

78. For instance, Stuhlfauth (*Altchristliche Elfenbeinplastik*), Leclercq, Delbrueck, and Volbach argue for specific identifications. Watson suggests that the four portraits on the back of the casket might be Saints Gervasius, Protasius, Felix, and Nabor. See Table of Identifications.

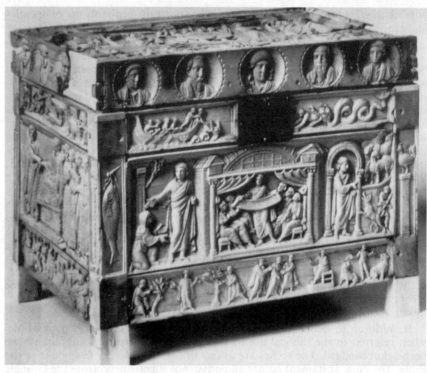

FIGURE 1

A final visual fact should be noted: when gazing at the casket, one can see more than a single surface at a time (as shown in Figs. 1, 8). The lid and the front are emphasized by position and can be seen together, along with part of one side or the other. One must turn the casket or circle it in order to see all of it. Logically, any program of decoration on the casket might well involve coordination of those images that one could see at the same time or sequentially. Thus one ought to consider the possibility of such patterns as theme and variation, parallelism, and sequence on the casket. Indeed, all of these patterns will be shown to be part of the design of the casket.

An important use of the sequence of scenes on the casket is evident on the front and sides. Note that the New Testament scenes on the sides of the casket are linked with those on the front, with which they can be seen. On the far right of the front New Testament register is the Good Shepherd of John 10 (Fig. 4), and around the corner the right side's New Testament register is devoted to John 11, the healing of a blind man and the raising of Lazarus (Fig. 5). On the far left of the front New Testament register is the hemorrhissa (Matt. 9:20-22; Fig. 4), and around the corner the left side's New Testament register is devoted to the resurrection of Jairus's daughter (Matt. 9:18-19, 23-26; Fig. 7). In short, the viewer can see simultaneously scenes that are textually linked, even, in the case of the hemorrhissa and Jairus's daughter, part of the same narrative. The

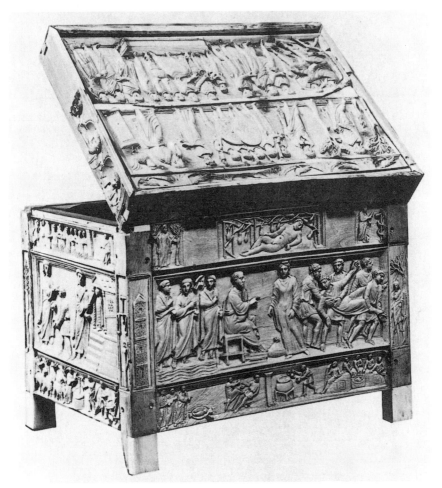

FIGURE 8. The Brescia Casket, rear view.

narrative coherence extends beyond the scope of a single face; it even wraps around the side of the casket. More significant, however, than the textual links is the shared *nature* of the events the designer of the casket has put before our eyes. Moving out from the center figure of the front, Christ with his arms extended, we move through a healing to a resurrection: through the hemorrhissa to Jairus's daughter, through the blind man to Lazarus. The full implications of these resurrections and of the Old Testament scenes which serve as prefigurations or "types" of Christ are basic to understanding the program of the Brescia Casket. Thus the next chapter takes up the interpretive method called typology and its role in the Early Christian imagination.

CHAPTER TWO:

TYPOLOGY AND THE EARLY CHRISTIAN IMAGINATION

For the designer of the Brescia Casket to draw on typology was quite reasonable and natural: as a basic exegetical technique, it was pervasive in the Early Christian church.[1] The term "type," used in both Testaments, has as its root meaning the impression made when a seal is struck; the word came to mean a foreshadowing of something fundamentally important.[2] For Christians, beginning with the writers of the New Testament, typology is the interpretation of Old Testament persons and events as foreshadowing persons and events in the New Testament,[3] and then the recognition that New Testament persons and events also are types of events in Christ's life and in the life of a Christian.[4] The post-biblical life of the Church continued to provide new types: St. Ignatius of Antioch, for in-

1. Woollcombe's "Biblical Origins and Patristic Development of Typology" remains an excellent introduction to the topic. An excellent account of typology and allegory, as well as their relevance to modern scholarship and theology, is Trigg's "Patristic Biblical Interpretation" in his *Biblical Interpretation*, 13-55. See also Hamman, "Typologie biblique chez Tertullien."

2. For etymologies, see Leonhard Goppelt, "Typos, antitypos, typikos, hypotyposis," *TDNT* 8:246-59; he cites Old Testament uses on p. 248 and New Testament uses on pp. 248-49. E. Kenneth Lee discusses *deigma, hypodeigma, typos, hypotyposis,* and *hypogrammos* as "Words Denoting 'Pattern' in the New Testament." See also Hanson, *Allegory and Event*, 37-41. The terms *antitypos* and *hypodeigma* are considered by Hurst, *Epistle to the Hebrews*, 13-14, 17-19, 138-39. See also Woollcombe, "Typology," 60-65; Selwyn, *First Peter*, 298-99; and Grant, *Letter and Spirit*, 137-39. For the classical origins of some pertinent terms, see Tate, "Plato and Allegorical Interpretation," 145-47, and Goppelt, ibid., 246-47.

3. Other, more detailed definitions of typology have also been given. See Hanson, *Allegory and Event*, 7; Charity, *Events and Their Afterlife*, 1; Woollcombe, "Typology," 39-40; Joseph W. Trigg, "Allegory," *EEC* 23-26; and Reicke, *Christian Baptism*, 74 and 103. Jean-Noël Guinot derives the rules of typological exegesis from Early Christian commentators; "Typologie comme technique herméneutique."

4. Richard K. Emmerson gives salutary emphasis to this point in his correction of Auerbach: "*Figura* and Medieval Typological Imagination," esp. 9-11.

stance, writing to the Church at Tralles ca. 107 describes the bishop as τύπον of the Father.[5]

Not to be confused with this theological typology is another, entirely different sense of the word typology. It can simply mean classification by formal traits; to avoid confusion "typology" will not be used in this other sense in this book outside this paragraph. An archaeologist may establish a typology of ceramic ware and use it to identify a piece of pottery as a Type I beaker (with one handle) or a Type II beaker (with a pair of handles). Obviously this is unrelated to theological typology.[6] A biblical scholar has constructed a "typology of parallelism" in Hebrew poetry, based on grammatical and semantic patterns in the verses of Isaiah 40-45.[7] Again, this is clearly not theological typology, even though the subject is the Bible. Typology in the sense of classification is also used to describe art, however, and this is potentially confusing. The distinction is easier to see in the case of non-Christian art. For instance, an art historian discovered that traits of depictions of Phaedra with Hippolytus and of Venus with Adonis were interchanged on some ancient sarcophagi, presumably because the scenes were formally alike, and he describes the phenomenon as "typological crossovers or contaminations."[8] In such discussions the word "typological" could be replaced by "formal" without changing the meaning. Regarding Early Christian art, some scholars discuss its typology in the sense of classifying its images according to formal traits. An example is a comparison of the meal depicted on the sarcophagus of Junius Bassus with meals depicted on a group of earlier Roman sarcophagi. The reclining diner(s), standing servant(s), and identical furniture common to all these scenes are described as "typological connections."[9] Once again, this is typology in the sense of classification by formal elements. Theological or exegetical typology–hereafter simply "typology"–is entirely different. When St. Paul wrote that Adam is a type of Christ he referred not to the fact that each had two legs and two arms but to Adam's role as an imperfect indication of what the Messiah would be.

5. Ignatius of Antioch, letter to the Trallians 3.1; *Lettres*, Gr. ed. with Fr. trans., P. Th. Camelot, O.P. Sources Chrétiennes, 3rd ed. (Paris: Éditions du Cerf, 1958) 112.

6. Warwick Bray and David Trump, "Typology," *The Penguin Dictionary of Archaeology*, 2nd ed. (Harmondsworth, Middlesex, Eng.: Penguin Books, 1972, repr. 1986) s.v. An example is Mary R. DeMaine's typology of glass grave goods from ancient Emona (in Slovenia).

7. Malcolm E. Elliot-Hogg, "The Poetry of Isaiah 40-45: A Typology of Parallelism," Ph.D. diss.: The Dropsie College, 1988.

8. "croisements ou contaminations typologiques"; Turcan, "Confusions typologiques dans l'iconographie des sarcophages romains," 445.

9. Malbon, *Iconography of the Sarcophagus of Junius Bassus*, 107-08, summarizing Himmelmann. Although Malbon notes parenthetically that here she is using typology in the sense of "shar[ing] certain formal elements and common models," it is confusing that she uses both senses of typology; Murray, review of Malbon, 689.

BIBLICAL AND RABBINIC TYPOLOGY

Christians did not invent typology; rather, they continued the revered Jewish tradition of its use.[10] Understanding that focal past events were in a sense predictive of future events in salvation history is already evident both within the Old Testament and also in many (though not all) Jewish theological writings before and of the time of Christ.[11] Typology was used by rabbinic exegetes as they considered how the Hebrew Bible forecast what the Messiah would be like and what his coming would bring about; in doing this, they were in turn following earlier biblical examples. Within the Hebrew Bible prophets refer to a new exodus, a new covenant, a second kingdom of David, a new Zion, all to come, and these types are reiterated in related Jewish texts.[12]

Jesus, and then the writers of the New Testament, drew on this tradition in order to demonstrate that Jesus was the Christ, the fulfillment of the prophesies about the Messiah.[13] Jesus relates himself to Old Testament figures including Jonah (Matt. 12:39, Luke 11:29-32) and Jacob (John 1:51).[14] He also

10. Kelly, *Early Christian Doctrines*, 71. For studies of particular areas in which the New Testament continues Old Testament typology, see Goff, "Biblical Typology: Continuity and Innovation," and Casey, "Exodus Typology in the Book of Revelation."

11. Lauterbach, "The Ancient Jewish Allegorists in Talmud and Midrash"; and Bonsirven, "Exégèse allégorique chez les rabbins tannaïtes."

12. Goppelt, "Typos," *TDNT* 8:254-55; Hanson, *Allegory and Event*, 13, 35. On Old Testament prophesies of a new exodus, see, e.g., Fischer, "Problem des neuen Exodus in Isaias c.40-55." For a general statement about the New Testament's background of a "corpus of traditional typology originally inherited from Jewish liturgical expressions," see pp. 72-73; see also Jeremias, "Mousas," *TDNT* 4a: 859-60 and Charity, *Events and Their Afterlife*, 13-80. Within the Old Testament and the Jewish Midrashim, typological patterns are also evident, as when Absalom (2 Sam. 16:22 = Vulg. 2 Kings 16:22) is seen as recapitulating Reuben (Gen. 35:22); Joel Rosenberg, "1 and 2 Samuel," 135, in Alter and Kermode, *Literary Guide to the Bible*. For a focus on those biblical passages containing the word *typos*, see Davidson, "Typological Structures in Old and New Testaments."

13. The debate over what properly comprises Holy Scripture and over the authenticity of the words ascribed to Jesus had, of course, already begun. For instance, Marcion wanted to expurgate much of what is now the New Testament (see below), and Jerome in his revision of the Latin version of the Gospels had to reinstate words attributed to Jesus that had been removed by ad-hoc editors who had not found the same passages in their defective manuscripts of the Old Testament. But irrelevant to the present study is the modern trend of the last one hundred and fifty years to parse the Bible into different temporal layers, using skeptical assumptions at odds with Early Christianity, for instance, the assumption that God cannot do prophecy; see a critique of this by Stump, "Biblical Scholarship, Philosophy of Religion." See also Pearson, "The Gospel according to the Jesus Seminar." For a summary of contemporary views regarding the authenticity of various words ascribed to Jesus, see Sloyan, *Crucifixion of Jesus*, 25-27 and passim.

14. On Jesus's use of types, see Selwyn, *First Peter* 203: "the 'type-theology' of the early Church –a form of theology which goes back in principle to such *verba Christi* as Luke xi.29-32, xvii.26-9, 32; Matt. xi.14, xvii.12." When considering the point of view

reiterates the necessity that the scriptures be fulfilled (Matt. 26:54-56, Mark 14:49, cf. Rom. 1:2). Acts has been shown to present a coherent program of fulfilled types.[15] The author of the Epistle to the Hebrews presents Abraham, Moses, Aaron, Joshua and David as types of Christ.[16] Paul uses typology and perhaps extends Jewish typology to new types, as when he describes Adam as a "type" of the one who was to come, i.e., Christ (Rom. 5:14).[17] Concerning Paul, H. A. A. Kennedy observes,

> The chief element of his education would be the art of interpreting the Old Testament according to the approved Rabbinic methods. These methods were pre-eminently allegorical or typological. Good examples in Paul's letters are Gal. iv.21-31, where he uses the Genesis-story of the quarrel between Sarah and Hagar as an allegory of the struggle between the servile religion of legalism and the freedom which belongs to the religion of Christ; and 1 Cor. x.6-11, where the temptations which overcame the Israelites in the wilderness are regarded as a direct warning written down for the sake of Christian readers in after ages.[18]

In the New Testament, Adam, Abel, Melchisedek, Jacob, Solomon, David, Jonah and Moses are among the Old Testament figures presented as types of Christ,[19] foreshadowing in various ways different aspects of Jesus's person, life, passion, and resurrection.

of the Early Christians toward the Gospels, it is irrelevant that some modern scholars of the historical-critical school view some of these words as interpolations by the evangelists.

15. "... St Luke develops the plot of Acts not just as revealing the fulfilment of isolated scriptures, but as showing an ordered fulfilment of the Torah, the heart of scripture, and of Joshua the first successor to Moses"; Goulder, *Type and History in Acts*, 174.

16. Denis Farkasfalvy, "Interpretation of the Bible," *EEC* 466. Sowers, *Hermeneutics of Philo and Hebrews*, esp. 115-26. Swetnam argues for implicit comparisons between Christ and Isaac in this epistle; *Jesus and Isaac*. On the authorship of this epistle, see Hurst, *Epistle to the Hebrews*, 4.

17. Goppelt, "Typos," *TDNT* 8:255-56. See also "Typology in the New Testament," Part 2 (pp. 81-164) in Charity, *Events and Their Afterlife*; Farkasfalvy, "Interpretation of the Bible," 466. David A. Sapp argues that "Judaism never arrived at an Adam-Messiah typology"; "Adam Christology in Paul: Romans 5:12-21"; quotation from abstract.

18. Kennedy, *Theology of the Epistles*, 15.

19. Jeremias, "Mousas," *TDNT* 4a:867. He cites the following New Testament passages: Adam (Rom. 5:12ff., 1 Cor. 15:15ff.), Abel (Heb. 12:24), Melchisedec (Heb. 7:1ff.), Jacob (John 1:51), Solomon (Matt. 12:42), David (Matt. 1:17, Luke 1:32, Mark 2:25 and par., 11:10), Rev. 3:7), Jonah (Matt. 12:39f. and par.). On Paul's use of the Law of Moses and the prophets to convert Jews, see Acts 28:23. The typology of Moses "is plainly formulated only in Ac., Hb. and Jn." and "briefly indicated in Pl. and Rev." Reicke treats Enoch and Elijah as types of Christ in the New Testament; *Christian Baptism*, 100-03. Hanson discusses Jacob, Moses, and Joshua as types in Stephen's speech in Acts 7:1-53; Hanson, *Allegory and Event*, 95. See also Charity, *Events and Their Afterlife*, 112, on Moses, Jonah, Elijah, Melchizedek, and David, 113-19 on the Suffering Servant, and 119-29 on the Son of Man. For a discussion of Jacob as a type of Christ, see

Early Christian Typology

In the first centuries of Christianity, typology was used in both Jewish and Christian exegesis and liturgy.[20] Contemporary with the New Testament, the haggadah[21] of the Tannaim employs typology, especially in eschatological writings, that is, in discussions of the last things. For instance, when God re-creates the world in the last days, the new paradise will surpass Eden.[22] An instance of Rabbinic typology before and during New Testament times is the "extraordinary haggadic development" on the Akedah or "binding" of Isaac (Gen. 22:9) which presents Abraham's son as an adult who readily consents to be sacrificed and whose sacrifice actually occurred; thus not only is Isaac a Messianic type, but this tradition underlies the Isaac-Jesus typology, as is seen in allusions to the Akedah in the New Testament.[23] Lists of types were evidently part of pre-Christian Jewish liturgy and these types were adopted in Early Christian texts and art.[24] Early Christian writers adapted Jewish typology and also extended the typology of the Gospels by relating the details of Jesus's life to Old Testament events typologically. Origen, Augustine, Jerome, Zeno of Verona and Ambrose were among those who discussed Jonah as a type

Paul-Marie Guillaume, "Jacob," *Dictionnaire de Spiritualité* 8 (1974) 8-9, 11-14. See also Fitzmyer, "Melchizedek," 221: "To show the superiority of Christ's priesthood over that of Aaron and the levites, the author of the epistle to the Hebrews introduces a comparison between Jesus and Melchizedek."

20. Kenneth J. Thomas notes that "the Hymn of Moses (Deut. xxxii) was used liturgically ... in the Church as a part of the Easter vigil"; "Old Testament Citations in Hebrews," 304.

21. A *Midrash* ("investigation") is "the reinterpretation of a specific text to update it or apply it to a specific situation." In contrast, *Targums* are "Aramaic translations and interpretation of the Hebrew scriptures carried out in synagogues when the Jews no longer could understand the original Hebrew text." A *halakhah* is a "division of exegesis which finds and explicates the text's moral implications, while *haggadah* is an expansion of the text, filling out its story with plot or subplot and additional details, often drawn from other scriptural passages. A *pesher* is an application of biblical prophecy to the last days; it often explicates a *raz* or mystery in this way"; Trigg, *Biblical Interpretation* 16-17. See also Sandmel, *Philo of Alexandria*, 128-29.

22. Goppelt, *Typos: The Typological Interpretation of the Old Testament in the New*, 33, see also 28-40. Hanson also notes that the typology in, e.g., the "*Habakkuk Commentary* and the *Damascus Document* . . . derive . . . from those quarters where a lively Messianic expectation is to the fore and where the emphasis is laid upon the prophetic rather than the legalistic aspect of Hebrew Scriptures"; *Allegory and Event*, 23. The so-called Tannaites was the most famous of Rabbinic teachers whose "elucidations and applications of the sacred text . . . were at a later date to be codified in the Mischna" and were part of the pre-Christian Judaism which formed Paul; Kennedy, *Theology of the Epistles*, 17.

23. Daly, *Christian Sacrifice*, 175-86.

24. Hanson, *Allegory and Event*, 16-17, 66-67, 108-09.

of Christ in his passion; Ambrose also interpreted Susanna, who did not speak
in her own defense, as a type of Christ, silent before Pilate, and Maximus of
Turin preached two sermons elaborating Susanna as a type of Christ; Jerome
was among those who found types of Christ's passion in Daniel and in the
Three Hebrews in the Fiery Furnace; Cyprian and Augustine considered Da-
vid thus. In addition to being taken as a type of Christ crucified, Jacob leading
his flocks to Beersheba was construed as a type of Christ the Good Shepherd,
while Moses in several details of his birth was construed as a type of Christ in
infancy.[25]

Typology's two referents: Christ and the Christian. Quite early the
Christians found a new role for typology as well: previously some people and
images and events had been understood to prefigure the coming Messiah; now
that the Messiah had come, those prefigurations remained as a historical re-
cord of his prediction, but another sort of typology existed as well: now the
Christian was to imitate Christ, to live so as to recreate the events of salvation
history. Typology was evident in the early liturgy for baptism and may even
have been recalled by the architecture of the Early Christian baptistery.[26] J. N.
D. Kelly notes that, among the Early Christian writers,

> There was general agreement about cardinal issues, such as that Adam, or again
> Moses the law-giver, in a real sense foreshadowed Christ; the flood pointed to bap-
> tism, and also to the judgment; all the sacrifices of the old Law, but in a pre-eminent
> way the sacrifice of Isaac, were anticipations of that of Calvary; the crossing of the
> Red Sea and the eating of manna looked forward to baptism and the eucharist; the
> fall of Jericho prefigured the end of the world. The list of correspondences could be
> expanded almost indefinitely, for the fathers were never weary of searching them
> out and dwelling on them.[27]

The purposes and functions of typology are important. Its prime role was to
help predict and, when they occurred, to recognize God's actions among men,
especially the coming of the Messiah. Thus typology serves to instruct the
faithful in recognizing the truth and validity of the Christian revelation. In ad-
dition, it points to ways of imitating Jesus which bring the believer into typolo-
gical likeness with Christ. For all Christians, this occurs through the
sacraments. Noah, for instance, is a type of Christ and also a type of the Chris-
tian being baptized:

> There are in typologies of this sort really three stages: Noah, in the Old Testament,
> prefiguring Christ in the New Testament, the reality, fulfilling; the Christian in sa-
> cramental imitation configured to Christ reproducing the experience.[28]

25. For the supporting texts for all these types, see Chapter Three.

26. ". . . the *Missale Gregorianum* and *Gallicanum* have the story of the Flood among
the lessons on the Easter *vigilia* before the great Day of Baptism. Here we have a practi-
cal connection of this pericope and Baptism which can very well be based on early tradi-
tions"; Reicke, *Christian Baptism* 247. On the architecture, see Ousterhout, "Temple,
Sepulchre, and *Martyrion* of the Savior," 51-52.

27. Kelly, *Early Christian Doctrines*, 72.

28. Hanson, *Allegory and Event*, 69. In this light, Charity writes vividly of "the phe-
nomenon's critical usage in the Old Testament to confront man with the action of God";

Typology in this way provides twofold references, indicating the saving events of Jesus's life, death and resurrection and also reminding the believer of his hope to imitate these events in his own life.[29] Thus typology played a vital role in the daily life of the Christian, a point which is often overlooked.[30]

Typology and the unity of the Bible. Another crucial role of typology concerns the unity of Christian thought. At the verge of the twenty-first century, when the Bible has for nearly two millennia been accepted as consisting of two Testaments, it is important to recall that in the early centuries of Christianity the question of what to make of the Old Testament was by no means an idle one. As Kelly observes:

> The fundamental issue here, as was very soon perceived, was to determine the precise relation of the Old Testament to the New, or rather (since at the earliest stage there was no specifically Christian canon), to the revelation of which the apostles were witnesses.[31]

Jesus's teaching had demonstrated a thorough knowledge and use of Jewish scriptures, and Paul, too, taught that they were divinely inspired and remain valuable (2 Tim. 3:16-17). Yet the Gnostics and Marcionists considered the Old Testament obsolete and urged that Christians abandon it entirely. Indeed, Marcion (d. ca. 160) limited the Bible to Luke and the Apostolicon, his much-edited version of ten Pauline epistles.[32] The early Church in responding to both Gnostics and Jews found typology essential. In response to Gnosticism it could show the harmony between the Jewish Law and the Prophets, on the one hand, and the Christian revelation, soon expressed in the writings of the New Testament, on the other. At the same time, in response to Judaism, typology showed

Events and Their Afterlife, 58, arguing for the continuing relevance of typology to Christianity.

29. See also points i and ii in the opening paragraph of T. W. Manson, "The Argument from Prophecy," *Journal of Theological Studies* 46 (1945) 129-36. Compare the comment by Goulder, whose focus is the role of typology in twentieth-century exegesis; he usefully identifies three varieties of types: Old Testament types; types within the Gospel story, such as the raising of Lazarus which prefigures Christ's resurrection; and Gospel events as "types of things still to come," as the resurrection of Christ is itself a type of the resurrection of the Church; *Type and History in Acts*, 1.

30. For instance, David Daube, writing on Exodus typology, observes that "little has been done on how its role in national redemption is related to the redemption of the individual"; *Exodus Pattern in the Bible*, 14.

31. Kelly, discussing "The Unity of the Two Testaments" (pp. 64-69), *Early Christian Doctrines* 64-65. On the Bible in the Early Christian era, see also Tkacz, "*Labor tam utilis*."

32. On the Gnostics's "contempt for the historical value of Scripture," see Woollcombe, "Typology," 70. On Marcion's Bible, see Trigg, *Biblical Interpretation*, 20 and "Allegory," *EEC* 24. Marcion, excommunicated in 144, considered the God of the Old Testament inferior and ignorant—after all, he had to ask Adam where he was; rejected the belief that Christ was the Messiah, rejected the twelve apostles as Judaizers, and found the idea of the incarnation repugnant; Henrik F. Stander, "Marcion," *EEC*, 568-69; Froehlich, *Biblical Interpretation in the Early Church*, 10-12.

the superiority of the New Testament over the Old.[33] The canon of the New Testament and its unity with the Old Testament were gradually settled by the Christian Church during its first two centuries, but both matters were to come under attack later.[34] In the very early fifth century the theme of the unity of the two Testaments and the superiority of the New is addressed in *Primum quaeritur*, the preface to the Vulgate translation of the Pauline epistles.[35]

Thus it is not surprising that in the late fourth century, the period which produced the Brescia Casket, the issue of the unity of the two Testaments was deeply significant for both Ambrose (b. 339) and Augustine (b. 354). Faustus of Milevus represented the version of Manichaeism which its adherents considered a new or reformed Christianity. Like Marcion earlier, Faustus repudiated the Old Testament as "unspiritual and disgusting."[36] Augustine, the classically trained rhetorician, initially found the style of the Old Latin Bible distasteful and scorned the Old Testament's "earthy and immoral stories."[37] Crucial to Augustine's converting to Christianity was his hearing Ambrose, bishop of Milan (374-97), expound the scriptures "spiritually," showing the value of the Old Testament and its harmony with the New.[38] Ambrose's writings are largely exegetical and he devotes great attention to the Old Testament. Following Philo and Origen, he employed allegorical interpretation and typological analysis.[39] Augustine, significantly influenced by Ambrose, became a Christian in 387, a priest in 391, and bishop of Hippo in 395. Knowing personally the importance to faith of understanding the unity of the Bible, he preached extensively on it.

> For Augustine and his hearers, the Bible was literally the 'word' of God. It was regarded as a single communication, a single message in an intricate code, and not as an exceedingly heterogeneous collection of separate books.

33. Daniélou, *From Shadows to Reality*, x; Trigg, *Biblical Interpretation*, 19-20; Manson, "Argument from Prophecy," 129, point iii.

34. Farkasfalvy, "Interpretation of the Bible," 466-67.

35. The author of the preface finds ten, the number of Pauline letters addressed to the churches (he includes Hebrews) to match the number of the commandments: "Ut ostenderet Novum non discrepare a Veteri Testamento et se contra legem non facere Mosi, ad numerum primorum decalogi mandatorum suas epistulas ordinavit et, quot ille praeceptis a Pharaone instituit liberatos, totidem hic epistulis a diaboli et idolatriae servitute edocet adquisitos. Nam et duas tabulas lapideas duorum Testamentorum figuram habuisse viri eruditissimi tradiderunt"; text in Stuttgart Vulgate 2:1748.11-15.

36. Brown, *Augustine* 43 (drawing on Augustine, *Contra Faustum* 4.1) and 58. Also like Marcion, these Manichees doubted the incarnation, finding it repugnantly corporeal, and thought Paul seemed dissonant with the Law and the prophets; *Confessions* 5.10 and 7.21; 2 vols., tr. W. Watts, Loeb Classical Library (Cambridge, MA: Harvard University Press, 1977, 1979).

37. *Confessions* 3.7.2; Brown, *Augustine* 42.

38. *Confessions* 5.14, 6.3-4; Brown, *Augustine* 84-85.

39. Louis J. Swift, "Ambrose," *EEC* (1991) 30-32; Brown, *Augustine* 153-54.

Augustine had always believed, with all the Christians of the Early Church, that what was most significant in history was that narrow thread of prophetic sayings and happenings that culminated in the coming of Christ and the present situation of the Church. . . . As a bishop, Augustine had been absorbed in following this narrow track, along which the history of the Old Testament had pointed to the new dispensation. The longest book in any of his works was written on this theme, against Faustus the Manichee.[40]

In this work, *Contra Faustum*, Augustine defends both the Christian acceptance of the Old Testament generally (book 4) and then, in the extraordinarily long book 22, its major figures—including Moses, Abraham, Isaac, Jacob, Sarah, Rebecca, Leah and Rachel—and several events which are, on first hearing, puzzling. (This is in line with his assertion in *Confessions* 12.14 that Genesis requires interpretation.) He uses historical and moral arguments, as when he defends Jacob's plural marriage as allowed by the custom of the time and as the result of the wish for progeny, not of lust; allegorical interpretations, as when he interpets the names of characters etymologically; and typological exegesis, as when he presents Moses's slaying the Egyptian as a type of Christ defeating the devil.[41] Indeed defending the sanctity of the Old Testament has been suggested as Augustine's dominant concern.[42]

Given the intellectual climate of the Church in Northern Italy in the later fourth century, it would be not at all surprising if the theme of celebrating and demonstrating the unity of the two Testaments should have been considered worthy of expression in a major work of art, and typology was the obvious means of expressing such a theme.

TYPOLOGY AND ART

Recognition of typology in Early Christian art. It is worth noting that theologians conversant with the liturgy have been readier than art historians to identify elements of Early Christian art as typological. Thus Hanson sees Jonah in some funerary art as a type of the Resurrection.[43] T. F. Glasson sees Moses depicted in the catacombs as a type of Christ.[44] Boniface Ramsey reads

40. Brown, *Augustine* 252, 318-19.

41. Jacob: *Contra Faustum*, see also *De civitate Dei* 16.38-39; Moses: *Contra Faustum* 22.90.

42. "... le souci dominant d'Augustin ... est de defendre la sainteté de l'Ancien Testament contre un parti-pris de condamnation"; Lubac, *Exégèse médiévale*, 178-80.

43. Hanson, *Allegory and Event*, p. 16 n. 1.

44. In the Catacombs in "several instances" a "representation of Moses and the rock from which the water flowed is paired with one of Jesus raising Lazarus from the dead," sometimes holding a rod like that of Moses. Glasson reasons that "the rod has been clearly introduced into the story of Christ from the Exodus story of Moses. Again there is a picture of the wedding at Cana, in which Jesus touches the water pots with a rod; and Moses appears in one of the marginal pictures adjoining"; *Moses in the Fourth Gospel*, 22-23.

a fourth-century mural in the Catacomb of Praetextatus typologically.[45] Martine Dulaey considers Early Christian images of the Good Shepherd with a lamb on his shoulder to express contemporary commentary on the Good Shepherd as the resurrected Christ carrying home saved man to God the Father.[46] And Robin M. Jensen argues that since typology is central to Early Christian exegesis and accessible to a popular audience through "homilies, liturgical settings, and catechesis," it is reasonable to see it as operative in art, as in the Sacrifice of Isaac.[47] One theologian has argued ambitiously but unsuccessfully for a fully typological program on a mid-fourth-century work, the sarcophagus of Junius Bassus.[48] In contrast, art historians have tended to identify few scenes in Early Christian art as types of Christ and rarely construe more than one scene on a monument as a christological type.[49] Charles Rufus Morey comes close to seeing as typological the scenes of Moses and Christ on the cypress doors of the church of Santa Sabina in Rome, ca. 432; but because patristic typology construed given Old Testament events in a variety of ways he doubted that depictions from the third through fourth centuries expressed "deep . . . significance."[50] André Grabar goes a step further, granting that sometimes in Early Christian art events were depicted to indicate their "typological significance," but he too maintains that the practice became "widely current" only in the Middle Ages.[51] It is interesting that an art historian thoroughly conversant with the schematic typology of the High Middle Ages, Avril Henry, also recognizes it in Early Christian art. "By the fifth century," she observes, "typology had long been implicit in art"; she instances only Jonah for the fourth century, however.[52]

Textual analogues. Among theologians and historians of the Early Church it is a commonplace that the authors of the New Testament books wrote with a thorough and detailed knowledge of the Law and the prophets:

> The astonishing speed at which they collected catenae of *testimonia* from the Old Testament proves how careful a study they had made of eschatalogical prophecy. Furthermore, since the Gospels are full of linguistic echoes of prophecies, it is evident that the Evangelists did not search the Scriptures superficially, but in minute detail.[53]

45. Ramsey, *Sermons of Maximus*, 323 n. 1.

46. Dulaey, "Brebis perdue dans l'Église ancienne."

47. Jensen specifically responds to art historians of the last fifty years; "Isaac in Jewish and Christian Tradition."

48. Malbon, *Iconography of the Sarcophagus of Junius Bassus*. Her endeavor to show that an Early Christian artwork had a wholly typological program is obviously pertinent to the present research; therefore a full critique of her book is included as an appendix to this volume.

49. See Chapter Three, notes 9, 12 and 13.

50. Morey, *Mediaeval Art*, 77, also *Early Christian Art*[2], 60-61.

51. Grabar, *Early Christian Art*, 38.

52. A. Henry, *Biblia Pauperum*, 10. It is interesting to note that a study arguing for typology in a sixth- or seventh-century manuscript may indicate typology in an earlier, lost model for the manuscript as well; Verkerk, "Exodus Cycle of the Ashburnham Pentateuch."

53. Woollcombe, "Typology," 46-47.

The implications of this richly allusive nature of the New Testament are important. Evidently the New Testament writers expected their audience to recognize these allusions. Not everyone would catch every reference, and surely it would take many people some time to identify all the nuances. Moreover, understanding the main sense of the passage would not require understanding all the allusions which enrich it, although, as one lived with and pondered the passage and more and more of its allusions became clear, one would understand more and more fully. It is plausible that an Early Christian would design a work of art comparably rich in associations, a work whose images would be literally understandable to everyone and whose nuances of meaning and reference would become apparent as one lived with and returned to it. Moreover, such a work of art could be analogous to a sermon which explains scripture, with the design and structural elements of the artwork being analogous to the sermon's rhetoric.

Besides this general analogy between Christian text and Christian artwork, one looks for Early Christian textual analogues to the specific images and types found depicted in the contemporary art. Details matter: it is insufficient to pair a depiction of a specific biblical event with a text not on the event but only generally on the biblical personnage.[54] Writings survive, often from the first four centuries of the Christian era, discussing the specific types of Christ which are relevant to the Brescia Casket. But it is not essential to have such texts in order to argue for the validity of a typological interpretation of an artistic image. The prevalence of typology in Christian thought, the aptness of the specific type proposed, and a reasonable explanation of the details of the image with regard to the type are sufficient. Henry Maguire makes a similar argument concerning allegory in Early Christian art, reasoning that a juxtaposition of scenes that is not intelligible literally can be a pointer to the need to interpet some or all of the scenes allegorically.[55] With this said, however, it is satisfying to add that for all but one detail of one type, clear textual evidence survives, attesting to the existence of the various types here suggested as pertinent to the casket. Indeed, Jonah, Daniel, the Three Young Men in the Fiery Furnace, and Moses are famous types of Christ. While Susanna is no longer commonly known as a type of Christ, two fourth-century bishops in northern Italy are among the Early Christian writers who compare the two.[56]

Searching Early Christian writings for textual evidence remains essential, for such evidence is valuable corroboration that a certain idea existed at a certain time and place. Nonetheless, even if all texts that were written then still survived, so that we had a comprehensive record of all written thought of the period, the lack of a written discussion of an idea would not prove it was not

54. E.g., Malbon explains an image of Daniel in the Lions' Den (Dan. 6 and 14) by citing a comment on Dan. 10:16; *Iconography of the Sarcophagus of Junius Bassus*, 59-60. See also 57-58 for tangential evidence on Job and Paul.

55. Maguire, "Adam and the Animals."

56. Ambrose, bishop of Milan, and Maximus, bishop of Turin; see Chapter Three. See also the present author's "Susanna as a Type of Christ," *Studies in Iconography* 20 (1999).

thought. And, when an important monument of art such as the Brescia Casket
is read with care and certainly seems to give evidence of an idea not recorded
in extant prose, although entirely consistent with the written record of Chris-
tian thought of the time, we are warranted in crediting the designer of the cas-
ket with the coherence and sophistication of thought which his work embodies.
The imagination and understanding are not limited, after all, to textual author-
ization. We may find, in short, that the Brescia Casket, beautiful and intri-
guing as it is, has the added value of representing an experiment in the
Christian imagination: using typology in a new way, to complete the fullest
passion sequence to date while pointing through types to the viewer's need to
respond to that passion, all in a coherent program of decoration which depicts
the unity of the Old and New Testaments through the unity of all its carved
surfaces.

CHAPTER THREE

THE INNOVATIVE PROGRAM OF TYPES ON THE BRESCIA CASKET

The provocative enigma of the casket's program of decoration has fasci-
nated scholars. Much has been made, also, of the important transitional role
of its decoration, which is indebted to that of the sarcophagi. Early in the
fourth century, Christians adorned the front of sarcophagi with a series of bib-
lical scenes; this developed into their treatment in two separate, horizontal reg-
isters.[1] The separate registers of the Brescia Casket carry scenes reminiscent of
those on Christian sarcophagi. Indeed, this has been a commonplace of scho-
larship on the casket since 1845.[2] Especially pertinent are the Passion sarco-
phagi, so-called because they depict events leading up to the Crucifixion. On
these, rather than portraying the Crucifixion literally, the artists presented it
and the Resurrection symbolically in a single image such as a small low-relief
cross, a cross (sometimes with a Chi Rho upon it) between two apostles, a Chi
on a lance or cross, or the Chi Rho upon the cross and, beneath it, two soldiers
watching or sleeping, as at the sepulchre.[3] The earliest known Christian depic-
tion of the crucifixion is on an ivory panel from a casket, ca. 420-430, now in
the British Museum (Fig. 9).[4]

1. Grabar, *Early Christian Art*, 240.

2. Odorici, *Antichità cristiane di Brescia*, 62-66, was the first to remark on this. See
also Volbach, *Early Christian Art*, 27; Soper, "Italo-Gallic School," 187-89; Dalton,
East Christian Art, 208; Victor Schultze, *Archäologie der altchristlichen Kunst* (Munich:
C. H. Beck, 1895) 279-80; C. M. Kaufmann, *Handbuch der christlichen Archäologie*, 556-
57; Kartsonis, *Anastasis*, 23-28.

3. A small cross is used on a frieze sarcophagus in the Basilica of Saint Ambrose in
Milan (56-57, fig. 18), a cross with Chi Rho and apostles is on a sarcophagus at the Mu-
seo di Spalato (138-41, fig. 36), one without a Chi Rho on the sarchophagus del Principe
at the Museo Archeologico at Istanbul (fig. 38); Saggiorato, *Sarcofagi paleocristiani con
scene di Passione*. See also Lawrence, *Sarcophagi of Ravenna*, passim. For the Chi Rho
on a lance or cross, see Grabar, *Early Christian Art*, 265, figs. 295-96; see also Saggiora-
to (1968) figs. 39-40, and Milburn, *Early Christian Art*, 69, fig. 40: Rome, Vatican Mu-
seum, Sarcophagus 171. Schiller convincingly relates the program of the Passion
sarcophagi to Christ's sovereignty; *Iconography*, 2:3.

4. Marcus Mrauss, "Kreuzigung," *RBK* 5:287-88; Leslie Brubaker, "Crucifixion,"
DMA 4:12b-13b with plate on 14a-b; Schiller (1968, tr. 1972) 2:91 and fig. 323; C. Mein-
berg, "Cross," *NCE* 4:473-75. Leclercq suggests that literal depictions of the Passion

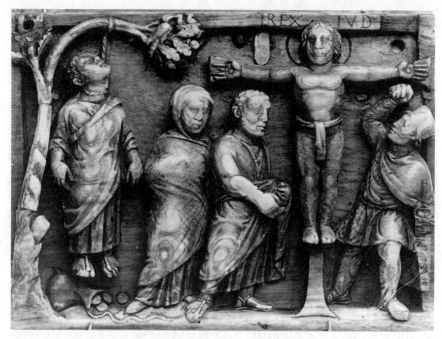

FIGURE 9. The earliest known depiction of the Crucifixion.

The Brescia Casket, created decades earlier, lacks a literal depiction of the Crucifixion, which is not at all surprising. The first remarkable, and often noticed feature, though, is that the casket depicts the events prior to the Crucifixion in an unusually full, chronologically ordered sequence of five scenes on the lid: Christ at Gethsemane, his arrest, Peter's denial, Christ before the high

were not created early on because "l'artiste n'ose encore aborder la représentation des scènes sanglantes du couronnement d'épines, qu'on rencontre une fois au IIᵉ siècle, dans les catacombes, et du crucifiement que nous rencontrerons un siècle plus tard sur les bas-reliefs de la porte de Sainte-Sabine"; "Brescia," *DACL* 2:1154. In contrast, Pierre du Bourguet ascribes the non-literal representation of the Crucifixion to the Early Christian "predisposition to symbolism"; *Early Christian Art*, 60. This does not, however, address why artists portrayed events leading up to the Passion historically, but switched to a symbolic depiction for the Passion itself. The answer is given by Kartsonis, who, in her magisterial work on the Anastasis argues convincingly that artists avoided portraying literally those events which were problematic christologically, being concerned with issues such as whether Christ's divine nature suffered; she cannily notes that personal scruples coupled with a practical sense of what was marketable led craftsmen to shun literal depictions; *Anastasis*, 19-39. We should not overlook the possibility that the intellectual, christological reasons led to or were otherwise accompanied by a reluctance based upon awe, as implied by Leclercq. Kartsonis's own language on this point is notable: she asserts that "artists had no *qualms*" about literally depicting other events from the life of Christ, but "apparently *felt* differently" about his death; p. 6, italics mine.

FIGURE 3

priests, and Christ before Pilate, who is shown washing his hands (Fig. 3). Notably, in order to achieve such a full series, the artist altered a scene common on sarcophagi—Christ foretelling Peter of his denial—and created the scene of Peter's actual denial.[5] Most formal aspects of the transitional nature of the casket have been recognized:

> Its five moments of the Passion are obviously a stage beyond even the most elaborate of the columnar "Passion sarcophagi," in which no more than two or three episodes appear with no regard for historical sequence. It is, on the other hand, less mature than monuments of the early fifth century in which are first found the scenes conspicuously lacking in its own arrangement, the Crucifixion and the following cycle of the Resurrection.[6]

What seems to be an obvious void in the passion sequence is often commented upon, as when Soper remarks that the casket "stops short" of the Crucixion itself.[7]

5. See Chapter One, n. 32.

6. Soper, review of Kollwitz, 430, and again Soper, "Italo-Gallic School," 178. See also McGrath, "Maccabees on the Brescia Casket," 257.

7. Soper, review of Kollwitz, 430. Watson, "Program of the Brescia Casket," 292, considers the completion of the Passion unnecessary on the casket, for she construes the work as a memorial of Ambrose's anti-Arian conflict with the government in Lent 386, which ended on Maundy Thursday. The second reason she suggests is that Ambrose himself was not required to be a martyr, but this indicates a problem with her thesis.

The passion sequence on the casket is not abridged, however. Strikingly, the
Brescia Casket is transitional in another, hitherto unrecognized way, one that
undercuts the assessment of this monument as "less mature" than later ones.
Whereas the Passion sarcophagi represent the Crucifixion symbolically and
fifth-century monuments represent it literally, the Brescia Casket presents it
and the Resurrection *typologically* and then elaborates on the Passion sequence
with a series of pertinent Old Testament types.

<center>TYPOLOGY AS THE KEY TO THE CASKET</center>

Quite simply, the key to the pattern on the casket has been hidden for so
long because it is unexpected. The Old Testament events that are depicted on
the sides of the casket are familiar from many Jewish and Early Christian
monuments where they stand as emblems of hope in God's power to deliver his
faithful from deadly peril, and it has been assumed that this is the limit of their
role on the Brescia Casket as well.[8] In other Early Christian art, amid the array
of Old Testament heroes depicted on a sarcophagus or on the walls of a cata-
comb, sometimes one or two depictions of a biblical hero will sound a typologi-
cal resonance. Thus, for two sarcophagi it has been suggested that the Sacrifice
of Isaac is depicted as a type of Christ included as a substitute for the crucifix-
ion. Again, "in the catacomb of Priscilla, Isaac with his heavy burden of wood
points forward to Christ and his cross." The depictions of Jonah and of the
Three Men in the fiery furnace on a Constantinian frieze sarcophagus (320-30)
have been deemed "allusions to the Resurrection" (albeit by a scholar who also
holds that typological motifs did not come into use in Christian art until the
ninth and especially the twelfth and thirteenth centuries), and another scholar
has held that on sarcophagi Jonah or Daniel may be depicted as a type of the
Resurrection.[9] For no Early Christian monument, however, has anyone as-
serted a full narrative of the passion with rich typological completion and
echoing of the events. And only a few typological scenes have been argued for
in art of the sixth through ninth centuries.[10]

Although she credits the bishop with the casket's design, she also interprets several
images of Christ on the casket, e.g., the Good Shepherd, as indicating Ambrose himself.
Subordinating Christ to the designer, especially in the Passion narrative itself, would be
at least vainglorious on the part of the designer.

8. E.g. Milburn, *Early Christian Art* (1988) 240.

9. Two sarcophagi with Isaac: Stommel, *Ikonographie der konstantinischen Sarko-
phagplastik*, 66ff, esp. 71; cited by Mrauss, "Kreuzigung Christi," *RBK* 5:291-92. Cata-
comb of Priscilla, with Isaac: Syndicus, *Early Christian Art*, 16, see also 19. Jonah and
the Three Young Men: Schiller (1968, tr. 1972) 2:4, ix, 124. Jonah and Daniel: Bourguet,
Early Christian Art, 62 (no monuments cited). For types of Christ not related to the Pas-
sion, note that on the cypress doors of Santa Sabina in Rome (shortly after 432), Grabar
recognizes the parallel, one-to-one pairing of scenes of Moses's miracles in the desert
with scenes of Christ's eucharistic miracles as typological; *Christian Iconography*, 142-
43, pls. 338-39; for date see Beckwith, *Early Christian and Byzantine Art*, 48-50, n. 51.

10. Two episodes from the life of Abraham as prefiguring the eucharistic sacrifice, in

But on the fourth-century Brescia Casket for the first time a host of Old Testament heroes—Jonah, Susanna, Daniel, Jacob, Moses, and David—have a dual significance related to the Passion narrative on the lid. Still salient examples of God's power to deliver, they also function as types of Christ engaged in the delivery of mankind by his Passion. That is, they simultaneously represent the Christian's hope for delivery as well as the grounds for that hope. The Brescia Casket is evidently the first work of art which depicts a series of events from the Old Testament alongside those events from the Passion of Christ to which they are linked typologically. The casket's program thus appears to be a much more developed use of types than anything earlier, in the catacombs or on the sarcophagi or indeed anywhere in any medium. At the same time, and not surprisingly, the casket's program is also much less systematic than the deliberate, explicitly labeled typological pairings developed in the later medieval *Biblia Pauperum*, for instance (Fig. 10).[11] In short, this transitional style of using types is *sui generis*, and therefore has escaped discovery. Even André Grabar, seeing no correspondence between the Old Testament and New Testament registers *on any given face* of the casket, concluded that these registers were unrelated:

> It is easy to establish the absence of any link (by likes or opposites) between the scenes of the two borders and those of the central panel. To take only the principal face of the casket: The borders show the stories of Jonah, Susanna, and Daniel, while in the central panel there are Christ and the hemorrhissa, Christ teaching, and Christ at the entrance of the sheepfold. Examination of the other sides of the casket (and its cover, which has only gospel scenes) leads to the same conclusion. The ensemble of subjects from the Old Testament and the ensemble of subjects from the New Testament on the Brescia casket cannot be compared with each other; there are no appropriate terms of comparison.[12]

Studying the individual surfaces of the casket in isolation, however, is not enough. This is clear from the discovery that the New Testament panels on the front and sides are linked. In the same way relationships between Old Testament panels and New Testament ones extend past the edges of a single face.

a mosaic in San Vitale: *Larousse*, fig. 64 on p. 37; pillar of fire as Paschal candle: Verkerk, "Exodus and Easter Vigil in the Ashburnham Pentateuch," 94-99; in seventh-through ninth-century psalter illustration: Corrigan, *Visual Polemics in Ninth-Century Byzantine Psalters*, 9, 11, 20-23, 37-38; Tkacz, review of Corrigan, 413-16.

11. See Bourguet, *Early Christian Art*, 62. For a concise, informative discussion of the *Biblia Pauperum*, which flourished in the twelfth through fourteenth centuries, see Richard K. Emmerson's introduction to *Biblia Pauperum Codex Palatinus Latinus 871*. For a brief analytical bibliography on the *Biblia Pauperum*, see Kaske, *Medieval Christian Literary Imagery*, 99. See also the discussion of blockbook editions of the *Biblia Pauperum*, which flourished between 1460 and 1490; Labriola and Smeltz, *Bible of the Poor*, 4-10.

12. Grabar, *Christian Iconography*, 138. In the 1961 lecture quoted here, Grabar identifies the first scene in the central panel as "the *Noli me tangere*," but in his 1968 book *Art de la fin de l'Antiquité* he includes the same essay in French, identifying the scene as Christ and the hemorrhissa, 1:509.

FIGURE 10. Susanna as a type of Christ in Gethsemane. *Biblia Pauperum.* 14th c.
Munich, Staatsbibliothek, CGM 20, fol. 11v.

This is a completely novel hypothesis. The idea that the Old Testament registers emphasize (but are not devoted exclusively to) scenes related to the New Testament scenes *on the cover* of the casket has never been advanced before. Very rarely has a scholar even hinted that one or a few christological types may exist on the casket. Georg Stuhlfauth in 1896 offered the sole eccentric exception. Attempting to explain several scenes on the casket typologically, he imposed a one-to-one correspondence between adjacent images in the manner of the much later *Biblia Pauperum*. That is, he made the mistake of confining his attention to a single surface at a time. Oddness characterizes the results. For instance, he presents Susanna and the Elders as analogous to Christ and Mary Magdalene (he misidentifies the scene of Christ healing the Hemorrhissa as Noli Me Tangere). Buried amid such incredible correspondences is the brilliant statement that the two Jonah scenes on the front of the casket refer to the Lord's resurrection after three days.[13] Unfortunately the overall weakness of Stuhlfauth's typological reading prevented anyone from recognizing this insight. Only two other scholars have made isolated references to types of Christ on the casket. Specifically, Odorici construed the image of Jonah on the back of the casket as "emblema della risurrezione"; and J. O. Westwood asserted that the image of the meeting of Jacob and Rachel at the well was "doubtless here introduced as a type of the scene of Christ and the Woman of Samaria at the well," and he silently indicates typology for the third Jacob scene on the same register when he identifies it (correctly) as Jacob ascending the Ladder.[14] None of these three scholars touch on the full meaning of the casket.

What is particularly notable in the innovative program of the casket is that the Old Testament types not only echo but even complete the depiction of salvation history on the casket, from the arrest in the Garden of Gethsemane through the Resurrection and perhaps the Ascension as well.

13. Stuhlfauth, *Altchristliche Elfenbeinplastik*, 50. He also, however, asserts other unlikely pairings, without explanation: he considers Susanna and the Elders appearing before the judge Daniel to be analogous to Christ teaching the disciples (his interpretation of the central front New Testament scene), and Daniel in the Lions' Den to be a prototype of Christ with the wolf, etc. On the other hand, Stuhlfauth sees much of the unity of the casket and its repetitions in series of three; he also recognizes such features as the deliberate contrast of the death of the prophet and the raising of Jairus' daughter, which are depicted adjacently. When one realizes he offers his brief remarks on the Brescia Casket in the context of a discussion of Early Christian ivory, his achievement, despite its flaws, is rather impressive. Cornell, *Biblia Pauperum*, 122, reiterates Stuhlfauth's interpretation, attributing it to J. Reil (1914).

14. Odorici, *Antichità cristiane di Brescia*, 75; Westwood, *Fictile Ivories in the South Kensington Museum*, 35. Watson also sees typological elements on the casket, but solely types of Christian experiences, not types of Christ: for instance she asserts, "Moses is a prototype of orthodox priests and bishops" and "Jacob is the model of righteous orthodoxy"; "Program of the Brescia Casket," 288.

The Christological Types on the Casket

The events involving Jonah, Susanna, Daniel, the Three Young Men, David, Jacob and Moses depicted on the Brescia Casket are familiar from the art of the catacombs and sarcophagi and grouped on monuments such as the Doclea Cup (see Chapter Four). Beyond this they are all—including Susanna—specific Old Testament figures that function as types of Christ in his Passion. Note that most of these figures appear at least twice on the casket: Jonah appears three times, Susanna thrice, Daniel thrice, the Three Young Men twice in the same scene, Jacob appears three times, Moses six. It appears that, just as the narrative sequence of the Passion on the lid of the casket is unusually full, so is its typological elaboration: the designer of the casket has depicted notable types of Christ in specific scenes evocative of the successive events of the Passion. Indeed, the casket will be shown to present fourteen events from the Old Testament and two from the New as prefigurations of the Passion and Resurrection of Christ.

Jonah. As has been discussed above, the sufferings of Christ during the Passion were not depicted in the Early Christian period. Thus, the lid of the Brescia Casket (Fig. 2), reserved for the events of the highest importance, depicts Christ historically in the events leading up to, but not including, the Passion. Examining the visual facts of the casket has revealed that it must be observed in the round, the eye moving from one surface to another in turn, and so it is with the Passion narrative. After "reading" the top register of the lid, and then the second register of the lid, the eyes move easily to the top tier of scenes which come immediately below the lid, i.e. the Jonah register on the front of the casket (Fig. 3). In doing so, the gaze travels across the ring of bust portraits of Christ, the apostles, and the evangelists which encircle the edge of the lid on its vertical surfaces; these portraits are a visual reminder that now when we look at events of the Old Testament we can see them through the eyes of the Church. The first scenes we see are of Jonah. Jonah being swallowed by the whale (Jon. 2:1) is a type of the death/entombment of Christ and Jonah being spewed forth (Jon. 2:11) is a type of his Resurrection.[15] Christ himself signaled this (Matt. 12:39-41).

As a result of Christ's comparing himself with the prophet, Jonah is one of the best known types of the Passion. Origen explains Christ's comparison at some length.[16] Augustine declares:

> The prophet Jonah prophesied Christ, not so much by what he said as by what he suffered, indeed he did so more openly than if he had proclaimed his death and resurrection aloud. For what else is to be understood from his returning from the belly

15. For pertinent texts and artworks, see Klaus Wessel, "Jonas," *RBK* 3:647-55; Alexander P. Kazhdan et al., "Jonah," *ODB* 2:1071; Leclercq, "Jonas," *DACL* 7.2:2572; Roldanus, "Usages variés de Jonas par les premiers Pères," 159-64 and 177-81; and Friedman, "Bald Jonah," 133.

16. Origen, *Commentaria in Matthaeum* 12, in *Origenes Werke* 10 (GCS 41, Berlin 1941) no. 269, p. 122.

FIGURE 4

of the whale, and on the third day, except that this should signify that Christ would return from the depths of Hell on the third day?[17]

In a letter, he succinctly compares the two: "Just as Jonah [went] from the ship into the stomach of the whale, so Christ [went] from the wood [of the cross] into the sepulcher or into the abyss of death."[18] Ambrose likewise describes Jonah as "a type [*typus*] of the Lord's Passion."[19] Similarly, Jerome (d. 419/20)

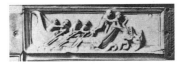

17. "Ionas autem propheta non tam sermone Christum, quam sua quadam passione prophetauit, profecto apertius, quam si eius mortem et resurrectionem uoce clamaret. Vt quid enim exceptus est uentre beluino et die tertio redditus, nisi ut significaret Christum de profundo inferni die tertio rediturum?" *De civitate Dei* 18.30 (CCL 48:621.18-23).

18. "Sicut ergo Ionas ex navi in alvum ceti, ita Christus ex ligno in sepulcrum vel in mortis profundum." Augustine, epistola 102, par. 34 (PL 33:384). See also his typological elaboration of Jesus's words in Matthew, *De utilitate credendi* 8: "For just as Jonah was in the belly of the whale for three days and three nights, so the son of man was for three days and three nights in the heart of the earth" (CSEL 25.1:10.26-28).

19. Ambrose, *Expositio Evangelii secundum Lucam* 7.97 (CCL 14.4:247). See also Augustine, *De utilitate credendi* 3.8-9.

treats it as a commonplace that Jonah "who is a type [*typus*] of the Savior, and who was held 'three days and nights in the belly of the whale,' prefigured the resurrection of the Lord."[20] Another point of typological comparison between Jonah and Christ is the similarity between what the sailors say and Pilate's famous disclaimer. Maximus of Turin (fl. 390-408/23) is among those who treat this:

> The sailors, about to cast Jonah overboard, nonetheless were afraid and said, "Lord, do not lay on us blame for this innocent blood" [Jon. 1:14]. Does it not seem to you that the sailors' outcry is like the admission of guilt [*confessio*] of Pilate, who handed Christ over, but nonetheless washed his hands and said, "I am clean from the blood of this just [man]" [Matt. 27:24]?[21]

Jerome echoes this comparison.[22]

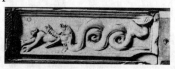

Zeno, bishop of Verona (fourth century), elaborates the comparison, discussing Jonah's sojourn in the belly of the whale as Christ's descent into hell:

> Jonah sleeping in the ship presented an image of the Lord's sacrament: for the material of the ship [i.e., wood] signified the cross, and the sleep signified the Passion. The sea, moreover, is this turbulent world; the storm we take as the peoples and nations of the Jews, who raged in vain against God. The casting of lots brought about Jonah's being cast overboard, [just as] prophecy had foretold that the Lord would suffer; both were willing, Jonah by agreement, the Lord by piety. The whale is undoubtedly Hell; for just as Jonah was three days and three nights in the belly of the whale and then, having been vomited forth, entered the city of Nineveh, so the Lord after three days, rising again from Hell, entered the city of Jerusalem and then Heaven.[23]

20. "Qui typus est Saluatoris, et 'tribus diebus ac noctibus in uentre ceti' moratus, praefigurauit Domini resurrectionem." St. Jerome, *Commentariorum in Ionam Prophetam*, Prologus and 1.14 (CCL 76:377.10-11 and 391-2, lines 406-7, 411-12). Jerome epitomizes his comments in Epistola 8, to Paulinus, "De studio Scripturarum" (PL 22:546).

21. "Nautae dimissuri Jonam, tamen verentur et dicunt: 'Domine, ne des super nos sanguinem innocentem' [Jon. 1:14]. Nonne vobis videtur nautarum increpatio Pilati esse confessio, qui tradit Christum et tamen lavat manuas suas, et dicit: 'Mundus ego sum a sanguine justi hujus'" [Matt. 27:24]. Maximus of Turin, *Homilia* 55: "In festo Paschae I" (PL 57:357C). This text is not in the CCL edition (1962) or mentioned in its introduction.

22. Jerome, *Commentariorum in Ionam Prophetam*. For further discussion of the scriptural context of the references to blood in the account of the Passion, see Tkacz, "Tormentor Tormented," 108-12; for the formulaic content of the scriptures on innocent blood, see Tkacz, "Literary Studies of the Vulgate: Formula Studies," 211-12, 217-18. Pilate's words are quoted on a twelfth-century portable altar which also depicts Jonah; Schiller, *Ikonographie* 2:127 and fig. 428.

23. "Jonas in navi dormiens sacramenti Dominici imaginem praeferebat; etenim significabat navis materia crucem, somnus vero passionem. Mare autem mundus est iste tumidus; fluctus ejus Judaeorum populos et gentes accipimus, qui adversus deum inaniter

Ambrose (d. 397) employs this typology to explain Psalm 43 with its reference to cries "from the belly of Hell" (de ventre inferni). Others to express this typology include Hilary of Poitiers (d. 397), Evagrius the monk (fifth century), and Isidore of Seville (ca.560-636).[24]

Thus Jonah's experiences of being cast from the wooden ship into the whale and then his coming forth *de ventre ceti* were widely known as the typological expression of the crucial and culminating events of salvation history of the Christ's Passion: first, the fullness of his sacrifice and sufferings—his death on the wooden cross, entombment and descent into Hell—and then the victory of his resurrection. In the symmetrical pair of Jonah scenes on the casket's front, the artist typologically displays these experiences of Christ: first his death, with the wood of the ship evoking the wood of the cross, with the whale's swallowing of Jonah indicating death's encompassing of Christ and also the tomb's containment of him, and the length of Jonah's time inside the whale foreshadowing Christ's three days of death; then his resurrection in Jonah's emergence from the whale.

On the casket as a whole, of course, are three Jonah scenes. They are the familiar trilogy of the swallowing, spewing forth, and resting under the gourd (Jon. 4:6). This trio appears on the Cologne Bowl (probably made in 326), on a sarcophagus of about 300, now in the British Museum, and on "the most famous of the 'Jonah sarcophagi,' Vatican 119," for instance.[25] The scene of Jonah under the gourd, depicted on the back of the casket, will be discussed below.

fremuerunt. Sors Jonam praecipitandum prodidit, prophetia passurum dominum praedicavit, utrosque volentes, illum condicione, dominum pietate. Cetum esse non dubitatur infernum; sicut enim Jonas tribus diebus et tribus noctibus fuit in ventre ceti, evomitusque Ninive se intulit civitati, ita dominus postridie ab inferno resurgens se civitati Jerusalem intulit ante quam coelo." Zeno of Verona, *Tractatus* 1.34.8 (CCL 22:87).

24. Ambrose, *Explanatio psalmi* 43.85-87 (CSEL 44:322-34); see also *Explanatio psalmi* 47.25 (ibid., p. 361). See also Hilary, *Tractatus in psalmum LXVIII.*5 (CSEL 22:316.10-18), the monk Evagrius, *Altercatio legis inter Simonem Iud. et Theophilum Christianorum* 6.176 (CSEL 45), Isidore of Seville, *Allegoria quaedam sacrae scripturae* (PL 83:115), Peter Chrysologus, *Sermo 37: De Jonae prophetae signo* (CCL 24:211-15), Paschasius Radbertus, *Expositio in Evangelium Matthaei* 6.12 and 7.16 (CCM 56A:679, 793), Theodulph's poetic prologue to his edition of the Vulgate, vv. 39-40 (Vatican Vulgate, vol. 1 [1926] 53), and Raoul Ardens (twelfth century), *Homily* 2.24 (PL 155:2028).

25. Cologne Bowl: Weitzmann, *Age of Spirituality*, no. 377; British Museum sarcophagus: ibid., p. 398, fig. 52; Jonah sarcophagus: Milburn, *Early Christian Art* (1988) 64 and fig. 34 on p. 62. Four scenes from Jonah appear on a red earthenware bowl from fourth-century Africa (Weitzmann, ibid., no. 384), and two on a sixth-century ivory pyxis at St. Petersburg (ibid., no. 385). As Erich Dinkler observes, "The Jonah story is frequent in funerary art beginning in the third century, mostly as a trilogy. Its Christian significance is rooted in Matt. 12:39-40, where Jesus relates the Jonah story to his own death and Resurrection"; in ibid., p. 406, entry on sarcophagus Lat. 119 in Museo Pio Cristiano in Vatican City. See also Leclercq, "Jonas," *DACL* 7:2577, who suggested that the Crypt of Lucinus in the catacombs bears the earliest extant depiction of the cycle.

Susanna. The bottom register of the front of the casket is filled with three scenes from the book of Daniel concerning Susanna and the Elders, and Daniel in the Lions' Den. Daniel and Susanna are each depicted twice in this register. They are shown in the process of being divinely delivered from mortal danger: Susanna, *de falso testimonio*, and Daniel, *de lacu leonis*. The very familiarity of these stories might lull one into construing this register as a careless arrangement, with two Susanna scenes followed by a Daniel scene only because Daniel's role as judge in the Susanna account prompted the artist to think of Daniel's own ordeal. On the contrary, the program of this register is conscious and richly appropriate, for Susanna here is no less than a type of Christ.

The Brescia Casket's presentation of Susanna as a type of Christ will surprise many modern readers who are more familiar with other traditions concerning her.[26] She is sometimes a type of Mary.[27] Of the Early Christian interpretations, probably the best known is one which sees Susanna as a type of Ecclesia with the two elders who attack her as the Jews and the Pagans.[28] Another Early Christian role is manifest on at least five monuments from the middle or third quarter of the fourth century: Susanna is a model of the learned woman. In a mosaic at Santa Costanza in Rome and on four sargophagi, at Arles, Cahors, the Lateran, and Gerona in Spain, she is shown holding an open book or roll or with a roll-case at her feet, imagery which indicates her education, as recorded in Dan. 13:3 and as commented upon by Jerome.[29] The

26. For a discussion of Susanna in art, see Henri Leclercq, "Suzanne," *DACL* 15.2:1742-52; and Réau, *Iconographie de l'art chrétien*, 2.1:392-98. See also Wilpert, *Malereien der Katakomben*, 1:362-66 and vol. 2, pls. 14, 86, 142, 220, 232, 251. Susanna's role as a type of Christ will particularly surprise those who know of this heroine primarily through the work of Margaret Miles and Jennifer A. Glancy, who scant Early Christian and medieval texts and images, skipping from biblical text to Renaissance image; *Female Nakedness in the Christian West*, 121-25; and "The Accused: Susanna and Her Readers," 108.

27. Susanna as a type of Mary: Augustine touches on this comparison in *Sermo* 343, ed. Lambot, p. 31, ll. 101ff. For Chromatius Aquileiensis, sermon on Joseph, see next note. Paschasius Radbertus (786-ca. 860) compares Mary and Susanna briefly, noting that each was falsely thought unchaste; *Expositio in Matheo. Libri XII* 2.163-65 (CCM 56:118). See also Colletta, "Prophet Daniel in Old French," 149-58.

28. Susanna as a type of Ecclesia: see, for instance, Hippolytus of Rome, *Commentaria in Danielem* 2, in *Hippolytus Werke* 1.1 (GCS 1, Leipzig 1897); Jerome, *In Sophoniam* 2.403-05 (CCL 76A:687); Chromatius Aquileiensis (bishop 387-407), Sermo 35, "De Susanna," ll. 46-47 (CCL 9A:160). For Susanna as a model for wives, see Chromatius, "De sancto patriarcha Joseph," ll. 40-43 (CCL 9A:109). Avitus elaborates on Susanna as courageous in her chastity in his poem *De virginitate*; PL 59:379A-380A. See also Isidore of Seville, *Allegoria* (PL 83:116); and Rabanus Maurus, *De universo* (ca. 844) PL 111:66.

29. Susanna as a model of the learned woman: Stern, "Mosaïques de Sainte-Constance à Rome," 169-171 and figs. 4-7. Commenting on Dan, 13:3–"For her parents, being just, had their daughter educated in the Law of Moses"–Jerome remarks, "This testimony should be used to exhort parents that they should teach not only their sons, but also their daughters the Law of God and divine knowledge"; *Comm. ad Danielem*

role of Susanna relevant to the Brescia Casket is as a type of Christ. It is worth noting that being a woman was no impediment to being seen as a type of Christ: in Jewish exegesis another Old Testament heroine, Ruth, was a type of the Messiah.[30]

The typology of Susanna as a type of Christ is based in both scripture and Early Christian commentary, Greek and Latin. While Augustine and Jerome make various isolated comments consonant with this typology,[31] Ambrose is the Church doctor who provides the germ for it in his repeated comparison of Susanna, who does not speak in her own defense, to Christ, silent before Pilate:

> A remarkable passage follows, through which the patience to undergo moral injury with equanimity is infused into human breasts. The Lord is accused and is silent. And certainly the one who has no need for defense can be silent: let those who fear to be conquered (*vinci*) cast about to defend themselves. By silence one does not confirm an accusation; rather one scorns it by not refuting it. What should one fear, who does not aim for safety/salvation (*salutem*)? The safety/salvation (*salus*) of all mattered more to him than his own, as he aimed to obtain the salvation of all. But why should I speak of God? Susanna was silent and she conquered (*vicit*). Indeed her case is better, for she did not defend herself yet was proven [innocent]. Also, this Pilate absolved, but he absolved in judgment, he crucified in mystery. Clearly in these trials, this one specific to Christ and that human [trial of Susanna], it can be seen that, before wicked judges, one may be unwilling, as opposed to unable, to defend oneself.[32]

13:3 (PL 25:580B), quoted by Stern, p. 171. For the sarcophagus at Arles, see Benoît, *Sarcophages paléochrétiens d'Arles*, no. 44 on p. 47 and pls. XVI, XVIII. The entire "Susanna sarcophagus" at Gerona is shown by Pedro de Palol, *Arte paleocristiano en España*, 112-15 and pl. 70. He dates the sarcophagus to ca. 300-15.

30. "In Rabbinic literature, Ruth['s] . . . life is often interpreted as prefiguring Messianic events" and, in the second and third centuries A.D., she was construed as a type of the Messiah; Daube, *New Testament and Rabbinic Judaism*, 33, 47-48; Hanson concurs, *Allegory and Event*, p. 30 and n. 6.

31. Augustine compares Susanna (and other Old Testament heroes) to Christ: God frees all the Old Testament heroes from danger, but Christ he would not deliver; *Epistle* 140, par. 11.24 (CSEL 44:178). He also compares the attitude of the elders towards Susanna to Judas's receiving the eucharist at the last supper like a thief; *Contra litteras Petiliani* 2.23.53.9-17 (CSEL 52:52). Jerome refers to the chaste as Susannas who change crowns of thorns into the glory of one triumphing ("coronam spineam mutant in gloriam triumphantis"); Epistle 65.2.22 (CSEL 54:618). Jerome and Ambrose both comment that there were two witnesses against Susanna and two against the Lord; Jerome, *In Sophoniam* 3.287-89 (CCL 76A:701); Ambrose, *De Nabuthae* 11.46 (CSEL 32.2:494.2-5).

32. "Sequitur admirabilis locus, quo subeundae aequanimiter iniuriae moralis infunditur patientia pectoribus humanis. Accusatur dominus et tacet. Et bene tacet qui defensione non indiget: ambiant defendi qui timent uinci. Non ergo accusationem tacendo confirmat, sed despicit non refellendo. Quid enim timeret, qui non ambiret salutem? Salus omnium suam prodit, ut adquirat omnium. Sed quid de deo loquar? Susanna tacuit et uicit; melior enim causa, quae non defenditur et probatur. Et hic Pilatus absoluit, sed absoluit iudicio, crucifixit mysterio. Verum hoc speciale Christi, illud humanum, ut aput iniquos iudices magis uideretur noluisse quam non potuisse defendi." Ambrose, *Expositio Evangelii secundum Lucam* 10.97 (CCL 14:373-74). See also Ambrose's *Explanatio*

Other points of comparison invited by scripture are explicitly depicted on the casket. Just as Susanna was in a garden when she was taken (Dan. 13:15-19), so Christ was in the Garden of Gethsemane when he was arrested. In each case, on the lid and the front of the casket, the garden is conventionally depicted as a pair of trees. Moreover, the scene of Susanna in the Garden, because it shows the menacing approach of the men who will seize her, recalls

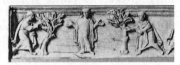

both Christ in the Garden of Gethsemane and his arrest. Next, just as Susanna was brought to judgment (Dan. 13:42-50), so was Christ. The two elders flank and hold Susanna, their hands on her shoulders. The very fact that Daniel is seated seems intended to recall the judgment scenes on the casket's lid, for the high priests and Pilate are all shown seated as they judge Christ. Moreover, the poses of Daniel and Pilate are quite similar.

The minor difference between how the casket shows Christ held in his arrest and how it shows Susanna held by the elders is easily explained. Consistently Early Christian art shows arrested saints, such as Susanna and Peter, held higher on their arms than the arrested Christ is held, if he is held at all.[33] Like Susanna, Peter is held on the upper arm in depictions of his arrest on the Junius Sarcophagus (359), a fourth-century sarcophagus now in the Musée Lapidaire at Avignon, the Dogmatic Sarcophagus (Lateran 104), and Lateran 164. Presumably the artist of the Brescia Casket placed the soldiers' hands lower on Jesus's arms to show respect for his divinity. This is also seen on a fragment of a thirteenth-century ivory at the Louvre: one of two soldiers arresting Christ holds him, by the left wrist. A soldier follows the arrested Christ without even touching him on an early sarcophagus from the Cemetery of Domitilla, Lateran 171. The same emphasis on Christ's serenely triumphant divinity leads the artist of the Brescia Casket not to show Jesus in the orant position in the garden, even though he was praying.

Another significant parallel between Susanna and Christ provided by the biblical accounts themselves is that the judge of each repudiates guilt for [innocent] blood. Daniel's first words in the story of Susanna are very close to those of Pilate when he washes his hands, and each judge is speaking before "all the

psalmi 38.7.3 (CSEL 44:189). Susanna's silence is explicitly emphasized in the fourteenth-century Miscellany of Velislaus, Prague, National Library, XXIII.C.124. The history of Susanna is depicted in seven scenes on fol. 106r-107v. Her silence is indicated by her holding the fingers of her left hand before her mouth and clasping her left hand with her right; fol. 107 (ICA).

33. For plates of the monuments cited in this paragraph, see the following: for the sarcophagus of Junius Bassus see Kitzinger, *Byzantine Art in the Making*, fig. 43; for the Avignon sarcophagus, see Grabar, *Early Christian Art*, pl. 299 (for other examples see pls. 296 and 298); for the Lateran sarcophagi see Malbon, *Iconography of the Sarcophagus of Junius Bassus*, figs. 5, 9; see also Leclercq, "Suzanne," *DACL* 15.2:1746. For the ivory in the Louvre see Carrà, *Ivories*, pl. on p. 127; for Lateran 171 (Museu Pio Cristiano, Vatican) see Malbon (1990) fig. 8.

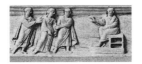

people": "mundus ego sum a sanguine huius" (Dan. 13:47), and "innocens ego sum a sanguine iusti huius" (Matt. 27:24). Furthermore, a later verse in the account of Susanna (Dan. 13:62), after the execution of the elders, concludes: "et salvatus est sanguis innoxius in die illa." Asterius of Amasus is among the Early Christian homilists who point to this similarity.[34] The designer of the Brescia Casket has chosen to depict precisely those moments from the history of Susanna in which she is a type of Christ; thus the casket lacks the other scenes known in Early Christian art, of the elders giving false testimony, their hands on Susanna's head to show that they are testifying, and of the elders again, when Daniel has proven that they lied, being stoned. In short, the selection of Susanna scenes on the Brescia Casket and the parallelism between the depictions of Christ and Susanna invite the viewer to read Susanna as a type of Christ.

The visual testimony of the casket is clear. But more evidence for Susanna's role as a type of Christ is extant, and from excitingly near the time and place the casket was carved. A pair of sermons expressing exactly the same typology was preached in Turin in North Italy, less than a hundred miles from Brescia (see map, p. 22),[35] around 390.[36] Maximus, the bishop of Turin (ca. 390-408/23), preached "On the Lord accused before Pilate and on Susanna."[37] The opening

34. Asterius of Amasus, *Logos eis ton propheten Daniel kai eis ten Sosannan* (PG 40:248). See also Maximus of Turin, discussed below. For his and Jerome's comparisons of a similar statement in Jonah 1:14 with Pilate's words and the washing of his hands, see above, nn. 21-22.

35. Turin, ancient Taurasia, is on the Po, eighty miles WSW of Milan; see introduction to CCL edition.

36. Almut Mutzenbecher suggests the date for a group of sermons that depends upon Ambrose's commentary on Luke, which is dated to 380-90; see the introduction to his edition of *Maximi Episcopi Taurinensis Sermones*, CCL 23: xxxii. The specific pair of sermons of interest in the present study are in that group. The fact that this pair elaborates upon Susanna as a type of Christ, a typology that Ambrose discusses (in the passage quoted above) in his *Expositio Evangelii secundum Lucam*, supports Mutzenbecher's dating.

37. Mutzenbecher established the dates of his bishopric and clarified that there were two Early Christian bishops of Turin named Maximus. In the late fifth century, Gennadius compiled a catalogue of Christian authors which includes our bishop and reports that he died during the reign of Honorius and the younger Theodosius, i.e. sometime 408-23. In the early seventeenth century, Cardinal Baronius argued that this was not a death date, but a floruit date, because the acts of the Council of Milan (451) and of the Council of Rome (465) involve a bishop of Turin named Maximus and Baronius could not believe there were two fifth-century bishops of Turin with the same name. The matter was debated until Mutzenbecher made a cogent case for Gennadius's accuracy and for the existence of two homophonous bishops. The probable dates of Maximus's work in Turin are ca. 390-408/23; see Mutzenbecher, introduction, xxix-xxxvi; and Ramsey, *Ser-*

paragraph treats the details that Christ was silent (*taceat*, 5) before Pilate and that Pilate disclaimed guilt for the just one's blood. Next the bishop recalls the similar case of Susanna who was silent (*tacuit*, 35) before the judge Daniel, but victorious because her chastity (*castitas*, e.g., 37) spoke for her and her cause was heard by a virtuous/modest man (*vir pudicus*, 48). Maximus then quotes and compares Daniel's and Pilate's assertions of innocence of the blood of the ones brought before them (51-57), contrasting the judges (57-58, also 70). Each recognized the innocence of the accused, but Daniel freed (*liberat*, 59) the "virtuous/modest blood" (*pudicum sanguinem*, 58), while Pilate handed over the just blood (*iustum sanguinem . . . tradit*, 59-60).

The typology is further elaborated in the complementary sermon the bishop preached the next day. He addresses other similarities between Susanna and the Lord: she suffered false attacks against her chastity and virtue/modesty (*castitatem, pudicitia*, 3, 5), and Christ's integrity and justice were belabored (*integritas, justitia*, 4, 6-7). Maximus then compares Susanna and Christ in that each was accused of what the accusers were in fact guilty of; moreover, the false accusations are typologically related, with adultery being a type of heresy:

> When she proves the priests guilty (*convincit*) of adultery, she herself is nevertheless detained as an adulteress; when he shows the Pharisees guilty (*arguit*) of sacrilege, he himself is nevertheless accused as sacrilegious. And indeed such sacrilege in the Pharasees can be called a great adultery; for adultery of religion is more serious than that of the body, and it is more to injure the integrity of divinity than to violate the integrity of a human being. Therefore Susanna was condemned and so was the Lord; she because she was safeguarding the chastity of the body and he because he defended the chastity of religion.[38]

The comparison of Susanna and the Lord is continued in the parallel clauses of the following sentences: "Him . . ., her Susanna's . . ., the Lord's . . . ". Emphatically the bishop asserts, "alike in nearly everything were the trials of Susanna and of the Lord, and only the accusations themselves were dissimilar."[39]

Quite important for our interest in the Brescia Casket is what Maximus says next. He compares the *locus* of each arrest:

mons of Maximus, 1-4. On just judgment in Maximus's sermon, see Kornbluth, "Susanna Crystal of Lothar II," 28.

38. "Illa enim dum in adulterio convincit praesbyteros, ipsa tamquam adultera retinetur; hic dum in sacrilegio arguit Pharisaeos, ipse tamquam sacrilegus accusatur. Quod quidem sacrilegium in Pharisaeis majus adulterium vocari potest; gravius est enim religionis adulterium esse quam corporis, et plus est integritatem divinitatis laedere quam integritatem hominis violare. Condemnatur ergo Susanna condemnatur et dominus; illa quia castitatem corporis tuebatur, hic quia religionis castimoniam defendebat." Maximus of Turin, *Sermo* 58.7-15 (p. 232). He returns to the discussion of sacrilege in the last half of the homily, lines 55-77.

39. "Simile ergo fuit paene per omnia Susannae dominique judicium, siquidem nec accusatio in his fuerit ipsa dissimilis"; Maximus of Turin, *Sermo* 58.22-24; the accusers are compared in ll. 24-29.

> For Susanna was in a man's garden when she was surrounded by her accusers, and the Lord was in the garden of a vineyard when he was encircled by his betrayors; she suffered schemers there, he put up with betrayal here.[40]

Thus, in a pair of sermons preached at about the same time that the casket was made and very near the place where it was apparently carved, the full typology of Susanna as a type of Christ was set forth with all the scriptural parallels of Daniel 13 and the Gospel account of the Passion. This is a significant discovery,[41] and one which argues strongly for the interpretation offered here, that Susanna on the casket is deliberately presented as a type of Christ.

And the Brescia Casket is not alone in expressing this.[42] Other earlier and contemporary depictions of Susanna may also present her as a type of Christ. Boniface Ramsey suggests there is a (far less detailed) typological image

> in a fourth-century mural in the Arcosolium of Celerina in the Catacomb of Praetextatus. The mural in question depicts Susanna as a lamb standing between two wolves. The lamb is, of course, primarily and almost exclusively associated with Christ, the Lamb of God, and this would certainly be understood as a representation of Christ between his persecutors were it not for the fact that SVSANNA is clearly printed above the lamb's head.[43]

An example of an early depiction of Christ shown as a lamb in fact has visual parallels with the depiction in the catacomb: the Lamb of God is shown between two apostles also represented as lambs on the marble saracophagus of Constantius III (d. 421/2) in Ravenna.[44]

A much more nuanced presentation of Susanna as a type of Christ may exist in the central figure on a tree sarcophagus from Gaul, 350-60 (Fig. 10). This figure has been identified simply as "Susanna as orant,"[45] but the context encourages a typological reading. Christ is the dominant figure in six of the seven scenes on the front of this sarcophagus, and its symmetry of design and meaning point provocatively to Susanna. Each representation of Christ has him face the central scene; each shows him performing a miracle with outstretched right

40. "Susanna enim in viri paradyso ab accusatoribus circumvenitur, dominus in hortuli paradyso a traditoribus circumdatur; illa ibi insidiatores patitur, iste hic sustinet proditorem." Ibid., 30-33 (pp. 232-33). In his prior sermon also Maximus had referred to Susanna's having been in the garden; 57.39 and 42 (p. 229).

41. The CLCLT database allowed me to retrieve this pair of sermons years after I had first hypothesized that Susanna on the Casket is a type of Christ. Thus, the discovery was personally exciting as confirmation that what the Casket manifests was also articulated in public texts in the same time and place.

42. For other Early Christian depictions and discussions, see also Tkacz, "Susanna as a Type of Christ."

43. Ramsey, *Sermons of Maximus*, 323, n. 1. The word SENIORIS is written over the wolf seen to the right of Susanna.

44. Beckwith, *Early Christian and Byzantine Art*, pl. 31. For some fifth- and sixth-century representations of Christ as a lamb central among other lambs, see Maguire, *Earth and Ocean*, 11-12, figs. 5-7.

45. Schiller, *Ikonographie*, vol. 1, pl. 464.

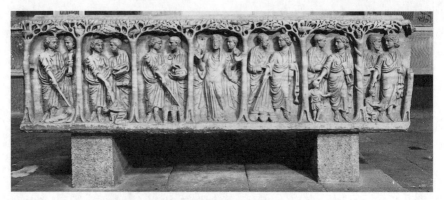

FIGURE 11. Susanna on a Sarcophagus from Gaul.

arm (its line sometimes lengthened by a rod with which he performs the miracle), and in each case his arm provides a diagonal line. These repeated diagonals draw the viewer's eye to the center scene. The four outermost miracles are healings, including the raising of Lazarus, and the two which bracket the central scene are types of the eucharist: Christ multiplies three baskets of bread on one side and on the other he changes three vessels of water into wine. In each of these seven scenes, a man in the background observes the miracle. Of all eighteen figures, only Susanna faces the viewer.

This seems a richly allusive representation of Susanna as a type of Christ. The trees which separate the seven scenes serve in the central scene to remind us that Susanna was accosted in one garden, and that Christ was arrested in another. The man observing Susanna is like the other witness-figures on the sarcophagus, but in the central scene he also functions to recall the elders who sought her. Susanna's graceful orant pose seems evocative of a transformed crucifixion pose; certainly the earliest extant depiction of Christ on the cross shows the ease and strength of the orant position with no hint of bodily pain (Fig. 9). Alternatively, Susanna here can be read with a different typology, simply as a type of the rescued soul. In this reading, she belongs in the midst of Christ's miracles and is flanked by the eucharistic ones as a reminder of how the soul is surrounded by God's healing and grace. We should not overlook a third alternative: just as she does on the Brescia Casket, perhaps here too Susanna bears both typologies, representing both Christ triumphing in his crucifixion and the redeemed soul giving thanks.

Could this rich typology also inform such sarcophagi as that of Sabinus, Lateran no. 161 (ca. 320), on which a central orant female figure is understood as the soul of the deceased? Though 161 lacks the symmetry of design and typology of the later sarcophagus discussed above, the orant of no. 161 is flanked by two men (their heads are shown over her uplifted hands) and is centered among seven scenes, including four of the miracles on the sarcophagus at Gaul: the multiplication of the loaves on one side, water into wine on the other, and the raising of Lazarus and the healing of the blind man.[46] Other monuments also

46. Plate: van der Meer, *Early Christian Art*, pl. 30c.

seem to point to the typology of Susanna. The scene of Susanna before Daniel is placed near the scene of Christ before Pilate on other Early Christian works, such as sarcophagus 3 of the Musée Lapidaire in Arles (ca. 350) and sarcophagus no. 88 at Cahors.[47]

Furthermore, Susanna is known as a type of Christ in the Middle Ages as well, in Latin and vernacular texts and in over a score of depictions.[48] In some fourteenth-century manuscripts of the *Biblia Pauperum*, for instance, Susanna in the Garden is depicted analogously to Christ in Gethsemane. Munich, Staatsbibliothek CGM 20, fol. 11v places the two scenes adjacently. In their respective scenes, Susanna and Christ each face to the viewer's left, kneel on a slope, facing up it, with gaze and clasped hands lifted in prayer; behind each figure are the other participants in the scene, the elders and the sleeping disciples respectively (Fig. 17). The same typology is again evident in Munich, Staatsbibliothek, CLM 4523, which includes several types of Christ on each page; in a central medallion he is depicted praying in Gethsemane, and the medallion is flanked by scenes of Hezekiah and Susanna praying in the same pose as Christ.[49] In texts such as Henry Suso's *Leben*, as well as plays, poems, and biblical commentaries into the seventeenth century, and in depictions including a mid-thirteenth-century fresco in Meldorf, illustrations in a score of manuscripts, the fifteenth-century typological window in the Frauenkirche in Munich, and sixteenth-century liturgical art in Tournai and Leuven, Susanna is presented as a type of Christ.[50] In short, the depiction of Susanna as a type of Christ on the Brescia Casket is part of a longlasting tradition that was established in the Early Christian period and survived for centuries.

Concerning Susanna on the Brescia Casket specifically, the biblical accounts of Susanna and Christ have additional pertinence. It appears that the designer of the casket deliberately presented on the front of the casket the only two Old Testament types which are verbally linked with the gospel account of the Passion.[51] How striking it is that the designer of the casket has portrayed Christ before Pilate on the lid of the casket and then, on the front, both of the only two Old Testament types of Christ—Jonah and Susanna—whose histories also refer to innocent blood, and in words formulaically like Pilate's.[52]

47. Arles, Musée Lapidaire, sarcophagus 3: see Benoît, *Sarcophages paléochrétiens d'Arles*, no. 44 on p. 47, pl. XVI.1; Réau, *Iconographie de l'art chrétien*, 2.1:401-06 apparently refers to the same sarcophagus. The sarcophagus at Cahors is described by le Blant, *Sarcophages chrétiens*, no. 88, pp. 71-72 and pl. XX fig. 1.

48. See Tkacz, "Susanna as a Type of Christ."

49. Fol. 53. Plate: Tkacz, "Susanna as a Type of Christ," fig. 8.

50. Tkacz, "Susanna as a Type of Christ."

51. Matthew uses the words *sanguinem iustum* another time in the account of the Passion: Judas repents of having betrayed "just blood" and hangs himself; Matt. 27:4-5. On the casket, the betrayer of Christ's just blood is sequestered on the back in a marginal panel. Regarding Early Christian texts, while I have found none comparing Matt. 27:24 to both Jon. 1:14 and also Dan. 13:47, Maximus's sermons on Jonah and on Susanna each treat the Gospel verse in connection with the pertinent Old Testament verse. See also Tkacz, "Literary Studies of the Vulgate: Formula Systems," 211-12.

52. Odorici, *Antichità cristiane di Brescia*, 73 hinted at a related verbal association.

Daniel. The lower register on the front ends with another orant pose, this time Daniel between the docile lions,[53] but it carries a different typological

meaning than the Susanna scene at the left of the register. Daniel sealed in the Lions' Den (Dan. 6:16-22) recalls a later event in salvation history, when Christ, though sealed in the tomb, could not be harmed by death. The Early Christian church readily interpreted Daniel as a type of Christ, partly because, as Jerome asserts, "None of the other prophets spoke so openly of Christ."[54]

Thus, read left to right, this register offers types of Christ's Passion in chronological sequence: Christ in the Garden, Christ before Pilate, and Christ in the tomb. Each of the Old Testament figures on the front of the casket has dual significance: the God who earlier had preserved Jonah, Susanna, and Daniel from harm, then became incarnate and underwent the events of the Passion which the accounts of these Old Testament figures prefigured typologically. Again, the God who preserved these Old Testament heroes, whose deliverance exemplifies the Christian hope for salvation, has now himself realized the means of salvation that the Old Testament events foreshadowed.

The Passion on the Lid and Front. Not only has the designer of the Brescia Casket used types innovatively on the front of the casket, but the arrangement of these scenes is remarkably orderly. The lid presents a narrative sequence of five events from the Passion. Now it has been shown that the top Old Testament register on the front of the box completes the sequence in a symmetrical pair of Jonah scenes which fills that register. The bottom register on the front begins a series of Old Testament types which will be shown to sur-

Although he did not see that innocent blood was common to the experiences of Susanna and of Christ, he did pause to explain Pilate's gesture as "Hebraic ritual for purifying oneself of innocent blood." He refers to the fact that Pilate's words and actions recall Deut. 21:6-8, which describes the proper response when a murdered body is found but the murderer is unknown: the washing of hands and the assertion that "our hands did not spill this blood." The passage stresses the diction of blood and innocence: *sanguinem, sanguinem innocentem, sanguinis, innocentis cruore.*

53. For discussions of Daniel in art and pertinent patristic texts, including Origen, *Contra Celsum* 5.57; Hippolytus, *Commentarium in Danielem* 3.31; and Ephrem, *Contra Nisib.* 11, see Henri Leclercq, "Daniel," *DACL* 4.1:221-48; Jean Daniélou, "Daniel," *RAC* 3:575-85, with comments on typology on col. 580-81; Klaus Wessel, "Daniel," *RBK* 1:113-20; and Catherine Brown Tkacz et al., "Daniel," *ODB* 1:583-84.

54. "Nullum prophetarum tam aperte dixisse de Christo"; Jerome, *Commentariorum in Danielem*, prologue, ll. 15-16 (CCL 75A:772), see also 1.3.92b (CCL 75A:807-08). Schiller argues that Daniel in Early Christian art represents redeemed and perfected humanity; *Ikonographie* 2:4-5 and 1:97. Prosper of Aquitaine compares Daniel emerging from the pit unharmed to Christ in his resurrection; *Liber de promissionibus et praedictionibus Dei* 35.77-81 (PL 51:810-12).

round the casket and which reiterate and emphasize different aspects of the events they foreshadow. If this were all, it would be stunning.

But the casket holds more treasures. The very number and sequence of scenes and of registers shows balance and structure. Consider first the pattern in the arrangement of New Testament and Old Testament in this four-register series. The lid holds five New Testament scenes in two registers, presenting the Passion narrative up to Pilate's judgment. The front holds five Old Testament scenes in two registers, presenting the typological completion and echoing of the full Passion narrative. Thus the number of registers and of scenes is equal, with the Old Testament types manifestly subordinate to the New Testament reality: the lid with the New Testament registers is higher than the front, and the Old Testament registers are smaller than the New Testament ones. This aptly demonstrates the Old Testament's role as support for the New Testament's complete revelation.

Beyond this, consider the relationship between the first three registers and the fourth. The narrative sequence of the lid fills its two registers, and, on the front, the top panel serves as a third register, completing the Passion sequence, from Christ in the Garden through the Resurrection. These three Passion registers are then brilliantly *recapitulated* by the three scenes of the bottom register. Thus Susanna about to be captured in the garden reiterates the two scenes of Christ in the first register, Susanna before Daniel recalls the two scenes (especially the second) in the second register, and Daniel in the Lions' Den evokes Christ's death and entombment which are indicated in the Jonah register. The layout is sophisticated: the lid's two New Testament registers and the front's two Old Testament registers together comprise three Passion registers recapitulated in a fourth register, with a one-scene: one-register correspondence.

The Brescia Casket in its top and front gives us the longest historical sequence of the Passion for its time, in five scenes, and the first typological completion and recapitulation of the Passion, also in five scenes. The front and lid of the casket, prominent by position, are the locus of the most sophisticated features of the casket's innovative, breathtaking program of decoration. It is in effect the heart of a visual homily on the unity of the Bible.

The Angel with the Three Hebrews.[55] Given the sophistication of meaning in the casket's program of images, effectively expressed in part through parallelism between lid and front, it is hardly surprising to discover parallelism in structure and meaning between the front and a side register. The structure of the central front register is repeated in the top register of the right side of the casket (Fig. 4). Central to this Old Testament register is the fiery furnace containing first the Three Hebrews and then immediately the Three Hebrews again

55. The identification of this scene is disputed. See Table of Identifications and Chapter Five.

with the fourth figure that Nebuchadnezzar saw in the flames (Dan. 3:91-92). The fourth figure is interpreted by the Fathers and Early Christian poets as representing or actually being Christ, and accordingly is sometimes depicted in Christian art as Christ.[56]

With regard to typology, the apostolic constitutions treat the event as a foreshadowing of Christ's Resurrection, as does Hippolytus of Rome (d. 235).[57] Jerome explains the meaning of the fourth figure in the furnace:

> In type the angel prefigures . . . our Lord Jesus, who descended into the furnace of Hell where the souls of both sinners and the just were held enclosed, so that he might free them from the blazing and the harm and from the bonds of death by which they were shut up.[58]

Thus, this scene on the casket provides another type of an aspect of salvation history, this time the descent into Hell.

Susanna, Jonah, and Daniel. On the back of the casket as well, typology appears operative. Consider the top register on the back of the casket, which shows Susanna, Jonah, and Daniel (Fig. 5). This trio of Old Testament types

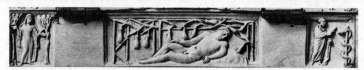

fills both Old Testament registers on the casket's front and celebrates there the events from the praying in the garden through the Resurrection; now in one serene series this trio appears again on the back, indicating the victorious triumph and effects of the Resurrection. Note that the six doves filling the upper margin of the lid, a standard image of souls in paradise,[59] are visible when one

56. Prudentius (b. ca. 348-d. after 405) is one who treats the fourth one in the furnace as "the Son of God"; *Liber Apotheosis* 132-42 (CCL 126:81); Dracontius (ca. 450-after 496) describes the angel as "like an image of the divine offspring"; *De laudibus Dei* 3.179-80, ed. Frideric Vollmer, MGH auct. ant. 14 (Berlin: Weidmann, 1905, new ed. 1961) 96-97; for dates, see Michael P. McHugh, "Prudentius" and "Dracontius," *EEC* 763 and 280.

For artworks, see e.g. a gold glass bowl from the later fourth century (Metropolitan Museum of Art, plate in Mathews, *Clash of Gods*, fig. 37 and p. 78) and the early twelfth-century Bible of Stephen Harding, fol. 64 (ICA). An illustration in a thirteenth-century Bible depicts Christ in the furnace with the Three Hebrews; Manchester, Rylands Library, 17, fol. 231 (ICA).

57. Hippolytus of Rome, *Comm. Daniel* 2:28 and 3:31; see also Henri Leclercq, "Hébreux (Les Trois Jeunes)," *DACL* 6.2:2107-26; Klaus Wessel, "Jünglinge im Feuerofen," *RBK* 3:668-76; Catherine Brown Tkacz et al., "Three Hebrews," *ODB*, 3:2081.

58. "In typum praefigurat iste angelus . . . Dominum nostrum Jesum, qui ad fornacem descendit inferni in quo clausae et peccatorum et justorum animae tenebantur, ut absque exustione et noxa suis eos qui tenebantur inclusi mortis vinculis liberaret." *Comm. in Danielem* 1.3.92 (CCL 75A:808).

59. For birds as "symbols of souls in paradise," see Maguire, *Earth and Ocean*, 29-30, 82, figs. 23 and 31. See also Table of Identifications.

looks at the back of the casket, so that a symbol of what Christ gained for the Christian through the Passion is around the edge of the casket from a trio of types celebrating the victory of the Resurrection. Literally, the first two scenes show these figures when they have been delivered. Thus, Susanna orant—without the wicked elders closing in—is the heroine praising God after she has been vindicated.[60] And Jonah reclining under the gourd plant has already been de-

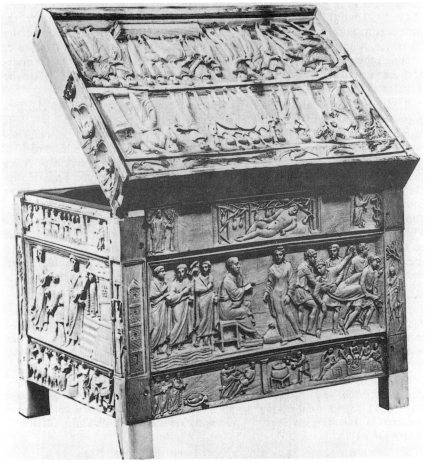

FIGURE 8

60. The vindicated Susanna orant appears in such Early Christian monuments as a tree sarcophagus from Gaul, ca. 350-60 (Fig. 10) and in the Capella Greca of the Catacomb of Priscilla in Rome; Grabar, *Early Christian Art*, pls. 113 and 114-15. On the ninth-century rock crystal of King Lothair II, which is devoted to narrative scenes of Susanna, the exact center of the round surface depicts the vindicated Susanna orant; Nees, *Tainted Mantle*, 267-69, fig. 71 (whole surface) and 72 (detail of center). See also Kornbluth, "Susanna Crystal of Lothar II."

livered *de ventre ceti* and, in the Vulgate and Hebrew Bible, has called Nineveh to repentance; his trials are over. It is well established that Jonah under the gourd plant, as he is shown here, is frequently included on sarchophagi to indicate the peaceful repose of the blessed soul.[61] Another typological role for Jonah may be suggested for this scene. Perhaps here the typology of the Jonah story, which is so effectively displayed on the front of the casket, is extended to include this third prominent scene from catacomb art, with Jonah still a type of Christ. Then this would be the resurrected Christ, who has endured death, risen again, and, by his blessings, has brought about the conversion of the Ninevites, that is, of sinners in general. Notably Jerome and Ambrose, although they do not explicitly construe Jonah as the ascended Christ, do interpret the period when Jonah is under the gourd as representing time "after the Resurrection of Christ" and "after the Resurrection of Lord Jesus."[62]

The third scene of this register may be read typologically also. Daniel offers poison to the dragon the Babylonians worshiped (Dan. 14:22-26), which is raised up on a rod. Visually this seems to be a comparison of Daniel's poisoning the dragon to Jesus's tricking and defeating the Devil through his Crucifixion. Such associations also explain the imagery on the sarcophagus at Arles that depicts Lazarus coming forth from a tomb, whose sculpted base depicts Daniel poisoning the dragon.[63] In any case, it is a commonplace that Jesus is compared to the serpent lifted up in the wilderness, and the serpentine "dragon" here seems to be lifted up in a comparable way. Indeed, Wolfgang Fritz Volbach at one time identified this scene as the brazen serpent.[64] Again, Jesus on the Cross was offered vinegar on a sponge; and here Daniel offers poison to the dragon; the image can be construed as a depiction of the paradox that, though Christ was crucified, it was the Devil and death that were defeated.

61. Nordström, "Jewish Legends in Byzantine Art," 504. He concludes that "The Jonah scenes on the Brescia casket should be regarded as inspired by a Rabbinically influenced Septuagint tradition." He reviews the comparison between the image of Jonah under the gourd to the classical image of Endymion (p. 506), as does Milburn—who also sees the gourd scene as indicating peace for the dead; (1981) 63.

62. Jerome, *Commentariorum in Ionam Prophetam* 4:7.8 (CCL 76:416-17); Ambrose, *Explanatio psalmi* 47.25 (CSEL 44:361). See also Evagrius the monk, *Altercatio legis* 6.176 (CSEL 45). Cf. Schiller's interpretation of the same event as depicted on a Roman sarcophagus as showing the prophet "awaiting the resurrection which Christ will effect"; *Ikonographie* 1:97.

63. Stommel discusses early depictions of Daniel killing the dragon as a type of Christ; *Ikonographie der Sarkophagplastik*, 78-80. Leclercq, "Daniel," *DACL* 4.1:223-24, n. 6.

64. Volbach, *Early Christian Art*, 328; but cf. his *Elfenbeinarbeiten*[3], 77, where he interprets the scene as Daniel and the dragon. The earliest known (eighteenth-century) identification of the casket's images construed this scene as Moses with the serpent; for a transcription of the document, see Kollwitz, *Lipsanothek von Brescia*, 6. Westwood, *Fictile Ivories in the South Kensington Museum*, 37 noted the similarity of the image on the Brescia Casket to that on a sarcophagus; Watson has reviewed a series of Early Christian images and concludes that the dragon in the Daniel scene "almost always has the form of a snake"; "Program of the Brescia Casket," 295, n. 28.

The three deaths depicted on the back of the casket are visually linked by being aligned with each other, and the two deaths in the Old Testament registers can be read typologically. Moses's slaying of the Egyptian, depicted in the left center of the lower register, was glossed by Hilary of Poitiers as Jesus's defeat of the Devil by the Crucifixion, as will be discussed below. The line formed by the falling body of the Egyptian slain by Moses (in the lower register) directs the eye to the prostrate form of Ananias (in the central register), whose surprisingly raised arm points straight to the serpent (in the top register), which may be a type of the Devil defeated by the Crucifixion. Tantalizingly, tradition links the first two of these events, according to Clement of Alexandria, who refers to the belief that Moses slew the Egyptian by his word alone (λόγῳ μόνῳ) and that Peter also, simply by his word (λόγῳ), killed those who had lyingly withheld part of the sale price.[65] This parallel is quite possibly indicated on the casket by the similarities of pose of Peter and Moses and by their juxtaposition: each faces to the right of the panel and extends his hand, pointing his index finger at the person who is about to die; also, the backs of Peter and Moses are lined up vertically. Such visual clues appear important for interpreting the program of images on the casket.

David and Goliath (1 Kings 17 = Prot. 1 Sam. 17). The artist has included typological or literal reminders of Christ's Passion on every face of the casket, and the left side is no exception. Here in the upper left David with the stone ready in his sling faces Goliath, the giant's great height indicated by his being

placed diagonally in the register (Fig. 6). The slanting of Goliath also recalls the position of the slain Egyptian on the back of the casket and adumbrates the Philistine's death, thus emphasizing that David was indeed, in the words of the popular Early Christian prayer, the *Commendatio*, delivered "from the hand of Goliath" (*de manu goliae*). This scene prefigures Christ, according to Cyprian, who interprets this combat as the defeat of the Devil, struck down by the rock of Christ.[66] Augustine construes David directly as a type of Christ, with Goliath as the Devil.[67]

65. Clement of Alexandria, *Stromata* 1.23.153.5-154.1.

66. "Hic . . . lapis . . . Christus . . ."; Cyprian, *Ad Quirinum* (also called *Testimoniorum libri tres*) 2, 16 (CCL 3:51-53). *De opere et eleemosynis* 17.340. See also Henri Leclercq, "David," *DACL* 4.1:295-303; Klaus Wessel, "David," *RBK* 1:1145-61; John H. Lowden et al., "David," *ODB*, 1:588-89; Marlia M. Mango, "David Plates," *ODB*, 1:590-91.

67. "Nam videtis quasi duas quasdam vitas; unam in alienigenis veterem, alteram in Israelitis novam, adversus invicem dimicare. In illa parte corpus diaboli, in ista praefiguratio domini Jesu Christi." Augustine, *Sermo* 32, "De Golia et David et de contemptu mundi," par. 5, ll. 81-84 (CCL 41:400). Presumably the fresco in the Baptistery at Dura

We have seen that Jonah, Susanna, Daniel, the angel with the Three Hebrews, and David on the Brescia Casket are types of Christ's passion, death and resurrection. Note that Jonah, Daniel, the Three Hebrews and Susanna are known primarily or exclusively for those events which are comparable to the passion. The lives of the next two figures to be discussed here are recorded in much greater detail in the Old Testament, and Rabbinic and Christian commentators connected all those details with the coming Messiah and Jesus, respectively. The designer of the Brescia Casket has depicted Moses and Jacob both in scenes which refer typologically to the crucifixion, and also in scenes which can refer to Christ typologically in other ways: Moses as a type of the infant Christ, and Jacob as a type of Christ the Good Shepherd.

Jacob (Gen. 28, 29, 32). On the right side of the casket, the bottom register is devoted to Jacob: he meets Rachel, wrestles with the angel, and ascends the ladder (Fig. 4).[68] These last two scenes concern blessing: at Bethel in his vision of the Lord and the ladder, Jacob received God's promise of blessing for himself, his descendants and all the families of the earth (Gen. 28:13-16), and near Gilead in his wrestling with the angel, Jacob obtained a blessing (Gen. 32:30).

The casket's Jacob register is not a straightforward depiction of Genesis 28-32, however. The scenes are out of order: the vision of the ladder comes first in scripture (Gen. 28:10-17), then the meeting at the well (Gen. 29:1-12) and only later the wrestling with the angel (Gen. 32:22-32). And the biblical well's mouth is covered by a large stone that Jacob rolls away for Rachel, whereas the well on the casket has a windlass erected above it with cross-bar handles at either end of the horizontal barrel for the hoisting of the rope. Finally, it is Jacob, not the angel who ascends the ladder: the figure climbing is clearly the same as the one who, carrying a rod, meets Rachel at the well.

Now, Jacob's ladder quite early became a symbol of spiritual ascent. Origen (d. 253), Ephrem (d. 373), Zeno of Verona (d. 380) and Gregory of Nyssa (d. 394) are among early expositors of this image.[69] Nothing precludes our

Europos showing David and the death of Goliath carries this apt typological meaning; Wessel, "David," *RBK* 1:1147.

68. By the fourth century this image had been depicted in the Via Latina Catacombs and at Dura Europos; Lowden and Tkacz, "Jacob's Ladder," *ODB* 2:1030. Jacob's struggle with the angel and his dream of the ladder are depicted adjacently on at least one other monument, the Hagia Sophia in Trebizond; Klaus Wessel, "Jakob," *RBK* 3:519-22.

69. Emile Bertaud and André Rayez, "Echelle spirituelle," *DS* 4.1:65-67. They cite Gregory of Nyssa, PG 44:1232d, 1248d-49a; Origen, *Contra Celsum* 6.21-23; a hymn of Ephrem; and St. Ambrose, *In Lucam* 5.47-73. The deacon Agapetus also describes spiri-

reading Jacob on the casket's ladder as a type of the good Christian ascending spiritually.

In addition to that moral typology, however, we should also explore the possibility that we are looking at another type of Christ. Even before New Testament times, Rabbinic commentaries had likened Jacob to the Messiah and interpreted his vision as a theophany of the glory of God; also, the Messiah's "mighty sceptre" (Ps. 110:2) was construed as the "rod of the patriarch."[70] In the Gospels Jesus refers to the ladder in a way that invites us to see the comparison between himself and Jacob (cf. John 1:51 and Gen. 28:12). Following up these leads, certain Early Christian commentators including Justin and Tertullian treated Jacob as a type of Christ; a recurring theme among them is to interpret Rachel as the Church.[71] At least one early commentator described the ladder as a cross provided with crossbars serving as rungs.[72] Jacob leading his flock is presented in terms of the Good Shepherd by at least one fourth-century commentator, Ephrem the Syrian.[73] Augustine interprets Jacob's wrestling with the angel as typologically representing the crucifixion.[74] In sum, the tiniest detail of Jacob's life was construed typologically.[75]

Given this line of interpretation of Jacob and Rachel, it is quite possible that the Jacob register is typological. The possibility is strengthened by the fact that only a typological explanation accounts for the events of the register being out of historical order, a trait otherwise decidedly uncharacteristic of the orderly program of the casket. The flock of sheep and Rachel both represent the Church, and Jacob at the well reprises the depiction on the front of the casket of Christ the Good Shepherd. Jacob at the well, holding a rod, appears on the

tual ascent by the ladder; *Expositio capitum admonitoriorum*, ch. 59 and 72 (PG 86.1:1181-82) as was noted by Berenice Cavarra in a presentation at Dumbarton Oaks in 1988. Watson cites Ambrose's discussion of Jacob's ladder; "Program of the Brescia Casket," 288 and n. 42.

70. Paul-Marie Guillaume, "Jacob," *DS* 8 (1974) 8.

71. Guillaume, "Jacob," 13-14 on Jacob as a type of Christ: Zeno of Verona, *Tractatus* 1,37,1 (CCL 22:101); Ambrose, *De excessu fratris sui* 2.100 (PL 16:1343D) and *De Jacob* 2,5,25 (PL 14:624A); Jerome, *In Osee* 3, 12, 13 (CCL 76:140), etc. Rachel as the Church (Guillaume, cols. 9, 14): Justin, *Dialogue* 125.5, 130.3, 134.3, 135.6; Hilary of Poitiers, *Tractatus de mysteriis* 1.22 (SC 19bis:12); Augustine, *Sermo* 4.13-23 (PL 38:40-46); Ambrose, *De Jacob* II.2.9 (PL 14:618a); Epistle 27.13 (PL 16:1049-50); Cesarius of Arles, *Sermo* 86.2-3 (CCL 103:354-55).

72. "The very ladder that Jacob saw is the mystery of our Savior, by which just men ascend from the depths on high. Especially this is the mystery of the cross of our Savior, which was set up like a ladder and at the top of which stood the Lord [God the Father]. For above Christ is the Lord of all, as the blessed Apostle said: 'God is the Head of Christ' (1 Cor. 11:3)." Aphraates (Syr. Aphrahat, d. before 345), *Demonstrationes* 4.5 in Patrologia Syrica 1:145-46; my English translation from the French translation of A. Vööbus, quoted by Grillmeier, *Christ in Christian Tradition*, 1:215.

73. Ephrem the Syrian, *Hymnes sur le paradis* 14, stanza 7 (SC 137:179-80).

74. *De civitate Dei* 16.39 (CCL 48:545).

75. Guillaume, "Jacob," 11.

casket directly under Christ in the New Testament register, who is also holding a rod. Could the tau-shape of the well's horizontal bar and the rope hanging from it be intended to suggest the shape of the cross, fitly surmounting the well of grace? If so, then the placement of the well rope exactly in the center of the register and directly under the depiction of Christ in the New Testament register is quite apt. Following the sort of interpretation found in Augustine's commentary, the struggle of Jacob with the angel could be a type of the crucifixion. Finally, Jacob's climbing the ladder could conceivably depict either the crucifixion (as Ephrem glosses it) or the ascension. That is, the scenes are out of historical order for the life of Jacob because they are in typological order for the Passion.

The register also presents two complementary halves: the entire left half depicts the Church, the entire right half depicts types of Christ, especially in his Passion, and the two halves meet at the well of grace surmounted by a reference to the cross. This meeting of the two halves is epitomized in the center of the register by the meeting of Rachel (the Church) and Jacob (Christ) facing each other across the cross-topped well.

The probability of this typological interpretation increases when one considers that the Jacob register is around the corner from the depiction of Christ the Good Shepherd. The flock gathered behind Christ is obviously the church while the image itself, based on John 10, refers to the passion. How fitting that around the corner we once again encounter a flock watered by Jacob, who is then depicted again as a type of Christ in his passion. Another argument for the coherence of this register, fully in accord with this typological reading, will be offered in the next chapter.

Moses. Moses appears in six scenes on the Brescia Casket, three on the lower back and two on the upper right, as well as the Transfiguration on the back. Five of the scenes are based on accounts in Exodus, and in addition all six events are recounted in Acts. Within individual registers, the Old Testament scenes are presented in historical order, but on the casket as a whole if one were to read all six scenes in biblical order, the bottom register of the back would come first, then the top register on the right, and finally the central register on the back. But narrative here is subordinate to other considerations. The Moses register on the back will be shown in the next chapter to express an idea from a popular prayer; here it will be shown that the first two scenes in that register can be read as types of Christ. In Moses's other three appearances on the casket, he is a witness to theophany: in the burning bush, on Mount Sinai, and then in the person of Jesus Christ.

1. Moses as a type of Christ[76] (Exod. 1:15-2:10, 2:11-15, 2:16-20; Acts 7:17-21, 7:22-25, 7:29). Moses appears three times on the back of the casket in

76. See Joachim Jeremias on Moses as a type of the Messiah from pre-Christian times and in later Judaism: "Mousas," *TDNT* 4a:848-73. See also Glasson, who identifies the influence of the Moses typology in Acts 3:22 and 7:37, Matt. 2:20 (cf. Exod. 4:19, esp. comparing the Greek of each), etc.; *Moses in the Fourth Gospel*, 21-22. Ambrose considers Moses to prefigure Christ by teaching the Law; *De Cain et Abel* 2.7 (PL 14:319). Several Early Christian texts presented Moses, orant before the Amalekites, as a type of

the lower register (Fig. 5). Note that the three scenes represent sequential passages in the Book of Exodus which are also recalled sequentially in the Book of Acts. First he is depicted as a swaddled infant beheld by three adults, then as an adult, slaying the Egyptian, finally as he feasts in the house of Jethro. The infancy of Moses has been contrued as parallel to that of Jesus: some evidence indicates "a Jewish legend of a conception without a human father, and the child in question may well be Moses," thus providing a possible allusion to the virgin birth.[77] A definite parallel between Moses and Jesus is that both were threatened by official commands to kill male Hebrew babies (Exod. 1:22 and Acts 7:17-21; Matt. 2:16).[78] Paulinus of Nola alludes to this when he declares that Christ was "in the Law concealed, in the Gospels revealed," and adds he was "in Moses exposed and put to flight."[79] In the next chapter another reason for the casket's including the finding of Moses will be offered.

Moses's slaying of the Egyptian (Exod. 2:11-12, Acts 7:22-25) is shown next. Moses's killing of the Egyptian was construed as Jesus's defeat of the Devil by the Crucifixion. Hilary of Poitiers explains:

> Match up the characters, compare the effects, examine the deeds, and you will discover in its conformity with present [events] the truth of the [original] sequence of events. . . . Moses, having been made great, seeks out his brothers detained in servitude. Then he strikes down an Egyptian dominating and inflicting injury on one of them. . . . Is this not Christ, who struck down and conquered the Devil dominating them? . . . Is this not demonstrated by the events themselves, in which upon the Devil he rendered retribution and out of servitude he brought liberty?[80]

Christ crucified; e.g., Justin Martyr, *Dialogus cum Tryphone Judaeo* 90, *The Sibylline Oracles* 8, 251-55; Tertullian, *Adversus Marcionem* 3.18.6 (CCL 1:532-33); see also Rabanus Maurus, *Commentaria in Exodum* 2.8 (PL 108:84-86); and Prosper of Aquitaine, *Liber de promissionibus* 1.40 (PL 51:766-67). For a different scriptural basis for the same typology, see Gregory of Nyssa, *Vita Moysis* 56 re Exod. 9:33; Macleod, "Allegory and Mysticism," 373. See also Henri Leclercq, "Moise," *DACL* 11.2:1648-89; Alexander Kazhdan et al., "Moses," *ODB*, 2:1416.

77. Daube, "A Supernatural Birth," in his *New Testament and Rabbinic Tradition* 5-9. He continues, "This would not be a virgin birth–both Miriam and Aaron were older than Moses"; p. 5.

78. See also Goulder, *Type and History in Acts*, 2-4. The fact that the casket shows *three* figures beholding Moses may be a typological reference to the magi.

79. "In lege velatur, in Evangeliis revelatur," "in Moyse expositus et fugatus." Paulinus of Nola, Epistola 38 to Aprus, PL 61:359. See also Prosper of Aquitaine, *Liber de promissionibus* 33 (PL 51:759).

80. "Junge personas, compara effectus, gesta intuere, invenies in praesentium imitatione consequentium veritatem. . . . Magnus factus Moyses detentos inservitio fratres requirit. Deinde dominantem et injuriam uni eorum inferentem Aegyptium prosternit. . . . Nonne Christus . . . dominantem eorum [i.e., domus Israhel] diabolum prostravit et vi-

Augustine makes the same point:

> The circumstance that Moses killed the Egyptian in order to defend his brother most readily has this counterpart [*cuius facillime occurrit*]: the Devil, who is injuring us in this pilgrimage, is killed by the Lord Christ in order to defend us.[81]

The third scene depicts the feast in the House of Jethro. On the casket, it does not readily suggest itself as a typological depiction of Moses representing Christ, except in that Early Christian banquet scenes have often been seen as having eucharistic overtones. Moses's meal, however, does present itself for comparison with the only other feast scene on the casket, the feasting of the Hebrews before the Golden Calf, shown around the corner of the casket on the left side. Moses's feasting in the house of Jethro is positive, the Israelites' disobedient idolatry is just the opposite. Moses's feasting occurred shortly before he returned to Egypt to lead God's people out; the feast before the Golden Calf occurred right while Moses was on the mountain, receiving the law from God, and the events are recalled right after each other in Acts (7:38, 7:39-43). It can hardly be chance that on the left side of the casket the idolatrous feast before the Golden Calf is shown, while on the opposite, right side of the casket the simultaneous event of Moses's receiving the Law is depicted. The opposition of the left and right sides is repeated in the two scenes of Bethel: Jacob's vision, depicted on the right side, and Jeroboam's disobedience, depicted on the left side.

Thus, on the back of the casket all three Moses scenes are part of the larger patterns of the casket, with connections beyond the register in which they occur.

2. Moses as a witness to Theophany. The theophanies to Moses in the Burning Bush and on Mount Sinai (discussed in more detail in Chapter Six) were construed by some Early Christian commentators as depicting human spiritual progress[82] and may have been understood by the author of Acts (7:30-35, 38) to indicate "Christ as present with the people of Israel in critical moments of their history under the old dispensation."[83] On the Brescia Casket,

cit? . . . Nonne ab his ipsis, quibus et de diabolo ultionem et de servitio libertatem reddebat, arguitur?" Hilary of Poitiers, *Tractatus mysterium* 1.29 (SC 19bis:122-24).

81. "Quod enim fratrem defendens occidit Aegyptium, cuius facillime occurrit iniuriosum nobis in hac peregrinatione diabolum a domino Christo nobis defensis occidi." Augustine, *Contra Faustum* 22.90. Elsewhere (22.70), he compares Moses's killing the Egyptian to Peter's striking the temple guard with a sword (Matt. 26:51ff.). See also Prosper of Aquitaine, *Liber de promissionibus* 33 (51:759) and Rabanus Maurus, *Commentaria in Exodum* 1.4 (PL 108:17).

82. Gregory of Nyssa, *Life of Moses*; Gregory associates the three theophanies to Moses, "the Burning Bush and the two Ascents to Sinai. The meaning of the Burning Bush is that God is the only reality (38.25-41.2); the first Ascent to Sinai signifies that to see God is to see that he is utterly unknowable (86.11-88.5), and the second that God is infinite, that to see him is never to cease searching for him or following him (114.5-116.23; 120.5-122.3)"; Macleod, "Allegory and Mysticism," 375.

83. Hanson, *Allegory and Event*, 95.

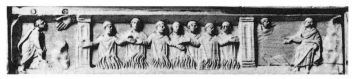

however, the pair of Old Testament theophanies to Moses emphasize his role as witness to the glorious presence and power of God (Fig. 4). This is true also in the other scene on the Brescia Casket in which Moses is depicted: the Transfiguration (Luke 9:28-36),[84] represented on the back, above the two scenes of

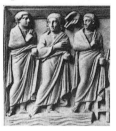

Moses's youth (Fig. 5). As in the depiction of the Burning Bush, the hand of God appears at the top, representing the glory of God. As in the Exodus accounts of the theophanies to Moses, glory, brilliant light, and a concealing cloud are described in the New Testament account of the Transfiguration.

In the three theophanies as depicted, Moses cannot be a type of Christ. Further, the artist of the Brescia Casket is obviously not interested in depicting the dominant typological scenes associated with Moses: the crossing of the Red Sea and the bringing of water from the rock, for instance, are not on the casket. These scenes are strongly associated with baptism and extremely common in Early Christian art. It seems that the artist of the Brescia Casket, rather than focusing on the sacraments, was primarily concerned with celebrating the central events of salvation history, the narrative of the Passion of Christ, literally on the lid and typologically on the vertical faces, and was additionally interested in showing the unity of biblical revelation, Old and New Testament. The three theophanies depicted on the casket indicate that the glorious God who appeared to Moses and gave the Law is the same glorious Lord, incarnate in Christ.

What of the arrangement of these six Moses scenes in the overall plan of the casket? He is after all shown more often than any other Old Testament person, befitting his importance, so one might expect the designer would take particular care in placing these scenes. Chapter Six presents a detailed argument for Moses's role in the upper right register on the right side, and for the relation of that register to the front's New Testament register. For now, suffice it to reiterate that on the right side of the casket he is a famous witness to theophany. On the back he is witness to the transfiguration of Christ, an even greater theo-

84. For a discussion of biblical, theological, and art historical points, see Gerhard Podskalsky, Robert F. Taft, Annemarie Weyl Carr, "Transfiguration," *ODB* (1991) 3:2104-05.

phany, shown in larger scale in a New Testament register. Thus, the upper right register on the right side is associated with the New Testament registers on both front and back. Moses in the back's lower register has three roles: in the register as a whole, as will be discussed in the next chapter, he is an exemplar of the faithful soul saved by God; on the right half of the register, as one feasting blessedly, he is in contrast to the Israelites depicted around the corner on the left end of the casket; and as a type of Christ on the left half of the register he fits into the pattern of depiction of christological types on the casket, and in particular the scene of his killing of the Egyptian is designed so as to link the punitive deaths on the back of the casket.

The Lock on the Casket

An additional typological feature is possible. Certainly the Jonah scenes are focal on the casket. Because Christ himself signaled this typology when he spoke of the sign of Jonah, this Old Testament figure was undoubtedly one of the most readily recognized types of Christ. The designer of the Brescia Casket chose well in deciding to use Jonah to complete the Passion narrative on the casket. The Jonah register provides the types one sees first.

It is worth considering, then, what else is in that register. It is not a carving, yet it may well be symbolic: the depictions of Jonah bracket the silver lock of the casket (Fig. 2). It is enticing to think that these Jonah scenes may have been deliberately placed by the lock, for these scenes indicate the key. When read correctly, as types, they unlock the meaning of several of the images of the casket, where typology and salvation history are paired. Jonah is, it is worth remembering, associated with the key of understanding in the Gospel of Luke: shortly after Christ discusses the sign of the prophet Jonah (11:29-32), he exclaims against the lawyers who do not understand the prophets and who take away the *clavem scientiae*, "the key of knowledge" (Luke 11:52). More generally, the word *clavis* 'key' had a number of pertinent uses in the Bible and in Early Christian writings. Hilary of Poitiers and Jerome, when discussing the Psalms, used *clavis* to mean "interpretive key."[85] Also, the sense of *clavis* 'key' as a glossary of biblical types or symbols is at least possible for the Early Christian period. The lost second-century *Clavis* by Bishop Melito of Sardis was thought to have been recovered when such a key to biblical symbols was found, and though this work was determined to be an eleventh-century compilation of patristic materials,[86] it is notable that such a meaning for the second-century title *Clavis* raised no scholarly eyebrows.

85. Hilary of Poitiers, *Tractatus super Psalmo* 1.24 (CSEL 22:18-19) and, probably borrowing from Hilary, Jerome, *Tractatus in Psalmo 1*, lines 10 following.

86. E. Renoir, "Clef de saint Méliton," *DACL* 3.2:1850-59.

Moreover, the images of Christ himself as the key, and of his Passion as the means by which the faithful can be delivered through his wielding the keys of hell and death, may be pertinent to the casket. These biblical images receive considerable Early Christian comment. The keys of the kingdom of heaven that Jesus entrusts to Peter (Matt. 16:19) are the best known biblical *claves*, but other, related key images are Isaiah's prophecy of the "key of the House of David" (22:22), and subsequent passages informed by Isaiah 22, namely, Christ's commission to Peter (Matt. 16:19) and the assertion that one "like to the Son of Man" has "the keys of hell and death" (Apoc. 1:13, 18). To move from these scriptures to identifying Christ as the key was an easy step for commentators. Apringius Pacencis, commenting on Apocalypse 1:18, recalls Isaiah 22:22 and concludes, "The key is the Lord Jesus Christ himself, who opened the portal of life and broke the gate of death."[87] Just as Christ himself is called the key, so his incarnation is the key of David,[88] his blood is described as the key of paradise,[89] and his resurrection is the key.[90]

Significantly, the cross as key is a dominant image. Augustine, Jerome, and other commentators use it.[91] Precisely by Christ's death and resurrection did he open wide the door of life and burst the gate of death. A number of Early Christian texts explicitly relate the image of the key, and sometimes the cross as key, to typology. Hippolytus of Rome interprets the sealed book spoken of by Isaiah (Isa. 29:11) as the fullness of prophecy, closed before the coming of Christ, who is the book's seal and the Church is the key.[92] Twice Augustine relates the key of the cross to typology. Expounding Psalm 45, he asserts: "the cross of our Lord was the key by which closed things were opened."[93] In another sermon, using language we shall examine below, he is more direct in indicating that it is the *clavis crucis* that opens the full meaning of the Old Testament:

87. "Clavis enim ipse Dominus Ihesus Christus est, qui et vite ianuam patefecit et mortis disrupit ingressum." Apringius Pacensis, *Tractatus in Apocalipsim*, PL Supplementum 4:1232. Apringius, a sixth-century bishop of Pace in Spain, wrote allegorical scriptural commentaries; Michael P. McHugh, "Apringius of Beja," *EEC* 78. See also Maximus of Turin, *Sermo* 43.37. Tertullian describes the lord as the key of the resurrection (*clavis . . . resurrectionis*); *De resurrectione mortuorum* 47.73.

88. Ambrosius Autpertus, *Expositio in Apocalypsin* 2.3.7.11 and passim.

89. "The whole key to paradise is your blood"; Tertullian, *De anima* 55.40; Jerome, "The blood of Christ is the key to paradise"; Epistle 129.2.4 (CSEL 56:165).

90. Gregorius Illiberitanus, *Tractatus Origenis de libris Sanctarum Scripturarum*, Cl. 546, tract. 17.94; Chromatius Aquileiensis, *Sermo* 1.87.

91. Augustine, *Enarratio in Ps.* 70, sermo 2, par. 9, l. 23; and *Sermo* 125a (ed. A. Mai), p. 372, l. 22; Jerome, *Tractatus in ps. 88*, l. 205, and *Homilia in Lucam de Lazaro et Divite*, l. 296; Rupertus Tuitiensis, *Liber de divinis officiis* 6.637; Petrus Pictor, *Carmina de sacramentis* 293.

92. Hippolytus of Rome, "Fragments from the Commentary on Daniel" 19-20, *Ante-Nicene Fathers*, 5:181.

93. "Crux domini nostri clavis fuit, qua clausa aperirentur." Augustine, *Enarratio in Ps. 45* 1.19.

For the Old Testament is the veiling of the New Testament, and the New Testament is the unveiling of the Old Testament. . . . The [Old Testament] had been closed because the key of the cross (*clavis crucis*) had not yet come.[94]

For Augustine, as for others, the key of the cross, then, is the ability to perceive typological relationships between the Old and New Testaments.[95]

The Brescia Casket certainly uses typology more deliberately, thoroughly, and coherently than has been shown to be the case in any other Early Christian monument.[96] Arguably the designer of the Brescia Casket had in mind that typology is the key to understanding the Old Testament images on the casket, and so put the primary pair of typological scenes—the Jonah scenes which complete the depiction of salvation history—beside the lock. Further, the artist may have intended that the Key of the Cross or Christ the Key—images rooted in his death and Resurrection—be recalled here as well. It is clear from surviving keys actually used for locking that sometimes they were adorned with a cross-form.[97] Conceivably the casket's actual physical key, now long lost, had a handle in the shape of the cross, making the symbolism explicit.[98]

WHAT CHRIST TEACHES IN THE SYNAGOGUE

Further to highlight typology, the artist selected with care the scene he placed directly below the lock and key. Delbrueck discovered that, of all the New Testament scenes on the casket, only this one does *not* depict a biblical reading from the liturgy during Lent or Easter.[99] Yet, on this ivory work which

94. "Testamentum enim vetus velatio est novi Testamenti, et Testamentum novum revelatio est veteris Testamenti. . . . Hoc utique clausum erat quia nondum clavis crucis accesserat." Augustine, "In solemnitate martyrum Machabaeorum," PL 38:1377-78.

95. For a later expression of this idea, see Paschasius Radbertus, *Expositio in Matheo, libri XII,* 10.695, 6.3862, and esp. 12.4135: "Ille autem sua voluntate eum emisit qui habet clavem David et omnia patefecit quae obscura erant a seculo et figuris obvoluta." See also Petrus Cellensis, *Tractatus de tabernaculo,* in which he vividly describes God's opening the golden door of venerable treasures with a wooden key ("clave lignea venerabilium thesaurorum ostium aureum resolvens"; Ia, cap. 5, l. 18ff.)

96. Malbon argues unsuccessfully that typology informs *The Iconography of the Sarcophagus of Junius Bassus;* see Appendix below.

97. Vikan and Nesbitt, *Security in Byzantium,* p. 3, fig. 6. The wards of the eighth-century Key of St. Hubert are pierced by four crosses; *Larousse,* fig. 466 on p. 228.

98. Visual puns have been claimed to be present on an early eighth-century Northumbrian casket as well: "The extrametrical words in the border, *hronæs ban,* play cleverly on 'whale's bone,' the material of the Franks Casket itself, and *hronæs bana,* the Eucharist as 'whale's bone', the sacred material which the casket was made to house"; Anderson, "Words and Pictures of the Franks Casket," A26.

99. Delbrueck, *Probleme der Lipsanothek,* 130-33. His findings must be taken with some caution: meticulously researching all extant and fragmentary readings for Lent and Passiontide, he drew on them all, but in some cases the basis for including a biblical character (e.g. Moses, Jacob) is that in some parts of the Christian world the entire

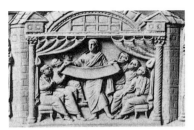

the Passion dominates, this scene is central on the front. I suggest that the artist of the casket has crafted this scene to serve as an invitation to understand the scriptures typologically. The scene depicts Christ teaching in the synagogue, opening the scriptures. Look once more at the last passage cited above from Augustine and consider his diction. He couples the image of the key opening what was closed with the image of the New Testament unveiling (or revealing) what the Old Testament veiled (or concealed). Christine Mohrmann has shown that the word *revelatio* is a Christian neologism, patterned after the Greek *apocalypsis* (ἀποκάλυψις).[100] In the sermon quoted above Augustine plays with the pair of words *velatio/revelatio*, using strictly parallel clauses to contrast the two terms:

> For the Old Testament is the veiling (*velatio*) of the New Testament, and the New Testament is the unveiling (*revelatio*) of the Old Testament.

> Testamentum enim vetus velatio est novi Testamenti, et Testamentum novum revelatio est veteris Testamenti.

Like *revelatio*, its counterpart *velatio* is a new, Christian term. *Velamen* and *velarium* were classical terms,[101] but Augustine is using a new word, minted from the new word *revelatio* and coined specifically to describe the Old Testament's veiling of what was revealed through the New Testament.[102] In eight other passages also, Augustine pairs cognates of *velatio/revelatio*, usually (five times) as rhyming adjectives. This word play directly contrasts Old to New Testament[103] or *evangelio revelato* with *lege velato*.[104] Other authors use the word play also, evidently deriving it from Augustine. For instance, Paulinus of Nola writes in

books of Genesis and Exodus might be read during Lent. His argument is addressed in full in the next chapter.

100. Mohrmann, *Études sur le latin des chrétiens*, 4:20.

101. Albert Blaise, *Lexicon latinitatis medii aevi: praesertim ad res ecclesiasticas investigandas pertinens = Dictionnaire latin-français des auteurs du Moyen-Age*, CCM (Turnholt: Brepols, 1975) s.v. The *Augustinus-Lexicon*, ed. C. Mayer et al., has not reached the letter *v* yet.

102. Tkacz, "*Velatio.*"

103. *In Ps. 105* 36.6ff., *Sermo* 300 (PL 38:1377.577ff.), *De spiritu et littera* 11.18 and 15.27 (pp. 171.4f. and 181.5f).

104. *Sermo* 300 (PL 38:1379.6f). See also ep. 237.5 (vol. 57:529.17), *In Ps.* 77.7.16, *Sermo* 132 (PL 38:735.12), *Sermo* 199 (PL 38:1028.31).

Letter 38 to Aprus, "Christ, who was veiled in the Law, is unveiled in the Gospel."[105]

Given this memorable word play, it is entirely possible that the puzzling visual fact of the synagogue's curtains, fastened back to reveal Christ, is nothing less than the artist's visual depiction of the Augustine's "veil" of the Old Testament. In short, in addition to the visual pun of the key, the casket offers us another visual pun, the *revelatio* of Christ. In the scene on the casket the curtain of the synagogue has been drawn wide open and secured, disclosing the figure of Christ opening the scroll. While the style of curtain is familiar from late antique depictions,[106] it seems that the innovative artist of the casket has, in effect, baptized them: the curtains look the same, but now they convey a new meaning. The scene depicts perfectly the twofold idea that it is Christ who opens the meaning of scripture, in that he fulfills its types foretelling him and in that he explains its meaning; and also that, with the meaning of scripture opened, what one sees centrally within them is Christ himself.

This scene thus embodies the result of typological interpretation. Note that the full-length figure of Christ opening the scriptures in this scene is directly below the lock, with the bust portrait of Christ immediately above it. On each side of the lock is Jonah as a type of Christ—the type, in fact, which Christ himself called attention to. The designer of the Brescia Casket has even made the body of Jonah in each scene a diagonal pointer to Christ, so that the type points to its fulfillment.[107] This placement of images strengthens the possibility that the lock and its key were intended as a visual analogue to what the central New Testament scene depicts.

THE PORTRAYAL OF THE PASSION UNLOCKED

The key of typology has unlocked the experimental portrayal of the full Passion sequence on the Brescia Casket. Typology informs the program of decoration of this ivory work, and this new and detailed finding reveals that the transitional aspects of the Brescia Casket are more numerous and striking than had been recognized. As has long been known, the Passion narrative on its lid is more extensive than on earlier and contemporary monuments, and distinctive in being historically ordered. Beyond this, for what appears to be the first time, typology instead of symbolism is used to complete the Passion narrative. And, just as the Passion narrative on the lid is unusually full, so the typological program on the sides richly elaborates upon and enhances it. Fittingly, the top register on the front, the register one "reads" next after the lid, completes the

105. "Christus . . . qui in lege velatur, in Evangelio revelatur. . . ." Paulinus of Nola, ep. 38 to Aprus (CSEL 29:326-27).

106. Weitzmann, *Late Antique and Early Christian Book Illumination*, 11-12, figs. IV-V, pl. 3. For a good plate showing such draperies in the image of Constantius II in the Calendar of 354, Biblioteca Apostolica Vaticana, see Mathews, *Clash of Gods*, 106.

107. I am grateful to Timothy C. Graham for calling this to my attention.

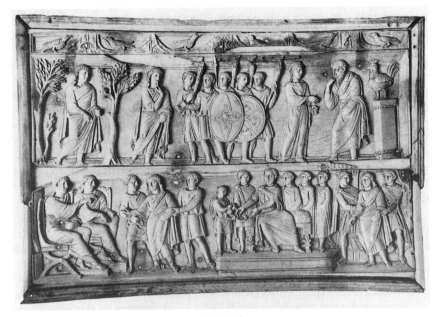

FIGURE 3

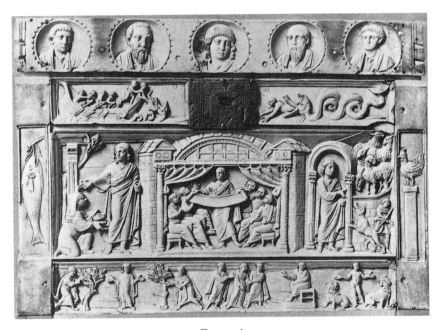

FIGURE 4

narrative with Jonah as a type of Christ. The lower register on the front, in de-
pictions of Susanna and Daniel, begins the typological recollection of the series
of events depicted on the lid and top front register, and does so in a concise,
historically ordered recapitulation of that series. The artist has even balanced
the number of scenes and of registers: five scenes in the two New Testament
registers on the lid present the historical narrative of the Passion; five scenes in
the two Old Testament registers on the front present first the types which com-
plete the Passion sequence and then a trio of types recapitulating that three-
register sequence in full. Moreover, each of the three types in the fourth regis-
ter epitomizes the Passion register that corresponds to it in order. That is, Sus-
anna and the Elders recall the top register of the lid, Susanna before Daniel
recalls the second register of the lid, and Daniel in the Lions' Den refers to the
same events pointed to by the typological Jonah register.

The sides and the back of the casket offer additional types. On the right side,
the Three Hebrews scene provides a type of Christ's descent into Hell, while,
on the right and left sides and back, Jacob as the Good Shepherd who will lay
down his life for his sheep, Jacob again wrestling with the angel, David killing
Goliath, Moses killing the Egyptian, and Daniel poisoning the dragon empha-
size Christ's Crucifixion typologically. The highly popular figures of Jonah,
Susanna, and Daniel, who fill both Old Testament registers on the front, recur
together to fill the top Old Testament register on the back in types celebrating
the triumph and effects of the completed Passion. Moreover, these Old Testa-
ment types are complemented by the New Testament types on the two ends of
the casket: the raising of Jairus's daughter and the raising of Lazarus. When
this typological arrangement is recognized, the Brescia Casket is seen to be the
result of a strikingly innovative approach to the Early Christian avoidance of
portraying the Passion and death of Christ literally.

It should also be noted that the artist of the Brescia Casket included three
other allusions to the Passion, all on the front surface. At the center of the en-
tire front is Christ standing with his arms spread wider and higher than on any
earlier Christian monument. To the right of this is Christ the Good Shepherd,
depicted specifically to recall the scripture which records Christ explaining that
the Shepherd will lay down his life for his sheep (John 10:11). In short, this de-
piction was invented, at least in part, to recall the passion. The third reference
to the Passion is in the lefthand edge panel: the fish, symbol of Christ,[108] is here
depicted caught and hung, an inventive reference to the crucifixion.

108. Augustine and other Early Christian authors explain that the Greek word for
fish is an acrostic referring to Christ: "If you join the first letters of five Greek words—
'Iesous Christos Theou Yids Soter,' which is, in Latin 'Jesus Christus Dei Filius Salvator'
(Jesus Christ, God's Son, Savior)—the word ICHTHYS, or 'fish' is formed, in which one
mystically understands Christ"; *Civ. Dei* 18.23; see also Villette, "Coupe chrétienne en
verre gravé," 139-42.

THE FULL ROLE OF TYPOLOGY ON THE BRESCIA CASKET

Thus the Brescia Casket carries a remarkably full depiction—narrative, typological, and symbolic—of the events from Gethsemane through the Resurrection, perhaps even the Ascension. The five-scene narrative sequence of the Passion on the lid is typologically completed and reprised in five scenes on the front. The Old Testament registers on the front are devoted to the Casket's three main types: Jonah, Susanna, and Daniel. The three other vertical surfaces of the box each present another of three additional Old Testament personages as a type of Christ: Jacob on the right side, Moses on the back, David on the left. As has been noted, the prominent typological trio from the front, Jonah, Susanna, and Daniel, also appear together as types of Christ on the back, filling its top register. They are the only personages to be depicted as types of Christ on two surfaces. Their presence on the front extablishes the iconographic program as typological, and their iteration together on the back is a graceful reprise within that program.

Moreover, typology on the Brescia Casket has a second focus as well: besides pointing to the Passion, death, and resurrection of Christ, types also serve to teach what the Christian should imitate or, especially on the left end of the casket, avoid. The designer of the casket uses models from both the Old and New Testaments, once again demonstrating the unity of Christian scriptures.

The casket presents several Old Testament types of good and bad responses to God, and the result of such responses. The Old Testament types of Christ —e.g. Jonah, Susanna, and Daniel—are also models of faithfulness and sanctity, divinely rescued from death. On the left end of the casket, Jeroboam at Bethel and the stricken Man of God present the result of infidelity, while the Golden Calf register shows a heedless disobedience, the aftermath of which is well known. The designer has placed the negative and positive types on the casket

in contrasting positions, and on the casket's surface the left end is truly sinister. It is no accident that the only two figures depicted in cerements on the casket are on its opposite ends: on the right end, Lazarus comes forth from the tomb, alive and walking upright; on the left end, the disobedient prophet lies stiff and

lifeless. Jacob's vision at Bethel, depicted on the right end, is contrasted by po-
sition to the negative type of Jeroboam at Bethel, depicted on the left end. On
the back is the feast of Moses in the House of Jethro, while around the corner
of the casket on the left end is the similar, but not identical feast before the
Golden Calf. The feast on the left end is composed of wine, bread, and fish, a

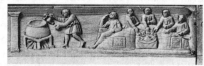

menu reminiscent of the wine Christ created out of water and the very foods
that he miraculously multiplied to feed the multitudes. The bread and wine are
the elements of the eucharist, and fish, too, is also a reference to the eucharist,
as explained by St. Augustine and shown in Early Christian epitaphs and fu-

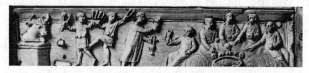

nerary art.[109] On the Brescia Casket the disobedient Israelites, however, are
concerned only with their belly; for them this is no foretaste of the eucharistic
feast. St. Paul makes of the Israelites' feasting before the Golden Calf a warn-
ing to Christians who receive the body and blood of Christ unworthily.[110] Thus

for the Christian viewer the scene epitomizes the choice one must
make, to be disobedient like the idolatrous figures shown feasting, or
to honor the supersubstantial food of the eucharist. The fish in the
center of the banquet table is very like the fish around the corner to
the right, where it is depicted hanging, an imaginative symbol of
Christ crucified. In other words, the designer of the Brescia Casket
has constructed the feast before the Golden Calf so as to recall
Christ's miracles and the eucharist in the midst of this Old Testament
type of disobedience, fitly placed on the left end.

109. St. Augustine: "Piscis assus, Christus est passus," *In Joann.* 2. Villette repro-
duces a carving from the tomb of Mercurius Vibius consisting of two fish, one with bread
at its mouth, the other with wine; Villette, "Coupe chrétienne en verre gravé," fig. 8 on
p. 141, discussed on p. 142. For Augustine and epitaphs, see pp. 140-42. Two overlapped
fish form a cross in the border of the floor mosaic in the narthex of the large basilica at
Heraklea Lynkestis in Macedonia, late fifth or early sixth century; Maguire, *Earth and
Ocean*, 36, 40, fig. 48.

110. 1 Cor. 10:6-7, 21 and 11:27-30. I am grateful to Thomas Nunnally for calling
my attention to this passage.

New Testament types, both positive and negative are also placed strategically on the casket. The precise moments depicted are well chosen. For instance, the hemorrhissa and the blind man, shown at the moment of their healings, embody active faith which seeks and obtains healing; Lazarus and Jairus's daughter, shown at the instant of their resurrections, dramatically encourage intercessory prayer for others, for Jesus raised them in response to the heartfelt requests of their relatives (Matt. 9:18, John 11:1-3). These four figures, blessed by miracles, are types of spiritual healing and rebirth, and the resurrection miracles are also types of the resurrection the Christian hopes for on the last day.

The most powerful types for Christian behavior are the only two disciples shown full-length on the casket, Peter and Judas. For the Early Church, St. Peter was a heartening model of repentance, and this is depicted in Early Christian art. For instance, the Dogmatic Sarcophagus (Lateran 104) presents in series the annunciation of Peter's denial, Peter's later arrest, and then his bringing of water from the rock: "Thus the story which began by showing St. Peter in his moment of human frailty leads up to his triumph as a second Moses giving those who believe in him the water of salvation."[111] On the Bres-

cia Casket's lid, Peter is depicted in the very act of denying Christ (Fig. 2). Restored through repentance, Peter appears again on the casket's back (Fig. 5).

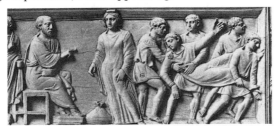

He and Sapphira face each other, types respectively of the restored sinner and of the sinning Christian. Peter sits in judgment, the authoritative head of the Church; Sapphira is about to die.[112] Judas is effectively contrasted to Peter on

111. Saxl, "Pagan and Jewish Elements in Early Christian Sculpture," 1:53, vol. 2, pl. 29b. See also Callisen, "Iconography of the Cock on the Column," 161 for other examples.

112. Watson sees Ananias' gesture in this scene as monitory, but construes the warning as solely against the Arian heresy; p. 286.

the casket. The traitorous disciple is not shown in the narrative registers at all: unworthy even to be depicted alongside Christ, Judas is absent from the scene of the Arrest on the lid. His solitary appearance is on the back, in an edge panel (Fig. 5). He is the only human to appear in an edge panel; non-human symbols fill the eight others. But Judas has degraded his humanity by betraying the Christ who would have been his savior. Judas compounds this sin with the sin of despair and hangs himself (Matt. 27:5). Judas, hanging from a tree, is

shown on the casket around the corner from the cross (in the left pilaster of the left end), the symbol of the salvation Judas cut himself off from. Significantly, the reason Judas gives for his remorse (Matt. 27:4) recalls the other three scriptural references to just blood which are pertinent to depictions on the lid and front of the casket. In direct discourse, Pilate judging Christ, the sailors deciding to toss Jonah overboard, and Daniel repudiating guilt for Susanna's wrongful condemnation all refer to just blood. Judas does so also: "Paenitet me, quia tradidi sanguinem iustum." Both Peter and Judas had drunk of that just blood at the last supper, both had denied or betrayed it, but Peter repented and became the head of the Church, while Judas despaired and hung himself. The two are quintes-

sential types of the penitent who becomes a saint and the sinner who destroys himself, and the designer of the Brescia Casket has presented them on the same surface of the casket in their final states: head of the Church, and suicide.

The designer of the Casket reiterates the contrast between the two, saint and sinner, in the contrast between the two trees in the edge panels on the right side of the reliquary: the flourishing tree representing the righteous man (Ps. 1:3), and the stunted tree depicted shrinking about a grave marker and surmounted by scales of justice, emblematic that the unrighteous shall perish (Ps. 1:6). Each detail of the twisted tree is alluded to in the depiction of Judas hanging. The tree from which he hangs is a tall version of the stunted tree, and the sling in which he hangs recalls the strands supporting the trays of the scales. No grave stele is needed, for death is brought to mind by Judas's very corpse. By their acts, Peter and Judas demonstrate the two opposite human responses to Christ; in symbols, the two trees on the right side present the same life-giving and self-destructive choices.

The casket's balanced presentation of both sexes as models of Christian responses to God and also as types of Christ is notable.[113] Moreover, this is particularly true on visually prominent parts of the casket, namely the front and the New Testament registers. The New Testament registers on the four vertical faces of the casket feature two healing miracles, two resurrection miracles, and

113. See also the Christian addition of petitions citing male and female examples in the *Commendatio animae*, discussed in the next chapter, and Table One, petitions 12-13.

two deaths for sin, each pair comprised of a woman and a man. This balance, while on the one hand is simply the result of depicting the balance in the selected biblical texts themselves, is on the other hand quite possibly a deliberate

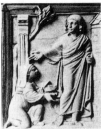

element of the iconographic program of the casket, insuring that it provides the viewer, whether male or female, with a set of same-sex models. In the case of the healings, only one is prominently on the front of the casket: the woman, the hemorrhissa who is portrayed with Christ at the moment when he tells her that her faith has made her whole. This instance of a woman who sought and

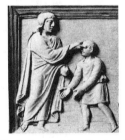

obtained healing for herself is balanced by the healing of the blind man on the right side of the casket, an instance of a man who sought and obtained healing

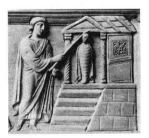

for himself. The designer of the casket also chose to include two New Testament resurrection miracles, whereas most Early Christian monuments (with fewer depictions overall) depict only the raising of Lazarus. This inclusion of both miracles retains and visually demonstrates the Gospels' equality of men and women as recipients of resurrection, and also as intercessors for each other: for Jairus' daughter received resurrection in response to her father's interceding with Jesus for her, and the man Lazarus received resurrection in response to his sisters' interceding with Jesus for him. On the back of the casket,

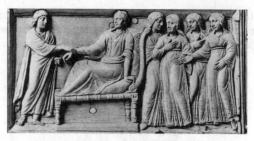

both Ananias and Sapphira are shown punished for their sin, demonstrating that men and women are equally capable of self-destructive choices. Encircling

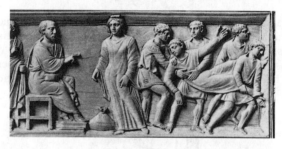

the casket are these positive and negative models of both men and women from the New Testament. On the visually emphasized front of the casket, the Old Testament heroine Susanna plays a focal role as a type of Christ in his arrest and also as a type of Christ in his trial, while on the back of the casket in the top Old Testament register she recurs, triumphant, as a type of Christ after his

Resurrection. Consistently the designer of the Brescia Casket has, without fanfare, included both men and women as types of Christ and as types of good and bad human responses to God.

In sum, the program of the casket is well-coordinated and sophisticated. The events of Christ's Passion are portrayed in full, beginning with the fullest, historically ordered series of historical scenes to date, from Gethsemane through Pilate's judgment, in five scenes filling two registers. The Passion is completed in a third register, through the very type of Christ's death and resurrection that Jesus himself had cited. Then, in a fourth register, three more typological scenes recapitulate the content of the preceding trio of registers. Christ is pre-eminent on the casket, filling the entire lid and visually dominant on each face in the taller, central New Testament register. In every way possible, the *revelatio* of the New Testament is shown as grounded in, but superior to

the Old Testament, which is consistently presented so that its *velatio* is removed and Christ revealed. Types encircle the casket, both types of Christ and also types of positive and negative responses to God. By drawing these types equally from Old and New Testaments, the designer of the casket again deftly demonstrates the unity of the Bible. What had seemed to many to be a loosely coordinated program turns out to have a great deal of order and purpose.

CHAPTER FOUR

A POSSIBLE SOURCE FOR THE CASKET'S PROGRAM OF TYPES:
THE *LIBERA* PETITIONS OF THE *COMMENDATIO ANIMAE*

With the program of types on the casket now discovered, a logical next question is whether a source for this program exists. Of course, no single text or tradition need constitute a source for the typological program: the general milieu of Early Christian ideas and typology can account for it. Nonetheless, if a specific source exists, identifying it would be useful and interesting. It might, for instance, shed further light on the program of the casket and also on Early Christian art and culture more generally. And in fact all of the biblical personages used as types of Christ on the casket do figure in a single, popular Early Christian text: the *Libera* petitions of the *Commendatio animae*.

THE *COMMENDATIO ANIMAE*

The term "commendatio animae" appears in medieval manuscripts and in scholarship with three meanings. The first is broad, indicating "the whole ritual [for the dead] from agony to burial and final commendation."[1] The second sense is specific, indicating the particular prayer the priest utters on behalf of someone at the point of death.[2] The third sense is again specific, designating the prayer some scholars call the *Proficiscere*, contained in the ritual known as the *Commendatio animae* of the second, broad sense.[3] The third sense is used in this study. The *Libera* petitions form the second part of the *Commendatio animae*.

The *Commendatio animae* is a prayer for the dead that was influential in religious art and literature.[4] Jewish in origin,[5] it relies heavily on Old Testament

1. Paxton, *Christianizing Death*, 117.

2. Sicard, *Liturgie de la mort*, 79, see also 20-22, text on pp. 355-56. Augustine refers to this prayer; p. 79, n. 99.

3. Sicard, *Liturgie de la mort*, 361; Paxton, *Christianizing Death*, 120.

4. Research on this prayer includes the following: Baumstark, "Eine Parallele zur Commendatio animae" and "Paradigmengebete östsyrischen Kirchendichtung"; Gougaud, "Ordines commendationis animae" and "Une oraison protéiforme" (on the petition "We commend the soul of your servant X"). See also F. Henry, *Irish Art*, 2:142;

figures who were delivered from death by God. The core of the *Ordo commen-dationis animae, quando infirmus est in extremis* (ritual for commending the soul of someone on the point of death), dates to the Early Christian era. The developed prayer, known from an eighth-century version extant in eighth- and ninth-century manuscripts,[6] begins with a long litany with the repeated accla-mation "Kyrie eleison, Christe eleison." After this is the series of formulaic pe-titions which may be the oldest part of the prayer and which concerns us. Each petition begins: "Libera, Domine, animam ejus [or, "animam servi tui" in some versions] sicut liberasti X de Z," each petition citing an example of one to three biblical personages who were delivered by God. (For two versions of the petitions, see Tables One and Two at the end of this section.) These include all the heroes of the Book of Daniel—Daniel himself, the Three Young Men, and Susanna[7]—as well as David, delivered "de manu Goliath." The final peti-tion in some versions is the only New Testament example: Peter and Paul, freed from prison (Acts 5:17-21). Other versions extend the time frame into the post-Testamental era, adding another example, a woman, in a petition recall-ing Thecla.[8] The order is generally historical, from Enoch (Gen. 5:21-24), saved *de communi morte mundi*, to Thecla. Some versions of the prayer include petitions recalling Jonah's rescue from the belly of the whale (*de ventre ceti*). The Early Christian *orationes cyprianes* similarly recall these figures in the for-mula, "as you heard so-and-so," so hear me now, Lord: "Sicut audisti tres pueros . . . , sicut exaudisti Danielem . . . , . . . sicut exaudisti Suzannam. . . ."[9] The mention of Daniel and the Three Young Men in the First Epistle of Clem-

Rizzardi, *Sarcofagi paleocristiani*, 19-20; Réau, *Iconographie* 2.1:393, 394, 402; Siger, "Job in the Renaissance"; and Wieck, "Commendation of Souls" in his *Time Sanctified*, 124-36, esp. 131-32. See also bibliography in note 27 below and Seeliger, "Palai mar-tyres," 301, 317-18, 328-29.

5. For instance, D. Kaufmann, "Symboles tumulaires de l'Ancien-Testament," 33-48, 217-53, esp. 251-53; Wilpert, *Sarcofagi cristiani*, 256-60, 366ff.; Hanson, *Allegory and Event*, 16-19; Delbrueck, *Probleme der Lipsanothek*, 136-37; and Rosenau, "Jewish Iconography," 13.

6. Dumas, CCL 159a: vii, xxiii; Sicard, *Liturgie de la mort*, 350-51; Paxton, *Christia-nizing Death*, 3, 119.

7. In several Early Christian texts, all the heroes from the Book of Daniel are men-tioned together: the *Acta S. Aureae* (see Le Blant, "Bas-reliefs," 233, nn. 3, 4, and 6); the Passion of St. Philip, the Oratio of Cyprian, the Sacramentary of Rheinau, the Sacra-mentary of Vich, the Roman Ritual (see Ntedika, *Prière pour les morts*, 77 and 79); and St. Augustine's *Liber de gratia Novi Testamenti ad Honoratum*, CSEL 44:15-19 (Seeliger, "Palai martyres," 308-09). Other such texts include Jerome, letter 1, par. 9 (CSEL 65:6). In the visual arts, the heroes from the Book of Daniel appear together in the mausoleum at El-Bagawat (fourth century, with the Jonah trilogy) and on a reliquary (fourth cen-tury, with Daniel appearing solely as judge); Seeliger, "Palai martyres," 272, 275. They are all depicted, though not adjacently, in the third-century "Greek Chapel" of the Pris-cilla Catacomb; Milburn, *Early Christian Art*, 35-36. See also the Doclea cup, nn. 57-58.

8. Sicard cites fifteen manuscripts with a petition citing Thecla; *Liturgie de la Mort*, 366-68.

9. Leclercq, "Défunts," *DACL* 4.1:434; Ntedika, *Prière pour les morts*, 76-79.

ent from Rome to the Corinthians also helps account for their prominence in Christian prayers for the dying.[10]

The petitions in the *Commendatio* are expressed in language drawn from the Bible. Individual petitions tend to use the language of the biblical account referred to. For instance, the petition naming Daniel in the *Commendatio* relies on the language of the sixth chapter of Daniel, where the phrase "in lacum leonum" occurs four times (vv. 7, 12, 16, 24) and Daniel is described as emerging unharmed *de lacu*. This is the obvious source for the *Commendatio*'s "de lacu leonum" (see Table One, petition 8) and perhaps even for the use of the accusative in the Gelasian Sacramentary: "de lacum leonum" (see Table Two, petition e). The language of Daniel 6 is reiterated in chapter 14, the account of the prophet's second sojourn *in lacu leonum* (vv. 30, 31, 33, cf. 35, 39). Further, I would argue that the emphasis on the verb *liberare* throughout the sixth chapter of the Book of Daniel[11] and the popularity of this account, in the office of matins, for instance,[12] are largely responsible for the fact that *liberare* is the oft-repeated verb in the petitions of the *Commendatio*.

Lest it seem unreasonable to see Daniel 6 as so influential in the *Commendatio*, its influence within scripture itself and more broadly in Christian culture may be demonstrated. Within scripture, the First Book of Maccabees adduces the examples of Ananias, Azarias and Misahel *liberati* from the flames and Daniel *liberatus* from the mouth of the lions (1 Mac. 2:59-60); in the New Testament, St. Paul alludes to Daniel's delivery when the apostle writes to Timothy, *liberatus sum de ore leonis* (2 Tim. 4:17). In early and medieval Christian texts, the phrase "nulla laesio" ("no wound," Dan. 6:23), describing Daniel's miraculous wholeness on emerging from the den of lions, is largely responsible for the use of the same phrase and such cognate expressions as "non laedere" to describe each of the other heroes of the Book of Daniel as well, although the phrase itself and its cognates do not appear in Dan. 3 or 13 or 14. St. Augustine, for instance, observes in separate works that "the lions did not hurt (*non*

10. Milburn, *Early Christian Art*, 35; see also 47-48. Among the myriad patristic texts coupling Daniel and the Three Hebrews are Cyprian's *Epistulae* 58.5, 61.2, and 67.8 (CSEL 3.2:660-61, 695-96, 741-42), and Hippolytus of Rome, *Commentaria in Danielem* 35 (GCS 1.1; SC 14:126). Anne-Marie La Bonnardière observes: "Saint Augustine, many times, calls the roll of Daniel and the three young men in the furnace"; *Chronologie Augustinienne*, 129. Several writers treat sequentially the divine rescues of the Three Hebrews, Daniel, and Jonah; see, for instance, Clement of Alexandria, *Stromata* 1.21.123.3-5 and 2.20.103.2-104.1 (GCS 52, 3rd ed., pp. 77 and 170). This series is also in the *Apostolic Constitutions* 5.7.12 (SC 329:26), a work compiled around 380 from various earlier sources from the first through third centuries; see SC 320:60. See also George D. Dragas, "Apostolic Constitutions," *EEC* 75-76.

11. Dan. 6:14, 16, 20, 27. The Old Latin has "eripuit" in v. 27, but forms of *liberare* otherwise.

12. For Daniel in the liturgy, see Mearns, *Canticles of the Christian Church*, 18-24; and Schneider, "Biblische Oden," 479-500. See also Tkacz, "Tormentor Tormented," 180-83. Augustine uses *liberare* frequently in his *Enarratio in psalmum* 68; see discussion below.

laeserunt) Daniel,"[13] that "the three boys were unhurt (*illaesi*) by the fire"[14] and again "the flame could not hurt (*laedere*) the innocent and just boys while they praised God,"[15] and that Susanna, before the false charge, was known to be "of unflawed (*illaesa*) and immaculate life."[16] Another Early Christian text using this diction in recounting the miracle in the furnace is Dracontius's *De laudibus Dei* 3.182 and 184: "nec . . . laesit," "illaesos pueros."[17] The diction recurs in an antiphon for the Benedicite at Lauds: "ut pueri tui liberarentur ill-aesi."[18] Maximus of Turin describes Jonah emerging from the whale as *illae-sum.*[19] The fact that "non laesus" is the most frequent expression for "unhurt" in the martyrologies of Bede, Florus, and the anonymous compiler of Lyons also seems due to the language of the popular text of Daniel 6.[20]

Presumably, as the *Commendatio* developed, it was refined and made to conform more to the locutions of the Vulgate. The verb *liberare*, reiterated in Daniel 6, occurs elsewhere in the Vulgate with *animam* and a personal possessive pronoun such as *ejus* or *tuam.*[21] Twice Jerome's Latin translation of the Psalms from the Greek and once his translation from the Hebrews use the full petition *O Domine libera animam meam* ("O Lord, deliver my soul").[22] Psalm 119:2 uses the full petition, and perhaps this recalled the *Commendatio* to the illustrator of a thirteenth-century Book of Hours who decorated the psalm with the history of Susanna.[23] The language of the biblical narratives of the events recalled in the prayer influenced the diction of the *Commendatio* also. Thus, in the eighth-century text edited by A. Dumas as part of the *Liber Sacramentorum Gellonensis* the non-biblical *crimine* (indictment or charge) has been replaced

13. Augustine, *Contra Gaudentium Donatistarum episcopum* 1.38.53 (CSEL 53.253.10-11).

14. Augustine, *De Magistro* 37 (CSEL 77:46.11-12).

15. Augustine, *Enarratio in psalmum* 33.22.4-5 (CCL 38:296).

16. Augustine, *De Susanna et Joseph* (*Sermo* 343) par. 1 (PL 39:1505). See also Zeno of Verona's assertion that Susanna's *pudor inlaesus* (unflawed modesty) adorned her; *Tractatus de sancta Susanna* (CCL 22:111).

17. Dracontius, *De laudibus Dei* 3.182 and 184, ed. F. Vollmer, MGH 14 (1905, new ed. 1961) 97.

18. Recorded in Steiner, "Antiphons for the Benedicite at Lauds," 1-17.

19. Maximus of Turin, *Homilia* 55 (PL 57: 357B).

20. See Tkacz, "Tormentor Tormented," 148-54.

21. For *liberare animam* [possessive pronoun], see, e.g., Est. 4:13, Job 27:8 and 33:28, Ps. (from the Greek) 68:19, Ps. (from the Hebrew) 24:20 and 55:13, Prv. 23:14, Isa. 44:20 and 47:14, Ez. 3:19 and 21. See also the next note.

22. Ps. (from the Greek) 114:4 and 119:2; Jerome's translation of the latter Psalm from the Hebrew retains the same words for the petition. Cf. Ez. 3:19 + 21 and 33:9: "tu animam tuam liberasti."

23. London, British Museum, Add. 49999, fol. 90 r and v, 95r, 96. In the decorated initial of the Psalm, on fol. 90r, she is shown kneeling in prayer with raised, clasped hands. The image may be influenced by the *Biblia Pauperum* which show her as a type of Christ in the Garden; see previous chapter.

by the *testimonio* of Dan. 13:21, 43, 49, and 61. Similarly, what appears to be an earlier version of the prayer (Table One) used the phrase *de manu X* six times, in the sixth, eighth, tenth, and twelfth *Libera* petitions; these cite Isaac, Moses, the Three Hebrews and David.[24] In contrast, the eighth-century version of the prayer (Table Two, petition f) introduces the unusual plural *manibus* in order to quote Dan. 3:17 more fully:

Vulgate: ecce enim Deus noster quam colimus

potest eripere nos de camino ignis ardentis et

de manibus tuis rex liberare

Commendatio: sicut liberasti tres pueṛus [!]

de camino ignis ardentis et

de manibus regis iniqui

Note that the doubling of related verbs, here *eripere* and *liberare*, is characteristic of Old Testament style. In fact, in the Vulgate *liberare* is paired with *eripere* in four verses and with *eruere* in seven.[25]

<center>THE DATE OF THE *COMMENDATIO ANIMAE*</center>

A focal issue in scholarship on the *Commendatio*, and one quite pertinent to the present discussion, is its date. Recently Lawrence Besserman has located it in the second century, a view in accord with the earlier datings of Edmond le Blant and Henri Leclercq, who placed it "in the first centuries of Christianity" and in the second half of the third century respectively.[26] Similarly, Charles Rufus Morey and André Grabar judged the prayer to record primitive prac-

24. The expression "*liberare* [direct object] *de manu/manibus* [possessive]" is a biblical idiom or formula, used forty-seven times, all in the Old Testament. Characteristic expressions are "liberavitque Dominus in die illo Israhel de manu Aegyptiorum" (Exod. 14:30), "rex liberavit nos de manu inimicorum nostrorum" (2 Sam. 19:9 = Vulg. 2 Kings 19:9), and "liberavit eum de manu potentioris" (Jer. 31:11). The idiom was so familiar that Isaiah's prophesy of Babylon is that they will not be able to free themselves "de manu flammae"; and, in some manuscripts, *manu* occurs instead of *lacu* in one verse of Daniel 6, yielding, "qui liberavit Danihelem de manu leonum" (Dan. 6:27); see *Novae concordantiae*, p. 2878.

25. Verses using *liberare* and *eruere*: Job 6:23, Ps. (from the Hebrew) 70:2 and 143:7 + 11, Isa. 36:15, Jer. 39:18, and John 8:36. Verses using *liberare* and *eripere*: Ps. (from the Greek) 70:2, 81:4, and 143:7, and Bar. 6:49. *Liberare* is also paired with *salvare* (e.g., Ps. from the Hebrew 21:9), *adjuvare* (Ps. from the Greek 36:40), and *redimere* (1 Mac. 4:11).

26. Besserman, *Job in the Middle Ages*, 57; Leclercq, "Défunts (commémoraison des)," *DACL* 4.1:437; le Blant, "Bas-reliefs," 231.

Table One

The Text of the *Commendatio animae*, earlier version (?)

The text as cited by Le Blant, "Bas-reliefs," 229, and Leclercq, "Défunts (commémoraison des)," *DACL* 4.1:435-36. For ease of reference to the petitions citing specific biblical personages, they have been numbered in the left-hand margin.

Libera, Domine, animam ejus ex omnibus periculis inferni,
 et de laqueis poenarum
 et ex omnibus tribulationibus.

1 Libera, Domine, animam ejus, sicut liberasti
 Enoch et Eliam de communi morte mundi.

2 Libera, Domine, animam ejus, sicut liberasti
 Noe de diluvio.

3 Libera, Domine, animam ejus, sicut liberasti
 Abraham de Ur Chaldaeorum.

4 Libera, Domine, animam ejus, sicut liberasti
 Job de passionibus suis.

5 Libera, Domine, animam ejus, sicut liberasti
 Isaac de hostia, et de manu patris suae Abrahae.

6 Libera, Domine, animam ejus, sicut liberasti
 Lot de Sodomis et de flamma ignis.

7 Libera, Domine, animam ejus, sicut liberasti
 Moysen de manu Pharaonis regis Ægyptiorum.

8 Libera, Domine, animam ejus, sicut liberasti
 Danielem de lacu leonum.

9 Libera, Domine, animam ejus, sicut liberasti
 tres pueros de camino ignis ardentis et
 de manu regis iniqui.

10 Libera, Domine, animam ejus, sicut liberasti
 Susannam de falso crimine.

11 Libera, Domine, animam ejus, sicut liberasti
 David de manu regis Saul, et de manu Goliath.

12 Libera, Domine, animam ejus, sicut liberasti
 Petrum et Paulum de carceribus.

13 Et sicut beatissimam Theclam virginem et martyrem tuam
 de atrocissimis tormentis liberasti,
 sic liberare digneris animam
 hujus servi tui, et tecum facias in
 bonis congaudere coelestibus.

Table Two

The Text of the *Commendatio animae*, eighth-century version

The text as edited by A. Dumas is part of the *Liber Sacramentorum Gellonensis* (CCL 159: 461): He dates the text to the eighth century; CCL 159a: vii, xxiii. The title in the manuscript is "Orationis svp. defvnctv[m] vel Co[m]mendacio Animę" (p. 460). See also Damien Sicard, *Liturgie de la mort*, 364-68; he identifies "Jacob per benedictionem maiestatis tuae" as a variant known through five manuscripts (p. 367). For ease in distinguishing the petitions in this table, they are presented schematically, and the ones citing specific biblical personages are identified by letter in the lefthand margin.

 Libera domine anima serui tui *illi*
 ex omnibus periculis infernorum
 et de laqueis poenarum
 et omnibus tribolationibus [sic] multis.

a Libera domine anima serui tui *ill.*
 sicut liberasti Noę per diluuium.

b Libera domine animam serui tui *ill.*
 sicut liberasti hęnoch et Hęliam
 de communi mortem mundi.

c Libera domine animam serui tui *ill.*
 sicut liberasti moysen de manu pharaonis regis ęgyptorum.

d Libera domine animam serui tui *ill.*
 sicut liberasti iob de passionibus suis.

e Libera domine animam serui tui *ill.*
 sicut liberasti danihęlem de lacum leonis.

f Libera domine animam serui tui *ill.*
 sicut liberasti tres puęrus [sic]
 de camino ignis ardentis et de manibus regis iniqui.

g Libera domine animam serui tui *ill.*
 sicut liberasti ionam de uentre c[o]eti.

h Libera domine animam serui tui *ill.*
 sicut liberasti susannam de falso testimonio.

i Libera domine animam serui tui *ill.*
 sicut liberasti dauid de manu saul regis et golię
 et de omnibus uincolis ęius.

k Libera domine animam serui tui *ill.*
 sicut liberasti petrum et paulum
 de carceribus ‹et› turmentis [sic].

 Sic liberare digneris animam hominis istius et tecum
 habitare concede in bonis cęlestibus. Pcr.

Table One, English translation:

Deliver, Lord, his soul from all the dangers of Hell, and from the toils of punishments and from all tribulations. 1) Deliver, Lord, his soul, just as you delivered Enoch and Elijah from the common death of the world. 2) Deliver, Lord, his soul, just as you delivered Noah from the deluge. 3) Deliver, Lord, his soul, just as you delivered Abraham from Ur of the Chaldeans. 4) Deliver, Lord, his soul, just as you delivered Job from his sufferings. 5) Deliver, Lord, his soul, just as you delivered Isaac from sacrifice and from the hand of his father Abraham. 6) Deliver, Lord, his soul, just as you delivered Lot from Sodom and from the flame of fire. 7) Deliver, Lord, his soul, just as you delivered Moses from the hand of Pharoah, king of the Egyptians. 8) Deliver, Lord, his soul, just as you delivered Daniel from the den of lions. 9) Deliver, Lord, his soul, just as you delivered the three boys from the furnace of burning fire and from the hand of the wicked king. 10) Deliver, Lord, his soul, just as you delivered Susanna from the false charge. 11) Deliver, Lord, his soul, just as you delivered David from the hand of Saul and from the hand of Goliath. 12) Deliver, Lord, his soul, just as you delivered Peter and Paul from prison, and just as you delivered blessed Thecla, your virgin and martyr, from the most atrocious torments. Thus deign to deliver the soul of this your servant and make him to rejoice with you in celestial blessings.

tice.[27] In contrast, most modern scholars assign the prayer a later date and consequently deny that the *Commendatio* was influential in Early Christian art. Some scholars consider the prayer a sixth-century text, and others locate it later. For instance, Aimé-Georges Martimort had placed it in the ninth century, and recently Joseph Ntedika and A. Dumas, the prayer's editor, assign it to the eighth century.[28] Damien Sicard, however, traces the Rheinau version of the Gelasian sacramentary, which contains our *Commendatio*, to the Early Christian *Ordines Romani*.[29] Frederick S. Paxton, writing in 1990, concurs, observing that "such prayers may have been in use in rites for the dying for some time before they were written into the Gellone and other eighth-century Gela-

27. Morey observes, "the *commendatio animae*, while perhaps no earlier than the fourth century as it is crystallized in the liturgy, inherits none the less a practice that must have been primitive in the Church"; *Early Christian Art*², 62. See also Grabar, *Early Christian Art*, 103-05.

28. Ntedika, *Prière pour les morts*, 73; Dumas, CCL 159a: xxiii. Similarly André Wilmart posited an eighth-century exemplar for a manuscript of ca. 830 which cites the *commendatio animae*; "Règlement ecclésiastique de Berne," 38, text on pp. 42 and esp. 50. See also Martimort, "Iconographie des catacombes et la catéchèse antique," 105. Although Bourguet (*Early Christian Art*, 56 and 214, n. 34) also places it in the ninth century, he acknowledges that it may be "inchoately present" in the *Gelasian Sacramentary* and pseudo-Cyprian and "perhaps even earlier in the prayers prescribed by the Jewish liturgy for fast days." Earlier Michel Andrieu had thought the prayer was not known until the eleventh century; "Chronique d'Archéologie Chrétienne," 368f, n.9.

29. Sicard, *Liturgie de la mort*, 350-51, 368 and n. 45.

Table Two, English translation:

Deliver, Lord, the soul of your servant [Name] from all the dangers of Hell and from the toils of punishments and from all the many tribulations. a) Deliver, Lord, the soul of your servant [Name] just as you delivered Noah from the deluge. b) Deliver, Lord, the soul of your servant [Name] just as you delivered Enoch and Elijah from the common death of the world. c) Deliver, Lord, the soul of your servant [Name] just as you delivered Moses from the hand of Pharoah, king of the Egyptians. d) Deliver, Lord, the soul of your servant [Name] just as you delivered Job from his sufferings. e) Deliver, Lord, the soul of your servant [Name] just as you delivered Daniel from the den of lions. f) Deliver, Lord, the soul of your servant [Name] just as you delivered the three boys from the furnace of burning fire and from the hands of the wicked king. g) Deliver, Lord, the soul of your servant [Name] just as you delivered Jonah from the belly of the whale. h) Deliver, Lord, the soul of your servant [Name] just as you delivered Susanna from the false testimony. i) Deliver, Lord, the soul of your servant [Name] just as you delivered David from the hand of Saul and of Goliath and from all his bonds. k) Deliver, Lord, the soul of your servant [Name] just as you delivered Peter and Paul from prison and torments. Thus deign to deliver the soul of this man and grant that he may live with you in celestial blessings. Through [Christ our Lord, Amen.]

sian books."[30] The fact that Augustine refers to a prayer known in the Gelasian sacramentary, a point Sicard and others make, is additional evidence that at least forerunners of those prayers were known in North Italy in the time of interest to us.[31] Moreover, even if an eighth-century dating may be appropriate for the elaborated prayer recorded in the Gelasian psalter, the question of the date of the petitions that form the core of the *Commendatio* is a separate matter. The evidence of hagiography shows the popularity of the petitions, and a thorough survey of early texts might corroborate a quite early date for them. Be that as it may, a fourth-century date for those petitions can now be confirmed by quotations of them in Augustine's second *Enarratio in Psalmum* 21 and upon the fourth-century Doclea cup, with corroborative evidence on other monuments. These indicate that the specific language and phrasing of the petitions came readily to the minds of Early Christian authors and artists.

The evidence in hagiography. Hagiography puts phrases from the *Commendatio* into the mouths of saints, especially those like Juliana of Nicomedia (d. betw. 305-11) who are about to undergo torments recalling those of the Three Hebrews.[32] The Latin Acta has Juliana pray, "Preserve me, Lord, in these torments,

30. Paxton, *Christianizing Death*, 119.

31. Paxton, *Christianizing Death*, 79, n. 99.

32. Tkacz, "Commendatio animae," *ODB* 1:488, and "Commendatio animae" (forthcoming); Leclercq, "Défunts," *DACL* 4.1:436; Ntedika, *Prière pour les morts*, 75-76; Seeliger, "Palai martyres," 301.

sicut servasti Danielem in lacu leonum, et sicut liberasti Ananiam, Azariam, Misae-
lem de camino ignis ardentis . . .[33]
[just as you preserved Daniel in the den of lions, and just as you delivered Ananias,
Azarias, Misael from the furnace of burning fire . . .]

Similarly, St. Lukillianos voices a version of the prayer.[34] The fifth- or sixth-
century Passion of St. Philip, bishop of Heracleia (d. ca. 304), derived from a
lost, older version, cites fifteen deliveries, including those of Jonah, Isaac, Lot,
and all the heroes from the Book of Daniel.[35] Several other Lives use figures
from the *Commendatio*: the *acta* of Sts. Anania and Peter, Aurea, Erasmus,
Terence, Timothy and Maur; the *vita* of St. Basiliscus; the *martyrium* of St.
Minias; and the *passio* of St. Vitus.[36]

The evidence from St. Augustine. Significant new evidence is that St. Au-
gustine quotes from the *Commendatio animae*.[37] Because the lines of argument
concerning this quotation are lengthy and detailed, it is useful to forecast here
what that argument will demonstrate. Specifically, Augustine quotes from a
series of three petitions and restructures a fourth to make a cleanly parallel set
of four examples of faithful Old Testament heroes delivered by God. His use of
the language of the petitions establishes their existence by the late fourth cen-
tury. This date is confirmed by quotations of the same language from the same
petitions on a contemporary artwork, the fourth-century Doclea cup, discussed
below. Moreover, the examples selected by both Augustine and the designer of
the Doclea cup match to a large degree the selection on the Brescia Casket.

Now for the full argument. Augustine, in his second *Enarratio in Psalmum*
21, which he wrote perhaps as early as 395,[38] quotes the sequence of the three
petitions citing all the heroes from the Book of Daniel (Table One, petitions 9-
11). Also, he first cites the delivery of Israel from Egypt, the subject of another
petition of the *Commendatio* (Table One, petition 7). Augustine beautifully
crafts his use of quotations here, which is hardly surprising in the master rhet-

33. AASS Feb. 2:868-87. Ntedika ascribes the text to sixth- or seventh-century Italy
and comments on the references to the figures named in the *Commendatio*; *Prière pour
les morts*, 75. Seeliger comments on this quoting of the *Commendatio animae*; "Palai
martyres," 301.

34. Halkin, "Deux passions du Lucillien," 16-26.

35. Ntedika, *Prière pour les morts*, 75-77.

36. Le Blant, "Bas-reliefs," 233.

37. No discussion of the *Commendatio animae*, its dating, or its role in art mentions
St. Augustine's use of it. Nor is it mentioned in, e.g., Saxer, *Morts en Afrique chrétienne*.
While it has been noticed that Augustine mentions a prayer known in the Gellasian sa-
cramentary (Paxton, *Christianizing Death*, 79, n. 99) no one has recognized the quotation
from the *Commendatio* which is here discussed.

38. Zarb, *Chronologia Enarrationum S. Augustini in Psalmos*, see table on 253-56, re-
peated in CCL 38: xv-xviii. Zarb dates the second *enarratio* on Psalm 21 precisely to
March 23, 395 (204-05, 209-10), which E. Dekkers, the editor of the sermon for CCL, ac-
cepts. Cf. Rondet "Chronologie des «Enarrationes in Psalmos»," 261-67, and La Bon-
nardière, *Chronologie Augustinienne*, 54-56.

orician who taught rhetoric in Rome (383), held the chair of rhetoric in Milan (384-86), and composed the "authoritative statement of Christian rhetoric for the West," *De doctrina christiana.*[39] Thus, in his commentary on Psalm 21:5 he strengthens the parallelism of the four clauses derived from the *Commendatio* by revising the clause concerning the delivery from Egypt in order to conform to the other three clauses. He thus achieves the rhetorical figure of parison, or the same general structure within successive clauses.[40] Further, he arranges his examples in historical order.[41] Note, too, that Augustine deftly substitutes the verb from the Psalm (*eruere*) for the usual *liberare*:

> See what [the Psalmist] says: "In you our fathers hoped; they hoped, and you rescued them." And we know, and we read how many of our fathers, hoping in God, God rescued. He rescued the people of Israel from the land of Egypt; he rescued the three boys from the furnace of fire; he rescued Daniel from the den of lions; he rescued Susanna from the false conviction. All of them called, and were rescued.[42]

Augustine skillfully incorporates quotations from the *Commendatio* here. He quotes the "meat" of each petition derived from the Book of Daniel, beginning his quotation in each case right after *liberasti*. Juxtaposing the relevant petitions of the *Commendatio* to Augustine's words highlights the pattern of his quotation. The italics in the petitions identify the sections which Augustine quotes:

Petitions from the *Commendatio*

Libera, Domine, animam ejus, sicut liberasti
 Danielem de lacu leonum.
Libera, Domine, animam ejus, sicut liberasti
 tres pueros de camino ignis ardentis et
 de manu regis iniqui.

39. The quotation is from Kennedy, *Greek Rhetoric under the Christian Emperors,* 183. See also Kennedy, *Classical Rhetoric and Christian Tradition,* 150-60.

40. Parison is one of the rhetorical features of Augustine's prose; see Campbell and McGuire, *Confessions of St. Augustine,* 18. For background on this figure, see Kennedy, *Classical Rhetoric and Christian Tradition,* 30 and 248.

41. That is, he retains the general order from the *Commendatio,* with the delivery of Egypt before the references to the Book of Daniel, but he reorders the Daniel references to replicate the order of the Old Testament book. The *Commendatio* cites the prophet first, putting Daniel in the Lions' Den before the Three Hebrews and Susanna (Table One, petitions 9-11; Table Two, petitions e, f, h). Augustine prefers historical order and so places the Three Hebrews first, so that his examples relate in order to the third, sixth, and thirteenth chapters of the Book of Daniel.

42. "Et uide quid dicat: 'In te sperauerunt patres nostri; sperauerunt, et eruisti eos.' Et nouimus, et legimus quam multos patres nostros sperantes in se eruit Deus. Eruit ipsum populum Israel de terra Aegypti; eruit tres pueros de camino ignis; eruit Danielem de lacu leonum; eruit Susannam de falso crimine. Omnes inuocauerunt, et eruti sunt." *Enarrationes in Psalmo 21, Enarratio 2,* par. 6 (CCL 38:124-25).

Libera, Domine, animam ejus, sicut liberasti
 Susannam de falso crimine.

Augustine's Reworking of Them

eruit *tres pueros de camino ignis;*
eruit *Danielem de lacu leonum;*
eruit *Susannam de falso crimine.*

Initially it may seem surprising that he uses *eruit* (rescued) instead of a form of *liberare* (deliver), the emphasized verb of Daniel 6 and of the *Commendatio*, and the verb which is used on the Doclea cup in the other known fourth-century quotation of the *Commendatio*. Recall, however, that he is commenting on a verse using *eruere* and observe that he repeats a form of that verb in every sentence of his comment on this verse, obviously for persuasive emphasis: *eruisti*, then *eruit* (five times), and finally *eruti sunt*. Moreover, Augustine first uses *eruit* in a general assertion (that God rescued our fathers who hoped in him) and then in four examples which substantiate the general assertion. By reiterating the verb Augustine uses the rhetorical figure of repetitive paronomasia, whereas switching to *liberavit* would have weakened the structure. To modern ears, *liberavit* might seem to provide interesting variety of expression, but according to the principles of classical rhetoric that Augustine knew, taught, and applied, such variety is provided through the different conjugated forms of *eruere*: *eruisti, eruit, eruti sunt.*[43]

Before we can pronounce this passage from Augustine a clear case of ready quotation of the *Commendatio animae* by a prominent Church author, however, it must be shown that this is indeed a reference to the prayer rather than a direct use of Scriptures. Because the prayer itself draws on the Scriptures, this point is difficult to prove, and the matter is made more complex by the variety of versions of Scriptures which Augustine might have used or emended, and the fact that not all of them are extant or known. Nevertheless, a case can be made, and it will be subsequently strengthened when the same wording is shown to be quoted on a contemporary monument.

Determining which version of the Bible St. Augustine used on a given occasion has been the subject of much scholarship. Anne-Marie La Bonnardière compiled a thorough, multi-volume analysis of the *Biblia Augustiniana* and has recently addressed the question of whether Augustine knew of and used Jerome's translations of various books of the Bible—the incipient Vulgate—as they were prepared. She concludes that the bishop preferred the Septuagint, but

43. In the five clauses using *eruit* Augustine creates both parison, "successive clauses having the same general structure," and repetitive paronomasia, "the rhetorical repetition of the same word in the same sense"; in the series of *eruisti, eruit, eruti sunt*, he offers polyptoton, "a repetition of the same word in different cases, either directly or after an interval"; Campbell and McGuire, *Confessions of St. Augustine*, 18-19. For other instances of Augustine's rhetorical use of the verb from a scripture he is analyzing, see Tkacz, "Seven Maccabees, the Three Hebrews, and St. Augustine," 67-68.

knew of and used some of the Vulgate books, primarily for comparison in his later works, such as the *Quaestiones in Heptateuchum*, that concern obscurities in scripture.[44] The editor of Augustine's *Enarrationes in Psalmos* clarifies as far as possible which version of the scriptures the theologian was using in individual passages:

> In the critical apparatus we have annotated the various readings of the Psalter according to the codices at Verona and St. Gall and the one very recently discovered at Mount Sinai, for these approximate very closely the text which Augustine had for his own use, which sometimes he emended so that he might more accurately render the Greek Septuagint translation.[45]

Note that we need not expect to find a version of scriptures that is word for word what we read in Augustine, because the bishop frequently emended the translation before him.

The first issue is, if Augustine were drawing on the Bible directly in the Second Enarratio on Psalm 21, which version was he likely to be using? This is not readily resolved, unfortunately. Both Jerome's Gallican Psalter (his revision of the Old Latin against the Septuagint of Origen's Hexapla) and his Hebrew Psalter (freshly translated into Latin from the Hebrew) existed, the former prepared sometime during 386-92 and the latter during ca. 390-94.[46] Whether a good copy of either was available to Augustine and whether he used it are separate issues; after Jerome died Augustine asserted his preference for the Septuagint over the Hebrew.[47] Robert Weber's edition of the Gallican Psalter records the verb *liberasti*, not *eruisti*, in 21:5 and lists no Old Latin variant for this verse.[48] The new critical edition of the Vulgate likewise shows *liberasti* in the Gallican Psalter and *salvasti* in Jerome's Hebrew Psalter.[49] Perhaps Augustine is quoting a lost Old Latin version of the Psalm. Certainly for the later *Enarratio in Ps.* 68, sermon 2, in his discussion of verse 19 (in which he discusses the Three Hebrews), he appears to use an Old Latin variant. This sermon is dated to the summer of 414,[50] and may thus be nearly twenty years later than his work on Psalm 21. Here, for comparison, are four versions of Ps. 68:19: first the Vulgate from Robert Weber's excellent edition of the Psalter, then the Old Latin variant cited in that edition, next the Vulgate from the new critical edition, and finally St. Augustine's version from the *enarratio*.

44. La Bonnardière, "Augustine a-t-il utilisé la «Vulgate»?" 303-12, esp. 304-07.

45. CCL 38: xii. For further discussion of Augustine's biblical texts, see Ongaro, "Saltero Veronese e revisione Agostiniana." It has long been known that St. Augustine "respects as much as possible the traditional text"; Salmon, "Problème des Psaumes," 173.

46. Tkacz, "*Labor tam utilis*," nn. 82, 94-95.

47. Ibid. n. 42.

48. *Psalterii secundum Vulgatam Bibliorum Versionem nova recensio*, ed. Robert Weber (Clervaux: Abbaye S. Maurice et S. Maur, 1961) 30.

49. *Biblia Sacra iuxta Vulgatam versionem*, 4th rev. ed. (Stuttgart: Württembergische Bibelanstalt, 1994); see vol. 1, pp. xx-xxi for dates.

50. CCL 38: xvii.

Intende animae meae, et libera eam;
propter inimicos meos eripe me.

Accede ad animam meam, et redime eam;
propter inimicos meos eripe me.

Accede ad animam meam [et] redime eam
propter inimicos meos libera me

Intende animae meae et redime eam.
Propter inimicos meos erue me.

Clearly the bishop's version of the first sentence is somewhat like but identical to none of the three versions cited, and the verb in the second sentence, *erue*, which is the same verb he uses in 21:5, is in none of the versions cited. The apparatus to the Corpus Christianorum edition of Augustine's text identifies two variants, each attested in a single manuscript: *eripe* and *libera*, which would match one or more of the versions cited. Augustine's unique series of verbs within this verse may simply be the result of his emending whatever version(s) he had before him.

A distinctive phrase marks his words when commenting on the verse as a quotation from the *Commendatio animae*. If Augustine were using either an Old Latin version of the Bible, or Jerome's Vulgate, he would find there much of the language of the *Commendatio animae*. After all, the petitions themselves are largely expressed in biblical language. One phrase, however, is not in scripture, neither in Old Latin nor Vulgate: the key phrase regarding Susanna. The Bible refers to *falsum testimonium* (e.g., Old Latin Dan. 13:21, Vulg. Dan. 13:49), but the *Commendatio* refers to *de falso crimine*, and *de falso crimine* is the language we find used both by Augustine and also on the Doclea cup.

Importantly, Augustine's use of *de falso crimine* is demonstrably atypical for him: it is unique to the passage in which he quotes the *Commendatio*.[51] Consistently in his other writings he uses the biblical phrases *falsum testimonium* and *falsi testes* in references to Susanna and the elders. Thus, he paraphrases the main clause of the elders' threat in Dan. 13:21—"dicemus testimonium [Old Latin: *falsum testimonium*] contra te"—in *Quaestionum libri septem*: "contra Susannam falsum testimonium dicentes seniores."[52] Through-

51. The author gratefully acknowledges the assistance of Joseph C. Schnaubelt, O.S.A., and Allan Fitzgerald, O.S.A., and the Augustine Concordance Project of the University of Würzburg, also located at Villanova University, in identifying many of the passages discussed in the following paragraphs.

52. CSEL 28.2:145.5-6. Throughout this study the following editions of the Bible are used: the Book of Daniel, for which the extant Old Latin is fragmentary, is cited from the 1949 reprint of the eighteenth-century edition by Pierre Sabatier: *Bibliorum Sacrorum versiones antiquae seu vetus italica et cetera quaecunque in codicibus antiquorum libris re-*

out his sermon on Susanna and Joseph, the spouse of Mary, as exemplars of chaste spouses, St. Augustine uses such phrases fourteen times, especially in the first two sections.[53] In this, of course, he is simply drawing on the biblical account which repeats *falsum testimonium* and indeed dramatizes the Mosaic law recorded in Deuteronomy 19:16-21.

That law stipulates the punishment of a *falsum testem* (Deut. 19:16-21). The false witness and the one accusing him of lying are to stand opposite each other in the midst of the people and judges, who are to scrutinize them with the greatest care (*diligentissime perscrutantes*). If they discover the witness did lie, then he is to be punished with whatever punishment his brother would have suffered, if the lie had been believed, eye for eye, tooth for tooth, hand for hand, foot for foot. The entire account of Susanna is informed by this law. The elders who accuse her are in fact judges (Dan. 13:5-6) and the technical language and procedures of formal testimony are used, first in the elders' threat, quoted above, then in the gathering of the "populus . . . et duo presbyteri" (28) and the public summoning of Susanna, who arrives accompanied by family and friends (29-30), and especially in the formal and public giving of evidence by the two elders. "They rose up together in the midst of the people and placed their hands upon her head . . . and spoke" (*dixerunt*; vv. 34-36). They conclude: "We are witnesses of her crime" (*huius rei testes sumus*, 40). The people believe them because they are "elders of the people, and judges," and so they condemn Susanna to death (41).

Then, just as the details of the process of the law have been important in the account of this false judgment, so now they are central to the divine correction of this judgment and the fulfilment of Mosaic law.

Susanna declares (*dixit*) her innocence to God and asserts that the elders "have given false testimony (*falsum testimonium*)" against her (43). Inspired, Daniel formally separates himself from the judgment that has been passed against her by exclaiming in a loud voice: "I am clean from the blood of this one" (*mundus ego sum a sanguine huius*," 46). Not surprisingly, all the people are struck by this and ask him to explain (47). He asserts that the case must be retried ("revertimini ad iudicium")[54] because *falsum testimonium* was spoken against Susanna (49). Everyone returns to the place of judgment where Daniel is appointed judge because God has given him the discernment of age (50). Daniel examines each elder (the narrator uses the formal "dixit" in each case—vv. 51, 55, 56, 59), catches them in a discrepancy in their lies, and announces they have brought about their own sentencing (55, 59). In pronouncing judgment, he asserts to each: "Fittingly you have lied (*mentitus es*) in a way that rebounds

periri potuerunt (Reims 1739-49, reprint Paris 1751, reprint 1949). The Book of Daniel is in 2.2. The new edition is appearing under the title *Vetus latina; die Reste der altlateinische Bibel, nach Petrus Sabatier neu gesammelt und hrsg. von der Erzabtei Beuren* (Freiburg: Herder, 1949-); the Book of Daniel has not yet appeared. For the Old Latin variants to the Psalter and for the Vulgate, see notes above.

53. *Sermo* 343 (PL 39:1505-1511).

54. Augustine quotes the verse using "redite" as the verb, in his sermon *De Susanna et Joseph* (*Sermo* 343), par. 1 (PL 39:1506).

upon your own head" (55, 59), thus using a cognate to the words *mendax* and *mendacium* of Deut. 19:16 and 18.[55] The people, convinced that the elders had given false testimony (*falsum dixisse testimonium*), execute the law of Moses and do to them what they would have had done to their neighbor, and innocent blood was saved on that day (64).

Throughout this account, accuracy in legal diction and detail is prominent. St. Augustine naturally echoes this when he refers to the biblical account. For instance, in his sermon on Joseph and Susanna he states: "[The charge] was declared, it was brought to court, it proceeded: the case came to judgment."[56]

Indisputably, it is only in the passage on Ps. 21:5 that Augustine uses the distinctive phrase *de falso crimine*, whereas he uses *falsum testimonium* in his three other discussions of Susanna, and fourteen times in one of these discussions alone. The only reasonable conclusion seems to be that the distinctive diction in his discussion of Ps. 21:5 derives from his quotations from the petitions which will form the core of the *Commendatio animae*. In one brief passage, Augustine's words thus provide significant testimony to the existence and popularity of the *Commendatio animae* in the late fourth-century Church, especially in North Italy. His historically ordered sequence of the delivery of Israel and of all the heroes of the Book of Daniel, rich with quotations from the petitions of the *Commendatio*, is a salient piece of evidence for the dating of those petitions. Importantly, this evidence has corroboration in a fascinating complement to Augustine's comment, namely the Doclea cup.

The art historical evidence. The evidence of the fourth-century Doclea cup (Fig. 12)[57] is crucial to the discussion of the date of the *Commendatio animae*, for it pairs the actual words of the prayer with images depicting the rescues recalled in the prayer. Surprisingly, however, this study is the first to relate the evidence of the cup to the date of the prayer. This gold-glass cup was found in 1870 in a tomb near Doclea in the vicinity of Podgoritza (later Titograd, now again Podgoritza; see map, p. 22).[58] The cup depicts the Sacrifice of Isaac in the center and, on the perimeter, the popular series of heroes from the Book of Daniel

55. For a discussion of the phrase "in caput tuum," used in Dan. 3:55 and 59, see Tkacz, "Literary Studies of the Vulgate: Formula Systems," 209-12, 217-18.

56. "Clamatum est, ventum est, processum est: pervenit causa ad judicium." *De Susanna et Joseph* (*Sermo* 343), par. 1 (PL 39:1505).

57. The cup has been variously called by the name of its modern discoverer, Basilewsky; by the modern city nearest to the site of the cup's discovery, Podgoritza, later Titograd; and by the city where it is now held, Leningrad, now again St. Petersburg. The present author prefers to denominate it as the Doclea cup, for it seems more appropriate to associate it with the name of the Roman town near which it was buried in a tomb.

58. Briefly in the Basilewsky collection, the broad, shallow cup has been in the Hermitage in St. Petersburg since 1885, with catalogue number ω 73. Its diameter is 23 cm.; Banck, *Byzantine Art in the U.S.S.R.*, 337 and pls. 27-31. For its discovery in a tomb, see Le Blant, "Bas-reliefs," 231-33. For nineteenth-century scholarship on the cup, see Henri Leclercq, "Coupe," *DACL* 3.2:3008, n. 7. Wessel mentions the cup's depiction of Jonah; *RBK* 3 (1978) 649. See also Levi, "Podgoritza Cup."

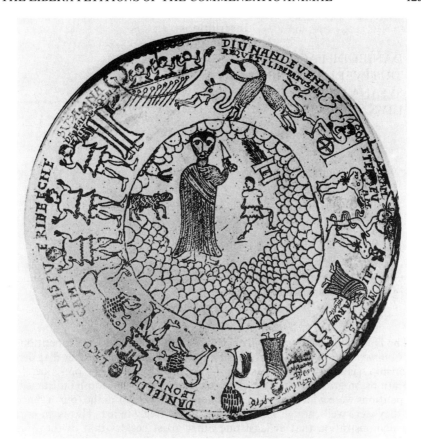

FIGURE 12. The Doclea Cup.

and the usual trilogy of Jonah scenes (somewhat conflated), as well as three other Old Testament scenes.[59] The artist labels all but the central scene, and for the four scenes from the *Commendatio* he has devised distinctive identifications: whereas the prayer has the common designations of the figures in the accusative, the cup has them in the nominative, amplified with the ablative phrases from the prayer which describe the dangers from which the saints were freed. Jonah receives a full clause, completed by an appropriate form of the verb in the prayer. Juxtaposing the inscriptions to the petitions of the prayer shows the borrowings clearly, despite the oddities of spelling on the cup:

59. The extant versions of the *Commendatio animae* each use four of the five deliveries depicted on the Doclea cup. One version has Isaac, Daniel, the Three Hebrews, and Susanna (Table One, petitions 5, 8-10), and the other has Daniel, the Three Hebrews, Jonah, and Susanna (Table Two, petitions e-h).

Inscriptions:

DANIEL DE LACO LEONIS
TRIS PVERI DE EGNE CAMI
SVSANA DE FALSO CRIMINE
DIVNAN DE VENTRE QUETI LIBERATVS EST.[60]

Petitions:

9 Libera, Domine, animam ejus, sicut liberasti
 Danielem de lacu leonum.
10 Libera, Domine, animam ejus, sicut liberasti
 tres pueros de camino ignis ardentis et
 de manu regis iniqui.
11 Libera, Domine, animam ejus, sicut liberasti
 Susannam de falso crimine.
g Libera domine animam serui tui *ill.*
 sicut *liberasti ionam de uentre ceti.*

The Doclea cup is thus striking evidence of the popularity of the petitions of
the *Commendatio animae*: so vivid is its connection with the prayer that the re-
lationship has been recognized from the start.[61] Moreover, the presence of the
quotations on grave goods in a rather ordinary provincial tomb indicates that
the petitions were widely popular. Not only did they exist in the fourth century,
but they were well enough known to be quoted freely in art. This is an impor-
tant demonstration that at least one other artist besides that of the Brescia
Casket was drawing on this prayer to enhance his work.

Two other fourth-century monuments have been discussed as comparable to
the Doclea cup and as informed by the *Commendatio animae*. While their evi-
dence is not as compelling and they lack the direct quotations of the Doclea
cup, they are worth review here. Alisa Vladimirovna Banck notes "a certain affi-
nity in shape, technique and the choice of subjects" between the Doclea cup

60. Banck, *Byzantine Art in the U.S.S.R.*, pl. 27. This photograph clearly shows that
Susanna's name is spelled on the cup with a single N, not the double N reported by le
Blant, "Bas-reliefs," shortly after the cup's discovery. Subsequently scholars have re-
peated le Blant's error; for instance, Leclercq, "Coupe," *DACL* 3.2:3008-11 and fig.
3336 (a drawing); and Michel, *Gebet und Bild in frühchristlicher Zeit*, 64. The correct
spelling is provided by Styger, *Altchristliche Grabeskunst*, 118, fig. 30; Levi, "Podgoritza
Cup," and Seeliger, "Palai martyres," 29-80.
 The spelling of the inscriptions is poor enough to warrant comment. I surmise that the
DI- in Jonah's name is a convention for indicating that the I is used here as a consonant,
not a vowel; the QU- instead of C- in QUETI seems likewise a clue to pronunciation.
 61. Kraus, *Christlichen Kunst*, 1:70.

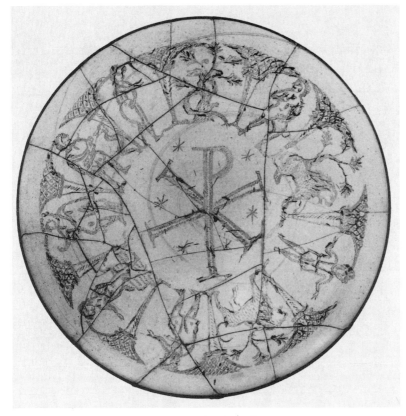

FIGURE 13. The Arras Cup.

and another cup found at Arras (Fig. 13).[62] The latter, now at the Louvre, is an incised cup with a chrismon in the center and, on the arcaded circumference, Daniel in the Lions' Den; Adam, the serpent, and Eve; Daniel poisoning the Dragon; and Susanna flanked by the elders (visually analogous to Daniel flanked by the two lions). Found in a woman's grave in a cemetery at Homblières (Aisne; see map), the cup has been dated by coins found there to 350-423, and may have been produced in the Rhineland or, note well, Italy.[63]

The Doclea cup has also been compared to a third work of fourth-century funerary art: a bronze medallion from the cemetery of Pontien in Rome (see

62. Banck, *Byzantine Art in the U.S.S.R.*, 337.

63. Louvre, no. MNC 919, diameter 91 cm.; Coche de la Ferté, *Antiquité chrétienne au Louvre*, pl. 54, catalogued on pp. 109-10. Leclercq discussed it as the "coupe d'Homblières"; "Coupe," *DACL* 3.2:3004-06 and fig. 3333. See also Morin-Jean, *Verrerie en Gaule*, 243-45; Pelliot, "Verres gravés au diamant," 304-07; and Pazaurek, "Glas- und Gemmenschnitt in ersten Jahrtausend," 7. See also Tkacz "Susanna as a Type of Christ."

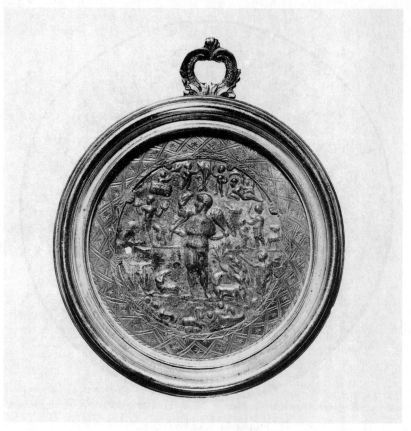

FIGURE 14. Bronze medallion.

map) and now at the Vatican has a similar set of images (Fig. 14).[64] The plane
of the medallion is in four parallel zones. In the center is a large Good Shep-
herd. Nine other, smaller-scale scenes fill the zones; these scenes are a sub-
group of the scenes on the Doclea cup, and include Noah and the Ark, Daniel
between two lions, the Jonah trilogy, and the Sacrifice of Isaac. The Arras cup
and the Vatican medallion appear to be further evidence of the popularity in
North Italy and its environs in the fourth century of the *Commendatio* and its
influence upon art.

Together the Doclea cup, the Arras cup, and the bronze medallion suggest a
tantalizing possibility. Could their general design—that is, the design of works
expressive of the *Commendatio animae*—have suggested an analogous arrange-
ment for the Brescia Casket? Each of the three round artworks has a central

64. For other illustrations see Styger, *Altchristliche Grabeskunst*, 116-17, fig. 29, and
Leclercq, "Jonas" *DACL* 7:2622 and fig. 6310. For Pope Pontien (d. 236) and the ceme-
tery, see "Pontien," *DACL* 14.1:1409ff.

image with an array of other images on its circumference. In the case of the Arras cup and the Vatican medallion, that central image—the chrismon and the Good Shepherd respectively—is unquestionably symbolic of Christ; on the Doclea cup, the central image—the Sacrifice of Isaac—may have been intended, or could have been construed, as a type of Christ.[65] And, on each of the three, some of the images on the circumference can be interpreted as types of Christ. Perhaps the designer of the Brescia Casket took a cue from such works and designed a box on which the central focal area—the lid—depicted Christ, and the perimeter—the four sides—included a series of types of Christ.

In addition to the monuments already described, others have been argued as expressive of the *Commendatio animae*. As is well known, figures recalled in the *Commendatio* also recur in the catacombs and on the sarcophagi of the third through fourth centuries; these include Noah's ark, the sacrifice of Isaac, the crossing of the Red Sea, the cycle of Jonah, the Three Young Men, Susanna, Daniel, and David.[66] Le Blant and Karl Michel argue that this is a deliberate patterning on the prayer,[67] while other scholars have responded that it is unnecessary and even anachronistic to turn to the *Commendatio* as a source for Early Christian art. Odo Casel is among these, and Ntedika reminds us that Christian culture was full of references to these images, through patristic texts, catecheses, preaching, and polemical works.[68] Martimort argues that since the sixth century, the Roman liturgy for the period from Septuagesima Sunday to the second Sunday after Easter, that is, the period devoted to the catechumenate, uses a series of readings recalled in the representations of the catacombs.[69] Seeliger agrees, but with an interesting qualification: he asserts that attempts to attribute Early Christian art *of the third century* to the influence of the *Commendatio animae* founder on chronological grounds.[70]

The late datings proposed by Martimort, Ntedika, and Dumas were suggested without reference to the fourth-century evidence gathered here, including the Doclea cup, and they pertain to the prayer as a whole, not its petitions. Moreover, Sicard and Paxton accept the strong possibility of an Early Christian date. Possibly the selection of images on the Arras cup and the bronze medallion shows the influence of those petitions, and emphatically the Doclea cup demonstrates that they did in fact exist, and indeed were well enough known in the fourth century to be used to entitle and epitomize Old Testament scenes. Moreover, it has now been demonstrated that Augustine himself quoted the prayer. This evidence by itself makes it plain that the prayer must have existed

65. As, indeed, Eduard Stommel has asserted it was on the Junius Bassos sarcophagus; see Chapter Three, note 9.

66. For instance, Ntedika, *Prière pour les morts*, 72. See also Monfrin, "Bible dans l'iconographie chrétienne," 216, 221-23.

67. Le Blant, "Bas-reliefs," 229-41; Michel, *Gebet und Bild in frühchristlicher Zeit*, esp. 27-29. See also Colletta, "Prophet Daniel in Old French," 121-24.

68. Casel, "Älteste christliche Kunst," n. 249 on pp. 78-79; Ntedika, *Prière pour les morts*, 73. Cf. Stuiber, *Refrigerium interim*, 170.

69. Martimort, "Iconographie des catacombes et la catéchèse antique," 105-14.

70. Seeliger, "Palai martyres," 317-18.

by his time. In sum, a series of petitions is attested to in saints' Lives and in pa-
tristic texts and art from at least the fourth century on, and this series is essen-
tially that which becomes the core of petitions in the prayer known as the
Commendatio animae. Indisputably, variety exists in the versions of the prayer
here called collectively the *Commendatio*.[71] Nonetheless, it is reasonable to po-
sit that the *Commendatio animae* that survives in manuscripts from the eigth
century and later, is simply a development of an Early Christian prayer whose
petitions are amply reflected in Early Christian texts and depicted on such
Early Christian monuments as the glass cup from Doclea, and possibly the cup
from Arras, and the bronze medallion at the Vatican as well. Thus, the peti-
tions can be seen to have existed and been popular in late fourth-century North
Italy, the place and time of the making of the Brescia Casket.

THE *COMMENDATIO ANIMAE* AND THE BRESCIA CASKET

A minor thesis of the present work may now be explored: that the petitions
of the *Commendatio animae* may well have suggested to the designer of the
Brescia Casket the series of personages to be depicted on it as types of Christ
in his passion and resurrection. It cannot be stressed too strongly that this min-
or thesis is separate from and independent of the main thesis of this book,
namely that the program of the casket is typological. The minor thesis, that the
petitions of the *Commendatio animae* may have inspired the selection of speci-
fic types on the casket, could even be disproven without undermining the main
thesis. Typology is the key to the casket; the *Commendatio animae* is only a
possible gilding of the key.

Jonah, Daniel, the Three Hebrews, Susanna, and David serve as types of
Christ in every occurrence on the Brescia Casket; they are all recalled in the
Commendatio animae through reference to the very events which are depicted
on the ivorywork, their various divine deliveries from danger: Jonah from the
belly of the whale, Daniel from the den of lions, the Three Hebrews from the
furnace of burning fire, Susanna from the false accusation and David from the
hand of Goliath. Moreover, these deliveries are cited in sequence amid the list
of *Libera* petitions of the prayer (Table One, petitions 9-12, and Table Two,
petitions e-i). Two other Old Testament figures, Moses and Jacob, serve as
types of Christ in some of their depictions on the casket. They, too, are cited in
the *Libera* petitions of the *Commendatio*: Moses, delivered from the hand of
Pharaoh (Table One, petition 7, right before the series of the other figures used
on the casket), and Jacob, delivered through the blessing of the majesty of God
(Table Two, variant listed in headnote). Both of these deliveries are unusual

71. See the table of variants, Sicard, *Liturgie de la mort*, 366-68. Earlier tables are
Ntedika, *Prière pour les morts*, 79, comparing forms of the prayer with references to it in
various hagiographic texts; Leclercq, "Défunts," *DACL* 4.1:437-38, comparing the fig-
ures and their order in seven versions of the prayer. Michel, *Gebet und Bild in frühchristli-
cher Zeit*, 53-54 catalogues the figures cited in seven Jewish and Early Christian prayers.
See also Le Blant, "Bas-reliefs," 224.

and difficult to depict, but it is characteristic of the inventive designer of the casket to undertake the unusual.

Moses's rescue from the hand of Pharaoh is cleverly and imaginatively portrayed in the Moses register on the back of the Brescia Casket. First, on the left

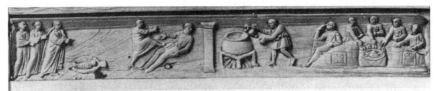

half of the register are shown those two instances when Moses personally was in great danger from Pharaoh: Moses's infancy, when the life of all Hebrew male babies was in jeopardy but Moses alone was spared, and his killing the Egyptian, for "when Pharaoh heard of this, he sought to kill Moses" (Exod. 2:15). (The crossing of the Red Sea was the delivery not of Moses alone, but famously of the whole of Israel, and is the subject of a separate *libera* petition in one version of the prayer.[72]) Then, on the right half of the register, we see Moses celebrating in the House of Jethro, a celebration possible because God had delivered Moses from the hand of Pharaoh. Thus, the Moses register as a whole constitutes a depiction of the delivery recalled in the *Commendatio animae*: "Libera, Domine, animam ejus, sicut liberasti Moysen de manu Pharaonis regis Ægyptiorum."

The Jacob register, like the Moses register, seems to draw much of its inspiration from the *Commendatio animae*, but we must be tentative with regard to Jacob. The pertinent petition is "Deliver, Lord, the soul of your servant X just as you delivered Jacob through the blessing of your majesty" (See Table Two, headnote). First, this petition is a less frequent variant. Elijah, Moses, and David are in every manuscript, and Jonah, Daniel, the Three Young Men, and Susanna are in all but one or two, but the Jacob petition is in only five. The earliest, eighth-century Rheinau manuscript lacks it, though it is present in, e.g., the tenth-century Sacramentary of Arezzo, and in eleventh-century manuscripts in the Vatican Library, the Vatican Archives, and the Bibliotheca Ambrosiana in Milan.[73] The fact that it is not attested in earlier manuscripts, coupled with the fact that Jacob does not appear on the Doclea cup, the Arras cup, or the Vatican bronze medallion, our other early witnesses to the *Libera* petitions of the *Commendatio animae*, indicate that the Jacob petition may be a later accretion. Second, this possibility is strengthened by the fact that the same manuscripts which contain the Jacob petition are also the only manuscripts to contain the other variant petitions which use the uncharacteristic pre-

72. "Populum Israël de manu Ægyptiorum," in the ninth-century Livre de prières de Fleury, Orléans, Bibl. Mun. ms. lat. 184 (161); Sicard, *Liturgie de la mort*, 366 and xiii.

73. Sicard, *Liturgie de la mort*, 366-67. The eleventh-century manuscripts referred to are Bibl. Vat. Chigi CV 134, Vatican Archives, S. Pietro H 58, and Milan, Bibliotheca Ambrosiana T. 96 Sup. An additional manuscript, of the eleventh or twelfth century, is Rome, Vallicelliana, cod. B 141.

position *per* rather than *de*: "humanum genus *per* passionem domini nostri ihe-su christ" and "Abel *per* sacrificium gratum."[74] The other petitions typically use *de*, although "Noae *per* deluvium" is also found.[75] If the Jacob petition was created after the Early Christian period, then naturally it could have had no influence on the artist of the Brescia Casket. If, however, it existed in the early period, but was not common, it could have influenced the artist and sur-vived to be included in later manuscripts of the prayer.

Recognizing that the link between Jacob and the Early Christian set of *Lib-era* petitions is uncertain, let us consider the case that can be made for the in-fluence of the Jacob petition on the casket's design. Jacob is presented as a type of Christ: by the well he is the Good Shepherd who will lay down his life

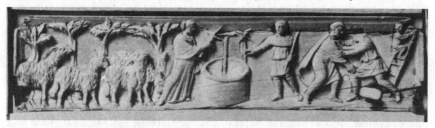

for his sheep (John 10:11), a reference to the Passion, though one not based on the *Commendatio*. He is also shown wrestling with the angel and ascending the ladder, both of which can be construed as types of Christ in his Passion and possibly in his ascension as well. The question, then, is whether these scenes are related to the petition of the prayer. And, especially together, they are. Ja-cob wrestling with the angel and his vision of the ladder are precisely the events which involved his receiving the "blessing of the majesty of God." Moreover, the astounding promise of God, that this blessing would be available through Jacob and his descendants to all the families of the world (Gen. 28:13-16) points both to blessing for Jacob and to the blessing made available through the Incarnation and Passion of Christ. In addition, relating the *Commendatio animae* to the Jacob register strengthens the rationale for this register's non-historical order.

Thus, even with regard to Jacob, whose place in the Early Christian set of *Libera* petitions is uncertain, a creditable case for the influence of those peti-tions in the design of the casket can be made. Quite strong is the case for the other figures used typologically on the casket—Jonah, Susanna, Daniel, whose typological roles on the casket are stunning; and also the Three Hebrews, Da-vid and Moses. Indeed, the Moses register on the back of the casket is fully in-telligible only with reference to the *Commendatio*.

74. See previous note. The Abel petition is in two of those manuscripts.

75. Sicard identifies nineteen petitions. In addition to those included above in Tables One and Two he has discovered these: "Abel per sacrificium gratum," "Populum Israël de manu Ægyptiorum," "Humanum genus per passionem domini ihesu christi," The Noah petition with "per" seems to occur in several manuscripts; *Liturgie de la mort*, 365-67.

Ironically, the *Commendatio*, the text which appears to shed the most light on the coordinated images on this ivory box, has been neglected or dismissed, even by the three scholars who have mentioned it in connection with the casket.[76] In 1913 Carl Maria Kaufmann noted that the *Commendatio animae* informed certain images on the Lipsanothek of Brescia, but concluded that no coherent pattern could be found for the casket's decoration except for those scenes depicting the life of Christ. More recently, Carl-Otto Nordström discussed the relationship between the *Commendatio* and the Jonah scenes on the casket, but as he was concerned with "Some Jewish Legends in Byzantine Art," not with the casket per se, he did not treat the casket's program of images at all. The only detailed discussion of the *Commendatio animae* in relation to the Brescia Casket is Richard Delbrueck's conclusion to his valuable monograph on the *Probleme der Lipsanothek in Brescia* (1952).

In a brilliant move, Delbrueck sought the basis for the program of the casket in the liturgy. He discovered that the readings for Lent and Holy Week included many of the scriptures depicted on the Brescia Casket. The serious limits to this discovery, however, are often overlooked by scholars who accept Delbrueck's thesis: the readings Delbrueck identified lack some of the events depicted on the casket; moreover they also include many others. He draws on readings from matins, mass, and vespers from throughout the forty days of Lent as well as Easter. Taken together, these readings refer to hundreds of events, not just the thirty-odd on the casket. An additional problem is that Delbrueck used readings from various localized liturgies from throughout the Christian world of the time; no single location had all of the pertinent readings. While some local liturgies clearly could bear on an artwork carved in Northern Italy, such as the liturgy used in Milan and the one used in Rome, this is not obviously true of other rites including those of East Syria, Spain, and Jerusalem.

Delbrueck found the following correspondences: in Milan the account of Daniel in the Lions' Den was read on the last Tuesday of Lent, and the accounts of Susanna and Jonah were read on Maundy Thursday. The events involving Jacob are related in Lenten readings, but this is only because the entire book of Genesis is read, so the liturgy in Italy accounts neither for the casket's selection of Jacob in particular nor for the choice of the specific events from his life. The call of Moses and the giving of the Law are linked in Rome in matins on the fourth Sunday of Lent, while the call alone figures in Milan in vespers on the second Friday of Lent. Both cities include the account of the feast of the Golden Calf during Lent. The other events from Moses's life as well as the scriptures concerning David and Goliath and Jeroboam and the Prophet are not known to be included in Italian services of this season; elsewhere in the Christian world, the pertinent scriptures for Moses are read during liturgy only if the whole of Exodus is included. That is, as with Jacob, no liturgy for Lent and Holy Week provides the basis for the casket's selection of Moses's finding,

76. C. M. Kaufmann, *Handbuch der christlichen Archäologie*, 324, 556; Nordström, "Jewish Legends in Byzantine Art," 501-08 and pl. VII; Delbrueck, *Probleme der Lipsanothek in Brescia*, 136-37.

his killing of the Egyptian, his feasting in the House of Jethro, David and Goliath, Jeroboam, or the Prophet.[77] In short, Delbrueck's meticulous search of liturgical sources failed to provide a complete or exact match for the program of the Brescia Casket.

He also explored the possibility that the *Commendatio animae* served as a model for the casket. He dismissed this, however, for two reasons: he believed that the casket lacked two Old Testament scenes mentioned in the prayer, and the casket in fact includes New Testament miracles absent from the prayer (pp. 136-37). Each of Delbrueck's objections can be answered.

First, the present thesis finds in the prayer a partial model only, a model for typology. Whereas Delbrueck sought in the *Commendatio* a pattern for all the images on the casket and rejected the prayer as a pattern because it lacks the New Testament miracles, my argument is that the prayer's petitions are the source for only the series of Old Testament types which appear on the casket as types of Christ, and so the prayer's lack of New Testament healing miracles poses no difficulty. Delbrueck also believed that the Brescia Casket lacked depictions of the Three Hebrews and the Sacrifice of Isaac; because of their prominence in the petitions of the *Commendatio*, he concluded that the casket was not patterned after the prayer. With regard to the Three Hebrews, Delbrueck was mistaken: actually they are present on the casket. (See next chapter.) Because Delbrueck construed the image of the Three Hebrews as a depiction of the Downfall of Korah, however, he thought that the Three Hebrews, an important element of the *Commendatio animae*, were absent from the Brescia Casket. For Delbrueck the absence of the Sacrifice of Isaac further weakened the relationship between the prayer and the casket (pp. 124-28). To be consistent he should have recognized the absence of Isaac as an argument against his own thesis also, that Lenten and Easter readings inspired the program of the casket, for they too include the Sacrifice of Isaac. On the casket, however, the omission of Isaac is deliberate and is evidence for, not against the prayer as the basis of the casket's program.

That is, certain events from the *Commendatio animae* were portrayed on the Brescia Casket because of their dual valence as images of God's deliverance of his faithful and also as types of Christ in his Passion; therefore the omission of events without such dual significance simply strengthens the case for this thesis. Moreover, the designer of the casket was perhaps particularly interested in the figures cited in sequence in the petitions and may have considered additional types unnecessary. Only those who could simultaneously serve as emblems of deliverance from danger and also as types of Christ's Passion were chosen for the casket. In fact, several figures named in the prayer lack this double potential, and so are either not on the casket, or are on for another reason. For instance, although Enoch and Elijah became types of Christ's Ascension, their delivery *de communi morte mundi* does not qualify as rescue from an immediate and unusual danger. Similarly, Noah in the ark could be a type of Christ on the cross, for the dimensions of the wooden ark were taken to repre-

77. Delbrueck, *Probleme der Lipsanothek*, 119-30; for New Testament readings see 130-33.

sent the proportions of the human body and the wood of the ark was seen as a foreshadowing of the wood of the cross. Nevertheless, the depiction of Noah on the bronze medallion shows him at the end of his sojourn in the ark, receiving the dove, an image which accents his deliverance but undercuts his role as a type of Christ.

With regard to Isaac, he presumably does not occur on the casket because of the nature of the event associated with the *Commendatio*. Since the prayer refers to Isaac's delivery "from sacrifice, and from the hand of his father Abraham," the images of him which derive from the *Commendatio* consistently depict the very moment of this delivery: Isaac at the altar, the knife in Abraham's hand, and the ram nearby. Such is the image on the Doclea cup. This scene perfectly shows God's providential delivery of his faithful from death. For Passion typology, though, a different event from earlier in the biblical account is required: Isaac carrying the wood for the fire is the type of Christ carrying the Cross. In each case the only-begotten son, obeying his father's will, carried the wood that was intended as the means of his sacrifice. Paul's epistles to the Romans (8:32) and especially to the Hebrews (11:17-19) touched on some of these points, and Early Christian writers, such as Melito of Sardis, Clement of Alexandria, Tertullian, Origen, Cyprian, and Augustine, elaborated the comparison. Melito of Sardis is the earliest known voice for the exegesis of Isaac carrying the firewood as a foreshadowing of Christ carrying the cross.[78] Clement of Alexandria identifies Isaac as *typos* of Christ, alike in sonhood, victim's role, and carrying the wood of sacrifice.[79] Tertullian refers to this typology in *Adversus Marcionem* 3.18.2 and, in a virtually identical sentence, in *Adversus Iudaeos* 10.6.[80] In a sermon, Augustine refers to Isaac's sacrifice as figurative, with details recalling the roles of God the Father and God the Son during the Passion: Abraham "lifted the wood onto the altar, he lifted his son upon the wood. This was in anticipation of the Son coming to the place of sacrifice, bearing the wood on which he was to be lifted up."[81]

78. Stuart G. Hall makes this point in his edition of *Melito of Sardis, On Pascha and Fragments*, Oxford Early Christian Texts (Oxford 1979) 74. Melito of Sardis provides his most detailed comparison of Isaac and Christ in texts which survive only in fragments; see fragments 9-11, pp. 74-78; cf. fragment 15, *De Fide*, l. 21 (p. 83). In *De Pascha*, the bishop cites a series of Old Testament parallels to the sacrifice of Christ, including "Isaac, similarly bound"; *De Pascha* 59 and 69, pp. 32, lines 415-17, and p. 36, lines 479-82.

79. Clement of Alexandria, *Paedagogus* 5.23.1 (SC 70:150-52). Elsewhere, without elaboration, he observes that Isaac represents the savior allegorically; *Stromata* 2.5.20.2-3 (SC 38:48).

80. Tertullian, *Adversus Marcionem* 3.18.2 (CCL 1:531-32), and *Adversus Iudaeos* 10.6 (CCL 2:1376). See also Origen, *Homilia in Genesim* 8.6 (GCS 29:81), and Cyprian, *De Pascha computus* 10 (CSEL 3.3:256-57).

81. "[L]evat lignum in altare, levat filium super lignum. Antequam veniat filius ad locum sacrificii, portat lignum quo levandus est." Augustine, *Sermo* 2.8.8 (PL 38:31). See also *De civitate Dei* 16.32. Jean Daniélou devotes a chapter to the typology of the sacrifice of Isaac in his landmark work, *From Shadows to Reality*, 115-30, in which he cites

Naturally, the scene of Isaac carrying the wood is never associated with the *Commendatio*, for it is irrelevant to Isaac's delivery. To the contrary, the scene depicting the event that is recalled in the *Commendatio*, with Isaac at the altar at the moment when the ram is discovered, might focus attention on the literal, historical level of the account, not the typological role of Isaac, and so this scene was not chosen for the casket.

Another reason may have argued against including Isaac as a type of Christ on this North Italian monument. No less a personage than Ambrose, bishop of Milan, discusses Gen. 22 focusing on Abraham, not Isaac. Indeed, in his *De excessu fratris* 2.97-98 he treats this passage without even naming Isaac (or Christ) because his emphasis is on the paternal sacrifice of Abraham and God the Father.[82] Fourth-century Verona, too, heard its bishop, Zeno, preach *De Abraham*, again focusing on the faith and sufferings of the father and mentioning Isaac only once.[83] Thus, the Sacrifice of Isaac might more readily have called to mind God the Father, rather than God the Son, for a northern Italian audience of the late fourth century. It was therefore inappropriate for the Brescia Casket.

INTRIGUING POSSIBILITIES

The typological program of the Brescia Casket was quite possibly inspired by the *Commendatio*. Certainly all the types of the Passion and Resurrection depicted on the casket—Jonah, Susanna, Daniel, the Three Hebrews, David, Jacob, Moses—are personages recalled in the petitions of that popular prayer for the dead, and their depictions on the casket present the events recalled in the prayer. This is striking in the Jacob and Moses registers. The Doclea cup and perhaps the Arras cup and the bronze medallion as well demonstrate that the *Libera* petitions could be coordinated with, could perhaps even inspire the selection of, images on contemporary Christian art. Provocative, too, is the thought that the design of such artworks might have suggested to the creator of the casket his overall arrangement: Christ focally, on the lid and center panel of each face, and petition-suggested types of Christ peripherally, surrounding the casket as they adorn the circumference of the Doclea cup. The designer of the casket has used more types from the prayer than are found on any of the other monuments, and has, perhaps uniquely for his time, paired types from the prayer with actual historical depictions of Christ in the events leading up to his Passion. Even if he found some inspiration in monuments like the Doclea cup, he has created on the casket a far more sweeping program than had been suggested to him by the other artworks.

passages in which Irenaeus, Tertullian, and Augustine include the wood in their discussion of this type. See also Deléani-Nigoul, "Modèles bibliques," 333, and "*Exempla* bibliques du martyre," 253 and n. 30; and Saxer, "Bible chez les Pères latins," 356, 358.

82. CSEL 73:303-04.

83. Zeno, *Tractatus* 1.43: "De Abraham" (CCL 22:114-16). Isaac is named in l. 72. The end of the sermon is lost.

Identifying Augustine's quotation of the *Commendatio animae* in the *Enarratio in Psalmum 21* has established that the petitions of the prayer existed as early as the fourth century. Thus it is plausible that the designer of the casket, like that of the contemporary Doclea cup, could have drawn from the prayer to create a new sort of program of decoration, typologically sophisticated in its depiction of the events of salvation history and at the same time evocative of the confident hope underlying the *Commendatio*, a hope grounded in what the Passion accomplished for mankind. Using the exemplar-saints of the *Commendatio animae* with a twofold focus, pointing equally to what Christ has done and to what Christians should imitate, is in perfect accord with the overall program of the Brescia Casket, for we have seen that its design presents both christological types and also types of blessed and damnable human responses to God.

CHAPTER FIVE

THE ENIGMA IN THE UPPER RIGHT REGISTER

The single most controversial image on the Brescia Casket is the central scene in the top Old Testament register on the right side (Fig. 5). Literally unique, having no exact visual parallels, it has prompted sustained discussion. By no means is it the only innovative depiction on the Brescia Casket; Peter's de-

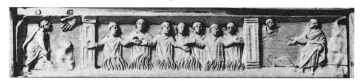

nial and both Jeroboam and the disobedient prophet had until its carving not been represented in Early Christian art, for instance, and the casket's distinctive Good Shepherd stands alone in depicting John 10 specifically. But the carving of the Three Hebrews is the only one of the casket's innovative depictions which modern viewers had trouble identifying, largely because no later depictions with precisely the same arrangement are known. A "visual *hapax legomenon*,"[1] the scene shows seven robed figures, the three foremost clearly orant, with flames concealing the feet of all of them. Variously scholars have tried to define it as a representation of the souls in Purgatory, the Band of Korah, the Seven Maccabees, or the Three Hebrews, or have simply thrown up their hands in despair (a posture not to be confused with the orant position) and called it "seven persons in the furnace"—noting parenthetically two possible interpretations.[2] The most recent contribution to the debate was Robert L. McGrath's elegant argument for the identification of the Seven Maccabees, largely on the strength of a partial visual parallel he had discovered in an eleventh-century Eastern manuscript.[3] Since then, the scholarly world has seemed to accept the matter as thus settled; for instance, recent scholarship and reference works have asserted McGrath's identification as correct.[4]

1. McGrath, "Maccabees on the Brescia Casket," 257.

2. "[S]ieben Personen im Feuerofen"; Kraus, *Christlichen Kunst* 1:503. For discussion of each of the identifications that have been proposed, see the sections below. See also Table of Identifications.

3. McGrath, "Maccabees on the Brescia Casket," 259-60.

4. For instance, Watson, "Program of the Brescia Casket," 288, and *LCI* 3:144-45.

McGrath himself, however, presented his evidence with the expressed wish of provoking a "continuing debate,"[5] and the grounds for doing so are ample. The present study will explore those grounds more fully than has been undertaken before. Specifically, logic, the visual facts of the casket itself, the techniques of narrative illustration, and parallels with other art monuments all support interpreting this unusual scene as the Three Hebrews. To prepare for this, the case for each of the three other identifications that have been proposed will be analyzed first. In some cases, arguments advanced for a given interpretation have never been refuted, even by those who reject that interpretation. Also, more can be said in favor of each interpretation than has been set forth before.

The focus on the central scene of this register has deflected scholarly attention from two other enigmas in the same register. In Chapter Six, the puzzling omission of fire from two scenes which are usually depicted with fire will be explored. It will be shown that these omissions can be explained by recognizing the fire in the furnace of the Three Hebrews as transformed into *gloria*, the fiery epiphany of God exemplified in several biblical accounts. This in turn leads to the perception of unity within this register and of parallels between it and the central front register of the casket. Demonstrating this unity and parallelism indicates afresh the coherence of the program of decoration of the ivory casket. The point is worth mentioning here because earlier discussions of this register frequently allude to its visual and logical unity, a topic on which recent scholarship has been silent.

THE VISUAL FACTS OF THE SCENE

The visual facts to be accounted for are these: the scene is comprised of seven men standing, their torsos frontal. The two on the ends look toward the center of the image; the second from the left is looking forward, the rest have their heads turned to their left. The four foremost are *orantes* and their bodies cover the arms of the three figures behind them; given the proportions of the figures, they are perhaps a bit short. Flames rise from the ground line of the scene along almost its entire width; a cluster of flames covers the base of each of five of the figures, and a sixth cluster covers the feet of the other two. The scene is bordered by a pillar on each side; and the outermost hand of the orant to the left of the scene extends over the pillar almost into the adjacent scene. Any identification of this problematic scene must account for these facts or at

least not be made unreasonable by them. One also wants to know how the scene is appropriate for the casket as a whole, and for the register and face in which it appears.

5. McGrath, "Maccabees on the Brescia Casket," 261.

THE RIVAL INTERPRETATIONS

The Souls in Purgatory. The three earliest discussions extant on the Brescia Casket suggested that the image represents souls in Purgatory. The earliest, an anonymous eighteenth-century description of the Brescia Casket, is recorded by Johannes Kollwitz. Here is the description for the entire register in question:

> "... one sees a prophet receiving a revelation, as is evident from the Hand which alludes to Purgatory through the seven nearby figures in the flames; and then another prophet has a vision, perhaps John in the Book of Apocalypse, Chap. 5, or more likely the prophet Malachi who foretells the purgation of the sons of Levi, in Malachi, Chap. 3.[6]

The next extant discussion is the full account by Federico Odorici. He reports that he initially construed the scene as "the seven Maccabees, or maybe again souls being purged."[7] (He does not mention the anonymous eighteenth-century document.) In a letter of March 23, 1847, he sought the opinion of Désiré Raoul-Rochette.[8] Raoul-Rochette replied from Paris on April 10, 1847, agreeing strongly with Odorici's other identifications, but adding: "I doubt that the seven half-figures in the middle of flames must be the Seven Maccabees; the second interpretation you suggest seems to me more plausible."[9] Commenting on this letter, Odorici seems not fully convinced; in his fuller discussion of the scene, which he decided represents the Seven Maccabees, he argued that the image is not likely to depict Purgatory.[10]

Since 1858, when Odorici reprinted his study, no voice has suggested that the scene represents Purgatory. Nonetheless, a sound case can be made for this interpretation, as long as the image and the register are considered in isolation. The purgatorial interpretation would account for the visual facts of the image

6. "... vede ... Profeta che ha una rivela ... come apparisce dalla mano a par che alluda al Purgatorio per le sette figure vicine tra le fiamme; e poi un altro Profeta che ha una visione, e sarà Giovanni nel libro Apocalissi Cap. 5 o piutosto il Profeta Malachia che predica la purgazione dei figlioli di Levi Malachia Cap. 3"; quoted in Kollwitz, *Lipsanothek von Brescia*, 8. The ellipses are Kollwitz's and must indicate indecipherable passages. The transcription was provided by the museum; Kollwitz gives no catalogue reference or codicological description of the manuscript, which apparently consists of one leaf.

7. "I sette Macabei, o forse ancora le anime purganti"; Odorici, *Antichità cristiane di Brescia*, 68. Odorici also ascribes this view to Polidori, who evidently expressed it to him in his letter of Jan. 10, 1847; see ibid., 67 and 86.

8. Odorici, *Antichità cristiane di Brescia*, 66, 68.

9. "... je douté[!] que ce soient les sept Machabées qu'il faut le[!] voir dans ces sept demi-figures au milieu des flammes; la seconde explication que vous indiquez me paroit bien plus plausible"; Odorici, *Antichità cristiane di Brescia*, 69.

10. Odorici, *Antichità cristiane di Brescia*, 86.

as follows: the number of figures, seven, is symbolic, and simply represents a large number, in this case, presumably all the souls in Purgatory. The figures are *orantes* because they are praying to atone for past sins; the flames they stand in are purifying them like a refiner's fire (Mal. 3:2-3) so that they may enter the presence of God and dwell in heaven for eternity, enjoying the beatific vision. So far, so good.

Considered in the context of the face of the casket in which it appears, the scene can still be argued to represent souls in Purgatory. One must ask why Purgatory would be placed between two scenes showing Moses encountering God, but a plausible answer is that the artist is contrasting Moses's readiness to be in the presence of God with the need of the souls in Purgatory to be purified first; the fact that some of the seven figures are looking to the sides, toward the Moses scenes, might even indicate their longing to enter God's presence as Moses did. Further, it could be argued that a depiction of Purgatory was placed above the New Testament scenes of Christ's healing of a blind man and the resurrection of Lazarus, because Purgatory affords a spiritual healing, or at least the bringing of the soul to full spiritual health. Also, at the resurrection on Judgment Day, souls that have completed their purgation may enter the presence of God. Thus far, plausible arguments can be made for the identification of this scene as Purgatory.

The problems with this interpretation appear when the image is considered in larger context. A fundamental difficulty is anachronism: Purgatory was not unequivocally depicted in art until after the doctrine of Purgatory had been defined at the Second Council of Lyons (1274), and even then its representations do not look like what we have on the casket.[11] Jacques Le Goff argues that, as the word *purgatorium* was not used as a substantive before the end of the twelfth century, neither did the concept of Purgatory exist.[12] Quite pertinent to our interests is his description of the first images of Purgatory, for he offers three monuments earlier than scholarship had discovered before. The earliest is from around 1296, and all three are quite unlike the image on the casket.[13]

11. The teaching from Lyons was reiterated at the Council of Florence (1438-39). McGrath considered the illustrated manuscripts of Dante to contain the first depictions of Purgatory; "Maccabees on the Brescia Casket," 258 and n. 22.

12. Jacques Le Goff analyzes the various passages on purgation after death in several Early Christian works by Clement of Alexandria, Origen, Augustine (here Le Goff relies much on Ntedika), Cyprian (relying on Jay), Lactantius, Hilary of Poitiers, Ambrose, Jerome, Ambrosiaster, and Gregory the Great; *Naissance du Purgatoire*, 79-131. He discusses the word *purgatorium* on p. 12, n. 1 and in App. II, which fills pages 489-93. See also Ntedika, *Purgatoire chez saint Augustine*; Jay, "Purgatoire dans saint Césaire d'Arles," 5-14, and "Saint Cyprien et la doctrine du Purgatoire," 133-36.

13. The monuments are the Breviary of Philippe le Bel, Paris, Bibliothèque Nationale, lat. 1023, fol. 49, which he dates to near 1296; the Breviary of Charles V, Paris, B.N., Lat. 1052, fol. 556v, executed between 1347-80; and a fresco in the old cathedral of Salamanca, dated by inscription to the year 1300 of the Spanish era, or 1262 C.E., but suggested by François Avril to be from the first half of the fourteenth century; Le Goff, *Naissance du Purgatoire*, 494-95 and pls. 1-3.

Thus it is highly unlikely that an early artist would think to depict Purgatory. Still, its existence is implied in the New Testament, and certain passages in the Church Fathers indicate belief in Purgatory, or rather in the need for purgation, so conceivably it could have been included on an Early Christian work of art.[14]

Another, indeed the major obstacle to accepting this interpretation of the image is that it simply does not fit the pattern of the casket's decoration. For all of the other thirty-two scenes on lid and sides represent narrative events chronicled in the Bible. In the Old Testament, the sole narrative passage that can support the doctrine of Purgatory is Second Maccabees 12:39-45, in which Judas Maccabee and his men pray for several dead comrades whom they have discovered to have been in violation of Mosaic Law when they died: they were wearing protective amulets, i.e., graven images. In short, it is the living who are described as praying for the dead, whose state the account does not describe. And the living are definitely not standing in fire as they pray on behalf of their comrades. Thus the image in question does not effectively depict the one Old Testament narrative that suggests Purgatory, and would seem instead to illustrate a concept, not an event. It is unlikely that the program of the casket would be interrupted in order to depict one concept amidst thirty-two narrative scenes.

Though this identification is to be dismissed, however, its creator should be given credit for an aspect of his interpretation that no one has bothered to remark upon.[15] That is, this anonymous eighteenth-century scholar saw unity in this register. He recognized the outer scenes, now universally accepted as being a pair of scenes depicting God's revelations to Moses, as scenes of revelation which somehow must be related in content to the inner scene which they frame so neatly.[16]

The Band of Korah. Ten scholars between 1902 and 1962[17] saw the Band of Korah in this scene. As described in Numbers, chapter 16, Korah, along with Dathan, Abiron, and Hon,[18] led two hundred and fifty leading men of the synagogue in rebellion against Moses, demanding to be priests. His response

14. Matt. 12:32, 2 Tim. 1:18, 1 Cor. 3:10-15. For patristic texts, see Le Goff, above.

15. Notably, both of the eighteenth-century identifications offered for the right-hand scene, now accepted as Moses receiving the Law, intelligently cite scriptures that refer to a book: the book of remembrance in Mal. 3:16 and the book of the seven seals in Apoc. 5:1-6, 7-8. The unusual depiction of the tablets of the Law of Exod. 24 as a book has puzzled many scholars.

16. E.g. McGrath, "Maccabees on the Brescia Casket," 257.

17. Gräven, *Antike Schnitzereien*, 13; Wulff, *Altchristliche und byzantinische Kunst*, 185; Achelis, "Totenmahle," 95; Volbach, *Elfenbeinarbeiten³*, 77; Dalton, *East Christian Art*, 208; Kollwitz, *Lipsanothek von Brescia*, 7, 26-27; Soper, "Italo-Gallic School," 177 and n. 4; Delbrueck, *Probleme der Lipsanothek*, 7, 15-17; Toynbee, review of Delbrueck, 240; and Stern, review of Delbrueck, 117.

18. Hon is not thereafter named in the account: cf. Num. 13:8-11, 12-16, and esp. 24. Whereas Korah, Dathan and Abiron, often identified by name, recur in depictions, I have never seen Hon so depicted and identified.

was that the next morning the Lord himself would indicate who was holy. Korah and his band of 250 men took their censers and put incense in them, while Aaron stood by with his censer (Num. 16:6-7, 17). Moses, Aaron and the rest of the people stood apart from the rebels, and—"the Glory of God appeared to all" (Num. 16:19). God intended to destroy everyone except Moses and Aaron (vv. 20-21), but Moses interceded on behalf of the people. God then indicated that he would distinguish between the faithful and the rebellious. Moses declared the possible courses of events that could now transpire and how each was to be interpreted, and then the judgment of the Lord came. God caused a new thing (*novam rem*) so that the earth, opening her mouth, swallowed the rebels down with everything belonging to them, and they went down alive into hell (30-34). Then fire went out from the Lord and killed the 250 men who were offering incense (35). Note well that the account clarifies that the brazen censers survived the fire and, at the Lord's direction, were beaten into plates and fastened onto the altar as a visible reminder (Num. 16:40).

These events are recalled in Psalm 106 (Vulg. 105):16-18. Verse 17 names Dathan and Abiram as being swallowed up by the earth, and the next verse describes the fire which burned up the rebel band.

Hans Achelis offers a brief explanation for construing the image on the casket as the Band of Korah: "We see the seven men sink into the earth, into the erupting flame, just as is described in Num. 16:32ff."[19] He goes on to explain that, as it would obviously have been impossible to depict all two hundred and fifty men of the Band of Korah on this ivory, the artist used the number seven to represent the large number. Most scholars, however, are tentative in this identification. For instance, Volbach consistently labels this scene "die Rotte Korah (?)."[20]

Several scholars include an argument from unity when suggesting Korah here. Dalton's one-paragraph description of the entire casket implies such an argument. He identifies its Old Testament scenes as "relating to Moses, Korah, David, Jeroboam, Daniel, and Susanna."[21] By naming three pairs of figures—Moses and Korah from Exodus, David and Jeroboam from the Books of Kings, and Daniel and Susanna from the Book of Daniel—Dalton indicates that he sees unity in the registers of the casket. By implication he accepts the identification of Korah on the basis of the coherence of the register. Johannes Kollwitz also sees a unity in the register, with two "Moses scenes" flanking a scene depicting an event in which Moses's role was crucial.

In addition to considering the unity of the register, Kollwitz attempts to deal with several of the visual facts of the scene itself. Following Achelis, he describes the men in the image as "sinking." Notably, Kollwitz provides the only attempt to explain the raised hands of the figures, seeing this not as an orans

19. "Wir sehen da sieben Männer in der Erde versinken, aus der Flammen herausschlagen, so wie es das Buch Numeri 16,32ff. schildert"; Achelis, "Totenmahle," 95.

20. Volbach, *Elfenbeinarbeiten*[3], 77; see also his *Early Christian Art*, pls. 85-89 described on p. 328: "Korah and His Band Swallowed Up (?)."

21. Dalton, *East Christian Art*, 208.

position, but a gesture of terror.[22] Still, Kollwitz's identification of this scene grants only that it is the "most plausible" interpretation.[23]

The next critic to espouse this identification, A. C. Soper, follows Volbach, mildly observing that his interpretation "seems correct."[24] Kollwitz had noted the lack of definitely identified contemporary or earlier depictions of the Band of Korah, and Soper affirms this lack.[25]

The fullest discussion of this interpretation is that of Richard Delbrueck in his monograph on the *Lipsanothek von Brescia*. Beginning with summaries of biblical, patristic, rabbinical, and Islamic textual evidence, he then analyzes the scene in two paragraphs. In his exposition of the visual facts of the scene, he states precisely that all seven men are shown only down to about knee-high.[26] In reporting the directions in which the figures look, he adds that five seem to look outside the bounds of the image toward Moses in the adjacent scene or to an undepicted comrade who prayed for them, according to rabbinical tradition.[27]

A compelling reason to accept this scene as Korah is, for Delbrueck, its placement in this Moses "frieze." He, too, evidently saw in this register a visual and logical unity; perhaps we may even say, he found the visual unity so strong that it implied a logical unity. And, not seeing how the Three Hebrews could logically be related to the arrangement of the register as a whole (*Bildbestand*), he rejected that identification in favor of the Band of Korah, so that all three scenes could be said to depict or relate to an event in the life of Moses. Another of his comments deserves emphasis here because it is pertinent to various interpretations of the enigmatic scene: it will be shown below that simultaneous depiction of two or more events is actually required to accept any of the three remaining interpretations. To accept the interpretation of the scene as Korah and his band, Delbrueck notes, it is necessary to see two sequential actions of the biblical account as depicted simultaneously: "the men sink and burn up at the same time" ("die Männer gleichzeitig versinken und verbrennen").

The last voice for the Band of Korah is brief and unconvinced. In a review of Delbrueck's monograph, Henri Stern presented Delbrueck's interpretation with reservations, describing the scene in question as "the end of the sons of

22. "Die Jünglinge sind als in den Flammen versinkend dargestellt. Für diese Deutung spricht auch die Stellung der Szene zwischen zwei Mosesszenen. Ebenso spricht hierfür die allen gleiche Kleidung. Die erhoben Hände sind dann wohl zu verstehen als Gestus des Erschreckens, ebenso wie mehrfach auf Sarkophagen in der Darstellung des Meerwurfes des Jonas eine Beifigur die Hände emporwirft. Sonst ist die Begebenheit nicht dargestellt"; Kollwitz, *Lipsanothek von Brescia*, 26-27.

23. "Am wahrscheinlichsten bleibt noch die Deutung auf die Rotte Korah"; Kollwitz, *Lipsanothek von Brescia*, 26.

24. Soper, "Italo-Gallic School," 177, n. 104.

25. Kollwitz, *Lipsanothek von Brescia*, 27; Soper, "Italo-Gallic School," 177.

26. "Alle kommen nur bis etwa Kniehöhe in Bild"; Delbrueck, *Probleme der Lipsanothek*, 15-17.

27. Delbrueck, *Probleme der Lipsanothek*, 16.

Korah (if that is the subject of the depiction)"; he followed this by suggesting that the scene really depicts the "three youths in the furnace."[28]

These, then, are the arguments scholars have offered on behalf of interpreting this scene as depicting Korah and his band.[29] Strikingly, scholarly response has ignored two of the arguments: that the men are depicted in the moment of sinking,[30] and that the unity of the register requires a scene that is appropriate with the pair of Moses scenes that flank it.

The first argument can be answered by referring to a fact discussed in the introduction of this volume, namely, the vertical compression or flattening in the Old Testament registers of the side panels. I would argue that the artist, wanting to emphasize the orant position of the Three Hebrews, felt it unnecessary to observe correct proportions for the whole human figure because the lower part of it was here covered by flames. This latter point is perhaps implicitly accepted by the several scholars who have seen no need even to respond to the assertion that the figures in this scene seem to be sinking. The second argument, about the unity of the register as a whole, will be taken up in the next chapter.

Notably, no scholar has seen any problem with Delbrueck's argument that the scene takes sequential events and makes them "gleichzeitig." This point is worth making, because in contrast scholars have faulted the argument for the Three Hebrews on just such grounds—while tacitly accepting such grounds as an implied argument for the Seven Maccabees!

The identification of this scene as the destruction of Korah is problematic because of the dissonance of the image with representations known to depict this event and, as will be discussed below, on logical grounds as well. Of the thirty representations of Korah identified—even tentatively—in the Index of Christian Art (ICA), all except the image on the Brescia Casket illustrate manuscripts: Bibles, Psalters, Octateuchs, and related works such as Aelfric's biblical paraphrase and the *Sacra Parallela* of John of Damascus.[31] The three and possibly the fourth earliest manuscripts are from the ninth century, but the other twenty-five are mostly from the twelfth and thirteenth centuries, with two possibly as late as the fifteenth. Thus, if the image on the Brescia Casket

28. "fin des fils de Cor (si tel est le sujet de la scène)" and "trois adolescents dans la fournaise"; Stern, review of Delbrueck, 117.

29. Another argument for this interpretation could be made by relating this scene to the larger context of the casket, for it depicts the deaths of two disobedient people who believed in God: the disobedient prophet of Kings, and Ananias. Korah and his band would thus provide another instance of rebellious disobedience punished fatally. Lacking an argument for multiplying such examples, however, this is a weak point.

30. McGrath, "Maccabees on the Brescia Casket," 257 does describe the scene as depicting "seven half-length figures," but without explaining why the Maccabees would be shown half-height and without responding to the argument that the figures are depicted sinking because they represent Korah's band.

31. The eleventh-century manuscript of Aelfric's paraphrase is London, British Museum, Cotton Claudius B.IV, fol. 120, and the ninth-century *Sacra Parallela* is Paris, Bibliothèque Nationale, gr. 923, fol. 352v.

represents the destruction of Korah and his followers, it not only lacks contemporary analogue, but is also the sole depiction outside a manuscript.

Moreover, when Korah is indisputably depicted several centuries later, the representations are quite different from the scene in question on the casket. *Never are the rebels orant.* Confused postures, chaotically varied, are typical. For instance, in the ninth-century Chludoff Psalter, Psalm 106:16-18 is illustrated with an image of three men falling in confusion into the earth.[32] Of the man at the left, only the head and arms are visible—he faces the viewer with his arms extended straight up. The other two figures are falling headfirst into the opened earth, their arms, head, and upper torsos already concealed. The positions of their legs show that one of these figures is facing toward the viewer and the other, away. The Gumpert Bible, prepared before 1195, likewise shows three men, identified by inscription as Korah, Abiram and Dathan, facing different directions and already fallen to different depths in the earth.[33] Particularly vivid is a detail in a Bible from the second half of the thirteenth century, now at Lausanne. Four figures in the center of the image are being swallowed by the earth, which rises around them (rather as the water rises to cover Christ in Byzantine depictions of his baptism).[34] Three are engulfed waist high, but the fourth has sunk so far that all we see of him is the top of his head with his eyes wide in horror.[35] The frontispiece to the Book of Numbers in a ninth-century Bible now in Rome is largely devoted to the account of Korah; this illustration shows a hellish confusion of bodies in a pit.[36] A manuscript at Amiens shows twenty-seven men falling into the earth, most indicated by little more than a head, with hands and arms flung out in random gestures.[37] In no illustration have the men sunk so uniformly or so slightly as in the image on the Brescia Casket. Thus the serene arrangement of seven men on the casket differs not just in circumstantial detail but in basic nature from the later depictions known to represent the destruction of Korah and his followers.

An additional problem is that the censers which figure so prominently in the biblical account are lacking from the image on the Brescia Casket. In contrast, censers are generally depicted in manuscript illustration, as in a Picture Bible of 1197 at Amiens, the frontispiece to the Book of Numbers in a ninth-century

32. Chludoff Psalter, ninth century: Moscow, Historical Museum, gr. 129, fol. 108v on Psalm 106 (LXX: 105); plate in Corrigan, *Byzantine Psalters*, fig. 45. Three other psalters carry similar schema of illustrations for this Psalm: a ninth- or tenth-century Psalter at Paris, Bibliothèque Nationale, gr. 20, fol. 16v (Corrigan, ibid., fig. 48); the Theodore Psalter of 1066, London, British Museum, Add. 19352, fol. 143v (ICA); and the thirteenth- or fourteenth-century Hamilton Psalter, Berlin, Köningl. Museum, Kupferstichkabinet, 78.A.9, fol. 190.

33. Gumpert Bible: Erlangen, Universität-Bibliothek, 121, fol. 33v (ICA).

34. For several instances of the water so rising on Christ, see Tkacz, "Susanna as a Type of Christ," 15.

35. Bible at Lausanne: Bibliothèque Cant. et Univ., U964, fol. 47v (ICA).

36. Bible (ca. 870) at Rome at the Monastery of San Paolo fuori le mura, fol. 39v (ICA).

37. Picture Bible, 1197*, Amiens, Bibliothèque de la Ville, 108, fol. 59v (ICA).

Bible at San Paolo, the Gumpert Bible, and a twelfth- or thirteenth-century Psalter at Munich.[38] As the means of expressing the men's presumption, the censers became part of the adornment of the altar, serving as a warning against such arrogance. This is depicted in the narrative sequence of illustrations in a fourteenth-century Picture Bible.[39] The most dramatic depiction of the censers is in a Bible at Lausanne:[40] a trio of legitimate priests are depicted behind Moses, each of the three swinging a censer. The various positions of these censers indicate a graceful, side-to-side ritual action. In contrast, the two groups of rebels who are being swallowed by the earth and consumed by flames, respectively, fling their censers about wildly.

Secondly, in the enigmatic scene on the casket the position of the figures, where it is fully shown, is clearly the orant position, not a gesture of terror, as Kollwitz had suggested. Significantly, it is exactly the position of the other orant figures on the casket: Susanna and Daniel in the lower front register and Susanna again on the top back register. In each case, the arms are held out at or just below shoulder level, slightly flexed at the elbows, with the palms facing forward. This artist is capable of showing contrasting states of mind through posture and gesture, as is shown by the marked difference between the tranquil, orant Susanna and the eager elders who dash toward her. How unlikely, then, that this artist would use the orant position as a gesture of terror. This is all the more unlikely because the Band of Korah were rebelling against the will of God as expressed through Moses and were not at all in a prayerful frame of mind as they tried to usurp the priestly role God had assigned to the Levites. It would be anomalous in the extreme to depict these men, who are being slain in the very act of disobedience, in the traditional posture of prayer. And, in fact, no depiction of these rebels shows them orant. Scholars have noted this difficulty before. For instance, E. Weigand, in his review of Johannes Kollwitz's monograph, observes:

> the arm-position of the three young men in the foreground can in no way be understood as a gesture of horror, for then the arms would have to be flung on high, and of course, by everyone; however, only the three young men in the foreground have the already mentioned peaceful orant pose . . .[41]

38. Picture Bible, Amiens, Bibliothèque de la Ville, 108, fol. 59v; San Paolo Bible, ca. 870: Rome, Monastery of San Paolo fuori le mura, fol. 39v; Gumpert Bible: Erlangen, Univ.-Bibl., 121, fol. 33v; Munich Bible, Staatsbibliothek, Clm. 835, fol 19v. Censers are also in the *Hortus deliciarum* belonging to Herrad, abbess of Hohenbourg, prepared ca. 1176-96; Green et al., *Hortus deliciarum*, 1:1, 2:91 no. 192.

39. London, British Museum, Add. 15277, fol. 42v-43v. Eleazar, son of Aaron, is shown collecting censers on 43r; on 43v, he supervises two men in the collecting of censers, next the censers are worked into plaques at a forge, and then Eleazar hammers the resulting squares onto the base of the altar. It may be that the diamond shapes decorating the base of the altar in an illustration of Psalm 106 in an earlier manuscript are intended to represent or prefigure these plaques; in any case, the rebels—Korah, Dathan and Abiron—and the true priest all carry censers in this depiction. Intriguingly, the diamond shapes on the altar are similar to the diamond shapes which fill the border to the illustration; see Munich, Staatsbibliothek, Clm. 835, fol. 19v.

40. Bible: Lausanne, Bibliothèque Cant. et Univ., U964, fol. 47v.

41. "[D]ie Armhaltung der drei vornestehenden Jünglinge kann niemals als Schreck-

Or, as McGrath puts it, "it seems impossible to reconcile the orant postures on the Brescia Casket with the gestures of alarm required by the Korah episode."[42]

The third difficulty in squaring the visual facts of this image with an interpretation of it as the Band of Korah is that the fire in the image on the Brescia Casket is not falling from heaven, it is rising from the bottom of the scene. Fire from God consistently falls from heaven in the Bible, as Chapter Six will show. Therefore, some rationale would have to be given to explain why the artist has shown the fire at the feet of the men, not in the air. Effectively depicting fire falling through the air in a monochrome medium would be difficult, and representing fire at all on ivory is a challenge, as seen in the awkward portrayal of the flame on the altar of the priestess of Bacchus depicted on the late fourth-century diptych of the Nichomachi and Symmachi.[43] Perhaps it could be argued that flame depicted arising from ground level would be more readily recognized. That neglects, however, the next question: why not depict recognizable flame rising from the base of the image and also flames in midair, to indicate the origin of the fire?

Comparing this image with the representations of Korah and his rebels identified in the Index of Christian Art (ICA) underscores the validity of the question. When the fire is depicted, artists use various means to represent it falling. In the Amiens Picture Bible, long stylized flames descend through three scalloped lines which span the top of the image and may represent clouds or the heavens. In the San Paolo Bible an angel stands with a torch above a pit in which the rebels are foundering.[44] In a ninth- or tenth-century Psalter at Paris, seven swirls of fire spin in a loose spiral above the pit into which the men have all but disappeared.[45] Fire descends from the arc of heaven in the Munich Psalter. Although two of the images catalogued in the ICA do depict the fire rising from below, each of these representations distinctly separates the fiery punishment from the sinking into the earth, and so neither depiction is analogous to the image on the Brescia Casket.[46] It is unlikely that the creative and inventive

ensgestus aufgefasst werden, dann müssten die Arme in die Höhe geworfen sein, und zwar bei allen; aber nur die drei vornestehenden Jünglinge haben die ausgesprochen ruhige Orantenhaltung"; Weigand, review of Kollwitz, 431.

42. McGrath, "Maccabees on the Brescia Casket," 259.

43. The diptych is at the Victoria and Albert Museum in London. Plates: Bourguet, *Early Christian Art*, 173 (color); Volbach, *Elfenbeinarbeiten³*, pl. 29; and Kitzinger, *Byzantine Art in the Making*, 34 and pl. 63.

44. It appears that the artist of this frontispiece intends a parallel between the angel depicted confronting Balaam in the upper right of the page and, in the lower right of the page, the angel standing above the pit and facing a prostrate Moses. Thus the angels serve as points of orientation for differing responses to God's will.

45. Paris, Bibliothèque Nationale, gr. 20, fol. 16v. The image accompanies Psalm 106 (LXX, 105).

46. An illustration in a Bible at Lausanne, Bibl. Cant. et Univ., U964, fol. 47v, from the second half of the thirteenth century, depicts the opening of the earth described in Ps. 106:17 beside a depiction of the flame which "burned up the wicked" (Ps. 106:18). The

artist of the casket would have failed to find some means to depict the destruction of Korah effectively, had he chosen to do so.

On these grounds, this scene is shown not to depict Korah and his Band.

The Seven Maccabees. An early and recurring interpretation of this unusual scene is that it represents the martyrdom of the seven Maccabee brothers. Their ordeal is recounted twice in the Bible: in the Second Book of Maccabees, chapter 7, and in the Fourth Book of Maccabees, chapters 7-18.[47] The martyrdom of Eleazar, the venerable elder who is traditionally taken to be the tutor or father of the brothers, is recounted in 2 Macc. 6:18-31 and again in 4 Macc. 5:1-7:3. The Fourth Book of Maccabees, which is in the Septuagint and the Eastern Catholic and Orthodox canon, though not in the Vulgate or the subsequent Roman canon, was a source for Early Christian thought and ought to be considered in any discussion of early representations of the Maccabees.

Odorici was the first to suggest, tentatively, that the enigmatic scene on the casket might depict the Seven Maccabees—or, alternatively, the souls in Purgatory. He maintained his suggestion of the Maccabees even when Raoul-Rochette disagreed with him.[48] Perhaps recalling 4 Macc. 16:21-23 and 18:12-14 (quoted below), Odorici reasoned that the scene was affected by the analogy between the experiences of the seven brothers and of the three youths. Further, he suggested that the sculptor of the casket, moved by wonder at the miracle of the Three Hebrews—"they walked about in the middle of the flame"—may have been prompted to depict the brothers in the same way. Odorici also refers, without elaboration, to the scriptural account[49] and to the fact that the ninth-century *Menologion* of Basil describes the Maccabees as "exposed to fire on account of their piety."[50]

A few other scholars have accepted this identification for the scene. For instance, the abbé V. Davin construed it as deriving from the same analogy: "instead of the Three Hebrews in the furnace, the Seven Maccabees in the flames that symbolize by one general trait their martyrdom."[51] André Pératé simply identifies the scene, without discussion, as "the seven Maccabee brothers orant amid the flames."[52] With equal brevity, Henri Leclercq identifies the scene as

other image, in a manuscript at Maihingen which contains a Picture Bible and the Vitae Sanctorum—Wallerstein Library, I.2.qu.15, fol. 70v (ICA)—shows ten men, full-length, in horizontal rows of three, four, and three, each man enclosed in a body-sized tulip-shape of blades of fire. The men stand in various postures of dejection, all with arms hanging down and feet dangling as they fall.

47. For information on the biblical account and the role of the Maccabees in Byzantium, see *ODB* 2:1261.

48. Odorici, *Antichità cristiane di Brescia*, 66-69, 86.

49. Odorici, *Antichità cristiane di Brescia*, noted: "era il fatto più clamoroso che ad accendere la costanza de quegli eroi potesse citarsi nelle pagine del Testamento"; 86.

50. "igni expositi pro pietate"; Odorici, *Antichità cristiane di Brescia*, 86.

51. "[A]u lieu des trois Hébreux dans le fournaise, les sept Machabées dans les flammes qui symbolisent d'un trait général leur martyre"; Davin, "*Capella greca,*" 314.

52. "les sept frères Machabées orants parmi les flammes"; Pératé, *L'archéologie chrétienne*, 343.

"the seven Maccabee brothers in prayers amid the flames"; this occurs in his discussion of the images. Accompanying this discussion, however, in the caption to the drawing of the right side of the casket, the same image is identified as "the Three Hebrews in the furnace."[53]

Georg Stuhlfauth refuted the Maccabee identification. He noted first that the various martyrdoms of the seven brothers did not occur simultaneously nor by the same means: "They were martyred, but not in one act, not together, and not at the same time."[54] Stuhlfauth refers to 2 Macc. 7 for details of the individual martyrdoms and notes that even those who did ultimately, after other tortures, die by fire, were not standing in it. He also observes that the final martyrdom recounted in chapter 7, that of the mother of the seven brothers, is not depicted on the casket. Myrtilla Avery advanced similar arguments at the same time that Stuhlfauth did, with both scholars publishing in 1924. Observing that depictions of the Maccabees are "very uncommon," she speaks specifically of the proposed identification for the scene on the Brescia Casket:

> The subject [of the Maccabees] does not appear at all in the Early Christian section of the Princeton Index of Christian Art, except in Cabrol's conjectural interpretation of the seven figures in the fire, on the fifth-century Brescia casket, assigned by Strzgowski to Asia Minor. The interpretation is dubious, first, because the martyrdoms were only partly by fire, but, principally because the mother is not represented, though the emphasis is so largely on her in Early Christian writing, where she is compared to the Mother of Sorrows.[55]

Thereafter for forty years the Seven Maccabees were not associated with this scene. Then Robert L. McGrath discovered an illustration of the brothers in an eleventh-century Byzantine manuscript, which he offered as a partial visual parallel to the scene on the casket (Fig. 15). Specifically, a manuscript of the homilies of Gregory of Nazianzos (Athos, MS Vatopedi 107) bears on folio 48 recto "a small unframed illustration at the base of the column of writing."[56] McGrath describes the illustration thus:

> At the left, seven in a row, stand the Maccabean brothers, half consumed by a stylized bed of flame. Despite the varied postures, at least one of the figures appears orant. The bearded tutor Eleazar and the mother Salomona, exhorting her sons to die nobly rather than forsake the law, are found on the right.[57]

53. "les sept frères Machabées en prières parmi les flammes"; caption: "Les trois Hébreux dans la fournaise"; Leclercq, "Brescia (archéologie)," *DACL* 2.1:1156 and fig. 1627.

54. "nicht in einem Akt, nicht zusammen und gleichzeitig gemartert"; Stuhlfauth, "Zwei Streitfragen," 48-64; the quotation is from page 50. He also responds to arguments by Becker, "Sieben makkabäischen Brüder auf der Lipsanothek," 72-74.

55. Avery, "Style at Santa Maria Antiqua," 141. Cf. "matri ecclesiae similis"; Augustine, *Enarratio in Ps. 68.19.*

56. McGrath, "Maccabees on the Brescia Casket," 259 and n. 30. The illustration is reproduced as his figure 5. Although he consistently locates this Vatopedi manuscript at "Sinai" (259 n. 30 and caption of fig. 5), it is on Athos. George Galavaris correctly locates it; *Illustrations of Liturgical Homilies,* 111 and fig. 322.

57. McGrath, "Maccabees on the Brescia Casket," 260.

FIGURE 15. The Seven Maccabees together in fire.

He addresses the absence of the mother and of Eleazar on the casket, suggesting that "they might have been omitted for lack of space."[58] He does not address the question of why the brothers would be depicted in fire, however, evidently on the assumption that the question is of little moment, given the fact that an eleventh-century manuscript has depicted them thus. This yet leaves open the silent question of why a fourth-century monument would have done so. (As will be shown below, an answer can be offered.)

Since McGrath's article appeared in 1965 many scholars including Watson have taken the matter as settled on behalf of the Maccabee brothers. Yet adherents of interpreting this scene as the seven Maccabees offer no reason for its occurrence in this particular register. Only McGrath even obliquely acknowledges the coherent design of the register by referring to its central scene as "bracketed by two Moses scenes."[59]

As one who has argued and maintains that the scene in question on the casket depicts the Three Hebrews, I find myself in the curious position now of offering another, closer visual analogue to the scene on the casket and also, more importantly, an overlooked and central body of scriptural evidence that can support an identification of the scene as the seven Maccabees. First the visual analogue. A closer analogue to the scene on the casket exists in a different manuscript than that cited by McGrath: the decorated initial tau of Vat. gr. 463, fol. 411, shows the seven brothers (none orant) in a furnace—three in

58. McGrath, "Maccabees on the Brescia Casket," 260.

59. McGrath, "Maccabees on the Brescia Casket," 257.

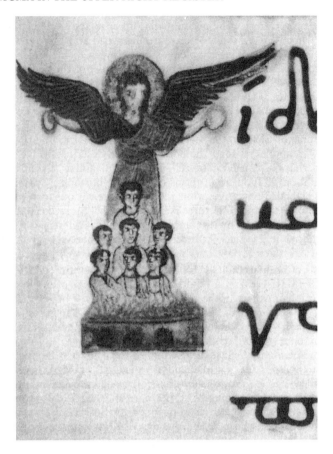

FIGURE 16. The Seven Maccabees together in fire.

front, three in a second row, and the seventh behind them—and above them an angel with outstretched wings and arms (Fig. 16). The brothers fill the stem of the initial; the angel's wings and arms form the cross bar. George Galavaris, who analyzes this image in his discussion of the illustrations of the liturgical homilies of Gregory of Nazianzos observes, "This scene is patterned after a similar presentation of the Three Holy Children in the Fire."[60] In the decorated initial not only are the seven brothers together in the furnace, but neither Eleazar nor Salomone is depicted.

More important, however, is the scriptural evidence, which has been generally ignored.[61] Only the first of two biblical accounts of the brothers' martyr-

60. Galavaris, *Illustrations of Liturgical Homilies*, 110, n. 277.

61. E.g. McGrath, "Maccabees on the Brescia Casket," 257. In contast, Galavaris, *Illustrations of Liturgical Homilies*, 111-12 draws on all the scriptural sources for the images of the Maccabees.

doms has been examined. The account that all scholars have referred to is 2 Macc. 7, in which the various tortures are described and fire, *ignem*, is mentioned only once (v. 5). This chapter also employs a theme which became a commonplace of Christian hagiography: the contrast of the persecutor to his victims, for it is Antiochus who is *inflammatus* (v. 34) and *accensus* (v. 39) because he cannot force compliance from the Maccabees. The single chapter of narrative in the Second Book of Maccabees is elaborated in the Fourth Book into a round dozen of chapters. The Fourth Book of Maccabees is devoted to the martyrdoms of Eleazar, the seven brothers, and their mother as a detailed exemplum of religious reason. The book has been described as "a diatribe or lecture, or perhaps a panegyric, on religious reason" and a "classic example of the interpretation of Judaism in terms of Greek philosophy," primarily Stoicism.[62] This extended narrative, while recounting the various tortures, also elevates fire into a theme with three variations: the Stoic constancy of the martyrs though consumed by fire, implicit and explicit references to the Three Hebrews, and, as in 2 Macc. 7, the contrast of the martyr's equanimity with the tyrant's fiery rage.

A synopsis of both accounts will be useful. First, the prior, shorter account. In 2 Macc. 6:18-31, Eleazar, an old scribe, is a conscious example of virtuous obedience to religious law in the face of persecution, for he refuses to violate dietary laws by eating pork. He dies suffering undefined tortures (*cum plagis*, v. 30; *supplicium*, v. 19). Thereafter, the seven Maccabee brothers are persecuted one by one, starting with the eldest, and each refuses to break the religious law, preferring to die instead. The eldest is tortured by having his tongue cut out, being scalped, having his hands and feet cut off, and then being fried in a huge pan (vv. 2-5). Five of his brothers die by equally hideous means. Then their mother is praised at length by the narrator (vv. 20-23). Her youngest son's martyrdom is recounted next, in much greater detail than previously: after the first brother, whose ordeal was described in four verses, the next five brothers are each handled in two or three verses each, but the youngest brother receives a seventeen-verse narration, including a description of the persecutor's attempt to flatter him into violation of his beliefs (v. 24), his mother's counsel (vv. 25-29), the boy's reply to Antiochus (vv. 30-38), his cruel death (v. 39), and his purity (v. 40). The chapter concludes with his mother's martyrdom (v. 41). The narrative is a well-structured whole; for instance, a stirring speech on the hope of resurrection (v. 14) is ascribed to the fourth son, and thus occurs centrally in the series of the brothers' deaths.

62. *The New Oxford Annotated Bible with Apocrypha*, RSV, ed. Herbert G. May and Bruce M. Metzger (New York: Oxford University Press, 1977) [309]. (Please note that the square brackets surrounding the page numbers are printed in the edition to distinguish the separate pagination of the apocrypha.) Of the four books of Maccabees, the first is from a Hebrew original ([221]), the second, originally in Greek, is an epitome of a five-volume history ([263]), and the third and fourth are part of the Septuagint only, not having been translated for the Vulgate and not accepted into the Roman canon ([294] and [309]).

The account in the Fourth Book of Maccabees is far more developed. Eleazar's ordeal fills more than two chapters (5:1-7:11). He scorns the tortures (5:30, 32), is scourged, kicked, and then, "brought to the fire" (6:24), agonized with fire-heated instruments and the pouring of hot liquids into his nostrils (6:3-27). He succumbs at last to the "burning torments" (v. 27), but remains faithful. The narrator then praises his Stoicism in persevering, rising to a treble apostrophe that introduces a trio of references to fire:

O aged man, more powerful than tortures!
O elder, fiercer than fire!
O supreme king over the passions, Eleazar! (7:10)

He is then immediately compared to Aaron who conquered the "fiery angel" that was devastating the people after the destruction of the band of Korah (7:11). "So the descendent of Aaron, Eleazar, though being consumed by fire, remained unmoved in his reason" (7:12). Such praise of Eleazar and equanimity fill the rest of the chapter (vv. 13-23).

Eleazar's serenity and steadfastness defeat Antiochus and provoke him to greater rage (8:2); this contrast becomes a commonplace of hagiography.[63] The seven Maccabee brothers with their elderly mother are then brought before him, and he first flatters them, praising their handsomeness and offering to be their friend, but then threatens worse tortures than Eleazar endured if they refuse (8:5-11). The pattern of flattering and then threatening martyrs also becomes a familiar theme of hagiography, particularly in narratives in which the martyr's reason and skill in argument are praised.[64] To frighten the brothers, Antiochus has the instruments of torture brought out: "wheels and joint-dislocators, rack and hooks and catapults and cauldrons, braziers and thumbscrews, and iron claws and wedges and bellows" (8:13). The brothers respond with reasonable arguments, and in turn warn Antiochus that his cruelty is earning him "eternal torment by fire" (9:9). Then the individual martyrdoms take place. The eldest brother is beaten, broken on a wheel, and then expires when a fire is placed beneath the rack (9:11-25). The next brother suffers having his sinews torn with iron hooks and having his scalp torn away (9:26-10:1). The third brother's hands and feet are disjointed; he is then dismembered, with fingers, arms, and legs and elbows broken, before being skinned and killed on the rack (10:1-12). The fourth

63. For a discussion of this commonplace, see Tkacz, "Topos in Aelfric."

64. In hagiography, the topos of Flatter, Then Threaten occurs in recognizable contexts: with wise young virgins, such as Juliana, Agatha, Agnes, Barbara, Blandina, Eulalie, Margaret, and Agape, Irene and Chionia; with adult male saints, such as George, the Forty Martyrs, the Forty-Two Martyrs of Amorion, Plato, and Eustratios. Sometimes the flattery includes attempted sexual seduction: Sts. Chrysanthus and Daria, Christopher, and Dorothea. Juliana: AASS Feb. and PG 116:584ff; Agatha: AASS Feb. 1:618-21 and PG 114:1332-45; Barbara: PG 116:301C-316C; Blandina: Eulalie: ninth-century *Cantiléne de Ste Eulalie* in *Chrestomathie de la littérature en Ancien Français*, ed. Albert Henry, 3rd ed. rev. (Berne: Editions A. Francke, 1965) 2-3; Margaret: AASS Jul. 5:36A ff.; Agape, Irene and Chionia: PG 116:580D ff.; Plato: PG 115:404B-425D; Eustratios: PG 116:468-506D; Chrysanthus and Daria: AASS Nov. 29. For Aelfric's use of this topos with some of these saints, see Tkacz, "Tormentor Tormented," 228-29.

brother defies the torturers: "You do not have a fire hot enough to make me play the coward" (10:14). He speaks so forcefully that Antiochus has his tongue cut out; this brother dies after unspecified tortures (11:1). The fifth brother is stretched over a catapult "so that he was completely curled back like a scorpion" and all his members disjointed (11:10). The sixth brother is stretched on a wheel, roasted thereon, and pierced with heated spits. Before he is thrown into the cauldron in which he dies, he defies the torturers, declaring:

> We six boys have paralyzed your tyranny! Since you have not been able to persuade us to change our mind or to force us to eat defiling food, is not this your downfall? *Your fire is cold to us*, and the catapults painless, and your violence powerless. . . . We hold fast to reason.(11:24-27, italics mine)

When the last and youngest boy comes forward, again Antiochus attempts persuasion, and enlists the boy's mother as well. She, however, exhorts him (in Hebrew, which Antiochus does not understand) to persevere in faithfulness. In response, the boy asserts to the king that "eternal fire and tortures" are prepared for him because of his cruelty (12:12). After asserting his fidelity to his faith, he casts himself into the braziers and dies (v. 19).

The narrator then delivers a lengthy praise of reason and of the seven brothers. Up to this point, the narration has emphasized fire; now, to this is added the first of four references to the Three Hebrews. He suggests that the Maccabee brothers had encouraged each other to "imitate the three youths in Assyria who despised the same ordeal of the furnace" (13:9). He discusses the seven brothers as a chorus (14:8, 8:4), emphasizing them as a group rather than as sufferers of individual torments, and speaks as if fire were the sole or most important torment: "For the power of fire is intense, and it consumed their bodies quickly" (14:10); "This mother . . . saw them tortured and burned one by one," "She watched the flesh of her children consumed by fire" (15:14-15). Consider this striking comparison, too:

> The lions surrounding Daniel were not so savage, nor was the raging furnace of Mishael so intensely hot, as was her innate parental love, inflamed as she saw her seven sons tortured in such varied ways." (16:13)

The narrator ascribes to her a moving exhortation to her sons, which concludes:

> And Daniel the righteous was thrown to the lions, and Hananiah, Azariah and Mishael were hurled into the fiery furnace and endured it for the sake of God. You too must have the same faith in God and not be grieved. It is unreasonable for people who have religious knowledge not to withstand pain. (16:21-23)

Her death, which was like that of her youngest son, is then described tersely: "she threw herself into the flames" (17:1). The book concludes with recalling another lengthy speech ascribed to her, in which she described to the sons their father and all that he had taught them, about Abel, Cain, Isaac, Jacob, and Phineas. She continues:

> and he taught you about Hananiah, Azariah, and Mishael in the fire. He praised Daniel in the den of the lions and blessed him. He reminded you of the scripture of Isaiah, which says, "Even though you go through the fire, the flame shall not consume you." (18:12-14)

The series of references to fire concludes in the last lines of the book, in a passage which notably stresses the variety of torments the individual brothers endured. The narrator speaks of that "bitter tyrant" who

> quenched fire with fire in his cruel cauldrons, and in his burning rage bought those seven sons of the daughter of Abraham to the catapult and back again to more [or, to all his] tortures, pierced the pupils of their eyes and cut out their tongues, and put them to death with various tortures. (18:20)

As this review of the two accounts shows, the concluding chapters of the Fourth Book of Maccabees provide considerable grounds for using fire as a generalized feature of their martyrdoms. Moreover, by the repeated references to the Three Hebrews, the analogy that Odorici and Pératé suggested is made plausible. Yet the account also and with equal clarity stresses the variety of different sufferings that the individual brothers endured. The early chapters detail the tortures vividly, and the concluding chapters refer to the "various tortures," as in the passage just quoted.

Further, when considering how an artist might be expected to depict all this, we have the unique instance of scripture addressing precisely this question, and the image suggested includes the mother as a witness to her sons' various sufferings:

> If it were possible for us to paint the history of your piety as an artist might, would not those who first beheld it have shuddered as they saw the mother of the seven children enduring their varied tortures to death for the sake of religion? (17:7)

This passage may well have influenced the standard depiction of the Maccabee brothers through a series of nine individual images, arranged in a grid like a tic-tac-toe board, with Eleazar and the eldest two brothers in the top three positions, the next three brothers comprising the middle row, and the youngest two brothers in the bottom row with their mother in the final position, shown, not martyred, but standing by, as Myrtilla Avery described, reminiscent of the Mother of Sorrows. Three of the four depictions of the Maccabees in manuscripts of Symeon Metaphrastes' *Menologion* include both Eleazar and Salomone and the fourth manuscript shows one of them.[65] Note, too, that Ambrose gives separate Christian glosses to the various tortures the Maccabees endured and discusses the brothers as well as their mother.[66]

Thus the grounds for interpreting this unusual scene on the Brescia Casket as the Seven Maccabees are not firm. On the other hand, the absence of Eleazar and their mother, and the lack of a rationale for placing the Maccabees in this position on the casket remain serious problems.

65. Moscow, State Historical Museum, gr. 9 (Vlad. 382), fol. 136; Paris, B.N. gr. 1528, fol. 131v; Alexandria, Greek Patriarchate 35 (303), fol. 99; Berlin, Staatsbibliothek Universitaria *San Salvatore* 27, fol. 188v. For color plates of the first three of these eleventh- or very early twelfth-century manuscripts, see Ševčenko, *Illustrated Manuscripts of the Menologion*, fiches 2B1, 4B9, 5F12. From the Berlin manuscript the miniature was cut out, "but the imprint remains on fol. 189r"; p. 72.

66. Nauroy, "Frères Maccabées dans l'exégèse d'Ambroise de Milan," 235-38.

The Three Hebrews. The interpretation of this distinctive scene as repre-
senting the Three Hebrews in the fiery furnace has been forcefully defended;
even those who disagree with it grant that it "more fully merits our considera-
tion" than the interpretations of the scene as the band of Korah or souls in
Purgatory.[67] Three different manners of identifying the seyen individual figures
as the Three Young Men have been proposed, a fact not previously mentioned
in scholarship. Of these, one has by far the strongest claim.

The first proponent of this view has been little noticed in subsequent scho-
larship on the Brescia Casket, although his perceptions are often clear sighted
and, in some cases, have never been replicated. J. O. Westwood prepared *A De-
scriptive Catalogue of the Fictile Ivories in the South Kensington Museum* (1876)
in which he described a reproduction of the Brescia Casket with great care, giv-
ing the measurements of each face separately and identifying all the images
succinctly. The scene in question he describes thus:

> The three children with outstretched arms, in the manner of the figures of the Or-
> antes in the catacomb frescoes, in the fiery furnace; behind them stand three atten-
> dants and one larger figure, probably intended for the angel.[68]

He accounts both for all seven figures being present in a single scene and also
for the differences in their placement and stance. As will be seen, most of the
others who accept this scene as depicting the Three Hebrews identify the seven
figures somewhat differently.

Georg Stuhlfauth is the next proponent of this scene's being a depiction of
Daniel 3. In 1896, in his book on Early Christian ivory carving, he identified
the scene as "the Three Hebrews in the fiery furnace."[69] His fullest discussion
of the scene dates from 1924:

> The way of understanding the seven figures is, and can only be, the Three Hebrews
> in the Fiery Furnace (as the essential heroes of the event) + three executioners + an
> angel (?) = seven persons. This view is quite clear, understandable and to the point,
> with the wording of the biblical text supporting it. . . . In Dan. 3 we read: "The fur-
> nace was exceedingly hot. Indeed the flames of the fire killed the men who put Sha-
> drac, Meshac and Abdenego into it. Those three men, however, namely Shadrac,
> Meshac and Abdenego, had fallen into the middle of the furnace of burning fire
> bound. Then King Nebuchadnezzar was stupefied, and rose up and hastened, and
> said to his attendants, 'Did we not send three men into the midst of the fire?' They
> answered the king and said, 'Certainly, King.' He responded and said, 'Behold, I see
> four men, unbound, and walking in the midst of the fire, and nothing of corruption
> is in them, and the face of the fourth is like a son of God." Here we have the seven
> men of our carving![70]

67. McGrath, "Maccabees on the Brescia Casket," 258.

68. Westwood, *Fictile Ivories in the South Kensington Museum*, 34-35.

69. "Die drei Hebräer im Feuerofen"; Stuhlfauth, *Altchristliche Elfenbeinplastik*, 41,
57; Stuhlfauth, *Engel in der alchristlichen Kunst*, 82-95.

70. "Die Lösung lautet und kann nur lauten auf die drei Hebräer im Feuerofen (als
die eigentlichen Helden des Geschehnisses) + drei Henker + ein Engel (?) = sieben Perso-
nen. Es ist die durchaus klare, sachlich vollkommen verständliche, mit dem Wortlaut des
biblischen Textes sich deckende Auffassung. Dan. 3. 22 f. 91 f. (Vulgata) lesen wir:

The next voice in support of the Three Hebrews speaks quite modestly—indeed, parenthetically—and refers to the image as a free handling of the event rather than specifying how the seven figures are to be accounted for.[71] In contrast, the most convincing account of each of the seven figures is given by the third proponent of the Three Hebrews. Adolfo Venturi described the scene in 1901:

> The other scene of the three brothers in the furnace relates directly to the resurrection: they stand with their arms in the pose of orantes, and behind them are four similar figures, namely the three brothers and the angel descended from heaven to save them from the fire. These are successive moments in the event, to illustrate the biblical text in the third chapter of the Book of Daniel, where one reads that Nebuchadnezzar saw four men in the middle of the fire.[72]

The other full defense of this interpretation E. Weigand includes in his review of Kollwitz's monograph on the casket in responding to Kollwitz's arguments for the Band of Korah. After refuting those arguments, Weigand makes the case for the Three Hebrews: The three front figures are plainly orant, he observes, and

> the one behind them, who lays his hands on their shoulders, is evidently present as a protector, and is in fact the angel; these four persons comprise the normal-sized portion of the scene, and the other three, quite uninvolved, are attendants and also a pictorial expansion, which has already been mentioned... As for the peculiarity that no oven is depicted—as would be usual in Western depictions—but instead the flames burst forth directly from the ground, this feature presents a full parallel with a somewhat later stone relief in Constantinople in the museum there.[73]

Fornax autem succensa erat nimis. Porro viros illos, qui miserant Sidrach, Misach et Abdenago, interfecit flamma ignis. Viri autem hi tres, id est Sidrach, Misach et Abdenago, ceciderunt in medio camino ignis ardentis, colligati. Tunc Nabuchodonosor rex obstupuit, et surrexit propere, et ait optimatibus suis: Nonne tres viros misimus in medium ignis? Qui respondentes regi dixerunt: Vere, rex. Respondit et ait: Ecce ego video quattuor viros solutos, et ambulantes in medio ignis, et nihil corruptionis in eis est, et species quarti similis filio Dei. *Hier haben wir die sieben Menschen unseres Reliefs*!"; Stuhlfauth, "Zwei Streitfragen," 52. Emphasis his.

71. Kraus, *Christlichen Kunst*, 1:503. McGrath, "Maccabees on the Brescia Casket," 257, faults Kraus's assessment as a "grand disclaimer," but omits, rather misleadingly, Kraus's parenthetical comment.

72. "L'altra scena de' tre fratelli nella fornace è relativa pure alla risurrezione: essi stanno con le braccia stese a mo' di oranti; e dietro loro, quattro figure simili, cioè i tre fratelli e l'angelo sceso del cielo a salvarli delle fiamme. È un momento successivo del fatto, ad illustrazione del testo biblico, del terzo capitolo del libro di Daniele, dove si legge che Nabuccodonosor vide quattro uomini in mezzo al fuoco"; Venturi, *Storia dell'arte italiana*, 1:461.

73. ". . . der eine hinter ihnen, der zweien die Hände auf die Schulter legt, tritt als Schützer auf, ist also der Engel; diese vier Personen sind regelmässiger Bestandteil der Szene, die anderen mehr unbeteiligten sind drei Diener, also eine scenische Erweiterung, die den bereits erwähnten zuzurechnen ist. Für die Eigentümlichkeit, dass kein Ofen dargestellt ist, wie gewöhnlich bei den westlichen Denkmälern, sondern die Flammen unmittelbar aus dem Boden schlagen, bietet ein etwas späteres Steinrelief aus Kpel im dortigen

The last voices in support of seeing this scene as the Three Hebrews are those of André Grabar, W. Lowrie, Henri Stern, and Ida Gianfranceschi, and each leaves the number of figures unexplained. In the caption of his plate of the right side of the Brescia Casket, Grabar simply identifies the scene as "the Israelites in the Furnace."[74]

Lowrie recognizes the Three Hebrews and designates the others as "four persons standing behind them."[75] With almost equal brevity, Stern, in a review of Delbrueck's monograph, doubts his interpretation of the scene as the band of Korah, and then adds, "It is, however, the most current presentation of the three youths in the furnace."[76] Gianfranco's new catalogue from Brescia simply identifies the representation as showing the three Hebrews in the furnace.[77]

In sum, everyone who accepts this scene as depicting the Three Hebrews interprets the front three figures, who are orant, as the Three Hebrews at the point when their bonds have been miraculously released (vv. 20-21, 23-24, 91-92) and they are walking in the midst of the fire, praising God. Also, every scholar who identifies the individual figures in this scene construes the figure who is behind the two orant figures and at the left as the angel. The three figures in the right background, whose arms are not visible, are variously described as attendants, torturers, or as the Three Hebrews themselves, depicted in an earlier moment from the account when they were still bound.[78] In the latter view, the scene represents the trio twice, both bound and orant.

The latter interpretation is the most convincing on two counts. As for the first interpretation, the attendants are an unlikely group to include. If the trio in the background are meant to be the nobles who attend Nebuchadnezzar (v. 91) then a reason must be given to explain why the designer of the casket would have depicted the nobles *rather* than the king. The king, after all, is prominent in the narrative and his conversion on account of the miracle is frequently discussed by exegetes.[79] Most depictions of this scene, and probably all of the early ones, lack the king and his courtiers. In late medieval manuscripts the king (always crowned) is found with attendants in the twelfth-century *Hortus Deliciarum* by Herradis of Hohenberg, the twelfth-century Bible of Stephen Harding, a thirteenth-century Moralized Bible, and the fourteenth-century

Museum eine volle Parallele"; Weigand, review of Kollwitz, 431. The parallel Weigand cited is catalogued by Mendel, *Catalogue des sculptures—Musées impériaux ottomans* 2:468-70, Nr. 671.

74. Grabar, *Christian Iconography*, pl. 336.

75. Lowrie, *Art in the Early Church*, 182.

76. "C'est pourtant la forme la plus courante de l'image des trois adolescents dans la fournaise"; Stern, review of Delbrueck, 117. He cites no analogous images.

77. *Area di Santa Giulia* (1996) 70.

78. Attendants: Westwood, *Fictile Ivories in the South Kensington Museum*, and Weigand, review of Kollwitz, *Lipsanothek von Brescia*—"Diener"; torturers: Stuhlfauth, "Zwei Streitfragen" (*Henker*); Three Hebrews: Venturi, *Storia dell'arte italiana*.

79. See below, p. 167, for examples of exegesis discussing Nebuchadnezzar's conversion in Daniel 3.

Miscellany of Vélislaus (Fig. 17).[80] No image includes the attendants in lieu of the king. Thus it is unlikely that the Brescia Casket would depict the courtiers.

As for the view that the trio in the background are torturers, this too is problematic. First, the torturers suggested by Stuhlfauth had already been slain by the *flamma ignis* (vv. 22, 48) prior to the time that the angel entered the furnace (v. 49). When torturers are depicted in this scene, they are not there as witnesses; they are building up the fire and being killed by it. The two twelfth-century manuscripts mentioned in the previous paragraph show flames attacking the executioners, while the fourteenth-century Miscellany shows two men with forks twice, first stoking the fire, then falling, one with his fork broken. A Greek Psalter shows the prone, flame-encircled bodies of dead executioners beside the furnace.[81] But on the casket the background figures are not depicted in the act of feeding the fire; indeed, they appear to be inside the furnace. Nor are they shown in the moment of their destruction. Why then would they have been depicted at all? Thus it seems that the background trio cannot be courtiers or executioners, and identifying them as the Three Hebrews remains the best solution.

A second reason argues for the double depiction of the Three Hebrews. The pillars at the edge of the scene seem to indicate the walls of the furnace; this is an unusual way of depicting the fiery furnace, to be sure, but an effective one. Logically, then, one expects all seven figures in the image to be persons who were within the furnace, not outside it. Only the Three Hebrews and the angel meet this requirement. It appears that the designer of the Brescia Casket depicted Shadrach, Meshach and Abednego twice and the angel once. The miraculously unbound and protected trio whose arms, freed from their bonds, are gracefully orant, span the front of the scene, literally to foreground the miracle. The protective angel like unto the son of man is behind the two orants on the left of the scene, while the earlier moment of the account when the three Hebrews had just been cast into the furnace and were still bound (though we do not see their arms, which are covered by the orants in front of them), is depicted in the background of the right side of the image. Thus the casket offers a distinctive, highly satisfactory image of the Three Hebrews.

McGrath, however, argues that no other monument from the third through the tenth centuries depicts more than four figures in an image of the Three Hebrews.[82] This is an odd criticism, since it is equally true that no other monument from the third through the tenth centuries depicts the seven Maccabees standing together in fire. If the lack of a visual parallel within this time frame were proof against an identification for this scene on the Brescia Casket, then both the Three Hebrews and the Seven Maccabees would be ruled out.

80. Nebuchadnezzar depicted with attendants: *Hortus Deliciarum* = Strasbourg, Bibl. de la Ville, fol. 65v. (destroyed during the bombardment of Strasbourg in 1870, but reproduced in Green et al., *Hortus deliciarum*); Bible of Stephen Harding fol. 64r (ICA); Moralized Bible = Paris, B.N. lat. 11560, fol. 205v (ICA).

81. De Wald, *Illustrations in the Septuagint*, vol. 3, part 1, pl. LXX, fig. 2, with description on p. 48.

82. McGrath, "Maccabees on the Brescia Casket," 258.

Now, for the first time, a partial visual parallel to the scene of the Three He-brews on the Brescia Casket can be offered. Even so, it should be noted that the identification originally proposed by Venturi and closely approximated by the other scholars mentioned above still stands more on logical grounds than on the basis of this newly discovered visual parallel. It is no more exactly paral-lel to the casket's image than is the eleventh-century illustration adduced by McGrath; indeed, his has the advantage of being separated from the date of manufacture of the casket by only seven centuries, while the following example is a millennium beyond it. In a fourteenth-century manuscript of a Miscellany of Vélislaus (Prague, Nat. Lib., XXIII.C.124, fol. 96r), we see a "Nimbed an-gel, hands raised, above Hebrews Three, hands bound, falling forward, and Hebrews Three, hands raised, all in fire. . ."[83] (Fig. 17). Thus, here and on the Brescia Casket we have exactly the same cast of characters–the three bound, the angel, the three orant–and all of them are inside the furnace.

It is essential at this point to assess the reasonableness of interpreting the unusual scene on the casket as a depiction of two scenes simultaneously, or, more precisely, a single depiction conflating two moments from a single narra-tion. This is vital because some scholars found this unreasonable and therefore rejected the identification of this scene as the Three Hebrews. Ironically, this objection has not been raised against the two other identifications which re-quire simultaneous action. As shown above, Delbrueck suggested that the scene showed Korah and his band as if two sequential actions of the account had occurred in one instant: "the men simultaneously sink and burn."[84] Nota-bly, no scholar has objected to his interpretation on the grounds that such a conflation is out of character for Early Christian art or for the casket. Equally, scholarship has been silent on this issue as it regards the interpretation of this scene as a depiction of the seven Maccabees.[85] Patently, showing seven broth-ers who died one by one, with one dead before the next is brought forward and his ordeal begun, as if they all died simultaneously, requires conflating seven actions from a single narrative. To show the reasonableness of simultaneity, then, is essential support for three interpretations of the enigmatic scene.[86]

83. The mid-fourteenth-century Miscellany constitutes "the most comprehensive Gothic picture book preserved in Central Europe. It is an incomplete picture bible con-taining scenes from the Old Testament, to which are added a cycle of pictures about An-tichrist, fragments of a Passion cycle and of Acts, a cycle of the Apocalypse and illustrations of St. Wenceslas [!] legend." Of ca. 800 pictures, 747 survive; Stejskal, *Veli-slai Biblia picta*, 1.

84. "die Männer gleichzeitig versinken und verbrennen"; Delbrueck, *Probleme der Lipsanothek*, 15-17.

85. The depiction of the seven Maccabees in the fire together in manuscript Vatopedi 107, fol. 48r, has, however, been correctly characterized as "a conflation"; Galavaris, *Il-lustrations of Liturgical Homilies*, 111.

86. The scene can be interpreted as the Three Hebrews without requiring simultane-ity, if one accepts Westwood's and Weigand's interpretation of the seven figures as the three Hebrews, the angel, and three attendants. This interpretation is overall less persua-

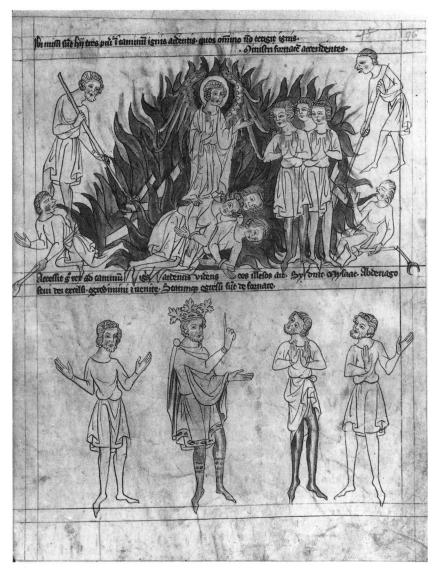

FIGURE 17. Three Hebrews depicted twice with Angel in one scene.

And indeed, simultaneous action can be shown to be possible on three grounds: as a known artistic convention in general, as known to have been

sive, however, than that which construes the seven figures as the saintly trio shown twice—before the angel's arrival, and afterwards, with the angel.

used specifically in depictions of the three scenes in question, and, significantly, as a technique manifestly used elsewhere upon the Brescia Casket itself. Furthermore, details of the use of this technique on the casket are in accord with what we see in this unusual scene.

That such *Gleichzeitigkeit* is possible is well established. Kurt Weitzmann discusses simultaneous depictions in his provocative work on *Illustrations in Roll and Codex*.[87] In Early Christian art, numerous instances of simultaneous depiction exist. For instance, the representation of the crucifixion and resurrection in one image, the Chi Rho on the cross with, at its base, the soldiers who fell asleep at the tomb. Émile Mâle has described "representing two different moments in a story" in one image as a "medieval custom"; he gives the example of the thirteenth-century Charlemagne window at Chartres cathedral. In the highest circular scene, Roland exhibits two actions at once, he "strikes the rock with his sword, he sounds his horn."[88]

This technique of simultaneous depiction was not only available to Early Christian artists, but was actually used in depictions (albeit medieval, not Early Christian ones) of the very scenes in question. For the band of Korah, a manuscript illustration shows Moses speaking with the band, which stands on the mountainside, and, on a slope further to their right, the band again, falling into the ground. That is, Moses and the mountain are shown once in this image and the band is depicted twice. In each case, the band is looking toward Moses. Such artistic economy is common. With regard to the seven Maccabees, McGrath has called attention to an eleventh-century depiction of all seven in a single fire. This illustration shows not only their mother as witness, but also Eleazar, who was martyred before any of the brothers. As for the Three Hebrews, it has now been shown that a fourteenth-century manuscript illustration shows exactly the simultaneity claimed for the scene on the casket: the Three Hebrews before *and* after, with the angel, in a single depiction of the furnace.

Weighty as such visual analogues are, the best evidence is that the Brescia Casket itself shows simultaneous action elsewhere: in the death of the Man of God, the raising of Jairus's daughter, and the judgment of Ananias and Sapphira. In the center of the New Testament register on the back of the casket, Peter faces Sapphira; to their right Ananias is being carried out. In Acts 5:1-7, he is dead and wound in burial clothes, but on the casket he seems to gesture with his full arm and, though his eyes are closed, his face is oriented toward Sapphira. In the account in Acts about three hours elapse after his burial before Sapphira arrives, but on the casket his death and her judgment are simultaneous. In Acts, Peter tells her that he hears the return of the men who buried her husband and he prophesies that they will carry her out also. One could therefore argue that the most effective way for the artist to depict such men recognizably was to depict them in an action related to the way Peter identifies them. That is, the image on the casket shows Ananias's surprise and death, but

87. Weitzmann, *Roll and Codex*, 13-14; see also his analysis of monoscenic and cyclic illustration, pp. 14-33. Although his focus is text illustration, he treats other media.

88. Mâle, *Gothic Image*, 351, fig. 164.

also the fact that the young men carried him out. The burial clothes were omitted to give the scene immediacy.

Note, too, that this scene not only shows actions simultaneously, but places the earlier scene to the right, not the left. The prior actions, Ananias's death and the carrying out of his body, are depicted in the right of the register. The same technique is evident in the scenes on the left end of the casket. The death of the Man of God is central in the top register, with Jeroboam to the right; the raising of Jairus's daughter is central in the middle register, with the mourners to the right. These scenes offer important technical parallels to the depiction of the Three Hebrews on the Brescia Casket. For in that depiction, too, the Before moment, with the Three Hebrews bound, is depicted in the right background within the furnace, while the After moment, the three orant with the angel, fills the left side of the furnace and spans its entire width at the front.

For the reasons cited, then, the enigmatic scene on the Brescia Casket can be identified as the Three Hebrews. The discovery of a modest visual parallel lends some interesting, definitely secondary support to this thesis. In Chapter Three, it has already been argued that this scene is appropriate to the casket as a whole by virtue of the scene's role as type of the Resurrection. Before turning in the next chapter to further arguments for the identification of this scene as the Three Hebrews, it is worthwhile here to explore a possibility never before suggested, but made a fit topic for examination because it is rooted in the pertinent biblical texts and in the works of Augustine and therefore could have been known to the designer of the casket.

THE POSSIBILITY OF A DUAL MEANING:

AUGUSTINE ON THE MACCABEES AND THE THREE HEBREWS

One other possibility warrants consideration, even though it finally proves unlikely: could the scene be meant to depict *both* the Three Hebrews *and* the Seven Maccabees? That is, could the scene on the casket be rather like the modern picture that is both two faces in profile and also an urn? In the case of the scene on the casket, it would be the intellectual perception of the meaning, not the differing visual perceptions of the image, which would account for its dual image. If the artist intended to create such a dual image, that would help explain why the scene seems to some to depict the Three Hebrews and to others to depict the seven Maccabees. The inspiration for such a twofold meaning for the scene could lie in the linking of the two groups in 4 Macc. 13-18 and in Early Christian discussions comparing them.[89] Notably St. Augustine compares the two sets of Old Testament heroes in no less than eighteen works, including sermons, commentaries and letters. Four of these texts cite the seven

89. See, e.g., Hippolytus of Rome, *Commentaria in Danielem* 2.35.

brothers and the *tres pueri* briefly, pointing to similarities.[90] Fourteen works, however, treat the differences between the experiences of the Maccabees and that of the Three Hebrews. It should be noted, though, that only three of these works are from the late 390s, while the rest are from 403-25; that is, few if any of Augustine's discussions of the comparison were written in time to have had any influence on the design of the Brescia Casket. Thus the present consideration is highly suppositional.[91]

As in the scriptural comparisons of the two groups in the Fourth Book of Maccabees, so too Augustine–unlike Ambrose–consistently simplifies the torments of the seven brothers into *ignes*. This makes a joint image of the two groups possible. The difference between their experiences, with Ananias, Azarias and Misahel miraculously saved, but all seven Maccabee brothers dying by torture, prompts the bishop to explain why God would have saved one group but not the other. Pastoral concern evidently underlies the question: Augustine sees that failure to explain this could tempt a Christian who calls to God for help to doubt either his own worthiness to be helped or God's care, if the call seems to go unanswered.

In Augustine's fourteen expositions of why the trio survived but the seven perished, he develops the theme of benefit. In every one of these texts he reasons that, although only the former were delivered physically, both groups had the benefit of spiritual deliverance, the three openly–e.g., *visibiliter, aperte, in manifesto*–and the seven secretly–e.g., *non visibiliter, occulte, in occulto*.[92] Indeed, *Sermo 286* contains his argument that the seven Maccabees were more fortunate, for they at once received the crown of martyrdom whereas the Three Hebrews remained in the dangers of the world.[93] Thus he satisfies his pastoral concern: even though some died, the prayers of all were answered.

90. This research has greatly benefited from use of the Augustine Concordance Project of the University of Warburg, also located at Villanova University. Information on access to the database can be obtained by writing to Fr. Allan Fitgerald, O.S.A., Villanova University, Department of Religious Studies, Villanova, PA 19085 U.S.A. The four texts treating similarities exclusively are *Contra Faustum* 19.14 (CSEL 25.1:511-12), written by 398 (Brown, *Augustine* 184); *Contra litteras Petiliani* 92.202 (CSEL 52:123.5-10), written by 405 (Brown, *Augustine* 184); *In Ps.* 78.8 (CCL 39:1104), written 414-16 (Dekker and Fraipont, p. xvii); *Sermo 350*, "De charitate, II" (PL 39:1533-35) emphasizes the common action of charity within the two groups, although their experiences were different: "In tribus pueris blandos ignos innocenter exspectat: in Machabaeis saevos ignes fortiter tolerat" (par. 3 in col. 1534).

91. Tkacz, "Seven Maccabees, the Three Hebrews, and St. Augustine." Augustine's fourteen works contrasting the Three Hebrews and the Seven Maccabees: second enarratio on Ps. 33:22; third enarratio on Ps. 36:9; second enarratio on Ps. 68.3; second enarratio on Ps. 90:11; the enarratio on Ps. 137:14; the enarratio on Ps. 148.11; *sermo 32.15*; *sermo 286.6*; *sermo 301.2*; *sermo 343.2*; *sermo* Mayence 50; epistle 111.5 (to Victorianus); *In evangelium Ioannis* 11.14; and *In Ioannis epistulam ad parthos*, tractatus 8. For dates, see pp. 66-67.

92. Tkacz, "The Seven Maccabees, the Three Hebrews, and St. Augustine," 66-71.

93. *Sermo 286*, caput 7 (PL 38:1300).

Important for the present study is Augustine's frequently expanding the discussion of benefit to focus on Nebuchadnezzar and Antiochus.[94] Augustine explains that secret, spiritual deliverance of tortured saints is for their own sake, but that visible, physical deliverance occurs either to "punish or free" their persecutors.[95] For instance, *Sermo 301*, "In solemnitate SS. Machabaeorum, III," puts forward the argument that "Nebuchadnezzar deserved to be converted" by the miracle, but "Antiochus deserved to be hardened."[96]

In sum, it would in any case have been an amazing innovation for an artist to attempt to depict two historical events in a single representation, with the same seven figures representing the seven brothers and, at the same time, the Three Hebrews both before the angel's arrival and afterwards. The fact that comparing the two sets of heroes was a minor theme with St. Augustine might have invited a depiction comparing them, and his simplifying the brothers' series of tortures into fire would have made such a dual image possible. Nonetheless, the effectiveness of a depiction comparing the two groups would presumably lie in its clarity. This would require a separate depiction of each group. Further, the different roles and responses of the persecutors is so important to comparing and contrasting the two events that it is unlikely that an artist would omit them. Finally, as with any other interpretation of the enigmatic scene on the casket, one wants a rationale for its inclusion, not just on the casket, but in that precise location. For a dual depiction, such a rationale is utterly lacking.

The Enigma Half Solved: The Three Hebrews

Of the four interpretations offered previously in scholarship, that of the Three Hebrews has been shown to be the most convincing. As yet, however, the enigma of this unusual scene has been only half solved. What of the visual fact of the unity of the register as a whole? In addition to justifying the presence of the Three Hebrews on the casket generally, it can now be shown that they, and the fire they stand in, belong in the center of that particular register, and that the parallelism between that register and the central New Testament register on the front is meaningful. That is, the holy trio fit both the design of the register in which they occur and also the visual and intellectual parallelism between that register and the central front register as well. This is the substance of the next chapter.

94. In seven of the thirteen texts Augustine discusses the persecutors, generally in the enarratio on Ps. 137:14 and naming one or both of Nebuchadnezzar and Antiochus in the second enarratio on Ps. 68.3; *In evangelium Ioannis* 11.14; *sermo* 286.6; *sermo* 301.2; *sermo* 343.2; and epistle 111.5 (to Victorianus).

95. "Est quaedam [liberatio] publica et manifesta: haec propter inimicos eorum fit, sive puniendos, sive liberandos"; *Enarratio in Psalmum 68, sermo 2*, section 3 (CCL 39:918-19).

96. "Nabuchodonosor meruit converti, Antiochus meruit obdurari"; *Sermo 301*, "In solemnitate SS. Machabaeorum, II," caput 3 (PL 38:1380-81).

CHAPTER SIX

GLORIA, INTELLIGENT FIRE
AND THEOPHANY ON THE BRESCIA CASKET

The previous chapter established that the Three Hebrews constitute the best identification of the enigmatic scene in the center of the upper Old Testament register on the right side of the Brescia Casket (Fig. 5). Earlier, the third chapter of this book clarified the appropriateness of the Three Hebrews for the casket's innovative program of types. That is, the Three Hebrews provides, in the fourth figure that Nebuchadnezzar saw in the furnace, a type of Christ in his resurrection. But, as is so often true of this Early Christian artwork, the meaning is richer yet.

The visual and intellectual unity which several scholars have recognized in the top right register[1] can now be explained, and the explanation reveals the Three Hebrews to be central both to the design and meaning of the register. On the Brescia Casket, the *gloria*-fire which burned in the bush when God called Moses and which flared on Mount Sinai when God gave Moses the Law are

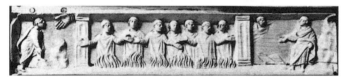

identified with the fire in the Babylonian furnace, for that fire was the environment for the miraculous presence of the angel who scattered the fire and who is frequently depicted as Christ himself. My thesis is that the artist of the Brescia Casket deliberately omitted fire from his renderings of the Burning Bush and of Moses Receiving the Law and instead depicted the Fiery Furnace. Thus the scene from the third chapter of Daniel is not a random or irrelevant image intruding between two depictions from the Book of Exodus; it is a means of focusing on the revelation of God *in medio ignis* in all three events depicted in the register.

1. For instance, the perception of unity is implicit in the description given in the eighteenth-century document and the interpretation offered by Dalton; for the document, see Kollwitz, *Lipsanothek von Brescia*, 8; Dalton, *East Christian Art*, 208. Kollwitz (pp. 26-27) and Delbrueck explicitly saw the unity of the register; Delbrueck, *Probleme der Lipsanothek*, 15-17.

Further, the reason for the parallel between this *gloria*-register and the center front register of the casket can be suggested: the designer of the casket depicted on its front three aspects of Christ revealed through the New Testament, and, on the side, in a register parallel in structure, depicted three

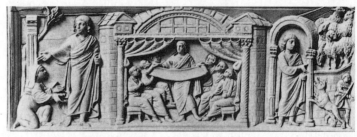

revelations granted through fiery epiphanies recorded in the Old Testament. Central among the Old Testament epiphanies is the revelation in the fire of the furnace of Christ's coming to deliver mankind; that is, the central revelation is also a type of Christ, and thus most fitting to be emphasized by central position on this artwork which celebrates Christ's passion through types.

Demonstrating the aptness of the Three Hebrews in the context of the register in which it occurs begins with the two Moses scenes which abut the furnace, a consideration of the traits of their characteristic depictions, and a close examination of the biblical accounts of all three events portrayed in the register. Such examination shows the prominence of fire, specifically revelation through fire, in each narration. Next the broader biblical context of the fiery phenomena of fire from heaven and *gloria* will be set forth to clarify the nature of the fire in the top right register. Early Christian evidence in the form of patristic analysis of "intelligent fire" assists here, largely to clarify an option the designer of the casket chooses not to develop because he is more interested in the *gloria* of the event. The end result of this analysis will be to set forth in further detail the intellectual and artistic sophistication of the casket as a whole.

THE TRIO OF SCENES IN THE UPPER RIGHT REGISTER

The three scenes that fill the upper register on the right end of the casket are 1) Moses before the Burning Bush, 2) the Three Young Men in the Fiery Furnace, and 3) Moses Receiving the Law. The two Moses scenes are the "two best-known scenes" associated with Sinai and Moses.[2] As we will see, however, these two scenes as depicted on the casket are, in a key detail, distinctively different from the familiar representations of them.

The Call of Moses: The Burning Bush. The biblical account of Moses and the Burning Bush is found in chapter 3 of Exodus. While tending the flocks of his father-in-law, Moses came "to the mountain of God" (*ad montem Dei*) and the Lord appeared to him in a flame of fire (*in flamma ignis*) from the

2. Weitzmann, "Crusader Icons on Mount Sinai," 192.

midst of a bush (*de medio rubi*). He saw that the bush burned, yet was not con-sumed (*arderet et non conbureretur*). He went to see this great sight, why the bush was not consumed. God called to him by name from the midst of the bush (*de medio rubi*) and told him to remove his sandals because he stood on holy ground; then God revealed to Moses, "I am the God of your father, the God of Abraham, the God of Isaac, the God of Jacob" (Exod. 3:1-6).

In the Early Christian period the depiction of Moses before the Burning Bush acquires a clear and enduring pattern. For instance, in the mosaic panel of the Call of Moses at St. Catherine's on Mount Sinai, ca. 550-65, we see Moses with his left foot on a rock in order to loosen his sandal more conveni-ently; his head is bowed; the enflamed bush is on the right side of the depic-tion, and the mountain is on the far right. Moses's right foot is already bare and his right sandal is on the ground between his feet. He is garbed in a long robe. The mosaic has an additional detail, one not in every depiction of the event: in the upper right corner, the Hand of God is depicted, to represent the presence of God.[3] Indeed, Moses is gazing intently at the Hand of God, not at the bush.[4] Byzantine and other Eastern representations of the Burning Bush frequently include the Hand of God. Examples of this in manuscript illumina-tion include the manuscript of 880-886 of the Homilies of Gregory of Nazian-zos, a tenth- or eleventh-century manuscript of Cosmas Indicopleustes, an eleventh-century manuscript in Prague, and a late-eleventh-century Gospel Book in Cracow.[5] The Sinai icon of Moses before the Burning Bush shows the well-established depiction of this scene, though without the Hand of God.[6]

Other depictions of the scene show some of the details, especially the fire, but are often less organized. A fresco in the fourth-century catacomb of Domi-tilla, in Rome, depicts Moses, his left foot on a rock, about to remove his san-dal; his head is turned over his right shoulder. It has been suggested that this pose derives from classical statues of Jason removing a sandal.[7] In a mosaic pa-nel at Santa Maria Maggiore (ca. 432-40) Moses is clad as a Greek shepherd and stands nonchalantly amid his flock with two other shepherds in the scene. No mountain is in sight, and in lieu of a bush are several trees, each with some fiery red among the foliage. This rudimentary depiction fails to convey the re-

3. For a plate, see Loerke, "Representation of *Doxa* in Mosaics," fig. 2. See also the fresco of the scene at the Synagogue of Dura Europos (244/45-256); Weitzmann and Kessler, *Frescoes of the Dura Synagogue*, 15 (for date), 34-35, pl. 41 (black and white) with pls. 1 and 3 showing context of entire Torah wall.

4. Weitzmann considers this "an archetypal feature"; Weitzmann and Kessler, *Fres-coes of the Dura Synagogue*, 37. The common characteristics of depictions of this scene have long been recognized; Leclercq, "Moise," *DACL* 11.2:1654-55, also citing San Vi-tale in Ravenna (fig. 8252) and the cemetery of Domitilla (fig. 8253).

5. The Homilies of Gregory of Nazianzos: Paris, Bibliothèque Nationale gr. 510, fol. 264v; Cosmas Indicopleustes manuscript: Mt. Sinai, Mon. Lib. 1186, fol. 103; and Cra-cow Gospel Book: Mus. Czartorisli, 1207, fol. 11v. All in ICA.

6. Weitzmann, "Crusader Icons on Mount Sinai," pl. 18.

7. Leclercq, "Moise," *DACL* 11.2:1655-56 and figs. 8253-54.

verence of the scene as well as its narrative details.[8] The later mosaic of this scene at San Vitale in Ravenna (540-48) uses the Jason-pose and the scattered fire; here Moses gazes up at the Hand of God in the sky behind him, and the mountain is in the background. Flames and greenery are dispersed throughout the scene.[9]

Clearly the scene on the Brescia Casket fits within the tradition of organized depiction shown on the Sinai icon. The ivory image has Moses with his right foot on a rock, loosing his sandal, and the other foot already bare, with its sandal between his feet. The Hand of God is in the upper right. The signal difference, however, is that this depiction of the Burning Bush has no bush and no burning. The shrub with flames is not in evidence at all. In all other details, though, this is a classic depiction in the pattern later to be seen in the Sinai icon. Even many representations out of this norm include the fire. Yet the Brescia Casket lacks it. What has happened to the fire?

Moses Receiving the Law: The Fire on the Mountain. Significantly, we must ask the same question about the other Moses scene on this panel of the Brescia Casket. That scene, the one on the right side of the panel, is now universally interpreted as Moses Receiving the Law. Notably, fire has the same role in the biblical account of this event that it did in the prior one. Once again Moses is at Mount Sinai. The Lord commanded him to come up and receive the Law. He ascended, and clouds (*nubes*) covered the mountain, and the glory of the Lord (*gloria Domini*) dwelt upon Sinai, covering it with a cloud (*nube*) for six days. On the seventh, God called Moses from the midst of the vapor (*de medio caliginis*). The sight of the glory of the Lord (*species gloriae Domini*) was like burning fire (*quasi ignis ardens*) upon the peak of the mountain in the sight of the sons of Israel. And Moses entered the midst of the cloud (*medium nebulae*) and remained there forty days and forty nights (Exod. 24:12-13, 15-18). God then spoke to Moses and gave him the tablets of the Law.

8. Leclercq, "Moise," *DACL* 11.2:1652 and fig. 8250; Grabar (1968), pl. 133; and Loerke, "Representation of *Doxa* in Mosaics," 16-17 and fig. 1 on p. 16.

9. Christine Smith, *Ravenna*, 79 for color plate, 72 for date. Other Western images are also unlike the casket's. In the West Moses is often shown actually seated on the rock, removing his sandals, and the presence of God is indicated by a face in, or a half-figure rising from, the bush. The Ingeborg Psalter (Chantilly, Musée Condé, 1695, fol. 12v) shows a Christ-Logos, cross-nimbed, with a roll or book, addressing Moses from the bush (ICA). See also the twelfth-century Bible of Souvigny (Moulina, Mus. Municipal, fol. 22v = ICA), the Prayer Book of St. Hildegard (Munich, Staatsbibliothek Clm 935, fol. 9v), and the ivory book cover of Munich, Staatsbibliothek Clm 12201b; Verkerk, "Exodus and Easter Vigil in the Ashburnham Pentateuch," 66.

In both accounts, the Burning Bush and the gift of the Law, God manifests himself in supernatural fire and speaks from the midst (*de medio*) of the wonder. Twice in the second account this fiery manifestation of God is termed the *gloria Domini.*

In art, the Reception of the Law is variously depicted, with the constants being Moses, the tablets or books of the Law, Mount Sinai, the face of God in a cloud, and, notably, the fire which figures so vividly in the scriptural account.[10] In the Ashburnham Pentateuch, for instance, the peak of Mount Sinai breaks the top of the frame of the illumination, as do huge flames, which flare into the top margin.[11] Consider, too, the illumination of this scene in the Moutier-Grandval Bible, made at Tours, perhaps in the mid-ninth century: Moses stands on the "blazing Mt. Sinai," receiving the law from the Hand of God, extended from the arc of heaven; half-figures of two nimbed angels are within the arc also.[12]

When paired with another scene, the depiction of Moses is often arranged to parallel its partner. Sometimes Moses receiving the Law is paired with the New Testament scene of Christ giving the New Law to the disciples. In such paired depictions fire and mountain are absent and Christ himself hands the Law to Moses; this is the case in two complementary mosaics in the lateral apses of the mausoleum of Santa Costanza in Rome.[13] Numerous sarcophagi pair a simplified scene of Moses receiving the Law from the hand of God with a visually analogous scene of Abraham, his knife upraised, forestalled by the hand of God from sacrificing Isaac. Moses and Abraham each has an arm and his gaze raised toward the hand of God. Moses is without fire or mountain; Abraham is without the ram in the thicket. These symmetrical scenes frame the center portrait of the deceased on, e.g., the sarcophagus of Adelfia (ca. 340) and the marble sarcophagus of the Two Brothers (mid-fourth century).[14]

10. Beckwith, *Early Christian and Byzantine Art*, 29. In fourth-century imperial art the hand of God can "displace fully embodied dieties"; Annemarie Weyl Carr and Anthony Cutler, "Hand of God," *ODB* (1991) 2:901. The only depictions of the giving of the Law which lack fire as a symbol of God's presence appear to be those which depict, not just the face of God, but his entire majestic person, as in the niche mosaic in Rome, Santa Costanza, cited above.

11. Ashburnham Pentateuch: Paris, Bibliothèque Nationale, nouv. acq. lat. 2334, fol. 76; Weitzmann, *Late Antique and Early Christian Book Illumination*, pl. 47. The height of the flames is fitting, as Moses described them as reaching "all the way to heaven" (*usque ad caelum*); Deut. 4:11-12. The manuscript is probably Italian, late sixth or seventh century, based on a fourth-century Roman model; Beckwith, *Early Christian and Byzantine Art*, 144-49.

12. Moutier-Grandval Bible: London, British Library, Add. 10546, fol. 25v (ICA). St. Clair dates its production to ca. 834-40; "Typological Iconography in the Moutier-Grandval Bible," 19, n. 1 on p. 25. The quotation is from the ICA's description of the scene. See also Oust et al., *Bibel von Moutier-Grandval.*

13. These mosaics "appear to be seventh-century restoration of fifth-century work"; Beckwith, *Early Christian and Byzantine Art*, 27-28 with pls. 12-13 on p. 29. See also Grabar, *Early Christian Art*, 188 and pl. 207 (color).

14. The former, probably carved at Rome, is now in Syracuse, Museo Archeologico Nazionale; the Two Brothers sarcophagus, carved at Rome, is still there in the Museo

The Hand of God, holding the tablet or book of the Law, figures in several Eastern depictions also. Manuscripts using this image include the Rabula Gospels of 586, an eleventh-century Octateuch at Constantinople, and a New Testament-Psalter combination from ca. 1265.[15] This trait is seen sometimes in the West as well, as in the Bible of Charles the Bald, made in the first half of the ninth century. Here the frontispiece of the Book of Exodus shows "Moses, nimbed, standing on the flaming mount, receiving the Tables of the Law from the Hand of God issuing from the arc of heaven."[16]

On the Brescia Casket, the artist has given us four out of five of these familiar elements: Moses, the Law, Mount Sinai, and the face of God in a cloud. The absence of fire and the orientation of the scene are noteworthy for understanding its role in the program of the casket.

In the following description bear in mind that the orientation is described rather in terms of stage directions. That is, from the point of view of someone examining the casket, "Moses's right" is actually to the left of the scene. Because the scene of Moses Receiving the Law is to the right side of the panel, "Moses's right" is actually in the direction of the center of the panel.

Moses stands upright, his right arm extended to gesture toward the book of the Law, which lies open on the ground to his right. At his right and in the upper corner of the scene is the face of God in a cloud, and Moses is gazing at this face. Mount Sinai is in the background.[17] By depicting the Law lying on the ground, not being handed from heaven to Moses, the artist has deemphasized it, making the focus of the scene the mutual gaze of God and Moses. For reasons to be discussed below, the artist placed the face of God adjacent to the center scene of this register.

Here again is a Moses scene which is characteristically depicted with fire as a key element, but no fire. Moreover, the artist has adapted the Early Christian

Lateranense. For other examples, see Chapter One. Beckwith, *Early Christian and Byzantine Art*, figs. 27 and 29; Grabar, *Early Christian Art*, 243 (Two Brothers); on general use of the pair of scenes on sarcophagi, see Leclercq, "Moise," *DACL* 11.2:1685-86.

15. Rabula Gospels: Florence, Laurenziana, Plut. I.56, fol. 3v (ICA); Octateuch at Constantinople: Seraglio, 8, fol. 252 (ICA); and New Testament-Psalter: University of Chicago Library, Greg. 1400, fol. 6v (ICA).

16. The Bible of Charles the Bald: Paris, Bibliothèque Nationale, lat. 1, fol. 27v (ICA). The quotation is from the ICA's description of the scene. Plate: St. Clair, "Typological Iconography in the Moutier-Grandval Bible," fig. 8.

17. Surpisingly, Mount Sinai is behind Moses and to his left. That is, Sinai is *opposite* the face of God, not under it. Presumably the artist considered it essential to include both the face of God and the mountain, and as he was working in a small space and a monochrome medium (ivory) he separated the two.

practice of pairing Moses with Abraham or Christ and innovatively paired two Moses scenes, arranging them so that each representation of Moses faces the center of the panel.[18] The traditional depiction of Moses and the Burning Bush always has Moses facing the viewer's right, just as we have on the casket. Depictions of Moses Receiving the Law, however, vary in their orientation of the patriarch. This arrangement of scenes on the casket, with each carving of Moses facing the furnace, is deliberate, and is integrally related to the lack of fire in each Moses scene.

The artist could omit fire from each Moses scene precisely because the same sort of fire was depicted in the scene placed between the Moses carvings, the scene which each figure of Moses is facing, the scene which is contiguous with the two images of God in the Moses scenes, i.e. the Hand of God and the Face of God in the cloud. That central scene is the miracle of the Three Hebrews in the Fiery Furnace, and the fire in the furnace is the unique conjunction of two fiery biblical phenomena, "intelligent fire" and *gloria*. That is, the fire in the furnace manifests both the power and the presence of God. Notably, the artist of the Brescia Casket chose to emphasize the fire as *gloria*.

The Three Hebrews: The Fire in the Furnace. The account of the Three Hebrews is lengthy; chapter three of the Book of Daniel runs a full one hundred verses in the Septuagint and Vulgate. (The Hebrew is shorter.[19]) Reviewing this narration shows the extraordinary role fire has in it. In some ways, the fire in the furnace partakes of the fire we have seen in Exodus, for a revelation comes again *de medio ignis*. In other ways, the fire behaves like a fiery phenomenon to be discussed below, fire from heaven.

In all versions of the biblical account—Hebrew, Greek, Latin—the fire of the furnace is stressed. Four times the threat of being sent "into the furnace of burning fire" (*in furnacem ignis ardentis*) is made (vv. 6, 11, 15, 20; see also 21 and 93). Unmoved, the three youths defied the king, refusing to worship his statue and declaring, in words that become part of the *Commendatio animae*: Our God whom we worship is able to rescue us "from the furnace of burning fire and to deliver us out of your hands, King" (*de camino ignis ardentis et de manibus tuis rex liberare*, Dan. 3:17; compare Chapter Four, Table Two, petition f).

Enraged, Nebuchadnezzar ordered the furnace to be heated seven times hotter than usual (v. 19) and had the trio bound and cast into the flames. The furnace was excessively overheated (*succensa nimis*); indeed the flame of fire (*flamma ignis*) killed the soldiers who sent Shadrach, Meshach and Abednego into it. But the holy three, who fell bound into the midst of the furnace of burning fire (*in medio camini ignis ardentis*), walked in the midst of the flame (*in medio flammae*), praising God and blessing the Lord. Shadrach stood praying in the midst of the fire (*in medio ignis*), saying, "Blessed is the Lord, the God of

18. The two scenes are also paired some centuries later in frescoes in a church in Cyprus; Stylianou and Stylianou, *Painted Churches of Cyprus*, 102.

19. The Hebrew lacks the extended section of praises sung in the furnace (vv. 24-90); to the Hebrew names of Shadrach, Meshach and Abednego, the Greek and Latin scriptures add their Persian names of Ananias, Azarias and Misahel.

our fathers, and worthy of praise; glorious is his name" (*gloriosum*) forever (v. 22). He praised God at length, declaring that he is glorious (*gloriosus*, v. 45) and calling on all creation to praise and exalt the Lord.

Meanwhile the king's men ceaselessly stoked the furnace so that the flame poured forth above it forty-nine cubits (v. 47); the flame burst out and inciner- ated those whom it found near the furnace. An angel, however, descended into the furnace with Shadrach and his companions and shoved the flame of the fire out of the furnace (*excussit flammam ignis de fornace*) and made the midst of the furnace (*medium fornacis*) like a dewy breeze. The fire (*ignis*) did not touch them in the least or grieve them or cause any harm. The three, as with one voice, praised and glorified God in the furnace. In their inspired praise, they called upon fire and heat (*ignis et aestus*) to bless the Lord forever. They also call upon themselves to praise God, because he "delivered us from the midst of the burning flame, and from the midst of the fire he took us up" (*liberavit de medio ardentis flammae et de medio ignis eruit nos*).

The king was astounded (*obstupuit*); though he had sent three men, bound, into the midst of the fire (*in medio ignis*), now he saw four, loosed and strolling in the midst of the fire (*in medio ignis*), quite unharmed, and the fourth, he said, is like the son of God. He called forth the Three Hebrews, who emerged from the midst of the fire (*de medio ignis*). Everyone present witnessed that the fire had had no trace of power (*nihil potestatis habuisset ignis*) over their bodies: not a hair of their heads was singed, nor had their garments been affected, and no odor of fire lingered upon them. Then the king burst forth, blessing God "who sent his angel and saved his servants" (Dan. 3:22-26, 45-52, 66, 88-95).

Obviously the fire depicted in the scene of the Three Young Men in the Fiery Furnace is no ordinary fire. As the fire did not destroy the Burning Bush and was not destructive upon Mount Sinai, so it does not destroy the Three Young Men in the furnace. As God was present in the fire in the bush and called Moses, and as God was again present in the flames on Mount Sinai when he gave Moses the Law, so God was present in the fire in the furnace, inspiring the young men to sing his praises. And, as Moses recognized the miraculous fire in the bush as a sign of God's power and presence, and as the Israelites re- cognized the fire on Sinai as the same sign, so Nebuchadnezzar was converted by the miracle of the fiery furnace.[20] The fiery *gloria* of God, known from Si- nai, was thus present in the Chaldean furnace. In addition, God transformed the persecutor's fire so that it behaved intelligently, burning only selectively. In the scriptural account, in fact, the fire in the furnace behaves like fire from hea- ven *and* like *gloria*. The designer of the casket, however, has chosen not to por- tray those details which recall fire from heaven and instead to concentrate on those details which identify the fire as *gloria*. Substantiating this assertion re- quires a thorough look at the biblical context of both fire from heaven and *gloria* and the patristic analysis of "intelligent fire."

20. The ensuing incidents of the Golden Calf (Exod. 32) and of Nebuchadnezzar's madness (Dan. 4) do not undercut the efficacy of the miracles; they rather demonstrate human weakness.

FIRE FROM HEAVEN, *GLORIA*, AND INTELLIGENT FIRE

Within the Bible are established the distinct patterns of "fire from heaven," which burns selectively, and the *gloria* of God himself. These two fires manifest the power and presence of God, respectively. The patristic discussion of "intelligent fire" illuminates the Early Christian understanding of fire from heaven and, in doing so, often draws on the account of the third chapter of Daniel.

Biblical evidence. Fire from heaven, in both the Old Testament and the Apocalypse, is a sign of God's sovereignty.[21] It can also punish obdurate sin, which is, after all, an arrogant flouting of God's sovereignty. Finally, because this supernatural fire demonstrates God's power, beholding it can instill or strengthen faith. All of these functions are clear in the narrative of 3 Kings 18, a dramatic instance of fire from heaven preferring a righteous sacrifice. This narrates the contest between Elijah and 450 of the prophets of Baal. The latter throng, even after imploring their god with loud cries and cutting themselves with knives to attract his attention (v. 28), cannot induce Baal to light their offerings, but solitary Elijah, in contrast, after thrice soaking his in water, serenely invokes God's aid, and the Lord responds by sending fire from heaven to consume wood, sacrifice, and all. Significantly, the assembled people who witness this recognize it as proof of God's sovereignty (v. 39). This sign of fire (*ignem*) from heaven coming to earth is recalled in the book of Sirach (48:1-3) whose author describes Elijah, filled with the Spirit of God, as being himself like fire (*quasi ignis*). Like Elijah's sacrifice, Solomon's burnt offerings are consumed by heavenly fire when he dedicates the temple (2 Chron. 7:1).

The fire "which distinguishes between the good and the bad" can also kill selectively; this is seen in the fiery hail sent upon the Egyptians, for it spares the Hebrew people.[22] On account of the adamant wickedness of their inhabitants, Sodom and Gomorrah were destroyed by the Lord by fire from heaven (*ignem a Domino de caelo*), such that the ashes of the two cities rose like the smoke of a furnace (*quasi fornacis fumum*, Gen. 19:24, 28). Fire from God slays false or iniquitous Hebrew priests—Nadub and Abihu, sons of Aaron who used unholy fire in the temple (Lev. 10:1-3),[23] and, as discussed in the previous chapter, Korah and Dathan and their rebels (Num. 16). Just so, fire from heaven destroys the armies of Gog and Magog (Apoc. 20:9).[24]

Distinct from what one might call "servant fire" is the "glory of the Lord," described in several Old Testament accounts. This *gloria* (Greek: δόξα, He-

21. Tkacz, "Tormentor Tormented," 126-29.

22. James, *Lost Apocrypha of the Old Testament*, 90. See Exod. 9:22-24, Ps. 103(104):132, and Ps. 17(18):8-14.

23. The "strange fire" offered by Nadab and Abihu is fire not derived from the consecrated flame on the altar; Laughlin, "Strange Fire."

24. In hagiographic legends and *acta*, fire frequently shows the selective behavior seen in the biblical texts. For a valuable summary of this evidence, with a list of seventeen saints' Lives in which the fiery furnace of Babylon was replicated by the persecutors of Christians, with equal unsuccess, see Loomis, *White Magic*, 30-35, 151-53.

brew: *kabod*) is the glorious, intelligible presence of God.[25] Like fire from hea-
ven, such fiery manifestations behave contrary to nature, but they express
more than God's power: they manifest the very presence of God. The glory of
the Lord demonstrates his sovereign presence, and characteristically confirms
the faith of witnesses. Significantly, it accompanies revelations: God reveals
himself from the midst of the *gloria*-fire. The account of the burning bush and
of God's revelation of his nature to Moses is the first instance within the
chronology of the Old Testament of God's epiphany in fire. Such manifesta-
tions recur during the journey to the promised land. God led Israel out of
Egypt, showing the way by means of a pillar of cloud (*columna nubis*) by day
and a pillar of fire (*columna ignis*) by night (Exod. 13:21-22). Having led his
people to Mount Sinai, God told Moses he would demonstrate his presence to
them from the darkness of a cloud in order to confirm their faith (Exod. 19:9);
then the whole mountain smoked and God descended upon it in fire (*in igne*)
while smoke arose as if from a furnace (*quasi de fornace*) and the entire moun-
tain was terrible (Exod. 19:18). Again, when God subsequently made the reve-
lation of the Law to Moses upon Sinai, "the sight of the glory of the Lord was
as ardent fire" (*species gloriae Domini quasi ignis ardens*) on the crown of the
mountain in the sight of the sons of Israel (Exod. 24:17).[26] Later (Deut. 4:11-
12) Moses reminds the people of these events in order to strengthen their faith;
he describes the mountain which "burned up to heaven" (*ardebat usque ad cae-
lum*) when God spoke to them from the midst of the fire (*de medio ignis*), and
again exhorts them to be mindful that they are the first people to hear the voice
of God speaking from the midst of the fire (*de medio ignis*) and to survive
(Deut. 4:33).

God appeared in fire to Ezekiel also. The prophet saw a great cloud and fire
turning about it and splendor in its circuit (*nubes magna et ignis involvens et
splendor in circuitu eius*), and from the midst of the fire (*de medio ignis*) came

25. Such fire "was the particular means or mode by which God revealed himself to
men. Abraham's covenant sacrifice (Gen 15), the revelation from the burning bush
(Exod 3,1-6) and the subsequent Sinai theophanies, the sacrifice of Gideon (Jud 6,19-24),
of Manoah (Jud 13,15-20), of Elijah on Mount Carmel (1 Kgs 18,30-40), and numerous
other incidents come immediately to mind"; Daly, *Christian Sacrifice*, 62. In Hebrew,
"*kabod* denotes the revealed being or character of Yahveh, and also a physical phenom-
enon whereby Yahveh's presence is made known"; it and related Hebrew terms meaning
majesty, beauty, excellence, etc., were all translated in the Septuagint by the Greek *doxa*
so that "the doctrine of the divine glory is presented with a greater unity and impressive-
ness"; Ramsey, *Glory and Transfiguration*, 10, 23-24. For *gloria* in Early Christian art,
see Loerke, "Representation of *Doxa* in Mosaics," 20; and Klaus Wessel, "Gloriole," in
RBK 2.

26. Richard J. Clifford, S.J., considers Exod. 19 and 24 to draw upon "the Canaanite
religious tradition of theophany in a storm, on a mountain"; *Cosmic Mountain in Ca-
naan and the Old Testament*, 113, see also 111, 122-23. He also notes that the mountain
on which Moses received the Law "is called Sinai in the Yahwist (J) and Priestly (P)
strands [of text] and Horeb in the Elohist (E) and Deuteronomic (D) traditions"; 107-08.
See also Booij, "Mountain and Theophany in the Sinai Narrative," and Dozeman, *God
on the Mountain*, esp. 101-02.

his vision (v. 4) of the four living creatures, described in terms of fire (v. 13), and of God enthroned, with the appearance of fire (*aspectum ignis*) and a vision of splendid fire round about (*quasi speciem ignis splendentis in circuitu*); like the rainbow in a cloud on a rainy day, so was the sight of the encircling splendor (vv. 27-28).

The New Testament also records fiery manifestations of God; usually, as accords well with the shift from Old Testament to New, these are resplendent rather than flaming epiphanies. For instance, when the angel appears to the shepherds to reveal the nativity of Christ, the "brightness of God shown around them" (*claritas Dei circumfulsit illos*) and the wonder was so great it frightened them (Luke 2:9). The Transfiguration of Christ recalls more directly and in more detail the Old Testament accounts describing the *gloria* of God. Significantly, the two major witnesses to that *gloria* and to fire from heaven, Moses and Elijah, appear with Christ during his Transfiguration. The three gospel accounts—Matt. 17:1-9, Mark 9:2-9, Luke 9:28-36—all place the event on a high mountain (*montem excelsum*), describe Jesus and his garments as becoming radiant and dazzling as sun and snow (e.g., *resplenduit facies eius sicut sol*, Matt. 17:2, and *refulgens*, Luke 9:29), and record that a cloud shot with light (e.g., *nubes lucida*, Matt. 9:5) overshadowed them and that the voice of God spoke to them from the cloud (*ex nube*), proclaiming Jesus his beloved son. Famously, the descent of the Holy Spirit on Pentecost was visible as tongues of fire (*linguae ignis*, Acts 2:3).[27]

In sum, fiery epiphanies of God are distinct from fire from heaven. Biblical fire from heaven serves the Lord by justly lighting the offerings of the righteous and destroying obstinent sinners. Quite different is the fiery revelation of God's presence *de medio ignis*—in the bush, in the pillar of fire, and on Mount Sinai.

The fire in the furnace in Babylon, recounted in the Book of Daniel, is the dramatic—and unique—bringing together of the fire that serves God and the fire that manifests Him. Like the lions that menaced Daniel in the pit, the fire in the furnace was intended by man to cause death. Despite its earthly source, however, by divine intervention it behaves like fire from heaven, showing its "intelligence" when it spares the three young men, but shoots out the sides of the furnace to consume the torturers who are adding more fuel. Indeed, the text ascribes intentionality to the fire by stating that the flame "killed" (*interfecit*) the torturers whom it "discovered" (*repperit*) near the furnace (Dan. 3:22, 48). Thus, the flame in the furnace behaves like fire from heaven; yet it is more. More than a bush is spared from burning here; three youths, singing and praising God, are protected by that fourth figure who enters the fire in this powerful fore-flaming of the incarnation, death, and resurrection of Christ. This fire has two natures—kindled by men, but filled with the *gloria* of God. And, as in all the focal visitations of the *gloria Domini* to man, a revelation is made from the midst of the fire, *de medio ignis*, in the shining aspect of the fourth figure with

27. Goulder, *Type and History in Acts*, 147-49 discusses typological links among these events.

the miraculously unharmed trio. No wonder that beholding this miracle converted King Nebuchadnezzar, who is convinced by it of God's sovereignty.

Patristic evidence. So far can analysis of the biblical accounts themselves
take us. Crucial to this discussion is evidence of how the early Church responded to these scriptures. Significantly, this response came early and was
sustained.[28] Quite early, fire from heaven is described as "intelligent"; thus
does Clement of Alexandria characterize the fire of Gen. 19:24-25, 28, which
destroys Sodom and Gomorrah.[29] Clement of Alexandria and Origen, Jacques
Le Goff has shown, interpret the fire of Lev. 10:1-2, which consumed the disobedient sons of Aaron, and the destroying fire of God, described in Deut.
32:22, as the work of a beneficent God who punishes man for his own good.[30]
Clement of Alexandria extrapolated from the dual functions of fire from heaven—to teach witnesses and to punish wrongdoers—when he contemplated the
afterlife. He conceived of two types of fire in the afterlife: the intelligent fire
(πῦρ φρόνιμον) which sanctifies those whose sins were minor, and the devouring
fire which punishes the incorrigible.[31]

Of interest for the present discussion, the fire in the Babylonian furnace is
also considered "intelligent." St. Jerome (347-419/20), commenting on Dan.
3:92, apostrophizes the flame in the furnace as "intelligent fire" and as the
"power of God": "Oh, fire how intelligent, power of God how unswerving:
the bodies were constrained with bonds, the bonds were burned, the bodies
were not burned."[32] Augustine imputes intelligence to the fire in the furnace
when he writes that it "knew" the youths and so did not burn them: "The fire
recognized as servants of God the three men, whom it did not burn, whose garments it did not foul."[33] Paulinus of Nola (353?-431) refers to the miracle in

28. The glory of God is also discussed by Early Christian theologians including Pseudo-Dionysios; Sheldon-Williams, "Philosophy of Icons," 506-17, esp. 507. Eva C. Topping analyzes the fire imagery of Romanos the Melode, finding it an expression of
divinity; she also notes similar discussions by, e.g., Symeon the New Theologian, Macarius of Egypt, and Seraphim of Sarov; "Byzantine Song for Simeon."

29. Clement of Alexandria. Hippolytus of Rome construes the fire of Sodom differently: he takes it and the fire of Dan. 3 to relate to divine justice in the way that the
waters of the Red Sea do. Each, he suggests, obeys God. Thus the sea allowed the Hebrews to pass safely, but judged and drowned the Egyptians. And the fire in the furnace
saw and feared the Angel, whom it recognized as its master; *Commentarium in Danielem*
2.32 (SC 14:124).

30. Clement's *Commentary on Leviticus*, the eighth homily; and Origen, *In Exodum*,
homily 6 (PG 12:334-35), and *In Leviticum*, homily 9 (PG 12:519); Le Goff, *Naissance
du Purgatoire*, 82.

31. Clement of Alexandria, *Stromata* 7.6, end (GCS 52:27); Le Goff, *Naissance du
Purgatoire*, 82-83.

32. "O quam sapiens ignis, quam inerrabilis Dei potentia: uinculis stricta sunt corpora, uruntur uincula, corpora non uruntur"; Jerome, *Commentaria in Danielem libri III*
1.3.92b (CCL 75A:807.719-21).

33. "Agnovit ignis servos dei tres viros, quos non ussit, quorum nec vestimenta corrupit"; Augustine, *In I Epistolam Ioannis tractatus* 8.7 (SC 75:352).

the furnace also, in a letter; he relates the experience of the faithful Christians who resist the fires of the world to the Three Hebrews, finding them alike in being refreshed by dew despite the flames surging around them.[34] In *Carmen* 6 he also treats the flame (*flamma*) as intelligent, obeying (*servire*) the holy boys while burning (*ardere*) the torturers.[35]

Liturgical texts also call attention to the intelligence of the fire in the furnace. In the Eastern church, a kanon for the forefeast of the Nativity of Christ recalls, "In Babylon of old by the command of God, the fiery furnace worked in contrary ways: burning the Chaldeans, it refreshed the faithful with dew as they sang"[36] In the West, the following antiphon for the Benedicite at Lauds identifies the fourth figure in the fire as Christ and presents the fire as intelligently fearing him: "A light was amid the flame, greater than the flame that was burning; for, when the king of Babylon had wanted to destroy the three boys, he saw with them as it were a fourth, in whom it is proper to believe: it was the Savior, whom the flame feared."[37]

Much of the patristic commentary on intelligent fire is in descriptions of purgation. Drawing on Origen, Paulinus of Nola writes to a certain brother Severus of that "intelligent fire" (*ignis sapiens*) which will test us with a soothing touch:

> And that intelligent fire coursing through us, worthy of punishment, will pursue its examination, not with a severe burning, but receiving us as commended, will with a soothing touch play about, so that we can say: We have gone through fire and water, and you have clad us in refreshment.[38]

Again, in *Carmen* 7, he speaks of that same judging, testing fire (*ignis arbiter*): "The testing fire runs through everything; what the flame does not cremate,

34. Paulinus of Nola, *Epistula* 44, par. 6 (CSEL 29). He refers to the dewy breeze again in *Carmen* 26.269-75, and to preservation inside the "Chaldean furnace" (*Chaldaei camini*); *Carmen* 27.610-12 (CSEL 30:289).

35. Paulinus of Nola, *Carmen* 26.263-65, see also 266-68 (CSEL 30:255-56).

36. Steiner, "Antiphons for the Benedicite at Lauds," 2. The same text is repeated for the Synaxis of John the Baptist, p. 400.

37. "Lux erat in flammis, major quam flamma urebat; nam, cum tres pueros Babylonis voluisset perdere rex, vidit junctum quasi quartum, in quem credere dignum est: Salvator erat, quem flamma timebat"; Steiner, "Antiphons for the Benedicite at Lauds," 16, no. 15. This antiphon is recorded in the troper from St. Martial, Limoges, copied before 1031 (Paris, B.N. lat. 1121, fols. 230-231v, also Paris, B.N. lat. 909, fols. 258-259) and in an eleventh-century monastic antiphonal from Aquitaine and two twelfth-century ones from Lucca and St. Denis; ibid., p. 3.

38. ". . . et ignis ille sapiens transeuntes nos per examen suum non seuero ardore ambiet puniendos, sed ut commendatos suscipiens blando lambet adtactu, ut possimus dicere: transiuimus per ignem et aquam, et induxisti nos in refrigerium"; Paulinus of Nola, *Epistula* 28: "Sancto fratri et unanimo conmilitoni Seuero Paulinus," par. 2 (CSEL 29:243.26-244.3). Le Goff traces this idea to Origen; *Naissance du Purgatoire*, 91 and n. 3.

but proves, that will be accounted for eternal reward."³⁹ In *Carmen* 17 he asks
that St. Nicetas aid souls at judgment (*die in illa*) and temper the fire, scattering
it with a dewy touch.⁴⁰

Caesarius of Arles (d. 542) continues the thought of Origen, Clement of
Alexandria, and Paulinus of Nola, even using the latter's words. Importantly,
Caesarius also relates the idea of the gentle purgatorial fire to the fire of the
Babylonian furnace. He in fact elucidates the nature of the afterlife by recalling
the experience of the Three Hebrews. He describes hell, and then the "fiery riv-
er" which will purge away the wrongs of lesser sinners. The just, however, will
experience this fire as "pleasant fountains" (*amoenos gurgites*) and will pass,
their bodies unharmed by the fire. Caesarius draws the analogy between the
Babylonian furnace of the Three Young Men and the fiery river of the next
world, between the "intelligent fire" (*sapiens ignis*) of the furnace and the "se-
lective fire" (*arbiter ignis*) of the fiery river:

> Thus the faith and justice of the three youths did not feel the Babylonian fire, but
> discovered amazing refreshments (*refrigeria*) in the middle of the blazing furnace.
> Before the merits of virtue, the rage of the flames ceased, and in a manner the mira-
> cle overshadowed with dewy conflagrations the condemned who were handed over
> to [the fire]; however, it consumed the ministers of the king's sacrilege who were
> placed a long way off and standing around at a distance. How much do the merits
> of religion and the privilege of holiness hold in the present! O unspeakable horror—
> roaring masses of fire, boiling up forty cubits, rage outwardly, while inwardly they
> spare: outside the furnace the intelligent fire (*sapiens ignis*) is enraged, yet to those
> enclosed within the furnace it is companionable. As much as bestial savagery does
> against the saints, so much does [the fire] rage violently against the impious without
> consideration; and all the reverence owed to chaste bodies the selective fire (*arbiter
> ignis*) recognizes, and it takes the food into itself, poured out with honor it rever-
> ently licks at the bodies consecrated by the fear of God and chaste fasts, allowing it-
> self to do nothing against them. So by secret dispensation it not only does not
> violate the precious deposit, but it vindicates them.⁴¹

39. "[O]pus per omne curret ignis arbiter; quod non cremarit flamma sed probauerit,
illud perenni praemio pensabitur"; Paulinus of Nola, *Carmen* 7.32-34 (CSEL 30:19). See
Le Goff, *Naissance du Purgatoire*, 91ff.

40. "[R]oscido nobis digito furentem discute flammam"; *Carmen* 17.309-15 (CSEL
30:95).

41. "Sic trium puerorum fides atque iustitia babilonicos non sentit ignes, sed stupen-
da refrigeria in medio camini exaestuantis inveniuntur. Cessit virtutum meritis aestus
flammarum, ac traditos sibi reos mirum in modum rorantibus obumbravit incendiis;
longe positos autem et eminus circumstantes sacrilegi regis consumpsit ministros. Quan-
tum etiam in praesenti obtinent merita religionis et privilegia sanctitatis! Ecce horren-
dum nescia quid anhelantes globi et per quinquaginta cubitos ebullientes extrinsecus
saeviunt, intrinsecus parcunt: extra fornacem sapiens ignis irascitur, et inclusis in fornace
famulatur. Quantum agit feritas bestialis in sanctis, impiis sine consideratione desaevit;
et ecce quanta castis corporibus reverentia debeatur arbiter ignis agnoscit, et ingesta sibi
pabula honore circumfusus adlambit, nihilque sibi licere miratur in corpora dei timore et
castis ieiuniis consecrata, et pretiosum depositum non solum ille non violat occulta dis-
pensatione, sed vindicat"; Caesarius of Arles, *Sermo* 167, par. 7 (CCL 104:686-87). He
discusses this *ignes transitorium*, this *purgatorium ignis* of the afterlife in *Sermo* 179 also,

Thus the concept of intelligent fire was not only strongly implicit in the Bible, but also explicitly discussed by Early Christian theologians.

Significantly, exactly the identification depicted on the Brescia Casket is also made in Early Christian texts: poets described the *gloria*-fire associated with Moses in terms of the fiery furnace. Avitus, bishop of Vienne (ca. 490-518),[42] in his biblical epic *De spiritalis historiae gestis* describes the pillar of cloud leading the exodus as filled with light, moist winds: "leni respergere flatu / ... umentes . . . ventos" (5.435-36). As Michael Roberts has noted, this recalls the dewy breeze in the fiery furnace ("ventum roris flantem," Dan. 3:50), an allusion which is appropriate because both the pillar of cloud and the dewy furnace are "capable of a soteriological explanation."[43]

The fiery furnace is again linked with a theophany to Moses, in Prudentius's *Peristephanon*.[44] The sixth hymn honors a trio of Spanish saints who were martyred in fire, so the references to the Three Young Men are just what one would expect. But the allusion to the Burning Bush is striking, however, and the combination of the two is intriguing. The trio of saints are Fructuosus, bishop of Tarraco, and two deacons. As the bishop approaches the fire, he removes his shoes: "he loosened the covering of his feet, just as Moses had done when approaching the divine bush."[45] As soon as Fructuosus is barefoot (91), a spirit from heaven ("caelo spiritus," l. 92) tells him he will journey to heaven through the fire. Like Moses, Fructuosus has received a call from a heavenly voice in the presence of fire. Once the trio are in the fire, it burns the bonds from their arms (103-05) so they can raise them to praise God (106-08), as the Three Young Men had done in the Babylonian fire (109-14). The fire turns aside from the Spanish saints as it did in the furnace, and the fire in Spain has the same moist character as the fire described in Dan. 3, for the martyrs' fire is a *vaporosus ardor* (115). Only when the saints pray for the fire to release them (116-17) do they die (118-20).

Thus, in addition to the Early Christian interest in the concept of intelligent fire, Early Christian poets associated the *gloria*-fire seen by Moses with the fire in the Babylonian furnace. The fire that inhabited the Babylonian furnace was both intelligent fire and the *gloria* of God. With that said, it can now be shown that the designer of the Brescia Casket focused on the latter.

but without referring to the Three Hebrews; CCL 104:723-29; quoted phrases from par. 1 and 5 on pp. 724 and 726.

42. Michael P. McHugh, "Avitus," *EEC* 129.

43. Roberts, "Avitus' Account of the Crossing of the Red Sea," 60. He cites also Rudolfus Peiper, ed., Avitus, *De spiritalis historiae gestis* (MGH Auct. Ant. 6.2), 306, note.

44. For the text, see CCL 126:251-389. I am grateful to Michael Roberts for calling my attention to this passage in a letter of August 22, 1993.

45. "[R]elaxat ipse / indumenta pedum, velut Moyses / quondam fecerat ad rubum propinquans"; ll.85-87, see also 88-90.

DE MEDIO IGNIS: REVELATION AND INCARNATION

The biblical accounts present the fire in the Burning Bush and on Mount Sinai as *gloria* and the fire in the Babylonian furnace as both *gloria* and "intelligent fire." The intelligence of this fire is shown both by its burning off the bonds of the Three Hebrews without harming them in the least, and also by its shooting out the sides of the furnace to slay the torturers. The designer of the casket, however, chose to indicate the first of these selective burnings only, by depicting the Hebrews bound, in the back right of the image, and also prominently unbound and orant across the front of the image. By this means, I would argue, he emphasizes the fire's role as *gloria*. Because it is *gloria*, the artist rightly decided that he could omit the fire from the two Moses scenes that flank the fiery furnace and let the fire in the furnace be the one *gloria* for all three scenes.

Further, he elegantly gives a range of four images for the presence of God in this panel: in the Burning Bush scene, we are shown the Hand of God; in the Fiery Furnace, we are shown both the *gloria*-fire and the figure of the fourth man, like unto the Son of God; and finally in the second Moses scene, we are shown the face of God in the cloud. The hand, the face, the full figure of God are depicted, a three-fold bodily representation, and in addition the *gloria* implicit in all three is given once, centrally, binding the three scenes together. Intellectually and artistically, the three scenes of the panel make a satisfying whole—a *gloria*-register.

The arrangement of these three scenes, then, is brilliantly original, joining for the first time a depiction of the Three Young Men, one of the most popular Early Christian images, with a traditional pair of scenes involving Moses. This grouping has not been discussed before, because the rationale for it has not been recognized before. Quite simply, these scenes belong together by virtue of their shared association with *gloria*.[46]

The top right register and the central one on the front are similar in several key respects, both structurally and in meaning. They are the only two registers on the casket which use an architectural structure as both the setting for a scene and also as a division of the register. Moreover, the front is the only face of the box depicting Christ three times in one register, and the *gloria*-register is the only one with three different symbols of God. Again, the central front scene has seven figures, one being Christ, and the depiction of the Three Hebrews, central in its register, has seven figures, one (the angel) representing

46. The analysis of this panel lends support to Stuhlfauth's hypothesis that three-foldness predominates in the design of the casket.

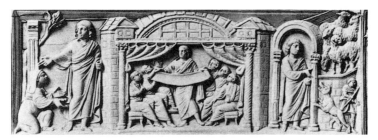

Christ.[47] Further, each of these two scenes is in a demarcated setting with the temple attractively indicated on the front and, in the vertically compressed scene of the furnace, the walls of the oven represented effectively by pillars. No other scene on the casket has an architectural setting so clearly defined as its frame.[48]

These distinctive structural similarities are apt, for each of these two registers depicts three aspects of God, in the revelations through fire recorded in the Old Testament and in Christ's ministry recorded in the New Testament. The link between the two is in the typology of the theophany in the fiery furnace, which foreshadows Christ's saving of mankind. The *gloria*-register recalls three revelations: on the left, the nature of God is revealed to Moses from the midst of the Burning Bush; on the right, the Law of God is revealed to Moses on the fiery mountain; but in the center of the register is a greater revelation: in the fourth figure in the furnace, who by his heavenly presence delivers the Three Hebrews from death, is seen a type of Christ. In the midst of the fire, *in medio ignis*, stands a prefiguration of God's coming incarnation. The parallelism of this register with the center front one is fitting, for the top right register recalls the revelations of God *in medio ignis* and the central front register recalls the generosity of God in coming incarnate into the midst of his people, not as terrifying fire, but as healer, teacher, and guardian.

47. For bibliography on the seven figures in the first Jonah scene, see Chapter One, n. 33.

48. Other scenes on the casket could readily have been set in a building. The scene of the Judgment of Ananias and Sapphira on the back, for instance, is implicitly within the single room or dwelling of Acts 5:1-11, indicated there by a solitary reference to a door (*ad ostium*, v. 9) and by verbs of motion into and out of someplace: *efferentes* (v. 6), *introiit* (v. 7), *intrantes* (v. 10), and *extulerunt* (v. 10).

CONCLUSION

Far from being a haphazard collection of biblical scenes, the decoration of the Brescia Casket is a well-thought program, richly expressive of Early Christian belief, and the imaginative product of North Italy in the later fourth century. Because so much in the artistry of the casket is innovative for its time, modern eyes have not readily seen how to read it coherently. Every surface presents the viewer with scenes not depicted before in art, or not depicted in quite the way seen on the Brescia Casket. As a result, wonderment at the individual trees has delayed the discovery that this is no mere forest but a well-planned, bearing orchard.

To see this, one must study the casket in the round, and in the context of the fourth century. A basic point to be made here is that it is necessary to compare presumably biblical images to the scriptures they are supposed to depict. It matters which details an artist has selected to portray. Only by reviewing the various scriptures which support an image of the Good Shepherd does it become clear that the Good Shepherd on the casket is not simply different from other Early Christian depictions; it uniquely portrays John 10. Reading the accounts of Susanna and Jonah—read on Maundy Thursday—reveals that they both use the words Pilate spoke when he washed his hands, as related in the gospel read on Good Friday. It is not enough to recognize a depiction as "a standard image" of Jonah, especially since that stock depiction may (at least in some works) mean more than is standardly assumed. Again, only reading the scriptural narratives shows that the Moses panel on the back treats a span of narrative without interruption, and that all Exodus events depicted on the casket were recalled by Stephen in his speech before he was stoned (Acts 7). It is too easy to take the scriptural background for granted, without checking the scriptural details; better to examine them and discover whether they are pertinent.

Once one knows the material being depicted and studies the casket in the round, then the narrative connections and other patterns appear. Only when the narrative of the hemorrhissa and Jairus's daughter is seen to extend around the front to the side of the casket is it possible to see the parallel with the story of Lazarus, with its reference to the healed blind man: each resurrection miracle is related in the gospels in connection with the healing depicted near it on the casket. The eye travels again from the front to the side, this time from the Good Shepherd with his flock on the right side of the front, around the corner to the right side, to the flock tended by Rachel, type of the church, and Jacob, type of the Good Shepherd. Looking from front to right end again, one sees

the parallel between whole registers, center front and upper right, each with its arch spanning the panel, each depicting three manifestations of God.

The casket also opposes contrasts. On the right half of the box are the Good Shepherd with his flock and his type in Jacob; reminders of the Church and of heaven. On the left half, Judas hangs, Ananias is dead, Goliath is about to die, Jeroboam and the disobedient prophet are punished, and though the Israelites are shown dancing and feasting before the Golden Calf, we know the sequel. The unique division of the New Testament register on the back by a center gap between Peter, seated in judgment, and Sapphira with her bag of money, dramatizes the decisiveness of moral choice for final judgment. The scales and grave stele depicted on the righthand posts on the right side also comprise a reminder of judgment. Thus the casket points beyond time to the result of human choices in the separation of the sheep, who will go to Christ's right, from the goats, who must go to the left.

The casket has other opposites as well. Jacob encountering God at Bethel on the right side contrasts with Jeroboam rejecting God at Bethel on the left. One Ananias, orant, rejoices in the furnace; the other, arms outflung, dies in sin. The hanging fish, a symbol of Christ in his lifegiving sacrifice, adorns the lefthand post of the front (here there is nothing "sinister" about the left side). In stark contrast, Judas hangs himself on the righthand post on the back (here there is nothing hopeful about the right side). In the larger pattern of the casket, the left half and especially the left surface bear the concentration of negative types, but even there they are subordinate to the raising of Jairus's daughter, with David as a type of Christ in the top register and the affirmative symbols of the cross and lamp in the edge panels. On the back, though Judas is on the righthand side of the surface, he is juxtaposed to the left end. On the front, though the symbol of Christ is in the lefthand side of the surface, it is part of the powerful positive imagery informing the program and is not contaminated by closeness to the left end.

Of all the patterns on the casket, the most unexpected to a modern audience are the typological ones. To see these, it is necessary to recapture something of the fourth-century point of view. The theory of typology, and particular types, notably the recovery of Susanna as a type of Christ; everyday religious life as expressed in the popular petitions of the *Commendatio animae* and the various monuments depicting them; the concepts of *gloria* and intelligent fire–these are part of the language of ideas of the late fourth century. It is in this language that the Brescia Casket is inscribed. When that language is forgotten, we see only nonsense syllables, not articulate and balanced statements. The Passion was always intelligible, so the lid was understandable as a narrative, but most of the casket's program has been incomprehensible to the audience of recent centuries.

Once the typological patterns are seen, they can be appreciated as a coherent and sophisticated use of types. The casket honors and celebrates the events of salvation history through its five-scene passion sequence on the lid and its five-scene typological completion and recapitulation on the front; through Old Testament types on every vertical face, as well as a matched pair of New Testament types, the resurrection miracles on the two ends. Moreover, the casket

gives the Christian observer clear examples of what to imitate and what to avoid, and this too is accomplished through both Old and New Testament types: it is good to pattern oneself after a type of Christ, to be like Susanna, Daniel, the Three Young Men trusting God. It is disastrous to be like Jeroboam, Ananias and Sapphira, rejecting him. Peter failed, denying Christ, but since he repented he is also an encouraging example. He is shown again, after his repentance, as the head of the Church, judging Ananias and Sapphira. In contrast, the betrayer Judas, unrepentant, hangs himself.

Because typology is basic to the casket, its designer wisely pointed to it by prominently centering visual puns on the front. The key of the cross of Christ unlocks the meaning of the Old Testament types, and the lock and key of the casket recall this. The *velatio* of the Old Testament is drawn aside as Christ opens wide the meaning of the Old Testament through the *revelatio* of the New, and the artist has expressed this by his distinctive depiction of Christ preaching in the synagogue.

With the coherence of the typological program recognized, what that implies about the Bible appears. Essentially, the program of the Brescia Casket constitutes the fourth-century argument of Ambrose, Augustine and others for the unity of the Bible. The casket, over and over again, demonstrates the unity of the two Testaments in ways that also emphasize the superiority of the New. The New Testament supercedes the Old: thus the cover, which caps the casket, is devoted to the New Testament account of the Passion narrative. The New Testament is central: this is a visual fact on every vertical face, for the largest, middle register is devoted to scenes from the New Testament. Moreover, on each surface of the casket, more area is devoted to depicting New Testament events; the very proportions of the registers accomplish this. All these design elements enhance the typological argument for the unity of the Bible, rather as rhetoric enhances logic.

Through the typological argument of the casket, it shows the Old Testament as preparation for the New, and the New as fulfilment of the Old. In that center front scene, the Old Testament is present and honored in the unfurled scroll, but it is Christ, fulfilling the Old Testament, who is focal. It is reasonable, given the importance of typology on the casket, to recall what Luke records about Christ's teaching after the resurrection, on the road to Emmaus: "And beginning at Moses and all the prophets, he expounded to them in all the scriptures, the things that were concerning him. . . . And they said one to the other: Was not our heart burning within us, whilst he spoke in the way, and opened to us the scriptures?" (Luke 24:27, 32).

Through just such typological interpretation is the program of the casket opened and the ivorywork shown to assert the unity of the Bible. The work as a whole speaks of salvation history and demonstrates models for imitating in one's own life. It also attests that the fourth century had an audience that could understand the rich program of the casket. It is probable that other works of Early Christian art remain as incompletely understood as the Brescia Casket has been. It would be well to fit the key of typology to other locks, test to see if it passes the wards and the bits engage, and if they do, open and see what is revealed.

APPENDIX:

The Iconography of the Sarcophagus of Junius Bassus

Elizabeth Struthers Malbon's analysis of *The Iconography of the Sarcophagus of Junius Bassus* recognizes the importance of typology in Early Christian art and argues ambitiously for a coherent program on the famous sarcophagus of 359.[1] Her work features a concise entree to typology (42-44), a sound discussion of Early Christian use of pagan materials (138-46), careful relation of her thesis to the work of others, and frequent reference to other contemporary depictions. She has insights into the general role of placement on the sarcophagus, with the lid and ends subordinate to the facade (147). Especially fine is her interpretation of the central region of the sarcophagus, including entablature and the facade's two registers and spandrels (123-24). Earlier commentators saw connections between the vineyards on the ends of the sarcophagus and the vines around the columns enclosing the central scenes of the facade; Malbon recognizes the full eucharistic symbolism in these vines, in the grain harvest on the right end and in the multiplication of the loaves in a central spandrel (133). Her reading of the monument entails seeing connections that round a corner, linking the far right of the registers and spandrel scene of the facade with the right end (129).[2]

But when it comes to typology her argument falters for lack of evidence. Some details certainly are accurate. The symmetrical correlation between the outermost spandrel scenes is real: the miracle of the Three Hebrews in the fiery furnace was assuredly construed in the fourth century as a type of Christ's resurrection, and Jesus's raising of Lazarus is clearly a prefiguration of both Christ's own resurrection and the resurrection for which each Christian hopes (see above in Chapter Three). This is indeed a pair of multivalent fourth-century types, symmetrically deployed in the small spandrels. Malbon also agrees with Stommel's understanding that Isaac on the sarcophagus is a type of Christ.[3] But the overall interpretive pattern is forced. For instance, regarding both upper and lower registers and the spandrel scenes, it is urged that the out-

1. See also Curran, review of Malbon, and Murray, review of Malbon. Though Murray errs in limiting Early Christian typology to Old Testament-New Testament pairs she correctly sees weaknesses in Malbon's argument.

2. Cf. Curran, review of Malbon, 306.

3. Stommel, *Ikonographie der Sarkophagplastik*, 66ff, esp. 71. See Chapter Three above and its n. 9 for discussion.

er scenes show sacrifice, the adjacent ones obedience, and the central ones victory (53, 68, 89). But it is not convincing that the arrests of Peter and of Christ prompt one to think of obedience and that in contrast the arrest of Paul would bring sacrifice to mind. And although on contemporary sarcophagi the event of Pilate washing his hands is often the depiction which is closest in chronology to the actual crucifixion of Christ, it does not follow that the image of Pilate would at once bring sacrifice to mind.

More seriously, several of Malbon's focal arguments for typology on the sarcophagus are not borne out by Early Christian evidence. Often the texts cited about a specific biblical personage have little or no relation to the event depicted. The sole passage cited on Daniel as a type of Christ, for instance, refers to Dan. 10:16, not to his ordeal in the lions' den (59-60). More seriously, the strong link that she asserts to exist between Isaac and Pilate is not supported by any textual evidence at all, although she terms this "a typological link . . . commonly given verbal expression in the Early Christian period" (47). The actual Early Christian typological interpretations of the Old Testament event are 1) Abraham as a type of God the Father, willing to sacrifice his son; 2) Isaac as the faithful soul delivered from death by God; and 3) Isaac as a type of Christ carrying the wood to his own sacrifice. The scene on the sarcophagus best fits the second, although it can be taken as the first, as Saxl construes it,[4] or, as Stommel, the third. In order to link Pilate with Isaac as a type of Christ, however, Malbon reads Pilate on the sarcophagus as a direct reference to Christ's sacrifice. In this she follows Schiller, whose reading of the sarcophagus is often astute, but who also cites no Early Christian texts supporting this interpretation of Pilate. The monuments Malbon cites as comparably depicting Pilate differ significantly from the Bassus sarcophagus in that they all include a symbolic conflation of crucifixion, burial, and resurrection, typically a chi rho or cross with crown and beneath it sleeping guards. This symbolic conflation clearly points to the crucifixion, and it is this symbolic scene, not Pilate, which constitutes the reference to the crucifixion and resurrection on those artworks. That is, Pilate is not shorthand for the crucifixion or the resurrection or both, and he is absolutely not a type of them. For this reason, it does not work to treat Pilate on the sarcophagus as if he is of himself a full allusion to Jesus's death and resurrection (47), and thus the proposed typological link between Isaac and Pilate dissolves. An equally strong link is asserted to exist between Job and Paul (54-55), but since this is supported only by general biblical references and a letter of Athanasius citing each as a model of suffering (57-58), it remains unconvincing that the Early Christian viewer of the sarcophagus would see the two as a pair of types of Christ's sacrifice.

Equally slim is the case for the symmetrical contrasts, both compositional and typological, between the Fall and Daniel in the Lions' Den. In order to provide a symmetrical contrast, the nude pair of Adam and Eve flanking one animal (the serpent wound on the tree) must be balanced by a nude Daniel flanked by a pair of animals (the lions). This argument has two problems. First, the Daniel scene on the sarcophagus has two additional figures not men-

4. Saxl, "Pagan and Jewish Elements in Early Christian Sculpture," 1:55.

tioned by Malbon, two men standing behind the lions. That is, the scene has three humans and two animals, not one and two. Second, it appears that the sarcophagus has lost its original Daniel (not the whole scene: just the figure of Daniel) yet no case is made for the validity of the 1632 engraving and the 1773 drawing of the sarcophagus upon which Malbon relies to provide a nude, orant, upward-looking Daniel. While that is a usual Early Christian Daniel, Malbon omits an argument for it. Was the original Daniel lost when the sarcophagus was discovered and its lid damaged in 1597 (104-05)? If so, did the engraving and drawing (p. 62, figs. 14-15) imaginatively supply a Daniel, just as they supplied the rest of the fragmentary lid? The restored and clothed Daniel (fig. 1) was evidently added after Wilpert's photograph of 1929-36 (see fig. 16 and p. 243).

Diagonal links are also claimed to exist between the outermost scenes on the two registers. True, the scenes diagonally placed are visual complements: Pilate and Job each sit, their bodies oriented toward the inside of the register; Abraham and Paul each stand, oriented to the outside of the register. But no typological basis is offered for linking Pilate washing his hands with Job suffering, or for linking Abraham spared from sacrificing Isaac with the arrest of Paul. Further, if Malbon sees Isaac, not Abraham, as the typologically important figure, then how does visually linking Abraham with Paul underscore Isaac's role as a type of Christ? Again, her summation of reading the program "concentrically" sounds very good, but does not bear close examination (135). For instance, Striking the Rock and Receiving the Law (scenes in spandrels) do not readily evoke thoughts of community (despite the suggestion on pp. 79-81); although Daniel in the Lions' Den may bring to mind "obedient death," Adam and Eve do not; Pilate is not an obvious reference to the resurrection, nor is Paul in his arrest, or Job suffering, or Abraham spared from sacrificing Isaac.

The physical description of the depictions is sometimes skewed to support the interpretation being offered. For instance, the claim that the direction of the gazes of the figures is significant is put provocatively, especially in the conclusion that the "enthroned Christ looks forward and outward" (123). But what of the only figure looking straight ahead, whose gaze is not even mentioned: Pilate? The impression is given that only "[d]isobedient Adam and Eve look down," in contrast to the (putative) Daniel, who "looks up" (123). Actually, Christ and Paul in their arrests and Job are also depicted with head and gaze directed downward. Similarly when Malbon assigns priority and honor to the scenes placed on the right (e.g. 109) and finds an "almost 'heavenly' stateliness and stability" to the whole upper register of the facade (122), no rationale is offered for Pilate's placement in Malbon's ideal position, the far right of the top register.

Thus, while the study shows nuanced meanings in specific elements of the sarcophagus' program and accurately identifies a few of its scenes as typological, the argument for an overall typological program is flawed and inconclusive.

TABLE OF IDENTIFICATIONS:

THE SCENES, MEDALLION PORTRAITS, AND SYMBOLS
ON THE BRESCIA CASKET

The Scenes

This table is chronologically ordered: the various identifications are presented in the order in which they were suggested, and under each identfication the scholars who subscribed to it are listed in chronological order. If a scholar proposed alternative identifications for a single scene or image, then each alternative is given, enclosed in square brackets. The letters cited by Odorici are also included in this table. Multiple years for a single work indicate translation, revised editions, or reprintings; the page reference is to the latest version of the work cited. If a work usually cited with more than one year is in a specific instance cited with only a single year, this indicates that the scholar gave that identification only in the version of the work of that date. The present author's identifications are found in the body of the present volume.

Lid. Upper Register, Left Scene:
Christ in Gethsemane
 18th-c document, see Kollwitz, *Lipsanothek von Brescia*, 6
 Westwood, *Fictile Ivories* (1876) 34
 Stuhlfauth, *Altchristliche Elfenbeinplastik* (1896) 41
 Sybel, *Christliche Antike* (1909) 247
 Kaufmann, *Handbuch der christlichen Archäologie* (1913) 555
 Leclercq, "Brescia," *DACL* 2.1 (1925) fig. 1624 + col. 1154
 Kollwitz, *Lipsanothek von Brescia* (1933) 14
 Soper, "Italo-Gallic School" (1938) 17
 Delbrueck, *Probleme der Lipsanothek*, (1952) 24, 29
 Morey, *Early Christian Art*[2] (1953) 284
 Volbach, *Early Christian Art* (1958, 1962) 328
 Panazza, *Musei di Brescia* (1959) 57
 Syndicus, *Early Christian Art*, (1960) 105
 Schiller, *Iconography* (1969, 1972) 2:48
 Bourguet, *Early Christian Art* (1972) 179
 Watson, "Program of the Brescia Casket" (1981) 289
 Area di Santa Giulia (1996) 70

L + M scenes construed as a single scene:
Judas's Betrayal
 Odorici, *Antichità cristiane di Brescia* (1845, 1853, 1858), 67, 71
 Kraus, *Christlichen Kunst* 1 (1896) 502 #1

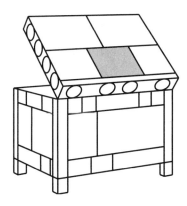

Lid. Upper Register, Middle Scene:
The Arrest of Christ
 18th-c document, see Kollwitz, *Lipsanothek von Brescia* 6
 Odorici, *Antichità cristiane di Brescia* (1845, 1853, 1858) 67, 71-72
 Westwood, *Fictile Ivories* (1876) 34
 Stuhlfauth, *Altchristliche Elfenbeinplastik* (1896) 41
 Sybel, *Christliche Antike* (1909) 247
 Kaufmann, *Handbuch der christlichen Archäologie* (1913) 555
 Leclercq, "Brescia," *DACL* 2.1 (1925) fig. 1624
 Kollwitz, *Lipsanothek von Brescia* (1933) 15
 Soper, "Italo-Gallic School" (1938) 177
 Delbrueck, *Probleme der Lipsanothek* (1952) 24, 29-30
 Morey, *Early Christian Art*[2] (1953) 284
 Volbach, *Early Christian Art* (1958, 1962) 328
 Panazza, *Musei di Brescia* (1959) 57
 Millet, *Iconographie de l'Évangile* (1960) 325
 Syndicus, *Early Christian Art*, (1960) 105
 Schiller, *Iconography* (1969, 1972) 2:52
 Bourguet, *Early Christian Art* (1972) 179
 Watson, "Program of the Brescia Casket" (1981) 289
 Area di Santa Giulia (1996) 70

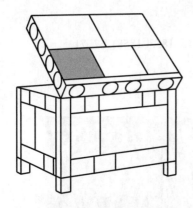

Lid. Upper Register, Right Scene:
The Denial of Peter
 18th-c document, see Kollwitz, *Lipsanothek von Brescia* 6
 Westwood, *Fictile Ivories* (1876) 34
 Schultze, *Altchristlichen Kunst* (1895) 280
 Kraus, *Christlichen Kunst* 1 (1896) 502 #2
 Stuhlfauth, *Altchristliche Elfenbeinplastik* (1896) 41
 Kaufmann, *Handbuch der christlichen Archäologie* (1913) 555
 Leclercq, "Brescia," *DACL* 2.1 (1925) fig. 1624
 Kollwitz, *Lipsanothek von Brescia* (1933) 15-16
 Soper, "Italo-Gallic School" (1938) 177-78, fig. 53
 Callisen, "Iconography of the Cock on the Column" (1939) 175
 Delbrueck, *Probleme der Lipsanothek* (1952) 24, 30
 Morey, *Early Christian Art*[2] (1953) 284
 Stommel, *Ikonographie der Sarkophagplastik*, (1954) 128-29, pl. 14.2
 Volbach, *Early Christian Art* (1958, 1962) 328
 Panazza, *Musei di Brescia* (1959) 57
 Millet, *Iconographie de l'Évangile* (1960) 345
 Syndicus, *Early Christian Art*, (1960) 105
 Schiller, *Iconography* (1969, 1972) 2:59
 Bourguet, *Early Christian Art* (1972) 179
 Watson, "Program of the Brescia Casket" (1981) 289
 Area di Santa Giulia (1996) 70

Lid. Lower Register, construed as one scene:
Jesus before the Sanhedrin
 Area di Santa Giulia (1996) 70

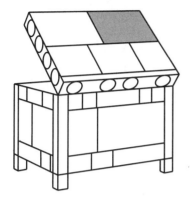

Lid. Lower Register, Left Scene:
Christ before Annas and Caiaphas/the highpriests
 18th-c document, see Kollwitz, *Lipsanothek von Brescia* 6
 Odorici, *Antichità cristiane di Brescia* (1845, 1853, 1858) 67, 72-73
 Schultze, *Altchristlichen Kunst* (1895) 280—names only Caiaphas
 Kraus, *Christlichen Kunst* 1 (1896) 502 #3
 Stuhlfauth, *Altchristliche Elfenbeinplastik* (1896) 41
 Sybel, *Christliche Antike* (1909) 247—names only Caiaphas
 Kaufmann, *Handbuch der christlichen Archäologie* (1913) 555
 Leclercq, "Brescia," *DACL* 2.1 (1925) fig. 1624
 Kollwitz, *Lipsanothek von Brescia* (1933) 16
 Soper, "Italo-Gallic School" (1938) 177—names only Caiaphas
 Delbrueck, *Probleme der Lipsanothek* (1952) 24, 30-31
 Morey, *Early Christian Art*[2] (1953) 284
 Volbach, *Early Christian Art* (1958, 1962) 328—names only Caiaphas
 Panazza, *Musei di Brescia* (1959) 57
 Syndicus, *Early Christian Art*, (1960) 105
 Schiller, *Iconography* (1969, 1972) 2:57
 Bourguet, *Early Christian Art* (1972) 179
 Watson, "Program of the Brescia Casket" (1981) 289

Christ before Pilate and Herod
 Westwood, *Fictile Ivories* (1876) 34

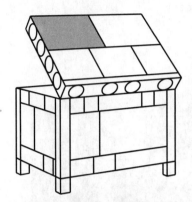

Lid. Lower Register, Right Scene:
Christ before Pilate

18th-c document, see Kollwitz, *Lipsanothek von Brescia* 6
Odorici, *Antichità cristiane di Brescia* (1845, 1853, 1858) 67, 72-73
Westwood, *Fictile Ivories* (1876) 34
Kraus, *Christlichen Kunst* 1 (1896) 502 #4
Stuhlfauth, *Altchristliche Elfenbeinplastik* (1896) 41
Maskell, *Ivories* (1905) 146
Sybel, *Christliche Antike* (1909) 247
Kaufmann, *Handbuch der christlichen Archäologie* (1913) 555
Leclercq, "Brescia," *DACL* 2.1 (1925) fig. 1624
Kollwitz, *Lipsanothek von Brescia* (1933) 16-17
Weigand, review of Kollwitz (1935) 432
Soper, "Italo-Gallic School" (1938) 177
Delbrueck, *Probleme der Lipsanothek* (1952) 24, 31-32
Morey, *Early Christian Art*[2] (1953) 284
Toynbee, review of Delbrueck (1955) 239
Volbach, *Early Christian Art* (1958, 1962) 328
Panazza, *Musei di Brescia* (1959) 57
Syndicus, *Early Christian Art*, (1960) 105
Schiller, *Iconography* (1969, 1972) 2:64
Bourguet, *Early Christian Art* (1972) 179
Watson, "Program of the Brescia Casket" (1981) 289

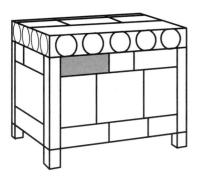

Front. Upper Register, Left Scene:
Jonah swallowed by the whale
 18th-c document, see Kollwitz, *Lipsanothek von Brescia* 8
 Odorici, *Antichità cristiane di Brescia* (1845, 1853, 1858) 67, 80-81
 Westwood, *Fictile Ivories* (1876) 36
 Kraus, *Christlichen Kunst* 1 (1896) 503 #15
 Stuhlfauth, *Altchristliche Elfenbeinplastik* (1896) 41
 Maskell, *Ivories* (1905) 143
 Sybel, *Christliche Antike* (1909) 247
 Kaufmann, *Handbuch der christlichen Archäologie* (1913) 555
 Leclercq, "Brescia," *DACL* 2.1 (1925) fig. 1625
 Kollwitz, *Lipsanothek von Brescia* (1933) 22
 Weigand, review of Kollwitz (1935) 430
 Delbrueck, *Probleme der Lipsanothek* (1952) 7, 21-22
 Morey, *Early Christian Art*2 (1953) 284
 Toynbee, review of Delbrueck (1955) 239
 Nordström, "Jewish Legends in Byzantine Art" (1955-57) 501-8
 [Volbach, *Early Christian Art* (1958, 1962) 328]
 Panazza, *Musei di Brescia* (1959) 57
 Bourguet, *Early Christian Art* (1972) 176
 Watson, "Program of the Brescia Casket" (1981) 286: Jon. 1:15-17.
 Friedman, "Bald Jonah" (1988) 133
 Area di Santa Giulia (1996) 70

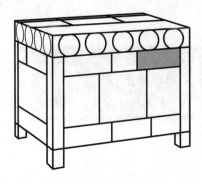

Front. Upper Register, Right Scene:
Jonah spewed forth
 18th-c document, see Kollwitz, *Lipsanothek von Brescia* 8
 Odorici, *Antichità cristiane di Brescia* (1845, 1853, 1858) 67, 80
 Westwood, *Fictile Ivories* (1876) 36
 Kraus, *Christlichen Kunst* 1 (1896) 503 #16
 Stuhlfauth, *Altchristliche Elfenbeinplastik* (1896) 41
 Maskell, *Ivories* (1905) 143
 Kaufmann, *Handbuch der christlichen Archäologie* (1913) 555
 Leclercq, "Brescia," *DACL* 2.1 (1925) fig. 1625
 Kollwitz, *Lipsanothek von Brescia* (1933) 22
 Weigand, review of Kollwitz (1935) 430
 Delbrueck, *Probleme der Lipsanothek* (1952) 7, 21-22
 Morey, *Early Christian Art*[2] (1953) 284
 Toynbee, review of Delbrueck (1955) 239
 Stern, review of Delbrueck (1955) 117
 [Volbach, *Early Christian Art* (1958, 1962) 328]
 Panazza, *Musei di Brescia* (1959) 57
 Bourguet, *Early Christian Art* (1972) 176
 Watson, "Program of the Brescia Casket" (1981) 286: Jon. 2:10.
 Friedman, "Bald Jonah" (1988) 133
 Area di Santa Giulia (1996) 70

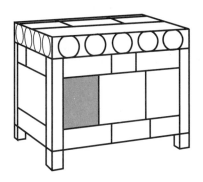

Front. Middle Register, Left Scene:
Christ Healing the Woman with the Flux of Blood
 18th-c document, see Kollwitz, *Lipsanothek von Brescia* 8
 Odorici, *Antichità cristiane di Brescia* (1845, 1853, 1858) 67, 81-82
 Schultze, *Altchristlichen Kunst* (1895) 279
 Kraus, *Christlichen Kunst* 1 (1896) 503 #18
 Venturi, *Storia dell'arte italiana* 1 (1901) 459
 Sybel, *Christliche Antike* (1909) 246: with trait from Noli me tangere
 Kaufmann, *Handbuch der christlichen Archäologie* (1913) 555
 Volbach, *Elfenbeinarbeiten*[3] (1916, 1962, 1976) 77
 Leclercq, "Brescia," *DACL* 2.1 (1925) fig. 1625
 Kollwitz, *Lipsanothek von Brescia* (1933) 21-22
 Delbrueck, *Probleme der Lipsanothek* (1952) 26-27
 Morey, *Early Christian Art*[2] (1953) 284
 Toynbee, review of Delbrueck (1955) 239-40
 Volbach, *Early Christian Art* (1958, 1962) 328
 Panazza, *Musei di Brescia* (1959) 57
 Grabar, *Art de l'antiquité* (1968) 1:509 (cf. below)
 Schiller, *Iconography* (1969, 1972) 2:178
 Bourguet, *Early Christian Art* (1972) 176
 Watson, "Program of the Brescia Casket" (1981) 285: Matt. 9:20-22.
 Milburn, *Early Christian Art* (1988) 239
 Area di Santa Giulia (1996) 70

Noli Me Tangere
 Westwood, *Fictile Ivories* (1876) 36
 Stuhlfauth, *Altchristliche Elfenbeinplastik* (1896) 41, 44
 Kollwitz, *Lipsanothek von Brescia* (1933) 21
 Grabar, *Christian Iconography* (1968, 1980) 138, fig. 335 (cf. above)

Jesus with the Magdalene
 Maskell, *Ivories* (1905) 143

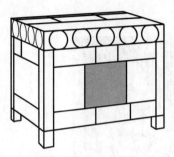

Front. Middle Register, Middle Scene:
Christ in the Temple at Jerusalem, Holy Week (Matt. 21)
 18th-c document, see Kollwitz, *Lipsanothek von Brescia* 8
 Odorici, *Antichità cristiane di Brescia* (1845, 1853, 1858) 67, 82-83

Christ Teaching His Apostles
 Westwood, *Fictile Ivories* (1876) 36
 [Stuhlfauth, *Altchristliche Elfenbeinplastik* (1896) 41]
 Maskell, *Ivories* (1905) 143
 Sybel, *Christliche Antike* (1909) 246
 Kollwitz, *Lipsanothek von Brescia* (1933) 19-20
 Gerke, "Plastik in der Theodosianisch-Honorarianische Zeit" (1935) 139-40
 Weigand, review of Kollwitz (1935) 431
 Soper, "Italo-Gallic School" (1938) 177
 Volbach, *Early Christian Art* (1958, 1962) 328
 Bourguet, *Early Christian Art* (1972) 176

Christ Among the Doctors
 Kraus, *Christlichen Kunst* 1 (1896) 503 #19
 Natanson, *Early Christian Ivories* (1953) 24
 Panazza, *Musei di Brescia* (1959) 57
 [*Area di Santa Giulia* (1996) 68, 70]

Christ's last words before the Ascension (Matt. 28:18ff)
 Schultze, *Altchristlichen Kunst* (1895) 279

Resurrected Christ with Apostles
 [Stuhlfauth, *Altchristliche Elfenbeinplastik* (1896) 44]

Christ Teaching in the Synagogue at Nazareth (Luke 4:16-21)
 Venturi, *Storia dell'arte italiana* 1 (1901) 459
 Leclercq, "Brescia," *DACL* 2.1 (1925) 1154 + fig. 1625
 Delbrueck, *Probleme der Lipsanothek* (1952) 24-26
 Morey, *Early Christian Art*² (1953) 284
 Toynbee, review of Delbrueck (1955) 240
 Watson, "Program of the Brescia Casket" (1981) 285
 Milburn, *Early Christian Art* (1988) 239
 [*Area di Santa Giulia* (1996) 68]

Christ as Teacher
 Kaufmann, *Handbuch der christlichen Archäologie* (1913) 555
 Grabar, *Art de l'antiquité* (1968) 1:509

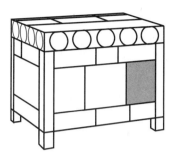

Front. Middle Register, Right Scene:
Christ the Good Shepherd
 18th-c document, see Kollwitz, *Lipsanothek von Brescia* 8: with a wolf
 Odorici, *Antichità cristiane di Brescia* (1845, 1853, 1858) 67, 83: with a faithful dog
 Westwood, *Fictile Ivories* (1876) 36: with a wolf
 Schultze, *Altchristlichen Kunst* (1895) 279
 Kraus, *Christlichen Kunst* 1 (1896) 503 #20: hastening to help his sheep
 Stuhlfauth, *Altchristliche Elfenbeinplastik* (1896) 41
 Maskell, *Ivories* (1905) 144
 Sybel, *Christliche Antike* (1909) 246-47
 Kaufmann, *Handbuch der christlichen Archäologie* (1913) 555
 Leclercq, "Brescia," *DACL* 2.1 (1925) col. 1154 + fig. 1625: with a dog
 Kollwitz, *Lipsanothek von Brescia* (1933) 20
 Weigand, review of Kollwitz (1935) 431
 Soper, "Italo-Gallic School" (1938) 177-8, fig. 56
 Delbrueck, *Probleme der Lipsanothek* (1952) 24, 28
 Morey, *Early Christian Art*[2] (1953) 284
 Volbach, *Early Christian Art* (1958, 1962) 328
 Panazza, *Musei di Brescia* (1959) 57
 Bourguet, *Early Christian Art* (1972) 176
 Watson, "Program of the Brescia Casket" (1981) 285
 Milburn, *Early Christian Art* (1988) 239

Christ at the entrance to a sheepfold
 Grabar, *Art de l'antiquité* (1968) 1:509

The parable of the mercenary shepherd
 Area di Santa Giulia (1996) 70

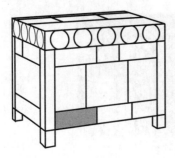

Front. Lower Register, Left Scene:
Susanna in the Garden
 18th-c document, see Kollwitz, *Lipsanothek von Brescia* 8
 Odorici, *Antichità cristiane di Brescia* (1845, 1853, 1858) 67, 83
 Raoul-Rochette, letter (1847), see Odorici, *Antichità cristiane di Brescia* 68
 Westwood, *Fictile Ivories* (1876) 36
 Schultze, *Altchristlichen Kunst* (1895) 279
 Kraus, *Christlichen Kunst* 1 (1896) 503 #22
 Stuhlfauth, *Altchristliche Elfenbeinplastik* (1896) 41
 Sybel, *Christliche Antike* (1909) 247
 Kaufmann, *Handbuch der christlichen Archäologie* (1913) 555
 Leclercq, "Brescia," *DACL* 2.1 (1925) fig. 1625
 Kollwitz, *Lipsanothek von Brescia* (1933) 23
 Delbrueck, *Probleme der Lipsanothek* (1952) 7, 19-20
 Morey, *Early Christian Art*[2] (1953) 284
 Volbach, *Early Christian Art* (1958, 1962) 328
 Panazza, *Musei di Brescia* (1959) 57
 Bourguet, *Early Christian Art* (1972) 176
 Watson, "Program of the Brescia Casket" (1981) 286: Dan. 13:19-24.
 Area di Santa Giulia (1996) 70

The Church between Peter and Paul
 Polidori, letter (1847), see Odorici, *Antichità cristiane di Brescia* 83

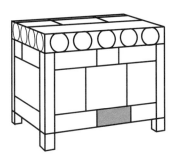

Front. Lower Register, Middle Scene:
Susanna brought before Daniel
 18th-c document, see Kollwitz, *Lipsanothek von Brescia* 8
 Odorici, *Antichità cristiane di Brescia* (1845, 1853, 1858) 67, 84
 Raoul-Rochette, letter (1847), see Odorici, *Antichità cristiane di Brescia* 67
 Westwood, *Fictile Ivories* (1876) 36-37
 Schultze, *Altchristlichen Kunst* (1895) 279
 Kraus, *Christlichen Kunst* 1 (1896) 503 #23
 Stuhlfauth, *Altchristliche Elfenbeinplastik* (1896) 41
 Sybel, *Christliche Antike* (1909) 247
 Kaufmann, *Handbuch der christlichen Archäologie* (1913) 555
 Leclercq, "Brescia," *DACL* 2.1 (1925) fig. 1625
 Kollwitz, *Lipsanothek von Brescia* (1933) 23
 Delbrueck, *Probleme der Lipsanothek* (1952) 7, 20
 Morey, *Early Christian Art*[2] (1953) 284
 Volbach, *Early Christian Art* (1958, 1962) 328
 Panazza, *Musei di Brescia* (1959) 57
 Bourguet, *Early Christian Art* (1972) 176
 Watson, "Program of the Brescia Casket" (1981) 286: Dan. 13:19-24.

Susanna condemned to death by a judge
 Area di Santa Giulia (1996) 70

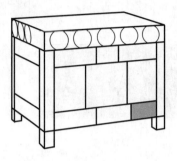

Front. Lower Register, Right Scene:
Daniel in the Lions' Den (Dan. 6 & 14)
 18th-c document, see Kollwitz, *Lipsanothek von Brescia* 8
 Odorici, *Antichità cristiane di Brescia* (1845, 1853, 1858) 67, 84
 Raoul-Rochette, letter (1847), see Odorici, *Antichità cristiane di Brescia* 67
 Westwood, *Fictile Ivories* (1876) 37
 Schultze, *Altchristlichen Kunst* (1895) 279
 Kraus, *Christlichen Kunst* 1 (1896) 503 #24
 Stuhlfauth, *Altchristliche Elfenbeinplastik* (1896) 41
 Sybel, *Christliche Antike* (1909) 247
 Kaufmann, *Handbuch der christlichen Archäologie* (1913) 555
 Leclercq, "Brescia," *DACL* 2.1 (1925) fig. 1625
 Kollwitz, *Lipsanothek von Brescia* (1933) 23
 Weigand, review of Kollwitz (1935) 430
 Delbrueck, *Probleme der Lipsanothek* (1952) 7, 21
 Morey, *Early Christian Art*[2] (1953) 284
 Stern, review of Delbrueck (1955) 117
 Volbach, *Early Christian Art* (1958, 1962) 328
 Panazza, *Musei di Brescia* (1959) 57
 Bourguet, *Early Christian Art* (1972) 176
 Watson, "Program of the Brescia Casket" (1981) 286: Dan. 6:17 and 14:31
 Area di Santa Giulia (1996) 70

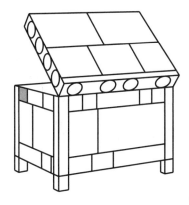

Right Side. Upper Register, Left Scene:
Prophet having a revelation
 18th-c document, see Kollwitz, *Lipsanothek von Brescia* 8

Moses loosing his sandals
 Odorici, *Antichità cristiane di Brescia* (1845, 1853, 1858) 68, 85-86
 Davin, "Capella greca" (1880) 314
 Kraus, *Christlichen Kunst* 1 (1896) 503 #30
 Panazza, *Musei di Brescia* (1959) 57

Moses and the Hand of God
 Westwood, *Fictile Ivories* (1876) 34
 Stuhlfauth, *Altchristliche Elfenbeinplastik* (1896) 41
 Leclercq, "Brescia," *DACL* 2.1 (1925) fig. 1627

Moses on Horeb
 Pératé, *Archéologie chrétienne* (1892) 343
 Sybel, *Christliche Antike* (1909) 247
 Leclercq, "Brescia," *DACL* 2.1 (1925) col. 1155
 Kollwitz, *Lipsanothek von Brescia* (1933) 27
 Weigand, review of Kollwitz (1935) 431
 Watson, "Program of the Brescia Casket" (1981) 288: Exod. 3:1-5

The Call of Moses
 Kaufmann, *Handbuch der christlichen Archäologie* (1913) 555
 Delbrueck, *Probleme der Lipsanothek* (1952) 6, 13

The Call of Moses, loosening his sandals, on Horeb
 Area di Santa Giulia (1996) 70

Moses on Mount Sinai
 Volbach, *Early Christian Art* (1952, 1968) 328

Moses
 Milburn, *Early Christian Art* (1988) 239

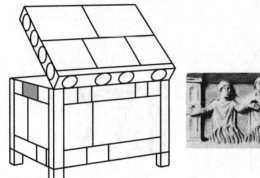

Right Side. Upper Register, Middle Scene:
Souls in Purgatory, in vision of a prophet (see above)
 18th-c document, see Kollwitz, *Lipsanothek von Brescia* 8
 [Odorici, *Antichità cristiane di Brescia* (1845, 1853, 1858) 68, 86]
 Polidori, letter (1847), see Odorici, *Antichità cristiane di Brescia* 86
 Raoul-Rochette, letter (1847), see Odorici, *Antichità cristiane di Brescia* 69

Seven Maccabees
 [Odorici, *Antichità cristiane di Brescia* (1845, 1853, 1858) 68, 85*]
 Davin, "Capella greca" (1880) 314
 Pératé, *Archéologie chrétienne* (1892) 343
 Becker, "Sieben makkabäischen Brüder auf der Lipsanothek" (1923) 72ff.
 [Leclercq, "Brescia," *DACL* 2.1 (1925) 2.1:1155]
 McGrath, "Maccabees on the Brescia Casket," (1965) 257-61
 Watson, "Program of the Brescia Casket" (1981) 288

Three Hebrews in the Fiery Furnace
 Westwood, *Fictile Ivories* (1876) 34-35: 3 Hebrews, 3 attendants, angel
 [Kraus, *Christlichen Kunst* 1 (1896) 503 #31: free rendering]
 Stuhlfauth, *Altchristliche Elfenbeinplastik* (1896) 41
 Venturi, *Storia dell'arte italiana* 1 (1901) 461
 Kaufmann, *Handbuch der christlichen Archäologie* (1913) 536, 555
 Stuhlfauth, "Zwei Streitfragen" (1924) 48ff.
 Avery, "Style at Santa Maria Antiqua" (1924-25) 141
 [Leclercq, "Brescia," *DACL* 2.1 (1925) fig. 1627]
 Weigand, review of Kollwitz (1935) 431: (contra Kollwitz on Korah)
 Lowrie, *Art in the Early Church* (1947) 182
 [Stern, review of Delbrueck (1955) 117]
 Grabar, *Christian Iconography* (1968, 1980) pl. 336
 Area di Santa Giulia (1996) 70

* McGrath (p. 257) construes Odorici as admitting confusion on the identification of this scene, uncertain whether it depicts the Three Hebrews or the Seven Maccabees. Odorici, however, went from an original indecision over whether the scene was the Seven Macca-bees or the souls in purgation (p. 68) to a clear identification of it as "The sufferings of the Maccabees" ("Il supplicio dei Maccabei," p. 85), arguing against the souls in purgation and urging that the image depicts the seven brothers in an image modeled on contemporary images of the Three Hebrews (p. 86).

Seven persons in the furnace
 [Kraus, *Christlichen Kunst* 1 (1896) 503 #31]
 Sybel, *Christliche Antike* (1909) II 247
 Panazza, *Musei di Brescia* (1959) 57

The Destruction of Korah and His Band (Num. 16:31-33)
 Gräven, *Frühchristliche Elfenbeinwerke* (1900) 13
 Wulff, *Altchristliche und byzantinische Kunst* (1909) 185
 Achelis, "Totenmahle" (1916) 95
 Volbach, *Elfenbeinarbeiten*[3] (1916, 1962, 1976) 328: with "(?)"
 Dalton, *East Christian Art* (1925) 208
 Kollwitz, *Lipsanothek von Brescia* (1933) 7, 26-27
 CONTRA: Weigand, review of Kollwitz (1935) 431
 Soper, "Italo-Gallic School" (1938) 177 + n. 4
 Delbrueck, *Probleme der Lipsanothek* (1952) 7, 15-17
 Morey, *Early Christian Art*[2] (1953) 284
 [Stern, review of Delbrueck (1955) 117]
 Toynbee, review of Delbrueck (1955) 240

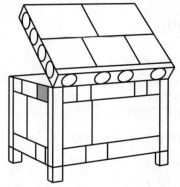
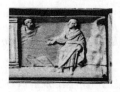

Right Side. Upper Register, Right Scene:

Another prophet having a vision, perhaps John (Apoc. 5) or Malachi (Mal. 3)
 18th-c document, see Kollwitz, *Lipsanothek von Brescia* 8

Moses on Sinai
 Odorici, *Antichità cristiane di Brescia* (1845, 1853, 1858) 68, 85
 Sybel, *Christliche Antike* (1909) 247

Moses Receiving the Law on Mount Sinai
 Westwood, *Fictile Ivories* (1876) 35: unique depiction
 Davin, "Capella greca" (1880) 314
 Kraus, "Gott" (1882) 1:629 + fig. 227
 Stuhlfauth, *Altchristliche Elfenbeinplastik* (1896) 41
 Kraus, *Christlichen Kunst* 1 (1896) 503 #32
 Kaufmann, *Handbuch der christlichen Archäologie* (1913) 555
 Leclercq, "Brescia," *DACL* 2.1 (1925) fig. 1627
 Morey, *Early Christian Art*[2] (1953) 284
 Volbach, *Early Christian Art* (1958, 1962) 328
 Panazza, *Musei di Brescia* (1959) 57
 Watson, "Program of the Brescia Casket" (1981) 288: Exod. 31:18, 34:27-28
 Area di Santa Giulia (1996) 70

Moses seated, a book at his feet, speaking to a youthful head appearing in the
clouds
 Pératé, *Archéologie chrétienne* (1892) 343

Moses
 [Leclercq, "Brescia," *DACL* 2.1 (1925) col. 1155]

St. Paul on the Road to Damascus
 [Leclercq, "Brescia," *DACL* 2.1 (1925) col. 1155]

Moses Receiving the Tables of the Law the second time
 Kollwitz, *Lipsanothek von Brescia* (1933) 27-28
 Weigand, review of Kollwitz (1935) 431
 Delbrueck, *Probleme der Lipsanothek* (1952) 6, 14

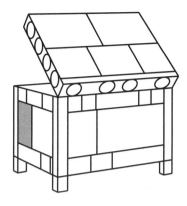
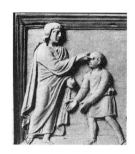

Right Side. Middle Register, Left Scene:
Healing of the Blind Man
 18th-c document, see Kollwitz, *Lipsanothek von Brescia* 9
 Odorici, *Antichità cristiane di Brescia* (1845, 1853, 1858) 68, 87
 Westwood, *Fictile Ivories* (1876) 34
 Kraus, *Christlichen Kunst* 1 (1896) 503 #33
 Stuhlfauth, *Altchristliche Elfenbeinplastik* (1896) 41
 Kaufmann, *Handbuch der christlichen Archäologie* (1913) 555
 Leclercq, "Brescia," *DACL* 2.1 (1925) fig. 1627: "a" blind man
 Kollwitz, *Lipsanothek von Brescia* (1933) 25
 Weigand, review of Kollwitz (1935) 431
 Delbrueck, *Probleme der Lipsanothek* (1952) 24, 28
 Morey, *Early Christian Art*[2] (1953) 284
 Volbach, *Early Christian Art* (1958, 1962) 328
 Panazza, *Musei di Brescia* (1959) 57
 Milburn, *Early Christian Art* (1988) 239

Healing of the Blind Man on the Jericho Road
 Venturi, *Storia dell'arte italiana* 1 (1901) 460: Mark 10:46-52

Healing of the Man Born Blind
 Delbrueck, *Probleme der Lipsanothek* (1952) 28
 Watson, "Program of the Brescia Casket" (1981) 287: John 9:1-7
 Area di Santa Giulia (1996) 70

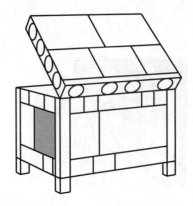

Right Side. Middle Register, Right Scene:
Raising of a dead man, as in Matt. 9 or John 2 [sic]
 18th-c document, see Kollwitz, *Lipsanothek von Brescia* 9

Raising of Lazarus
 Odorici, *Antichità cristiane di Brescia* (1845, 1853, 1858) 68, 87
 Westwood, *Fictile Ivories* (1876) 34
 Schultze, *Altchristlichen Kunst* (1895) 280
 Kraus, *Christlichen Kunst* 1 (1896) 503 #34
 Stuhlfauth, *Altchristliche Elfenbeinplastik* (1896) 41
 Kaufmann, *Handbuch der christlichen Archäologie* (1913) 555
 Kollwitz, *Lipsanothek von Brescia* (1933) 25-26
 Delbrueck, *Probleme der Lipsanothek* (1952) 24, 29
 Morey, *Early Christian Art*[2] (1953) 284
 Volbach, *Early Christian Art* (1958, 1962) 328
 Panazza, *Musei di Brescia* (1959) 57
 Watson, "Program of the Brescia Casket" (1981) 287
 Milburn, *Early Christian Art* (1988) 239
 Area di Santa Giulia (1996) 70

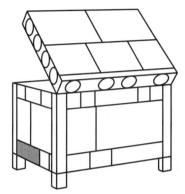

Right Side. Lower Register, Left Scene:
The Meeting of Jacob and Rachel at the Well
 18th-c document, see Kollwitz, *Lipsanothek von Brescia* 9
 Odorici, *Antichità cristiane di Brescia* (1845, 1853, 1858) 68, 86-87: Gen. 29
 Westwood, *Fictile Ivories* (1876) 35: typology
 Pérat é, *Archéologie chrétienne* (1892) 343
 Kraus, *Christlichen Kunst* 1 (1896) 503 #35
 Stuhlfauth, *Altchristliche Elfenbeinplastik* (1896) 41
 Sybel, *Christliche Antike* (1909) 247
 Kaufmann, *Handbuch der christlichen Archäologie* (1913) 555
 Leclercq, "Brescia," *DACL* 2.1 (1925) fig. 1627
 Kollwitz, *Lipsanothek von Brescia* (1933) 28
 Delbrueck, *Probleme der Lipsanothek* (1952) 6
 Morey, *Early Christian Art*² (1953) 284
 Toynbee, review of Delbrueck (1955) 239
 Volbach, *Early Christian Art* (1958, 1962) 328
 Panazza, *Musei di Brescia* (1959) 57
 Watson, "Program of the Brescia Casket" (1981) 288: Gen 29:9-10
 Milburn, *Early Christian Art* (1988) 240
 Area di Santa Giulia (1996) 70

Moses and the flock of Jethro
 anonymous, see Odorici, *Antichità cristiane di Brescia* (1853, 1858) 86-87

Jacob scenes
 Weigand, review of Kollwitz (1935) 431

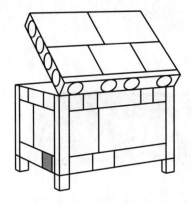

Right Side. Lower Register, Middle Scene:
Laban and Jacob first meet
 18th-c document, see Kollwitz, *Lipsanothek von Brescia* 9

Encounter of Jacob with Esau
 Odorici, *Antichità cristiane di Brescia* (1845, 1853, 1858) 68, 86-87
 Kraus, *Christlichen Kunst* 1 (1896) 503 #36

Jacob Wrestling with the Angel
 Westwood, *Fictile Ivories* (1876) 35
 Pératé, *Archéologie chrétienne* (1892) 343
 Sybel, *Christliche Antike* (1909) 247
 Kaufmann, *Handbuch der christlichen Archäologie* (1913) 555
 Leclercq, "Brescia," *DACL* 2.1 (1925) fig. 1627
 Kollwitz, *Lipsanothek von Brescia* (1933) 28
 Soper, "Italo-Gallic School" (1938) 177
 Delbrueck, *Probleme der Lipsanothek* (1952) 6
 Morey, *Early Christian Art*[2] (1953) 284
 Volbach, *Early Christian Art* (1958, 1962) 328
 Watson, "Program of the Brescia Casket" (1981) 288: Gen. 32:24-26
 Area di Santa Giulia (1996) 70

Moses defending Jethro's well from a Midianite
 anonymous, see Odorici, *Antichità cristiane di Brescia* (1853, 1858) 86-87

M + R scenes construed as a single Jacob scene:
Stuhlfauth, *Altchristliche Elfenbeinplastik* (1896) 41
Panazza, *Musei di Brescia* (1959) 57

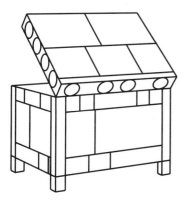

Right Side. Lower Register, Right Scene:
The ladder/Jacob's ladder/Jacob's dream
 18th-c document, see Kollwitz, *Lipsanothek von Brescia* 9
 Odorici, *Antichità cristiane di Brescia* (1845, 1853, 1858) 87
 Pérat é, *Archéologie chrétienne* (1892) 343
 Sybel, *Christliche Antike* (1909) 247
 Kaufmann, *Handbuch der christlichen Archäologie* (1913) 555
 Leclercq, "Brescia," *DACL* 2.1 (1925) fig. 1627
 Kollwitz, *Lipsanothek von Brescia* (1933) 28
 Soper, "Italo-Gallic School" (1938) 177
 Delbrueck, *Probleme der Lipsanothek* (1952) 7
 Volbach, *Early Christian Art* (1958, 1962) 328
 Watson, "Program of the Brescia Casket" (1981) 288
 Milburn, *Early Christian Art* (1988) 240: angel on the ladder
 Area di Santa Giulia (1996) 70

Jacob ascending a ladder
 Westwood, *Fictile Ivories* (1876) 35

symbol
 Kraus, *Christlichen Kunst* 1 (1896) 503 #37

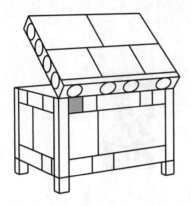

Back. Upper Register, Left Scene:
Eve
 18th-c document, see Kollwitz, *Lipsanothek von Brescia* 6
 Area di Santa Giulia (1996) 70: Eve newly created

Woman praying
 Odorici, *Antichità cristiane di Brescia* (1845, 1853, 1858) 67, 74-75
 Westwood, *Fictile Ivories* (1876) 37
 Kraus, *Christlichen Kunst* 1 (1896) 502 #5

Susanna triumphant
 Stuhlfauth, *Altchristliche Elfenbeinplastik* (1896) 41
 Leclercq, "Brescia," *DACL* 2.1 (1925) fig. 1626 + col. 1155
 Kollwitz, *Lipsanothek von Brescia* (1933) 30: Susanna's thanksgiving

Susanna in the Garden
 Sybel, *Christliche Antike* (1909) 247

Susanna Orans
 Kaufmann, *Handbuch der christlichen Archäologie* (1913) 555
 Delbrueck, *Probleme der Lipsanothek* (1952) 20
 Morey, *Early Christian Art*² (1953) 284
 Panazza, *Musei di Brescia* (1959) 57
 Watson, "Program of the Brescia Casket" (1981) 287

Susanna
 Volbach, *Early Christian Art* (1958, 1962) 328
 Bourguet, *Early Christian Art* (1972) 178

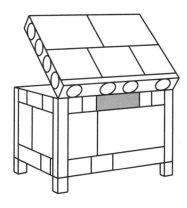

Back. Upper Register, Middle Scene:
Adam asleep
 18th-c document, see Kollwitz, *Lipsanothek von Brescia* 6
 [*Area di Santa Giulia* (1996) 70: after creation of Eve]

Jonah resting under the Gourd Plant
 Odorici, *Antichità cristiane di Brescia* (1845, 1853, 1858) 67, 75
 Westwood, *Fictile Ivories* (1876) 37
 Kraus, *Christlichen Kunst* 1 (1896) 503 #6
 Stuhlfauth, *Altchristliche Elfenbeinplastik* (1896) 41
 Venturi, *Storia dell'arte italiana* 1 (1901) 461
 Sybel, *Christliche Antike* (1909) 247
 Kaufmann, *Handbuch der christlichen Archäologie* (1913) 555
 Leclercq, "Brescia," *DACL* 2.1 (1925) fig. 1626
 Kollwitz, *Lipsanothek von Brescia* (1933) 21, 30
 Weigand, review of Kollwitz (1935) 430
 Delbrueck, *Probleme der Lipsanothek* (1952) 7, 22-24
 Morey, *Early Christian Art*² (1953) 284
 Panazza, *Musei di Brescia* (1959) 57
 Grabar, *Christian Iconography* (1968, 1980) pl. 337
 Bourguet, *Early Christian Art* (1972) 178
 Watson, "Program of the Brescia Casket" (1981) 287: Jon. 4:6-8
 [*Area di Santa Giulia* (1996) 70]

Drunkenness of Noah
 Volbach, *Early Christian Art* (1958, 1962) 328
 [*Area di Santa Giulia* (1996) 70]

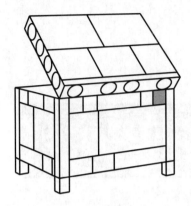

Back. Upper Register, Right Scene:
Brazen Serpent (Num. 21:8-9)
 18th-c document, see Kollwitz, *Lipsanothek von Brescia* 6
 [Westwood, *Fictile Ivories* (1876) 37]
 Volbach, *Early Christian Art* (1958, 1962) 328
 Area di Santa Giulia (1996) 70

Daniel poisoning the dragon
 Odorici, *Antichità cristiane di Brescia* (1845, 1853, 1858) 67, 75
 [Westwood, *Fictile Ivories* (1876) 37]
 Kraus, *Christlichen Kunst* 1 (1896) 503 #7
 Stuhlfauth, *Altchristliche Elfenbeinplastik* (1896) 41
 Venturi, *Storia dell'arte italiana* 1 (1901) 461
 Sybel, *Christliche Antike* (1909) 247
 Kaufmann, *Handbuch der christlichen Archäologie* (1913) 555
 Volbach, *Elfenbeinarbeiten*[3], (1916, 1962, 1976) 77
 Leclercq, "Brescia," *DACL* 2.1 (1925) fig. 1626
 Kollwitz, *Lipsanothek von Brescia* (1933) 30-31
 Delbrueck, *Probleme der Lipsanothek* (1952) 7, 21
 Morey, *Early Christian Art*[2] (1953) 284
 Grabar, *Christian Iconography* (1968) 30-31
 Panazza, *Musei di Brescia* (1959) 57
 Bourguet, *Early Christian Art* (1972) 178
 Watson, "Program of the Brescia Casket" (1981) 287: Dan. 14:27

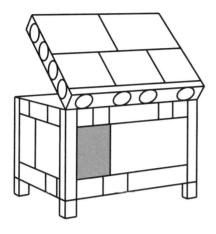

Back. Middle Register, Left Scene:
A revelation
 18th-c document, see Kollwitz, *Lipsanothek von Brescia* 8

The Redeemer, Peter and Andrew on the seashore
 Odorici, *Antichità cristiane di Brescia* (1845, 1853, 1858) 67, 76-78
 Kraus, "Gott" (1882) 1:629 + fig. 227
 Kraus, *Christlichen Kunst* 1 (1896) 503 #9

The Transfiguration
 Westwood, *Fictile Ivories* (1876) 37
 Stuhlfauth, *Altchristliche Elfenbeinplastik* (1896) 41
 Sybel, *Christliche Antike* (1909) 247
 Kaufmann, *Handbuch der christlichen Archäologie* (1913) 555
 Leclercq, "Brescia," *DACL* 2.1 (1925) fig. 1626 + col. 1154
 Kollwitz, *Lipsanothek von Brescia* (1933) 28-29
 Soper, "Italo-Gallic School" (1938) 177
 Panazza, *Musei di Brescia* (1959) 57
 Area di Santa Giulia (1996) 70

Glorification of Christ before Matthew and Philip
 Venturi, *Storia dell'arte italiana* 1 (1901) 460: John 12:20-30

Apocryphal appearance of the resurrected Christ
 Delbrueck, *Probleme der Lipsanothek* (1952) 24, 32-34

Calling of Peter and Andrew
 [Toynbee, review of Delbrueck (1955) 240]
 [Watson, "Program of the Brescia Casket" (1981) 286, 295: Matt. 4:18-20]

Appearance of Resurrected Christ by Sea of Tiberias
 [Toynbee, review of Delbrueck (1955) 240: John 21:4-8]

Christ on the shore of Galilee, standing between two youths
 Volbach, *Early Christian Art* (1958, 1962) 328

Christ and the apostles at the water's edge
 Bourguet, *Early Christian Art* (1972) 178

Commission to Peter, with John
 [Watson, "Program of the Brescia Casket" (1981) 286, 295: John 21:15-17]

"[A] recognition by apostles of Christ's unique calling"
 Milburn, *Early Christian Art* (1988) 239

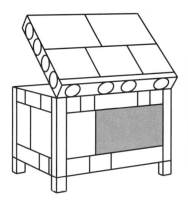

Back. Middle Register, Right Scene:
Judgment of Ananias and Sapphira
 18th-c document, see Kollwitz, *Lipsanothek von Brescia* 8
 Odorici, *Antichità cristiane di Brescia* (1845, 1853, 1858) 78-79
 Westwood, *Fictile Ivories* (1876) 37
 Schultze, *Altchristlichen Kunst* (1895) 280
 Kraus, *Christlichen Kunst* 1 (1896) 503 #10
 Stuhlfauth, *Altchristliche Elfenbeinplastik* (1896) 41
 Sybel, *Christliche Antike* (1909) 247
 Kaufmann, *Handbuch der christlichen Archäologie* (1913) 555
 Leclercq, "Brescia," *DACL* 2.1 (1925) fig. 1626
 Kollwitz, *Lipsanothek von Brescia* (1933) 29-30
 Weigand, review of Kollwitz (1935) 432
 Soper, "Italo-Gallic School" (1938) 177
 Delbrueck, *Probleme der Lipsanothek* (1952) 24, 35-6
 Morey, *Early Christian Art*[2] (1953) 284
 Volbach, *Early Christian Art* (1958, 1962) 328
 Panazza, *Musei di Brescia* (1959) 57
 Kessler, "Acts of the Apostles on Early Christian Ivories" (1979) 110
 Watson, "Program of the Brescia Casket" (1981) 286
 Milburn, *Early Christian Art* (1988) 239
 Area di Santa Giulia (1996) 70

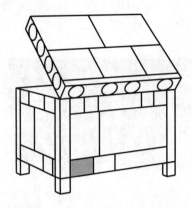

Back. Lower Register, Left Scene:
The Finding of Moses
 18th-c document, see Kollwitz, *Lipsanothek von Brescia* 8
 Odorici, *Antichità cristiane di Brescia* (1845, 1853, 1858) 67, 79
 Westwood, *Fictile Ivories* (1876) 37
 Kraus, *Christlichen Kunst* 1 (1896) 503 #12
 Stuhlfauth, *Altchristliche Elfenbeinplastik* (1896) 41
 Sybel, *Christliche Antike* (1909) 247
 Kaufmann, *Handbuch der christlichen Archäologie* (1913) 555
 Leclercq, "Brescia," *DACL* 2.1 (1925) fig. 1626
 Kollwitz, *Lipsanothek von Brescia* (1933) 31
 Delbrueck, *Probleme der Lipsanothek* (1952) 6, 10-11
 Morey, *Early Christian Art*[2] (1953) 284
 Volbach, *Early Christian Art* (1958, 1962) 328
 Panazza, *Musei di Brescia* (1959) 57
 Bourguet, *Early Christian Art* (1972) 178
 Watson, "Program of the Brescia Casket" (1981) 287: Exod. 2:5-6
 Area di Santa Giulia (1996) 70

Moses
 Milburn, *Early Christian Art* (1988) 240

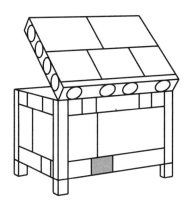

Back. Lower Register, Middle Scene:
Moses Killing the Egyptian
 18th-c document, see Kollwitz, *Lipsanothek von Brescia* 8
 Westwood, *Fictile Ivories* (1876) 37
 Kraus, *Christlichen Kunst* 1 (1896) 503 #13
 Stuhlfauth, *Altchristliche Elfenbeinplastik* (1896) 41
 Sybel, *Christliche Antike* (1909) 247
 Kaufmann, *Handbuch der christlichen Archäologie* (1913) 555
 Leclercq, "Brescia," *DACL* 2.1 (1925) fig. 1626
 Kollwitz, *Lipsanothek von Brescia* (1933) 31
 Delbrueck, *Probleme der Lipsanothek* (1952) 6, 11-12
 Morey, *Early Christian Art*[2] (1953) 284
 Réau, *Iconographie de l'art chrétien* (1956) 2.1:183
 Volbach, *Early Christian Art* (1958, 1962) 328
 Panazza, *Musei di Brescia* (1959) 57
 Bourguet, *Early Christian Art* (1972) 178
 Watson, "Program of the Brescia Casket" (1981) 287
 Area di Santa Giulia (1996) 70

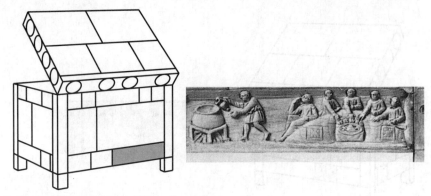

Back. Lower Register, Right Scene:
An agape
Odorici, *Antichità cristiane di Brescia* (1845, 1853, 1858) 67, 79
Westwood, *Fictile Ivories* (1876) 37: "agape (Moses feasting his brethren?)"

Banquet
Kraus, *Christlichen Kunst* 1 (1896) 503 #14
Sybel, *Christliche Antike* (1909) 247

Meal
Stuhlfauth, *Altchristliche Elfenbeinplastik* (1896) 41

Feast of the Quail (Num. 11:31-33)
Venturi, *Storia dell'arte italiana* 1 (1901) 464
Kaufmann, *Handbuch der christlichen Archäologie* (1913) 555
Achelis, "Totenmahle" (1916) 96, Taf. II.2
Kollwitz, *Lipsanothek von Brescia* (1933) 31
[Delbrueck, *Probleme der Lipsanothek* (1952) 6, 12-13]

The Hebrews eating in the desert
[Leclercq, "Brescia," *DACL* 2.1 (1925) col. 1155]
Panazza, *Musei di Brescia* (1959) 57 (with a "?")

Wedding at Cana
[Leclercq, "Brescia," *DACL* 2.1 (1925) fig. 1626]
[Volbach, *Early Christian Art* (1958, 1962) 328]
Bourguet, *Early Christian Art* (1972) 178
Area di Santa Giulia (1996) 70

Feast in the House of Jethro (Exod. 2:20)
[Delbrueck, *Probleme der Lipsanothek* (1952) 6, 12-13]
[Volbach, *Early Christian Art* (1958, 1962) 328]
Grabar, *Christian Iconography* (1968, 1980) pl. 337
Watson, "Program of the Brescia Casket" (1981) 287

Miracle of Manna (Exod. 16)
Morey, *Early Christian Art*[2] (1953) 284

Scene of feasting
Milburn, *Early Christian Art* (1988) 240

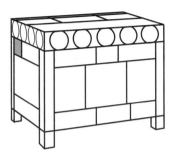 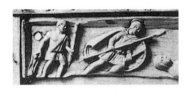

Left Side. Upper Register, Left Scene:
David and Goliath
 Odorici, *Antichità cristiane di Brescia* (1845, 1853, 1858) 67, 84
 Kraus, *Christlichen Kunst* 1 (1896) 503 #25
 Stuhlfauth, *Altchristliche Elfenbeinplastik* (1896) 41
 Sybel, *Christliche Antike* (1909) 247
 Kaufmann, *Handbuch der christlichen Archäologie* (1913) 555
 Leclercq, "Brescia," *DACL* 2.1 (1925) fig. 1628
 Kollwitz, *Lipsanothek von Brescia* (1933) 24
 Soper, "Italo-Gallic School" (1938) 177
 Delbrueck, *Probleme der Lipsanothek* (1952) 7, 17-8
 Morey, *Early Christian Art*[2] (1953) 284
 Volbach, *Early Christian Art* (1958, 1962) 328
 Panazza, *Musei di Brescia* (1959) 57
 Watson, "Program of the Brescia Casket" (1981) 288: 1 Sam. 17:49
 Milburn, *Early Christian Art* (1988) 240
 Area di Santa Giulia (1996) 70

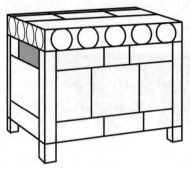 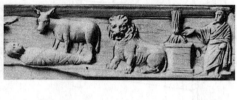

Left Side. Upper Register, Middle and Right Construed as One Scene:
Symbol of the Incarnation surrounded by symbols of idolatry, persecution, heresy
 Polidori, letter Jan. 10, 1847; see Odorici, *Antichità cristiane di Brescia* 67

The Man of God (3 Kings 13:4)
 Kaufmann, *Handbuch der christlichen Archäologie* (1913) 555
 Kollwitz, *Lipsanothek von Brescia* (1933) 25
 Delbrueck, *Probleme der Lipsanothek* (1952) 7, 18

Left Side. Upper Register, Middle Scene:
 Prophet from Judah (3 Kings 13:24)
 18th-c document, see Kollwitz, *Lipsanothek von Brescia* 8
 Odorici, *Antichità cristiane di Brescia* (1845, 1853, 1858) 67, 84
 Kraus, *Christlichen Kunst* 1 (1896) 503 #26
 Stuhlfauth, *Altchristliche Elfenbeinplastik* (1896) 41, 50
 Sybel, *Christliche Antike* (1909) 247
 Kaufmann, *Handbuch der christlichen Archäologie* (1913) 555
 Leclercq, "Brescia," *DACL* 2.1 (1925) fig. 1628
 Kollwitz, *Lipsanothek von Brescia* (1933) 24-25
 Soper, "Italo-Gallic School" (1938) 177
 Delbrueck, *Probleme der Lipsanothek* (1952) 7,18-9
 Morey, *Early Christian Art*[2] (1953) 284
 Panazza, *Musei di Brescia* (1959) 57
 Watson, "Program of the Brescia Casket" (1981) 288
 Area di Santa Giulia (1996) 70

Left Side. Upper Register, Right Scene:
King Jeroboam at the Altar of Bethel (3 Kings 12:33, 13:4)
 18th-c document, see Kollwitz, *Lipsanothek von Brescia* 8
 Stuhlfauth, *Altchristliche Elfenbeinplastik* (1896) 41
 Venturi, *Storia dell'arte italiana* 1 (1901) 463
 Sybel, *Christliche Antike* (1909) 247
 Leclercq, "Brescia," *DACL* 2.1 (1925) fig. 1628
 Kollwitz, *Lipsanothek von Brescia* (1933) 24-25
 Panazza, *Musei di Brescia* (1959) 57
 Volbach, *Early Christian Art* (1958, 1962) 328
 Grabar, *Christian Iconography* (1968, 1980) pl. 334
 Watson, "Program of the Brescia Casket" (1981) 288
 Area di Santa Giulia (1996) 70

The Sacrifice of Elijah (3 Kings 18)
 Odorici, *Antichità cristiane di Brescia* (1845, 1853, 1858) 67, 84

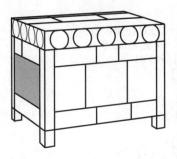 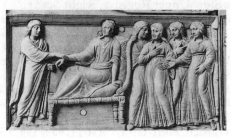

Left Side. Middle Register:
Healing of Peter's Mother-in-Law (Luke 4:38-39)
 18th-c document, see Kollwitz, *Lipsanothek von Brescia* 8
 Venturi, *Storia dell'arte italiana* 1 (1901) 459f

Raising of Jairus's Daughter (Luke 8:52-55)
 Odorici, *Antichità cristiane di Brescia* (1845, 1853, 1858) 67, 84-85
 Kraus, *Christlichen Kunst* 1 (1896) 503 #27
 Stuhlfauth, *Altchristliche Elfenbeinplastik* (1896) 41
 Sybel, *Christliche Antike* (1909) 247
 Kaufmann, *Handbuch der christlichen Archäologie* (1913) 555
 Leclercq, "Brescia," *DACL* 2.1 (1925) fig. 1628
 Kollwitz, *Lipsanothek von Brescia* (1933) 23-24
 Weigand, review of Kollwitz (1935) 431
 Soper, "Italo-Gallic School" (1938) 177
 Delbrueck, *Probleme der Lipsanothek* (1952) 27
 Morey, *Early Christian Art*[2] (1953) 284
 Volbach, *Early Christian Art* (1958, 1962) 328
 Panazza, *Musei di Brescia* (1959) 57
 Schiller, *Iconography* (1969, 1972) 2:179-80
 Kessler, "Acts of the Apostles on Early Christian Ivories" (1979) 112
 Watson, "Program of the Brescia Casket" (1981) 287
 Milburn, *Early Christian Art* (1988) 239
 Area di Santa Giulia (1996) 70

Woman with Flux of Blood
 Grabar, *Christian Iconography* (1968, 1980) pl. 335[1]

[1] Watson is surely correct that this "must be an error"; (1981) 296 n. 32.

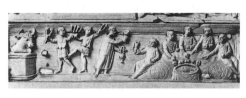

Left Side. Lower Register. Construed as a single scene:
The Israelites eating and dancing before the golden calf (Exod. 32)
 18th-c document, see Kollwitz, *Lipsanothek von Brescia* 8
 Achelis, "Totenmahle" (1916) 96, Taf.II.3
 Leclercq, "Brescia," *DACL* 2.1 (1925) col. 1155
 Panazza, *Musei di Brescia* (1959) 57

Left Side. Lower Register, Left Scene:
Golden Calf
 Odorici, *Antichità cristiane di Brescia* (1845, 1853, 1858) 67, 85
 Raoul-Rochette, letter (1847), see Odorici, *Antichità cristiane di Brescia* 67
 Cav. Zardetti, letter, see Odorici, *Antichità cristiane di Brescia* (1853) 84
 Kraus, *Christlichen Kunst* 1 (1896) 503 #28
 Stuhlfauth, *Altchristliche Elfenbeinplastik* (1896) 41
 Sybel, *Christliche Antike* (1909) 247
 Kaufmann, *Handbuch der christlichen Archäologie* (1913) 555
 Leclercq, "Brescia," *DACL* 2.1 (1925) fig. 1628
 Kollwitz, *Lipsanothek von Brescia* (1933) 25: cf. Jeroboam's golden calf
 Soper, "Italo-Gallic School" (1938) 177
 Delbrueck, *Probleme der Lipsanothek* (1952) 7, 14-15: uncertain
 Morey, *Early Christian Art*2 (1953) 284
 Volbach, *Early Christian Art* (1958, 1962) 328
 Watson, "Program of the Brescia Casket" (1981) 289: Exod. 32:1-6
 Area di Santa Giulia (1996) 70

Left Side. Lower Register, Right Scene:
Agape
 Odorici, *Antichità cristiane di Brescia* (1845, 1853, 1858) 67-68
 Raoul-Rochette, letter 1847, cited Odorici, *Antichità cristiane di Brescia* 68

Meal
 Kraus, *Christlichen Kunst* 1 (1896) 503 #29
 Stuhlfauth, *Altchristliche Elfenbeinplastik* (1896) 41

The feast before Jeroboam's golden calves (3 Kings 12:28-33)
 Kaufmann, *Handbuch der christlichen Archäologie* (1913) 555

Scene of feasting
 Milburn, *Early Christian Art* (1988) 240

Miracle of the loaves and fishes
 Area di Santa Giulia (1996) 70

The Medallion Portraits

The various identifications of the figures portrayed in the medallions are better presented in prose rather than a table, because no scholar proposes a specific identification for each and every medallion portrait. The earliest witness, the eighteenth-century document reported by Kollwitz, simply terms the figures "prophets."[1] Moreover, the number of portraits is variously treated: in fact, of the seventeen original medallions, two have obviously been lost and fifteen survive—five across the front, three out of four survive on each side, and on the back, the pair of hinges limited the number of portraits to four. Nonetheless, many scholars suggest enough identifications to supply as few as thirteen portraits, without noting the numerical discrepancy.[2]

1. Cited by Kollwitz, *Lipsanothek von Brescia* (1933) 6, 8.

2. Leclercq actually refers to "quatorze médaillons" and supplies identifications for only fourteen—Jesus and the twelve, with Matthew replacing Judas, and Saint Paul—but his figures clearly show the fifteen surviving medallions; (1925) col. 1152, but cf. figs. 1625-28. The fullest discussion, treating all seventeen, is Kollwitz (1933) 10-14.

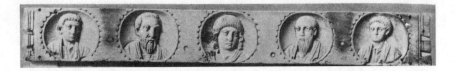

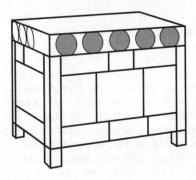

The most sure identifications are that the center front figure is Christ, with Peter to his right (the viewer's left) and Paul to his left.[3] Schultze agrees that the figures are Christ, Paul and the twelve apostles but doesn't indicate which image depicts which man–and ignores the math.[4] Similarly, Kraus notes there are fifteen medallions (but omits the two gaps which indicate lost portraits) and then identifies the medallion portraits as Christ and the apostles, the identifications Dalton also accepts, neither scholar mentioning the problem of the numbers.[5]

While many scholars simply note that the other busts depict apostles or evangelists, a few scholars suggest specific identifications. The outside portraits on the front are identified as Luke on the viewer's left and John on the viewer's right, by Stuhlfauth and Leclercq, and as James and John, the sons of Zebedee, by Delbrueck.[6]

3. Odorici, *Antichità cristiane di Brescia* (1845, 1853, 1858) 74, 79-80, 84-85; Stuhlfauth, *Altchristliche Elfenbeinplastik* (1896) 41; Sybel, *Christliche Antike* (1909) 246; Kaufmann, *Handbuch der christlichen Archäologie* (1913) 555; Leclercq, "Brescia," *DACL* 2.1 (1925) figs. 1625-28; Kollwitz (1933) 11-12; Watson, "Program of the Brescia Casket" (1981) 290; and *Area di Santa Giulia* (1996) 70. Maskell, *Ivories* (1905) 143, and Morey, *Early Christian Art*[2] (1953) 285, identify Christ only, with Morey adding that the twelve apostles are certainly on the rest of the medallions.

4. Schultze, *Altchristlichen Kunst* (1895) 278.

5. Kraus, *Christlichen Kunst* 1 (1896) 502; Dalton, *East Christian Art*, 208.

6. Stuhlfauth, *Altchristliche Elfenbeinplastik* (1896) 41; Leclercq, "Brescia," *DACL* 2.1 (1925) fig. 1625-28; Delbrueck, *Probleme der Lipsanothek* (1952) 37, 39.

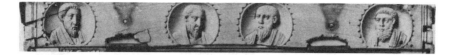

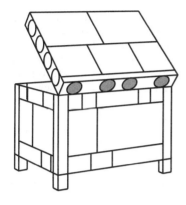

Kaufmann and Kollwitz see the quartet on the back of the casket as the four evangelists.[7] Delbrueck is rare in paying attention to the numbers and in identifying each portrait, even the missing ones.

7. Kaufmann, *Handbuch der christlichen Archäologie* (1913) 555; Kollwitz, *Lipsanothek von Brescia*, 13.

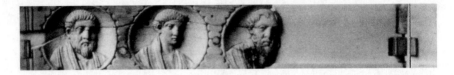

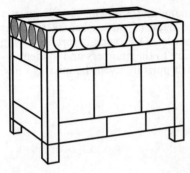

He locates on the left side of the casket, from the viewer's left to right, Thaddaeus, Thomas, Bartholomew, and Andrew (whose bust is missing); and on the right side, from the viewer's left to right, Simon, James Alphaeus, Matthew, and Philip (whose bust is missing); Delbrueck further suggests that, as Weigand had proposed, the other busts may portray prophets, or, Delbrueck adds, Church teachers.[8]

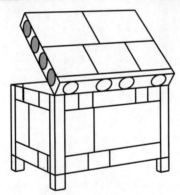

Volbach also provides a full fifteen identifications, though without matching them to specific portraits—Christ, eleven apostles, Saints Matthew, Paul, and Barnabas; he also notes that other portraits have been obliterated.[9] Panazza acknowledges all seventeen medallions and finds in their busts portraits of Jesus, the apostles, and the evangelists.[10] Watson suggests that two of the four medallions on the back might be Gervasius and Protasius and/or that the two others might be Felix and Nabor; she does not suggest which medallions might be which saints.[11] A recent text identifies these medallions only as fifteen "portrait-busts" of Christ, the Apostles, the Evangelists.[12]

8. Delbrueck, *Probleme der Lipsanothek* (1952) 39, cf. to pls. 2-3; Weigand, review of Kollwitz (1935) 430.

9. Volbach, *Early Christian Art* (1958, 1962) 328.

10. Panazza, *Musei di Brescia* (1959) 57.

11. Watson, "Program of the Brescia Casket" (1981) 290.

12. Milburn, *Early Christian Art* (1988) 239.

Symbols

Symbols appear on the casket in nine narrow panels placed along the top edge of the cover and the outer edges of each vertical face, bracketing the New Testament register. Scholarly consideration of these images has varied from general comments about them collectively, which are omitted from this synopsis, to identifications of one or all of them.[1] Watson observes "The placement of these images outside the main compositional rectangle on each face, and in alignment with the scenes of Christ, suggests their function as transcendent allegorical images of the Savior."[2]

1. The scholars whose comments are presented in this appendix are, in chronological order, Odorici, *Antichità cristiane di Brescia* (1845, 1853, 1858) 67, et passim; Kraus, *Christlichen Kunst* (1896) 502-3, figs. 385-87; Schultze, *Altchristlichen Kunst* (1895) 280, n. 1; Stuhlfauth, *Altchristliche Elfenbeinplastik* (1896) 41; Sybel, *Christliche Antike* (1909) 247; Leclercq, *DACL* 2 (1925) col. 1154 and figs. 1625-28; Kollwitz (1933) 23, 25, 28, 32; Soper, "Italo-Gallic School" (1938) 177; Callisen, "Iconography of the Cock on the Column" (1939) 174; Delbrueck, *Probleme der Lipsanothek* (1952) 36-37, 40-50; Morey, *Early Christian Art*² (1953) 136-37, 143, 145; Stern, review of Delbrueck (1955) 117; Volbach, *Early Christian Art* (1956, 1962); Panazza, *Musei di Brescia* (1959) 57; Sauser, (1966) 180-91; Bourguet, *Early Christian Art* (1972) 178; Watson, "Program of the Brescia Casket" (1981) 289-90; Milburn, *Early Christian Art* (1988) 240; *Area di Santa Giulia* (1996) 70.

2. Watson, "Program of the Brescia Casket" (1981) 290.

The Lid. Six birds are shown in side view: the two at the left face each other, as do the two in the center and the two at the right. The birds are separated by five uprights which support a fabric or net that curves beneath the birds: they are either standing on it or caught by it. The birds are almost unanimously construed as doves; a few scholars simply term them birds. Morey finds the doves like those on another ivory casket on which they flank a cross, and construes them as a symbol of heaven.[3] Odorici simply described the cascading draperies without interpreting them.[4] Delbrueck construed them as the veil of the Holy of Holies, language which may well have influenced Panazza, who described it as "un velo disposto a festone."[5] Volbach avoids comment on the cloth, but observes that the six doves represent souls.[6] Recently the drapery has been interpreted as a net. Watson finds in it an allusion to Ps. 124:7 and 91:3 and interprets the symbol as representing souls caught in the snare of sin, whom Christ will free by his passion.[7]

3. Morey, *Early Christian Art*[2] (1953) 136-37, 143, 145.

4. Odorici, *Antichità cristiane di Brescia* (1845, 1853, 1858) 69-71.

5. Delbrueck, *Probleme der Lipsanothek* (1952) 50-51, Panazza, *Musei di Brescia* (1959) 57.

6. Volbach, *Early Christian Art* (1958, 1962). See also Schiller's interpretation of birds on the earliest Passion sarcophagus, ca. 340; (1969, 1972) 2:15.

7. Watson, "Program of the Brescia Casket" (1981) 289. Cf. Milburn: "doves caught in a net, to represent the capture of human souls in the net of salvation"; (1988) 240.

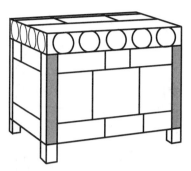

Front. The hanging fish on the left is sometimes just identified as a fish,[8] simply termed "symbolic,"[9] or deemed purely decorative.[10] Watson offers the fullest, and multiple explanation: "The fish is a sign for the title of Christ, IXΘYC being an acrostic of the phrase 'Jesus Christ of God the Son Saviour' in Greek."[11]

On the right of this face, the rooster on a column has been merely identified[12] or held purely decorative.[13] Odorici and Kraus construed it as a symbol of vigilance[14] and Stuhlfauth concurs, adding that it was fittingly juxtaposed to the vigilant Good Shepherd.[15] Delbrueck, Sauser and Watson suggest that it represents the resurrected Christ.[16] The latter scholar also cites Prudentius's "Hymn at Cockcrow" as evidence that "the cock is a sign of the renewed faith, hope, and vigor that come with the dawn.[17] More recently it has been seen as the cock whose crowing marked Peter's denial of Christ.[18] Callisen reads the two symbols on the front as a balanced pair: the rooster probably "symbolizes Peter just as the fish opposite signifies Christ."[19]

8. Sybel, *Christliche Antike* (1909) 247; Schultze, *Altchristlichen Kunst* (1895) 280, n. 1; Panazza, *Musei di Brescia* (1959) 57.

9. Odorici, *Antichità cristiane di Brescia* (1845, 1853, 1858) 67, 81; Kraus, *Christlichen Kunst* (1896) 503 #17; *Area di Santa Giulia* (1996) 70: symbol of Christ.

10. Kollwitz, *Lipsanothek von Brescia* (1933) 23: "rein decorativ."

11. Watson, "Program of the Brescia Casket" (1981) 290. Stuhlfauth, *Altchristliche Elfenbeinplastik* (1896) 49.

12. Sybel, *Christliche Antike* (1909) 247. Panazza, *Musei di Brescia* (1959) 57; Leclercq, *DACL* 2.1 (1925) col. 1154 and figs. 1625;

13. Kollwitz, *Lipsanothek von Brescia* (1933) 23: "rein decorativ."

14. Odorici, *Antichità cristiane di Brescia* (1845, 1853, 1858) 67, 83; Kraus, *Christlichen Kunst* 1 (1896) 503 #17.

15. Stuhlfauth, *Altchristliche Elfenbeinplastik* (1896) 49.

16. Watson, "Program of the Brescia Casket" (1981) 290 and 297 n. 54; see also *Area di Santa Giulia* (1996) 70.

17. Ibid., 290.

18. Milburn, *Early Christian Art* (1988) 240.

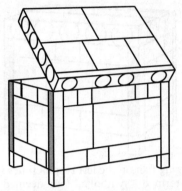

Right Side. Most scholars simply refer to the image at the left as a tree.[20] Stuhlfauth is unique in calling it an oak.[21] Watson asserts that "The tree refers to the tree of life in paradise (Revelation II, 7; XXII, 2), embodiment of the spiritual life available only through Christ. The tree may represent also the righteous man (Jeremiah XVII, 7-8; Matthew VII, 17-20) and thus Christ, the author of all righteousness."[22] The new catalogue from Brescia suggests the tree is the symbol of the knowledge of good and evil.[23]

The righthand panel contains a column with a short tree curved around it, the whole surmounted by a scales. Most scholars simply mention one or more elements of this.[24] Stuhlfauth, however, interpreted the entwined column as a grave stele, and others scholars have followed him.[25] Watson justifies these images thus: "The scale and the grave stele refer to Christ as judge, and to the dead who will rise to the judgment at the end of time (Revelation XX, 12)."[26]

19. Callisen, "Iconography of the Cock on the Column" (1939) 174.

20. Kollwitz, *Lipsanothek von Brescia* (1933) 28, citing similar trees in Early Christian art; Panazza, *Musei di Brescia* (1959) 57.

21. "Eiche": Stuhlfauth, *Altchristliche Elfenbeinplastik* (1896) 41.

22. Watson, "Program of the Brescia Casket" (1981) 290.

23. *Area di Santa Giulia* (1996) 70.

24. Odorici lists "la colomma, il lauro, la bilancia" (1845, 1853, 1858) 87. Schultze mentions only scales; (1895) 280, n. 1. Kollwitz mentions all the elements, describing the tree as a frequent mytholigical motif; (1933) 28.

25. "Wage / Cypress an einer stele"; Stuhlfauth, *Altchristliche Elfenbeinplastik* (1896) 41. Subsequently, "la stadera, una stele con albero," Panazza, *Musei di Brescia* (1959) 57; "scales over grave stele," Watson, "Program of the Brescia Casket" (1981) 290.

26. See also *Area di Santa Giulia* (1996) 70.

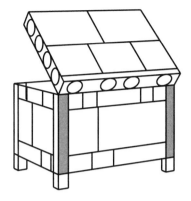

Back. The tower is the sole image which has been interpreted from the start: Odorici considered it a figure for the mystical Jerusalem, which Kraus and Delbrueck accepted.[27] Stuhlfauth takes this further, construing it as pertinent to the Transfiguration which is depicted beside it.[28] Nevertheless, some scholars simply call it a tower.[29] Watson disagrees with Delbrueck and suggests instead that the tower represents "the protective power of God, who is called a strong tower or fortress (Psalm LXI, 3)."[30] Other interpretations have been that it shows a "Hauptbilder" or "the strong tower which represents the Church."[31] A new interpretation is that it is a lighthouse.[32]

The hanging man in the right panel is now universally identified as Judas, as indeed all but one scholar have taken him to be from the start.[33] Panazza considered him to be Absalom,[34] even

27. "La mistica Gerusalemma raffigarata nella torre," Odorici, *Antichità cristiane di Brescia* (1845, 1853, 1858) 67, 76; "Thurm, Sinnbild des mystischen Jerusalem," Kraus, *Christlichen Kunst* 1 (1896) 503, #8; Delbrueck, *Probleme der Lipsanothek* (1952) 36-37, 40-50.

28. Stuhlfauth, *Altchristliche Elfenbeinplastik* (1896) 49.

29. Leclercq calls it a campanile in his text, but simply a "tour" in the caption; *DACL* 2 (1925) col. 1155 and fig. 1626. Scholars who call it simply a tower include Sybel, *Christliche Antike* (1909) 247; Kollwitz (1933) 32; and Panazza, *Musei di Brescia* (1959) 57.

30. Watson, "Program of the Brescia Casket" (1981) 290.

31. Schultze, *Altchristlichen Kunst* (1895) 280, n. 1; Milburn, *Early Christian Art* (1988) 240.

32. *Area di Santa Giulia* (1996) 70.

33. For instance, Odorici, *Antichità cristiane di Brescia* (1845, 1853, 1858) 76; Kraus, *Christlichen Kunst* (1896) 502-3, figs. 385-87; Stuhlfauth, *Altchristliche Elfenbeinplastik* (1896) 41; Sybel, *Christliche Antike* (1909) 247; Leclercq, *DACL* 2 (1925) fig. 1626; Kollwitz (1933) 32; Soper, "Italo-Gallic School" (1938) 177; Stern, review of Delbrueck (1955) 117; Volbach, *Early Christian Art* (1956, 1962); Schiller, *Iconography* (1969, 1972) 2:77; Bourguet, *Early Christian Art* (1972) 178; *Area di Santa Giulia* (1996) 70.

34. Panazza, *Musei di Brescia* (1959) 57.

though Absalom hung by his long hair, not in a noose. Delbrueck and Watson address the similarity between Judas and Christ as portrayed on the casket.[35] Stuhlfauth notes the fitting correspondence between Judas and the adjacently depicted Ananias, for each brought about his own death through avarice and betrayal of the Lord or, in the case of Ananias, the Lord's community.[36]

35. Delbrueck, *Probleme der Lipsanothek* (1952) 36-37, 40-50; Watson, "Program of the Brescia Casket" (1981) 290.

36. Stuhlfauth, *Altchristliche Elfenbeinplastik* (1896) 49.

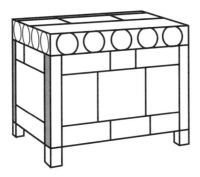

 Left Side. The cross on the left side has drawn little comment, presumably because scholars consider its presence self-explanatory.[37] Stuhlfauth asserts that both the *crux immissa* and the lampstand on the right refer to the resurrection, depicted beside this symbol in the raising of Jairus's daughter.[38] Watson observes that "the cross symbolizes Christ as redeemer."[39] The righthand symbol is universally taken as a lampstand,[40] Watson suggests this "signifies both Christ as the light of the world (John VIII, 12), and also the righteous believer (Matthew V, 14) whose righteousness is not his own but is derived from Christ.[41]

37. The presence of the cross is mentioned by e.g. Odorici, *Antichità cristiane di Brescia* (1845, 1853, 1858) 87, Kollwitz (1933) 25, and Panazza, *Musei di Brescia* (1959) 57.

38. Stuhlfauth, *Altchristliche Elfenbeinplastik* (1896) 49-50.

39. Watson, "Program of the Brescia Casket" (1981) 290. See also *Area di Santa Giulia* (1996) 70.

40. For instance, Odorici, *Antichità cristiane di Brescia* (1845, 1853, 1858) 87; Schultze, *Altchristlichen Kunst* (1895) 280, n. 1; Stuhlfauth, *Altchristliche Elfenbeinplastik* (1896) 41; Sybel, *Christliche Antike* (1909) 247; Kollwitz (1933) 25; Panazza, *Musei di Brescia* (1959) 57; and Milburn, *Early Christian Art* (1988) 240; *Area di Santa Giulia* (1996) 70.

41. Watson, "Program of the Brescia Casket" (1981) 290.

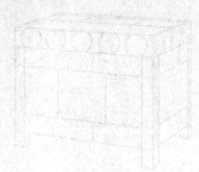

BIBLIOGRAPHY

Abbreviations are included in the second section. In the third section of the bibliography, the asterisk (*) identifies those works which are represented in the Table of Identifications.

1. Sources

A) *The Bible*

Biblia Sacra iuxta Vulgatam versionem, 4th rev. ed. Stuttgart: Württembergische Bibelanstalt, 1994.

Bibliorum Sacrorum latinae versiones antiquae seu vetus italica et cetera quaecunque in codicibus manuscriptis et antiquorum libris reperiri potuerunt. Ed. Pierre Sabatier. Reims 1739-49. Repr. Paris 1751. Repr. 1949.

The New Oxford Annotated Bible with the Apocrypha. Ed. Herbert G. May and Bruce M. Metzger. Expanded Edition. RSV. New York: Oxford University Press, 1977.

Psalterii secundum Vulgatam Bibliorum Versionem nova recensio. Ed. Robert Weber. Clervaux: Abbaye S. Maurice et S. Maur, 1961.

Vetus latina; die Reste der altlateinische Bibel, nach Petrus Sabatier neu gesammelt und hrsg. von der Erzabtei Beuren. Ed. Bonifatius Fischer, Herman Josef Frede. Freiburg: Herder, 1949-.

B) *Patristic and hagiographic texts*

Acta S. Julianae. Acta Sanctorum Feb. 2:868-87.

Agapetus. *Expositio capitum admonitoriorum*. (PG 86.1:1164-85).

___. *De Cain et Abel* (PL 14:315-60).

Ambrose. *De Cain et Abel libri duo* (PL 14:315-60).

___. *De excessu fratris* (CSEL 73)

___. *De Nabuthae* (CSEL 32.2:467-516).

___. *Expositio Evangelii secundum Lucam* (CCL 14:1-400).

___. *Explanatio psalmi* (CSEL 44).

Apringius Pacencis, *Tractatus in Apocalipsim*. PL Supplementum 4:1222-48.

Asterius. *Logos eis ton propheten Daniel kai eis ten Sosannan*.

Augustine. *Confessions*.

___. *Contra Faustum*. (CSEL 25.1).

___. *Contra Gaudentium Donatistarum episcopum libri duo* (CSEL 53).

___ *Contra litteras Petiliani* (CSEL 52.2:1-228).

___ *De civitate Dei* (CCL 47-48).

___ *De magistro* (CSEL 77).

___ *De utilitate credendi* (CSEL 25.1:1-48).

___ *Enarrationes in Psalmos* (CCL 38-40).

___ Epistola 102, to Deogratias (CSEL 34.2:544-78).

___ Epistola 111, to Victorianus (CSEL 34.2:642-57).

___ Epistola 140, "Liber de gratia Novi Testamenti ad Honoratum" (CSEL 44:155-234).

___ Epistola 150 (CSEL 44:382).

___ *In Joannis evangelium tractatus CXXIV* (Bibliothèque Augustinienne 71).

___ *In epistolam Joannis ad Parthos tractatus decem* (PL 35:1377-2062).

___ *In I Epistolam Joannis tractatus* (Bibliothèque Augustinienne).

___ *Quaestionum libri septem* (CSEL 28.2).

___ *Sermo 2: De tentatione Abrahae a Deo* (PL 38:26-32).

___ *Sermo 17: In solemnitate SS. Machabaeorum* (PL 46:874-81).

___ *Sermo 32: De Golia et David et de contemptu mundi* (CCL 41:397-411).

___ *Sermo 286: In natali martyrum Protasii et Gervasii* (PL 38:1297-1301).

___ *Sermo 300: In solemnitate martyrum Machabaeorum* (PL 38:1376-80).

___ *Sermo 301: In solemnitate SS. Machabaeorum, II* (PL 38:1380-85).

___ *Sermo 343: De Susanna et Joseph* Ed. Cyrille Lambot. *Revue Bénédictine* 66 (1956) 20-38.

___ *Sermo 350: De charitate, II* (PL 39:1533-35).

Avitus. *De spiritalis historiae gestis*. Ed. Rudolfus Peiper. MGH auct. ant. 6.2.

___ *De virginitate* (PL 59:369-82).

Caesarius of Arles. *Sermo 86*. (CCL 103:354-57).

___ *Sermo 87: De scala Iacob*. (CCL 103:357-61).

___ *Sermo 88: De Beato Iacob et Laban*. (CCL 103:361-65).

___ *Sermo 167*. (CCL 104:682-87).

___ *Sermo 179*. (CCL 104:723-29).

Chromatius Aquileiensis. *Sermo 24: De Sancto Patriarcha Joseph* (CCL 9A:107-11).

___ *Sermo 35* (fragment): *De Susanna* (CCL 9A:158-60).

Clement of Alexandria. *Paedagogus* 5 (SC 70).

___ *Stromata*. (CGS 52, 3rd ed.)

Les constitutions apostoliques. Ed. Marcel Metzger. SC 320, 329, 336 (1985, 1986, 1987).

Cyprian. *Ad Quirinum*. (CCL 3.1:1-179).

___ *De opere et eleemosynis* (CSEL 3:373-94).

___ *De Pascha computus* (CSEL 3).

___ *Epistulae* (CSEL 3.2).

___ *Testimoniorum libri tres*, or, *Ad Quirinum*. (CSEL 3.1.35-184).

Dracontius. *De laudibus Dei*. Ed. Frideric Volmer in MGH auct. ant. 14 (1905, new ed. 1961).

Eusebius of Caesarea. *De laudibus Constantini oratio in ejus tricennalibus habita.* (PG 20:1316-1440).

Eusebius Gallicanus. *Homilia XIII: De Pascha, 2.* (CCL 101:155-61).

Evagrius monachus. *Altercatio legis inter Simonem Iud. et Theophilum Christianum.* (CSEL 45).

Faustinus. *Homilia de passione Domini.* (PL 59:407-10).

Faustus Rhegiens. *Epistola XXIV: Seu sermone de resurrectione Domini.* (PL 30:215-20).

Hilary of Poitiers. *Tractatus in psalmum 1* (CSEL 22).

___ *Tractatus in psalmum 68* (CSEL 22).

___ *Tractatus mysterium* (CSEL 65).

Hippolytus of Rome, *Commentaria in Danielem* in *Hippolytus Werke* 1.1 (GCS 1, Leipzig 1897). See also SC 14.

Ignatius of Antioch. *Lettres.* Greek ed. with Fr. trans. P. Th. Camelot, O.P. Source Chrétiennes. 3rd ed. Paris: Éditions du Cerf, 1958.

Isidore of Seville. *Allegoria quaedam sacrae scripturae* (PL 83: 97-130).

Jerome, St. *Commentaria in Danielem* (CCL 75A).

___ *Commentaria in Ionam Prophetam* (CCL 76).

___ *Commentaria in Sophoniam Prophetam liber unus* (CCL 76A:655-711).

___ Epistola 1 (CSEL 65).

___ Epistola 8, "De studio scripturarum." (CSEL 65).

___ Epistola 65 (CSEL 65).

___ Epistola 129 (CSEL 66).

___ *Tractatus de Psalmis* (CCL 78).

Maximus, bishop of Turin. *Sermones* (CCL 23).

Melito of Sardis. *On Pascha and Fragments.* Ed. and tr. Stuart George Hall. Oxford Early Christian Texts. Oxford: Clarendon Press, 1979.

Origen. *Commentaria in Matthaeum 12,* in *Origenes Werke* 10. (GCS 40, Berlin 1935).

___ *Homilia in Genesim* (GCS 29).

Paschasius Radbertus. *Expositio in Matheo. Libri XII* (CCM 56, 56A, 56B).

Paulinus of Nola. *Carmina.* (CSEL 30).

___ *Epistula* 28. (CSEL 29:240-47).

___ *Epistula* 38. (CSEL 29:323-34).

Peter Chrysologus. *Sermo 37: De Jonae prophetae signo* (CCL 24:211-15).

Prosper of Aquitaine. *Liber de promissionibus et praedictionibus Dei* (PL 51:733-858).

Prudentius. *Liber Apotheosis* (CCL 126:73-115).

___ *Peristephanon* (CCL 126:251-389).

Pseudo-Dionysios. Epistles (PG 3).

Rabanus Maurus. *Commentaria in Exodum* (PL 108:1-246).

___ *De universo* (PL 111:1-614).

Raoul Ardens. *Homiliae* (PL 155).

Tertullian. *Adversus Marcionem* (CCL 1:441-726).

___ *Adversus Iudaeos* (CCL 2:1339-1396).

___ *De anima* (CCL 2:781-869).

Zeno of Verona. *Tractatus* (CCL 22).

___ *Tractatus de sancta Susanna* (CCL 22).

2. Research Tools and Series

Andresen, Carl. *Augustinus-Gespräch der Gegenwart.* Bound with *Augustinus-Bibliographie.* Cologne: Wienand Verlag, 1962.

___, ed. *Bibliographia Augustiniana.* Darmstadt: Wissenschaftliche Buchgesellschaft, 1973.

Atlas of the Early Christian World. F. van der Meer and Christine Mohrmann. Tr. and ed. Mary F. Hedlund and H. H. Rowley. London: Thomas Nelson and Sons, Ltd, 1958.

Augustine Concordance Project of the University of Würzburg, also located at Villanova University. Machine-readable collection of the critical Latin editions of the works of St. Augustine, first established by Professor Cornelius Mayer, O.S.A. (For information, contact Fr. Allan Fitzgerald, O.S.A., Villanova University, Department of Religious Studies, Villanova, Pennsylvania 19085 U.S.A.)

Augustinus-Lexikon. Ed. Cornelius Mayer et al. Vol. 1 still in progress. Basel: Schwabe & Co, 1986-.

Bavel, T. van. *Répertoire bibliographique de saint Augustin, 1950-1960.* Instrumenta Patristica 3. Steenbrugis: In Abbatia Sancti Petri, 1963.

Biblia patristica: Index des citations et allusions bibliques dans la littérature patristique. 1. Des origines à Clément d'Alexandrie et Tertullien. 2. Le troisième siècle (Origène excepté). 3. Origène. 4. Eusèbe de Cèsarèe, Cyrille de Jérusalem, Epiphane de Salamine. Paris: CNRS, 1975, 1977, 1980, 1987.

Blaise, Albert. *Lexicon latinitas medii aevi: praesertim ad res ecclesiasticas investigandas pertinent = Dictionnaire latin-fançais des auteurs du Moyen Âge.* CCM. Turnholt: Typographi Brepols, 1975.

BTT: Bible de tous les temps. 6 vols. Ed. Charles Kannengiesser. Paris: Beauchesne, 1984-.

CLCLT: CETEDOC Library of Christian Latin Texts. CD-ROM. Brepols: Catholic University of Louvain, 1991.

CCL: Corpus Christianorum, Series Latina.

CCM: Corpus Christianorum, Continuatio Mediaevalis.

Clavis patrum latinorum qua in novum Corpus Christianorum edendum optimas quasque scriptorum recensiones a Tertulliano ad Bedam commode recludit, Elegius Dekkers opera usus qua rem praeparavit et iuvit Aemilius Garr vindobonensis editio altera aucta et emendata. Steenbrugis: In Abbatia S. Petri, 1961. Published as a special issue of *Sacris Erudiri.*

Clavis patrum graecorum. Ed. M. Geerard. Corpus Christianorum. Turnhout: Brepols, 1974-.

CSEL: Corpus Scriptorum Ecclesiasticorum Latinorum.

DACL: Dictionnaire d'archéologie chrétienne et de liturgie. 15 vols. Ed. Fernand Cabrol and Henri Leclercq. Paris: Letouzey et Ane, 1924-53.

DMA: *Dictionary of the Middle Ages*. Ed. J. Strayer. 13 vols. New York: Charles Scribner's Sons, 1982-89.

DS: *Dictionnaire de Spiritualité, ascétique et mystique, doctrine et histoire*. 6 vols. in 8. Paris: G. Beauchesne et ses fils, 1937-67.

EEC: *Encyclopedia of Early Christianity*. Ed. Everett Furguson et al. New York: Garland Publishing, 1990.

GCS: Der Griechischen Christlichen Schriftsteller der Ersten Jahrhunderte.

ICA: Princeton Index of Christian Art. If a note cites no plate for a work of art but cites ICA, then a photograph of the image is on file in the ICA.

Larousse: *Larousse Encyclopedia of Byzantine and Medieval Art*. New York: Promethius Press, 1958.

LCI: *Lexikon der christlichen Ikonographie*. Ed. E. Kirschbaum, W. Braunfels. 8 vols. Rome-Freiburg-Basel-Vienna, 1968-76.

MGH, auct. ant. = Monumenta Germaniae Historica, auctorum antiquissimorum.

Miethe, Terry L., comp. *Augustinian Bibliography, 1970-1980*. Westport, Connecticutt: Greenwood Press, 1982.

NCE: *New Catholic Encyclopedia*. 18 vols. New York: McGraw-Hill Book Company, 1967.

Novae concordantiae Bibliorum Sacrorum iuxta Vulgatam versionem critice editam. Ed. Bonifatius Fischer. 5 vols. Stuttgart: Frommann-Holzboog, 1977.

ODB: *The Oxford Dictionary of Byzantium*. Ed. Alexander P. Kazhdan et al. 3 vols. New York: Oxford University Press, 1991.

PG: Patrologia Graeca.

PL: Patrologia Latina.

RAC: *Reallexikon für Antike und Christentum: Sachwörter-buch zum Auseinandersetzung des Christentums mit der antiken Welt*. Ed. Theodor Klauser. vol. 1-. Stuttgart: Anton Hiersemann, 1950-.

RBK: *Reallexikon zur byzantinischen Kunst*. Ed. Marcell Restle. vol. 1-. Stuttgart: Anton Hiersemann, 1966-.

SC: Sources Chrétiennes.

TDNT: *Theological Dictionary of the New Testament*. 9 vols. Ed. G. Kittel and Gerhard Friedrich. Grand Rapids: William B. Eerdmans, 1964-74.

3. Secondary Literature

Aberbach, Moses, and Leivy Smolar. "Aaron, Jeroboam, and the Golden Calves." *Journal of Biblical Literature* 86 (1967) 129-40.

*Achelis, Hans. "Altchristliche Kunst, 5: Die Totenmahle." *Zeitschrift für die neutestamentliche Wissenschaft und die Kunde des Urchristentums* 17 (1916) 81-107. Earlier parts in 12 (1911) 296ff., 13 (1912) 212ff., 14 (1913) 324ff., 16 (1915) 1ff.

Alter, Robert, and Frank Kermode, ed. *The Literary Guide to the Bible*. Cambridge, MA: The Belknap Press of Harvard University Press, 1987.

Anderson, James E. "The Words and Pictures of the Franks Casket, Front Panel." Paper read at the Thirtieth International Congress on Medieval Studies, Western Michigan University, May 4-7, 1995. Abstract in *Old English Newsletter* 28.3 (1995) A26-A27.

Andrieu, Michel. "Chronique d'Archéologie Chrétienne: Les origines de l'iconographie médiévale," *Revue des Sciences Religieuses* 4 (1924).

L'area di Santa Giulia: un itinerario nella storia: la domus, e capanne longobarde, il monastero, il tesoro. Ed. Ida Gianfranceschi and Elena Lucchesi Ragni. Brescia: di Monastero di Santa Giulia, 1996.

*Avery, Myrtilla. "The Alexandrian Style at Santa Maria Antiqua, Rome," *Art Bulletin* 7 (1924-25) 131-49.

Banck, Alisa Vladimirovna. *Byzantine Art in the Collections of the U.S.S.R.* Leningrad: Sovietsky Khudozhnik, 1966. English trans.: Alice Bank, *Byzantine Art in the Collections of Soviet Museums.* Trans. from the Russian by Inna Sorokina, photographs by Lydia Tarasova. Leningrad: Aurora Art Publishers, 1977; New York: Harry N. Abrams, Inc., Publishers, 1978.

Bargebuhr, Frederick P. *The Paintings of the "New" Catacomb of the Via Latina and the Struggle of Christianity against Paganism.* Heidelberg: Winter, 1991.

Baumstark, Anton. "Eine Parallele zur Commendatio animae in griechischer Kirchenpoesie," *Oriens Christianus,* n.s. 4 (1914-15) 298-305.

___ . "Paradigmengebete östsyrischer Kirchendichtung," *Oriens Christianus,* n.s. 10-11 (1920-21) 1-32.

*Becker, Erich. "Das Martyrium des sieben makkabäischen Brüder auf der Lipsanothek von Brescia," *Monatschrift für Gottesdienst und kirchliche Kunst* 28 (1923) 72-74.

Beckwith, John. *Early Christian and Byzantine Art.* 2nd ed. New York: Penguin Books, 1979.

Benoît, Fernand. *Sarcophages paléochrétiens d'Arles et de Marseille.* Supplément à "Gallia" 5. Paris: CNRS, 1954.

Besserman, Lawrence L. *The Legend of Job in the Middle Ages.* Cambridge, MA: Harvard University Press, 1979.

Bonsirven, Joseph. "Exégèse allégoriques chez les rabbins tannaites." *Recherches de science religieuse* 23 (1933) 513-41 and 24 (1934) 35-46.

Booij, Th. "Mountain and Theophany in the Sinai Narrative." *Biblica* 65 (1984) 1-26.

*Bourguet, Pierre du. *Early Christian Art.* Tr. Thomas Burton. London: Weidenfeld and Nicolson, 1972.

Brescia, Cittá di S. Giulia: The History of the Town. Brescia: Azienda di promozione turistica, [1996 or 1997].

Brown, Peter. *Augustine of Hippo: A Biography.* Berkeley: University of California Press, 1967. Reprint 1969.

___ . Review of Mathews. *Art Bulletin* 77.3 (1995): 499-502.

Buschhausen, Helmut. *Die spätrömischen Metallscrinia und frühchristlichen Reliquiare.* Vol. 1: *Katalog.* Wiener Byzantinische Studien, Bd. 9. Vienna: Hermann Böhlaus, 1971.

*Callisen, S. A. "The Iconography of the Cock on the Column." *Art Bulletin* 21 (1939) 160-78.

Campbell, James Marshall, and Martin R. P. McGuire, eds. *The Confessions of St. Augustine, Books I-IX (Selections).* Englewood Cliffs, N.J.: Prentice-Hall, Inc., 1931.

Carrà, Massimo. *Ivories of the West.* Tr. Raymond Rudorff. New York: Hamlyn, 1970.

Casel, Odo. "Alteste christliche Kunst und Christus-mysterium." *Jahrbuch für Liturgiewissenschaft* 12 (1932) 1-86.

Casey, Jay Smith. "Exodus Typology in the Book of Revelation." Ph.D. diss.: Southern Baptist Theological Seminary, 1982.

Charity, Alan Clifford. *Events and Their Afterlife: The Dialectics of Christian Typology in the Bible and Dante.* Cambridge: Cambridge University Press, 1966.

Clifford, Richard J., S.J. *The Cosmic Mountain in Canaan and the Old Testament.* Harvard Semitic Monographs 4. Cambridge: Harvard University Press, 1972.

Coche de la Ferté, Etienne. *L'antiquité chrétienne au Musée du Louvre.* Paris: Editions de l'Œil, 1958.

Colletta, John P. "The Prophet Daniel in Old French Literature and Art." Ph.D. diss.: The Catholic University of America, 1981.

Cornell, Henrik. *Biblia Pauperum.* Stockholm: Thule-Tryck, 1925.

Corrigan, Kathleen. *Visual Polemics in the Ninth-Century Byzantine Psalters.* Cambridge, Eng.: Cambridge University Press, 1992.

Curran, John. Review of Malbon. *The Journal of Roman Studies* 82 (1992) 305-08.

*Dalton, Ormonde Maddak. *East Christian Art: A Survey of the Monuments.* Oxford: Clarendon Press, 1925.

Daly, Robert J. *Christian Sacrifice: The Judaeo-Christian Background Before Origen.* The Catholic University of America Studies in Christian Antiquity 18. Washington, D.C.: The Catholic University of America Press, 1978.

Daniélou, Jean. *From Shadows to Reality: Studies in the Biblical Typology of the Fathers.* Trans. Dom Wulstan Hibberd. Westminster, England: The Newman Press, 1960. Original: *Sacramentum futuri: Etudes sur les origines de la typologie biblique.* Études de Théologie Historique. Paris: Beauchesne et ses fils, 1950.

Daube, David. *The Exodus Pattern in the Bible.* All Souls Studies 2. London: Faber and Faber, 1963.

⸺ *The New Testament and Rabbinic Judaism.* Jordan Lectures in Comparative Religion 2. London: University of London, The Athlone Press, 1956. Reprint New York: Arno Press, 1973.

*Davin, (l'abbé V.). "La *capella greca* du cimetière de Priscille. Quinzième article. Susanne dans l'antiquité chrétienne." *Revue de l'art chrétien* 29 (1880) 127-66, 286-358.

Davidson, Richard Melvin. "Typological Structures in the Old and New Testaments." Ph.D. diss.: Andrews University, 1981.

Deichmann, Friedrich Wilhelm. *Repertorium der Christlich-Antiken Sarkophage.* Vol. 1: *Rom und Ostia.* Pt. 2: *Tafelband.* Wiesbaden: Franz Steiner Verlag, 1967.

*Delbrueck, Richard. *Probleme der Lipsanothek in Brescia.* Theophaneia: Beiträge zur Religions- und Kirchengeschichte des Altertums 7. Bonn: Peter Hanstein Verlag, 1952.

Deléani-Nigoul, Simone. "Les *exempla* bibliques du martyre." *Le monde latin antique et la Bible.* BTT 2 (1985) 243-60.

⸺ "L'utilisation des modéles bibliques du martyre par les écrivains du IIIe siècle." *Le monde latin antique et la Bible.* BTT 2 (1985) 315-38.

de Palol, Pedro. *Arte Paleocristiano en Espana.* Biblioteca de Arte Hispanico. Barcelona: Ediciones Poligrafa, n.d.

De Wald, Ernest T. *The Illustrations in the Manuscripts of the Septuagint.* Vol. 3: *Psalms and Odes.* Part 1: *Vaticanus Graecus 1927.* Princeton: Princeton University Press, 1941.

Diehl, Charles. *L'art chrétien primitif et l'art byzantin*. Paris and Brussels, 1928.

Dozeman, Thomas B. *God on the Mountain: A Study of Redaction, Theology and Canon in Exodus 19-24*. The Society for Biblical Literature Monograph Series 37. Atlanta: Scholars Press, 1989.

Dulaey, Martine. "La parabole de la brebis perdue dans l'Église ancienne: De l'exégèse à l'iconographie." *Revue des études augustiniennes* 39 (1993) 3-22.

__. "Le symbole de la baguette dans l'art paléochrétien." *Revue des études augustiniennes* 19 (1973) 3-38.

Dumas, A., ed. *Liber Sacramentorum Gellonensis*. (CCL 159a).

Emmerson, Richard K. *The Biblia Pauperum Codex Palatinus Latinus 871 in the Vatican Library*, published separately as *Commentary to the Facsimile Volume Pal. Lat. 871*. Yorktown Heights, NY: Belser Incorporated, 1989.

__. "*Figura* and the Medieval Typological Imagination." Pp. 7-42 in *Typology and English Medieval Literature*. Ed. Hugh T. Keenan. Georgia State Literary Studies 7. New York: AMS Press, 1992.

Fischer, J. "Das Problem des neuen Exodus in Isaias c.40-55." *Theologische Quartalschrift* 110 (1929) 111-30.

Fitzmyer, Joseph A. "Now This Melchizedek . . . (Heb 7:1)." *Catholic Biblical Quarterly* 25 (1963) 305-21. Reprint as pp. 221-43 in his *Essays on the Semitic Background of the New Testament*. London: Chapman, 1971; reprint Missoula, Mon.: Scholars Press, 1974.

Friedman, John B. "Bald Jonah and the Exegesis of 4 Kings 2.23." *Traditio* 4.4 (1988) 125-44.

Froehlich, Karlfried, ed. and tr. *Biblical Interpretation in the Early Church*. Sources of Early Christian Thought. Philadelphia: Fortress, 1984.

Galavaris, George. *The Illustrations of the Liturgical Homilies of Gregory Nazianzenus*. Princeton: Princeton University Press, 1969.

*Gerke, F. "Des Verhältnis von Malerei und Plastik in der Theodosianisch-Honoraria-nische Zeit." *Rivista di Archeologia Cristiana* 12 (1935) 119-63.

Glancy, Jennifer A. "The Accused: Susanna and Her Readers." *Journal for the Study of the Old Testament* 58 (1993) 103-16. Reprint in *A Feminist Companion to Esther, Judith and Susanna*. Ed. Athalya Brenner. The Feminist Companion to the Bible, vol. 7, pp. 288-302.

Glasson, Thomas Francis. *Moses in the Fourth Gospel*. Studies Biblical Theology 40. London: SCM Press, 1963.

Goff, Alan Rex. "Biblical Typology: Continuity and Innovation." Ph.D. diss.: State University of New York at Albany, 1993.

Goppelt, Leonhard. *Typos: The Typological Interpretation of the Old Testament in the New*. Tr. Donald H. Madvig. Grand Rapids: William B. Eerdmans, 1982.

Gougaud, L. "Étude sur les «Ordines commendationis animae»." *Ephemerides liturgicae*. N.s. 49 (1935) 3-27.

__. "Une oraison protéiforme de l'Ordo commendationis animae." *Revue Bénédictine* 47 (1935) 8-11.

Goulder, Michael Douglas. *Type and History in Acts*. London: Society for the Promotion of Christian Knowledge, 1964.

*Grabar, André. *L'art de la fin de l'Antiquité et du Moyen Âge.* 3 vols. Paris: Collége de France, 1968.

*___. *Christian Iconography: A Study of Its Origins. The A. W. Mellon Lectures in the Fine Arts, 1961. The National Gallery of Art, Washington, D.C.* Bollingen Series 35.10. Princeton: Princeton University Press, 1968, reprint 1980.

___. *Early Christian Art from the Rise of Christianity to the Death of Theodosius.* New York: Odyssey Press, 1968. Published in Europe as *Premier art chrétien.* France: Éditions Gallimard, 1966; and *The Beginnings of Christian Art, 200-395.* Trans. Stuart Gilbert and James Emmons. London: Thames and Hudson, 1967.

Grant, Robert McQueen. *The Letter and the Spirit.* New York: Macmillan, 1957.

*Gräven, Hans. *Antike Schnitzereien aus Elfenbein und Knochen.* Series 1. Rome: 1902.

___. *Frühchristliche und mittelalterliche Elfenbeinwerke in photographischer Nachbildung.* Series 2: Aus Sammlungen in Italien. Rome: Istituto archeologico germanico, 1900.

Green, Rosalie, et al. *Herrad of Hohenbourg, Hortus deliciarum.* Studies of the Warburg Institute 36. London: Warburg Institute, 1979.

Grillmeier, A. *Christ in Christian Tradition.* Tr. J. Bowden. 2d. ed. Atlanta: John Knox Press, 1975.

Guinot, Jean-Noël. "La typologie comme technique herméneutique." Pp. 1-34 in *Figures de l'Ancien Testament chez les Pères.* Cahiers de Biblia Patristica 2. Strasbourg: Centre d'analyse et documentation patristiques, 1989.

Halkin, François. "Les deux passions inédites du martyr Lucillien." *Analecta Bollandiana* 84 (1966) 5-28.

Hamman, A.-G. "La typologie biblique et sa formulation chez Tertullien." Pp. 137-46 in *Eulogia: Mélanges offerts à Antoon A. R. Bastiaensen à l'occasion de son soixante-cinquième anniversaire.* Instrumenta Patristica 24. Ed. G. J. M. Bartelink et al. Steenbruge: In Abbatia S. Petri, 1991.

Hanson, Richard Patrick Crosland. *Allegory and Event: A Study of the Sources and Significance of Origen's Interpretation of Scripture.* Richmond, VA: John Knox Press, 1959.

Henry, Avril. *Biblia Pauperum: A Facsimile and Edition.* Ithaca: Cornell University Press, 1987.

Henry, Françoise. *Irish Art.* 2 vols. Ithaca: Cornell University Press, 1967.

Hurst, Lincoln Douglas. *The Epistle to the Hebrews: Its Background of Thought.* Cambridge: Cambridge University Press, 1990.

James, Montague Rhodes, ed. *The Lost Apocrypha of the Old Testament: Their Titles and Fragments.* London: Society for Promoting Christian Knowledge, 1936.

Jay, Pierre. "Le Purgatoire dans la prédication de saint Césaire d'Arles." *Recherches de théologie ancienne et médiévale* 24 (1957) 5-14.

___. "Saint Cyprien et la doctrine du Purgatoire." *Recherches de théologie ancienne et médiévale* 27 (1960) 133-36.

Jensen, Robin M. "The Offering of Isaac in Jewish and Christian Tradition: Image and Text." *Biblical Interpretation* 2.1 (1994) 85-100.

Kampen, Natalie Boymel. Review of Michael Koortbojian, *Myth, Meaning and Memory on Roman Sarcophagi.* Berkeley: University of California Press, 1995. In *Bryn Mawr Classical Review* 95.12.21. Online.

Kartsonis, Anna D. *Anastasis: The Making of an Image.* Princeton: Princeton University Press, 1986.

Kaske, R. E. in collaboration with Arthus Groos and Michael W. Twomey. *Medieval Christian Literary Imagery: A Guide to Interpretation*. Toronto Medieval Bibliographies 11. Toronto: University of Toronto Press, 1988.

*Kaufmann, Carl Maria, *Handbuch der christlichen Archäologie*, 2nd ed., rev. and enl. Paderborn, F. Schoningh, 1913.

Kaufmann, David. "Sens et origine des symboles tumulaires de l'Ancien-Testament dans l'art chrétien primitif." *Revue des études juives* 14 (1887) 33-48, 217-53.

Kelly, John Norman Davidson. *Early Christian Doctrines*. 4th ed. London: Adam & Charles Black, 1969.

Kennedy, George A. *Classical Rhetoric and Its Christian and Secular Tradition from Ancient to Modern Times*. Chapel Hill: The University of North Carolina Press, 1980.

___. *Greek Rhetoric under the Christian Emperors*. Princeton: Princeton University Press, 1983.

Kennedy, Harry Angus Alexander. *The Theology of the Epistles*. London: Duckworth, 1919. Reprint 1959.

*Kessler, Herbert. "Scenes from the Acts of the Apostles on Some Early Christian Ivories," *Gesta* 18 (1979) 109-19. Reprint as pp. 89-100 in *Art, Archaeology, and Architecture of Early Christianity*. Ed. Paul Corby Finney. Studies in Early Christianity 18. New York: Garland Publishing, Inc., 1993.

Kitzinger, Ernst. *Byzantine Art in the Making: Main Lines of Stylistic Development of Medieval Art, 3rd-7th Century*. London: Faber and Faber, 1977.

Kleinbauer, W. Eugene. Review of Mathews. *Speculum* 70.4 (1995) 937-41.

*Kollwitz, Johannes. *Die Lipsanothek von Brescia*. Studien zur spätantiken Kunstgeschichte 7. Berlin: Walter de Gruyter & Co., 1933.

Kornbluth, Genevra. "The Susanna Crystal of Lothar II: Chastity, the Church, and Royal Justice." *Gesta* 31.1 (1992) 25-39.

*Kraus, Franz Xaver[!]. *Geschichte der christlichen Kunst*. 2 vols. in 3. Freiburg im Bresgau: Herder, 1896-1908.

*___. "Gott." *Real-Encyklopädie der christlichen Alterthümer*. Ed. F. X. Kraus. Freiburg im Breisgau: Herder Verlags, 1882. 1:628-30 and fig. 227.

La Bonnardière, Anne-Marie. "Augustine a-t-il utilisé la «Vulgate» de Jérôme?" *Saint Augustin et la Bible*, ed. la Bonnardière, BTT 3 (1986) 303-12.

___. *Biblia Augustiniana*. Paris: Études Augustiniennes, 1960-.

___. *Recherches de Chronologie Augustinienne*. Paris: Études Augustiniennes, 1965.

Labriola, Albert C. and John W. Smeltz, tr. and comm. *The Bible of the Poor [Biblia Pauperum]: A Facsimile and Edition of the British Library Blockbook C.9 d.2*. Pittsburgh: Duquesne University Press, 1990.

Laughlin, John C. H. "The 'Strange Fire' of Nadab and Abihu." *Journal of Biblical Literature* 95 (1976) 559-65.

Lauterbach, Jacob Z. "The Ancient Jewish Allegorists in Talmud and Midrash." *Jewish Quarterly Review* n.s. 1 (1910-11) 291-333, 503-31.

Lawrence, Marion. *The Sarcophagi of Ravenna*. College Art Association Study 2. 1945.

Le Blant, Edmond. "Les bas-reliefs des sarcophages chrétiens et les liturgies funéraires." *Revue archéologique*, n.s. 38 (1879) 223-41.

___. *Les sarcophages chrétiens de la Gaule*. Paris: Imprimerie Nationale, 1886.

*Leclercq, Henri. "Brescia (archéologie)." *DACL* 2.1:1139-56.

Lee, E. Kenneth. "Words Denoting 'Pattern' in the New Testament." *New Testament Studies* 8 (1962) 166-73.

Le Goff, Jacques. *La naissance du Purgatoire.* Bibliothèque des histoires. Editions Gallimard, 1981.

Levi, Peter. "The Podgoritza Cup." *Heythrop Journal* 4 (1963) 52-60. Reprinted as pp. 158-66 in *Art, Archaeology and Architecture of Early Christianity.* Ed. Paul Corby Finney. Studies in Early Christianity 18. New York: Garland, 1993.

Loerke, William C. "Observations on the Representation of *Doxa* in the Mosaics of S. Maria Maggiore, Rome, and St. Catherine's, Sinai." *Gesta* 20 (1981) 15-34.

Longhurst, Margaret H. *Catalogue of Carvings in Ivory. Part 1: Up to the Thirteenth Century.* London: Victoria and Albert Museum, 1927.

Loomis, Charles Grant. *White Magic: An Introduction to the Folklore of Christian Legend.* Cambridge, Massachusetts: The Mediaeval Academy of America, 1948.

*Lowrie, W. *Art in the Early Church.* New York, 1947.

McGrath, Robert L. "The Martyrdom of the Maccabees on the Brescia Casket." *Art Bulletin* 47 (1965) 257-61.

Macleod, C. W. "Allegory and Mysticism in Origen and Gregory of Nyssa." *Journal of Theological Studies* N.s. 22 (1971) 362-79.

Maguire, Henry. "Adam and the Animals: Allegory and the Literal Sense in Early Christian Art." *Studies on Art and Archeology in Honor of Ernst Kitzinger on His Seventy-Fifth Birthday.* Ed. William Tronzo and Irving Lavin. *Dumbarton Oaks Papers* 41 (1987) 363-73.

___. *Earth and Ocean: The Terrestrial World in Early Byzantine Art.* University Park: The Pennsylvania State University Press, 1987.

Malbon, Elizabeth Struthers. *The Iconography of the Sarcophagus of Junius Bassus.* Princeton: Princeton University Press, 1990.

Mâle, Émile. *The Gothic Image: Religious Art in France of the Thirteenth Century.* Tr. Dora Nussey. New York: Harper & Row, 1958.

Martimort, Aimé-Georges. "L'iconographie des catacombes et la catéchèse antique." *Rivista di archaeologia cristiana* 25 (1949) 105-14.

*Maskell, Alfred. *Ivories.* Methuen: The Connoisseur's Library, 1905. Reprint Rutland, VT: Charles E. Tuttle Co., 1966.

Mathews, Thomas F. *The Clash of Gods: The Reinterpretation of Early Christian Art.* Princeton: Princeton University Press, 1993.

Mearns, James. *The Canticles of the Christian Church, Eastern and Western, in Early and Medieval Times.* Cambridge, Eng.: Cambridge University Press, 1914.

Mendel, Gustave. *Catalogue des sculptures grecques, romaines et byzantines; Musées impériaux Ottomans.* 3 vols. Constantinople: Musée Impérial, 1912-14. Reprint 1966.

Michel, Karl. *Gebet und Bild in frühchristlicher Zeit.* Studien über christliche Denkmäler 1. Leipzig: Dieterich, 1902.

*Milburn, R. L. P. *Early Christian Art and Architecture* Berkeley: University of California Press, 1988.

Miles, Margaret. *Carnal Knowing: Female Nakedness and Religious Meaning in the Christian West.* Boston: Beacon Press, 1989.

Millet, Gabriel. *Recherches sur l'iconographie de l'Évangile aux XIVe, XVe, et XVIe siècles d'après les monuments de Mistra, de Macédoine et du Mont-Athos.* 2nd ed. Paris: Éditions E. de Boccard, 1960.

Modigliani, Ettore. "Il ripristino della Lipsanotheca di Brescia." *Bollettino d'arte del ministerio della publica instruzione.* 2nd. ser. VIII (1928-29) 96-102.

Mohrmann, Christine. *Études sur le latin des chrétiens.* 4 vols. Rome: Edizioni di Storia e Letteratura, 1961, 1965, 1977.

Monfrin, Françoise. "La Bible dans l'icongraphie chrétienne d'Occident." *Le monde latin antique et la Bible.* BTT 2 (1985) 207-41.

Morey, Charles Rufus. *Early Christian Art: An Outline of the Evolution of Style and Iconography in Sculpture and Painting from Antiquity to the Eighth Century.* Princeton: Princeton University Press, 1942. 2nd ed. 1953.

___ *Mediaeval Art.* New York: W.W. Norton & Company, Inc., 1942.

Morin-Jean. *La verrerie en Gaule sous l'Empire romain: essai de morphologie et de chronologie.* Paris: H. Laurens, 1913. Reprint Paris: Jacques Laget-Philippe Daviaud, 1977.

Murray, Mary Charles. Review of Malbon. *The Journal of Theological Studies* 43.2 (1992) 685-90.

Mutzenbecher, Almut. *Maximi Episcopi Taurinensis Sermones.* CCL 23. Turnholt: Brepols, 1962.

Narkiss, Bezalel. "The Sign of Jonah." *Gesta* 18 (1979) 63.

*Natanson, Joseph. *Early Christian Ivories.* London 1953.

Nauroy, Gérard. "Les frères Maccabées dans l'exégèse d'Ambroise de Milan ou la conversion de la sagesse judéo-hellénique aux valeurs du martyre chrétien." Pp. 215-45 in *Figures de l'Ancien Testament chez les Pères.* Cahiers de Biblia Patristica 2. Strasbourg: Centre d'analyse et de documentation patristiques, 1989.

Nees, Lawrence. *A Tainted Mantle: Hercules and the Classical Tradition at the Carolingian Court.* Middle Ages Series. Philadelphia: University of Pennsylvania Press, 1991.

*Nordström, Carl-Otto. "Some Jewish Legends in Byzantine Art." *Byzantion* 25-27 (1955-57) 487-508.

Ntedika, Joseph. *L'évocation de l'au-delà dans la prière pour les morts. Étude de patristique et de liturgie latines (IVe-VIIIe S.).* Recherches Africaines de Théologie 2. Paris-Louvain: Nauwelaerts, 1971.

___ *L'Evolution de la doctrine du Purgatoire chez saint Augustin.* Publications de l'Université Lovanium de Léopoldville 20. Paris: Études Augustiniennes, 1966.

*Odorici, Federico. *Antichità cristiane di Brescia.* Two parts. Brescia 1845; rev. ed., 1853; reprint Milan, 1858.

Ongaro, Giovanni. "Saltero Veronese e revisione Agostiniana," *Biblica* 35 (1954) 443-74.

Oust, Johannes, et al. *Die Bibel von Moutier-Grandval Britism Museum Add. 10546.* Bern: Verein Schweizerischer Lithographiebesitzer, 1971.

Ousterhout, Robert. "The Temple, the Sepulchre, and the *Martyrion* of the Savior." *Gesta* 29.1 (1990) 44-53.

*Panazza, Gaetano. *I musei e la pinacoteca di Brescia.* Gallerie e musei del mondo. Bergamo: Istituto Italiano d'Arti Grafiche, 1959.

Paxton, Frederick S. *Christianizing Death: The Creation of a Ritual Process in Early Medieval Europe.* Ithaca: Cornell University Press, 1990.

Pazaurek, Gustav E. "Glas- und Gemmenschnitt im ersten Jahrtausend." *Belvedere: Illustrierte Zeitschrift für Kunstammler* 11 (1932) 1-22.

Pearson, Birger. "The Gospel According to the Jesus Seminar." *Religion* 25 (1995) 317-38.

Pelliot, Marianne. "Verres gravés au diamant." *Gazette des Beaux-Arts* 72.1 (1930) 302-27.

*Pérraté, André. *L'archéologie chrétienne*. Paris: Alcide Picard & Kaan, Editeurs, 1892.

Ramsey, Arthur Michael. *The Glory of God and the Transfiguration of Christ*. London: Longmans, Green and Co, 1949.

Ramsey, Boniface. "The Life of Maximus." Pp. 1-4 in his translation, *The Sermons of St. Maximus of Turin*. Ancient Christian Writers 50. New York: Newman Press, 1989.

Réau, Louis. *Iconographie de l'art chrétien*. 3 vols. Paris: Presses Universitaires de France, 1956. Vol. 2: *Iconographie de la Bible*. Part 1: *Ancien Testament*.

Reicke, Bo Ivar. *The Disobedient Spirits and Christian Baptism: A Study of 1 Pet. III.19 and Its Context*. Acta Seminarii Neotestamentici Upsaliensis 13. Copenhagen: E. Munksgaard, 1946. Reprint New York: AMS Press, 1984.

Rizzardi, Clementina. *I sarcofagi paleocristiani con rappresentazione del passaggio del Mar Rosso*. Faenza: Fratelli Lega Editori, 1970.

Roberts, Michael. "Rhetoric and Poetic Imitation in Avitus' Account of the Crossing of the Red Sea ('De spiritalis historiae gestis' 5.371-702)." *Traditio* 39 (1983) 29-80.

Roldanus, Johannes. "Usages variés de Jonas par les premiers Pères." Pp. 159-88 in *Figures de l'Ancien Testament chez les Pères*. Cahiers de Biblia Patristica 2. Strasbourg: Centre d'analyse et documentation patristiques, 1989.

Rondet, Henri. "Essais sur la chronologie des «Enarrationes in Psalmos» de saint Augustin." *Bulletin de littérature ecclésiastique* 61 (1960) 111-27, 258-86, and 65 (1964) 110-36.

Rosenau, Helen. "Problems of Jewish Iconography." *Gazette des Beaux-Arts*, series 6, 56 (1960) 5-18.

Saggiorato, Annarosa. *I sarcofagi paleocristiani con scene di Passione*. Studi di Antichità Cristiane. Bologna: Casa Editrice Prof. Riccardo Pàtron, 1968.

Salmon, Dom P. "Le probléme des Psaumes: Le texte et l'interprétation des Psaumes au temps de s. Jérôme et s. Augustin." *L'Ami du clergé: Revue de toutes les questiones ecclésiastiques* 64 (1954) 161-73.

Sandmel, Samuel. *Philo of Alexandria: An Introduction*. New York: Oxford University Press, 1979.

Sapp, David A. "An Introduction to Adam Christology in Paul: A History of Interpretation, the Jewish Background, and an Exegesis of Romans 5:12-21." Ph.D. diss.: Southwestern Baptist Theological Seminary, 1990.

Saxer, Victor. "La Bible chez les Pères latins du IIIe siècle." *Le monde latin antique et la Bible*. BTT 2 (1985) 339-69.

___. *Morts, martyrs, reliques en Afrique chrétienne aux premiers siècles. Les témoignages de Tertullien, Cyprien et Augustin à la lumière de l'archéologie africaine*. Collection Théologie historique 55. Paris: Beauchesne, 1980.

Saxl, Fritz. "Pagan and Jewish Elements in Early Christian Sculpture." In *Lectures*. 2 vols. London: Warburg Institute, 1957. 1:45-57 and vol.2, pl. 26-33.

*Schiller, Gertrud. *Iconography of Christian Art.* 2 vols. Greenwich, Conn.: New York Graphic Society, Ltd., 1971-72. Trans. by Janet Seligman of *Ikonographie der christlichen Kunst.* Vols. 1-2 only. 2nd ed. Gutersloh: 1969.

Schlatter, Fredric W., S.J. Review of Mathews. *Heythrop Journal* 37.1 (1996) 110-11.

Schneider, Heinrich. "Die biblische Oden, im Mittelalter." *Biblica* 30 (1949) 479-500.

*Schultze, Victor. *Archäologie der altchristlichen Kunst.* Munich: C. H. Beck, 1895.

Seeliger, Hans Reinhard. "Palai martyres: Die Drei Jünglinge im Feuerofen als Typos in der spätantiken Kunst, Liturgie und patristischen Literatur. Mit einigen Hinweisen zur Hermeneutik der christlichen Archäologie." In *Liturgie und Dichtung. Ein interdisziplinäres Kompendium.* 2 vols. Ed. H. Becker and R. Kaczynski. St. Ottilien: Eos Verlag Erzabtei, 1983. 2:257-334.

Selwyn, Edward Gordon. *The First Epistle of St. Peter.* 2d ed. New York: Macmillan & Co., 1946. Reprint Grand Rapids: Baker Book House, 1981.

Ševčenko, Nancy Patterson. *Illustrated Manuscripts of the Metaphrastian Menologion.* Chicago: University of Chicago Press, 1990.

Sheldon-Williams, I.-P. "The Philosophy of Icons," in *The Cambridge History of Later Greek and Early Medieval Philosophy.* Cambridge: Cambridge University Press, 1970, 506-17.

Sicard, Damien. *La liturgie de la mort dans l'église latine des origines à la réforme carolingienne.* Liturgiewissenschaftliche Quellen und Forschungen 63. Muenster: Aschendorffsche Verlagsbuchhandlung, 1978.

Siger, Leonard. "The Image of Job in the Renaissance." Ph.D. diss.: The Johns Hopkins University, 1960.

Sloyan, Gerard S. *The Crucifixion of Jesus: History, Myth, Faith.* Minneapolis: Fortress Press, 1995.

Smith, Christine. *Ravenna: i secoli d'oro.* Ravenna: Edizioni Salera, 1977.

Smith, E. Baldwin. *Early Christian Iconography and a School of Ivory Carvers in Provence.* Princeton Monographs in Art and Archaeology 6. Princeton: Princeton University Press, 1918.

Smith, Kathryn A. "Inventing Marital Chastity: The Iconography of Susanna and the Elders in Early Christian Art." *Oxford Art Journal* 16.1 (1993) 3-24.

*Soper, A. C., III. "The Brescia Casket: A Problem in Late Antique Perspective." *American Journal of Archaeology* 47 (1943) 278-90.

___. "The Italo-Gallic School of Early Christian Art," *Art Bulletin* 20 (1938) 145-92.

___. Review of *Die Lipsanothek von Brescia* by Johannes Kollwitz. *American Journal of Archaeology* 39 (1935) 430-33.

Sowers, Sidney G. *The Hermeneutics of Philo and Hebrews: A Comparison of the Interpretation of the Old Testament in Philo Judaeus and the Epistle to the Hebrews.* Basic Studies of Theology 1. Richmond: John Knox Press, 1965.

St. Clair, Archer. "A New Moses: Typological Iconography in the Moutier-Grandval Bible Illustrations of Exodus." *Gesta* 26 (1987) 19-28.

Steiner, Ruth. "Antiphons for the Benedicite at Lauds." *Journal of the Plainsong and Mediaeval Music Society* 7 (1984) 1-17.

Stejskal, Karel, ed. *Velislai Biblia picta.* Editio cimelia Bohemica 12. Prague: Prago Press, 1970.

Stern, Henri. "Les mosaïques de l'église de Sainte-Constance à Rome." *Dumbarton Oaks Papers* 12 (1958) 157-218.

*___ Review of Delbrueck, in *Römische Quartalschriften* 50 (1955) 115-18.

*Stommel, Eduard. *Beiträge zur Ikonographie der konstantinischen Sarkophagplastik.* Theophaneia: Beiträge zur Religions- und Kirchengeschichte des Altertums 10. Bonn: Peter Hanstein Verlag, 1954.

*Stuhlfauth, Georg. *Die altchristliche Elfenbeinplastik.* Archäologische Studien zum christlichen Altertum und Mittelalter, ed. Johannes Ficker. Zweites Heft. Freiburg im Bresgau and Leipzig, J. C. B. Mohr, 1896.

___ *Die Engel in der altchristlichen Kunst.* Archäologische Studien zum christlichen Altertum und Mittelalter. Ed. Johannes Ficker. Dreites Heft (1897) 82-95.

___ "Zwei Streitfragen der altchristlichen Ikonographie. 1. Die sieben makkabäischen Brüder oder die drei hebräischen Jünglinge? 2. Die Martha-Szene oder die Sünderin?" *Zeitschrift für die neutestamentliche Wissenschaft und die Kunde der Älteren Kirche* 320 (1924) 48-64.

Stuiber, Alfred. *Refrigerium interim. Die Vorstellungen vom Zwischenzustand und die frühchristliche Grabeskunst.* Bonn: Peter Hanstein Verlag, 1957.

Stump, Eleanore. "Modern Biblical Scholarship, Philosophy of Religion and Traditional Christianity." *Truth Journal* 1 (1995). http://www.leadesu.com/truth/1truth20.html

Styger, Paul. *Die altchristliche Grabeskunst.* Munich: Verlag Josef Kösel & Friedrich Pustet, 1927.

Stylianou, Andreas, and Judith A. Stylianou. *The Painted Churches of Cyprus: Treasures of Byzantine Art.* London: Trigraph, 1985.

Swetnam, James, S.J. *Jesus and Isaac: A Study of the Epistle to the Hebrews in the Light of the Aqedah.* Investigationes scientificae in res biblicas 94. Rome: Pontifical Biblical Institute, 1981.

*Sybel, Ludwig von. *Christliche Antike: Einführung in die altchristliche Kunst. 2: Plastik, Architektur und Malerei.* Marburg: N. G. Elwert, 1909.

Syndicus, Eduard. *Early Christian Art.* New York: Hawthorn Books, 1962. Trans. by J. R. Foster of *Die Frühchristliche Kunst.* Paul Pattloch Verlag, 1960.

Tate, J. "Plato and Allegorical Interpretation." *The Classical Quarterly* 23 (1929) 142-54 and 24 (1930) 1-10.

Thomas, Kenneth J. "The Old Testament Citations in Hebrews." *New Testament Studies* 11 (1965) 303-25.

Tkacz, Catherine Brown. "Commendatio animae."

___ "Commendatio animae." *Sources of Anglo-Saxon Literary Culture.* Ed. Paul Szarmach. Forthcoming.

___ "*Labor tam utilis*: The Creation of the Vulgate." *Vigiliae Christianae* 50.1 (1996) 42-72.

___ "Literary Studies of the Vulgate: Formula Studies." *Proceedings of the Patristic, Mediaeval, and Renaissance Studies Conference* 15 (1990) 205-19.

___ Review of Corrigan, q.v. *Studies in Iconography* 17 (1996) 413-16.

___ "The Seven Maccabees, the Three Hebrews, and a Newly Discovered Sermon of St. Augustine (Mayence 50)." *Revue des études augustiniennes* 41.1 (1995) 59-78.

___ "Susanna as a Type of Christ." *Studies in Iconography* 20 (1999) 101-53.

___. "The Topos of the Tormentor Tormented in Selected Works of Old English Hagiography." Ph.D. diss.: University of Notre Dame, 1983.

___. "The Topos of the Tormentor Tormented in Aelfric's *Passio Sancti Vincentii Martyris."* *Ball State University Forum* 25 (1984) 3-13.

___. *"Velatio."* In *Saint Augustine through the Ages: An Encyclopedia.* Ed. Allan Fitzgerald. Grand Rapids: William B. Eerdmanns Publishing Company, forthcoming.

Topping, E. C. "A Byzantine Song for Simeon." *Traditio* 24 (1968) 409-20.

*Toynbee, J. M. C. Review of Delbrueck, in *The Antiquaries Journal* 35 (1955) 238-40.

Trigg, Joseph W. *Biblical Interpretation.* Message of the Fathers of the Church 9. Wilmington: Michael Glazier, 1988.

Tronzo, William. *The Via Latina Catacomb.* University Park and London: 1986.

Turcan, Robert. "Déformation des modèles et confusions typologiques dans l'iconographie des sarcophages romains." *Annali della Scuola Normale di Pisa.* Ser. 3, vol. 17.2 (1987) 429-46.

van der Meer, F. *Early Christian Art.* Trans. Peter and Friedl Brown. London: Faber and Faber Limited, 1967.

*Venturi, Adolfo. *Storia dell'arte italiana,* 11 vols. (Milan: Ulrico Hoepli, 1901-75).

Verkerk, Dorothy Hoogland. "Exodus and Easter Vigil in the Ashburnham Pentateuch." *Art Bulletin* 77.1 (1995) 94-105.

___. "Liturgy and Narrative in the Exodus Cycle of the Ashburnham Pentateuch." Ph.D. diss.: Rutgers, 1992.

Vikan, Gary K., and John Nesbitt. *Security in Byzantium: Locking, Sealing, Weighing.* Dumbarton Oaks Byzantine Collection Publications, no. 2. Washington, D.C.: Dumbarton Oaks, 1980.

Villette, Jeanne. "Une coupe chrétienne en verre gravé, trouvée à Carthage." *Monuments et mémoires.* Institut de France, Académie des inscriptions et de belles lettres, Commission de la Fondation Piot. Tome 46. Paris, 1952. Pp. 131-51.

Volbach, Wolfgang Fritz. *Early Christian Art.* Tr. Christopher Ligota. New York: H. Abrams, 1962. Translation of *Frühchristliche Kunst; die Kunst der Spätantike in West und Ostrom.* Munich: Hirmer, 1958.

___. *Elfenbeinarbeiten der Spätantike und des frühen Mittelalters.* 1st ed. 1916, 2nd 1952. 3rd ed. Mainz: Verlag des Römisch-Germanischen Zentralmuseums, 1976.

*Watson, Carolyn Joslin. "The Program of the Brescia Casket." *Gesta* 20 (1981) 283-98.

*Weigand, E. Review of Kollwitz. *Byzantinische Zeitschrift* 35 (1935) 429-34.

Weitzmann, Kurt, ed. *Age of Spirituality: Late Antique and Early Christian Art, Third to Seventh Century.* Catalogue of the exhibition at the Metropolitan Museum of Art, November 19, 1977, through February 12, 1978. New York: The Metropolitan Museum of Art in association with Princeton University Press, 1979.

___. *Illustration in Roll and Codex: A Study of the Origin and Method of Text Illustration.* Studies in Manuscript Illumination 2. Princeton: Princeton University Press, 1947. Reprint with addenda, 1970.

___. *Late Antique and Early Christian Book Illumination.* New York: George Braziller, 1977.

___. "Thirteenth Century Crusader Icons on Mount Sinai." *Art Bulletin* 45 (1963) 179-203.

Weitzmann, Kurt, and Herbert L. Kessler. *The Frescoes of the Dura Synagogue and Christian Art.* Dumbarton Oaks Studies 28. Washington, D.C.: Dumbarton Oaks Research Library and Collection, 1990.

*Westwood, J. O. *A Descriptive Catalogue of the Fictile Ivories in the South Kensington Museum.* London: Eyre & Spottiswoode, 1876.

Wieck, Roger S. *Time Sanctified: The Book of Hours in Medieval Art and Life.* New York: George Braziller, Inc., with The Walters Art Gallery, 1988.

Wilmart, André. "Le réglement ecclésiastique de Berne." *Revue Bénédictine* 51 (1939) 37-52.

Wilpert, Josef. *I sarcofagi cristiani antichi.* 2 vols. Rome: Pontifico Istituto di Archeologia Cristiana, 1932.

Wilpert, Joseph (!). *Die Malereien der Katakomben Roms.* 2 vols. Freiburg im Breisgau: Herder, 1903.

Wilpert, Joseph, and Walter N. Schumacher. *Die Römischen Mosaiken der kirchlichen Bauten vom IV.-XIII. Jahrhundert.* Freiburg im Breisgau: Herder, 1916, repr. 1976.

Wirth, Karl-August. "Neuerworbene Armenbibel-Fragmente in der Bayerischen Staatsbibliothek." *Münchner Jahrbuch der bildenden Kunst* 14 (1963) 51-78.

Woollcombe, Kenneth J. "The Biblical Origins and Patristic Development of Typology." Pp. 39-75 in Geoffrey William Hugo Lampe and Woollcombe, *Essays on Typology.* Studies in Biblical Theology 22. London: SCM Press, 1957.

*Wulff, Oskar Konstantin. *Altchristliche und byzantinische Kunst.* Berlin: Akademische Verlagsgesellschaft Athenaion, 1909.

___. *Altchristliche und mittelalterliche byzantinische und italienische Bildwerke. Beschreibung der Bildwerke der christlichen Epochen.* 2 vols. Berlin: Reimer, 1909-11.

___. "Ein Ganz durch die Geschichte der altchristlichen Kunst mit ihren neuen Pfadfindern." *Repertorium für Kunstwissenschaft* 34 (1911) 281-314 and 35 (1912) 193-240.

Zarb, Seraphinus M., O.P. *Chronologia Enarrationum S. Augustini in Psalmos.* Malta, 1948. Originally published as a series of articles in *Angelicum,* beginning with 12 (1935) 52-81 and continuing through 1948.

INDEX

Biblical personages, patristic authors, Jewish texts, persons contemporaneous with the Brescia Casket, Christian symbols, Latin terms, and artworks cited in the text and captions (and, rarely, those cited in the notes) are referenced in this union index. All figures in the text are included; for full captions, see pp. 13-15. "Detail figure" indicates a photograph cropped to show the single depiction or register indexed. See also Table of Identifications.

COLLECTION DES ÉTUDES AUGUSTINIENNES

CLASSIFICATION PAR SÉRIES ET NUMÉROS

(La date de publication est donnée entre parenthèses)

Série «Antiquité»

55	HADOT, P. - Plotin ou la simplicité du regard.- 2^e éd. (1973)
56	BLUMENKRANZ, B. - Die Judenpredigt Augustins ... (1973)
57	MOREAU, M. - Le dossier Marcellinus dans la Correspondance de saint Augustin (1973)
58-59-60	COURCELLE, P. - «Connais-toi toi-même» de Socrate à saint Bernard (1975)
61	MADEC, G. - Saint Ambroise et la philosophie (1974)
62-63-64	CLAESSON, G. - Index Tertullianeus (1974-1975)
65	Ambroise de Milan. XVIᵉ centenaire de son élection épiscopale (1974)
66	TARDIEU, M. - Trois mythes gnostiques, Adam, Eros et les animaux d'Égypte ... (1974)
67	LA BONNARDIÈRE, A.-M. - Biblia Augustiniana. Le Livre des Proverbes (1975)
68	ORIGÈNE. - Traité des principes. Traduction de la version latine de Rufin ... (1976)
69	PÉPIN, J. - Mythe et allégorie ... (1976)
70	BRAUN, R.- Deus christianorum ... - 2ᵉ éd. (1977)
71	DAGENS, C. - Saint Grégoire le Grand. Culture et expérience chrétiennes (1977)
72-73	SAVON, H. - Saint Ambroise devant l'exégèse de Philon le Juif (1977)
74-75	DECRET, F. - L'Afrique manichéenne (IVᵉ-Vᵉ siècles). Étude historique et doctrinale (1978)
76	HADOT, I. - Le problème du néoplatonisme alexandrin: Hiéroclès et Simplicius (1978)
77	LEWY, H. - Chaldaean Oracles and Theurgy ... (1978)
78	Dieu et l'Être. Exégèses d'*Exode* 3, 14 et de *Coran* 20, 11-24 (1978)
79	DELÉANI, S. - Christum sequi. Étude d'un thème dans l'œuvre de saint Cyprien (1979)
80-81	LEPELLEY, C. - Les cités de l'Afrique romaine au Bas-Empire (1979-1981)
82	BURNS, J. P. - The Development of Augustine's doctrine of operative Grace (1980)
83	COURCELLE, J. et P. - Iconographie de saint Augustin - XVIIIᵉ siècle. L'Allemagne (1980)
84	Pélagie la Pénitente. Métamorphoses d'une légende. Tome I (1981)
85	FONTAINE, J.- Naissance de la poésie dans l'Occident chrétien (IIIᵉ-VIᵉ siècles) ... (1981)
86	THÉLAMON, F.- Païens et chrétiens au IVᵉ siècle ... (1981)
87	Hagiographie. Cultures et sociétés (IVᵉ-XIIᵉ siècles) (1981)
88	HADOT, P. - Exercices spirituels et philosophie antique (1981)
89-90	MONAT, P. - Lactance et la Bible ... (1982)
91	LUCIANI, E. - Les *Confessions* de saint Augustin dans les Lettres de Pétrarque (1982)
92-93-94	CAMBRONNE, P. - Recherches sur la structure de l'imaginaire dans les *Confessions* ... (1982)
95	BOCHET, I. - Saint Augustin et le désir de Dieu (1982)
96	FLUSIN, B. - Miracle et histoire dans l'œuvre de Cyrille de Scythopolis (1983)
97	SCHMITT, É. - Le mariage chrétien dans l'œuvre de saint Augustin ... (1983)
98	Les Lettres de saint Augustin découvertes par J. Divjak. Colloque de 1982 (1983)
99	CANÉVET, M.- Grégoire de Nysse et l'herméneutique biblique ... (1983)
100-101-102	FONTAINE, J. - Isidore de Séville et la culture classique ... (1983)
103	COURCELLE, P. - Opuscula selecta (1984)
104	Pélagie la Pénitente. Métamorphoses d'une légende. Tome II (1984)
105	POQUE, S. - Le langage symbolique dans la prédication d'Augustin d'Hippone (1984)
106	MILLET-GÉRARD, D. - Chrétiens mozarabes et culture islamique ... (1984)
107	HADOT, I. - Arts libéraux et philosophie dans la pensée antique (1984)
108	JAY, P. - L'exégèse de saint Jérôme d'après son *Commentaire sur Isaïe* (1985)
109	AMAT, J. - Songes et visions. L'au-delà dans la littérature latine tardive (1985)
110-111	LE BOULLUEC, A. - La notion d'hérésie dans la littérature grecque (IIᵉ-IIIᵉ siècles) (1985)
112	ANDIA, Y. de - Homo vivens. Incorruptibilité et divinisation ... (1986)
113-114-115	HUMEAU, G. - Les plus beaux sermons de saint Augustin (1986)
116	MÉASSON, A. - Du char ailé de Zeus à l'Arche d'Alliance ... (1986)
117	WARTELLE, A. - Saint Justin, *Apologies* ... (1987)
118	HADOT, P. - Exercices spirituels et philosophie antique. - 2ᵉ éd. (1987)
119	Augustiniana Traiectina. Colloque d'Utrecht 1986 (1987)
120	PÉPIN, J. - La tradition de l'allégorie. De Philon d'Alexandrie à Dante (1987)
121	DUVAL, Y. - Auprès des saints corps et âme. L'inhumation «ad sanctos» ... (1988)
122	Jérôme entre l'Occident et l'Orient. Colloque de Chantilly 1986 (1988)
123	HADOT, P. - Plotin ou la simplicité du regard. - 3ᵉ éd. (1989)
124	PICARD, G.-Ch. - La civilisation de l'Afrique romaine. - 2ᵉ éd. (1990)
125	BACKUS, I. - Lectures humanistes de Basile de Césarée ... (1990)

126 DEPROOST, P.-A. - L'Apôtre Pierre dans une épopée du VI^e siècle ... (1990)

127 Troisième centenaire de l'édition mauriste de saint Augustin. Colloque de Paris 1990 (1990)

128 COURCELLE, J. et P. - Iconographie de saint Augustin - XVII^e et XVIII^e siècles (1991)

129 Basiliques chrétiennes d'Afrique du Nord. - I, 1 : Inventaire de l'Algérie. Texte par J.-P. CAILLET, N. DUVAL, I. GUI (1992)

130 Basiliques chrétiennes d'Afrique du Nord. - I, 2 : Inventaire de l'Algérie. Illustrations par N. DUVAL (1992)

131 «Chercheurs de sagesse» : Hommage à Jean Pépin (1992)

132 De Tertullien aux Mozarabes. Mélanges offerts à Jacques Fontaine. Tome 1 : Antiquité tardive et christianisme ancien (III^e-VI^e siècles) (1992)

133 BOUFFARTIGUE, J. - L'Empereur Julien et la culture de son temps (1992)

134 BRAUN, R. - Approches de Tertullien ... (1992)

135 HARL, M. - Le déchiffrement du sens ... (1993)

136 HADOT, P. - Exercices spirituels et philosophie antique. - 3^e éd. rev. et augm. (1993)

137-138 PERNOT, L. - La rhétorique de l'éloge dans le monde gréco-romain (1993)

139-140 DULAEY, M. - Victorin de Poetovio, premier exégète latin (1994)

141 DUFRAIGNE, P. - Adventus Augusti, Adventus Christi ...(1994)

142 MADEC, G. - Petites études augustiniennes (1994)

143 BOULNOIS, M.-O. - Le paradoxe trinitaire chez Cyrille d'Alexandrie (1994)

144 DUVAL, Y. - Lambèse chrétienne : la gloire et l'oubli... (1995)

145 INGLEBERT, H. - Les Romains chrétiens face à l'histoire de Rome (1996)

146 DELAROCHE, B. - Saint Augustin lecteur et interprète de saint Paul (1996)

147 DOLBEAU, F. - Augustin d'Hippone : vingt-six sermons au peuple d'Afrique (1996)

148 HOMBERT, P.-M. - Gloria gratiae... (1996)

149 MADEC, G. - Saint Augustin et la philosophie (1996)

150 MADEC, G. - Introduction aux « Révisions »... (1996)

151 ANDIA, Y. de. - Denys l'Aréopagite et sa postérité... (1996)

152 Titres et articulations du texte dans les oeuvres antiques. Actes du Colloque de Chantilly, 1994 (1997)

153 BUREAU, B. - Lettre et sens mystique dans l'*Historia Apostolica* d'Arator (1997)

154 Du héros païen au saint chrétien. Actes du Colloque de Strasbourg, 1995 (1997)

155 LAURENCE, P. - Jérôme et le nouveau modèle féminin... (1997)

156 DAGUET-GAGEY, A. - Les *opera publica* à Rome : 180-305 ap. J.-C. ... (1997)

157 Chronica Tertullianea et Cyprianea 1975-1994 (1999)

158 LABARRE, S. - Le manteau partagé... (1998)

159 Augustin prédicateur (395-411). Actes du Colloque de Chantilly, 1996 (1998)

160 MADEC, G. - Chez Augustin (1998)

161 JEANJEAN, B. - Saint Jérμε ετ λ'θερεσιε (1999)

162 GOUNELLE, R. - La descente du Christ aux Enfers... (2000)

163 HOMBERT, P.-M. - Nouvelles recherches de chronologie augustinienne (2000)

164 DUVAL, Y. Chrétiens d'Afrique à l'aube de la paix constantinienne (2000)

165 TKACZ, C. - The key to the Brescia casket... (2001)

Série «Moyen Âge et Temps Modernes»

1 POUCHET, R. - La «Rectitudo» chez saint Anselme. Un itinéraire augustinien ... (1964)

2 BLUMENKRANZ, B. - Le Juif médiéval au miroir de l'art chrétien (1966)

3 WILMART, A. - Auteurs spirituels et textes dévots du Moyen Âge latin (1971)

4-5 LONGÈRE, J. - Œuvres oratoires de Maîtres parisiens au XII^e siècle ... (1975)

6 BOUHOT, J.-P. - Ratramne de Corbie. Histoire littéraire et controverses doctrinales (1976)

7 LOUIS DE LÉON. - Les Noms du Christ (1978)

8 VERNET, A. - Études médiévales (1981)

9 LONGÈRE, J. - La prédication médiévale (1983)

10 Le troisième Concile du Latran (1179) ... Table Ronde du CNRS 1980 (1982)

11 BARENNE, O. - Une grande bibliothèque de Port-Royal ... (1985)

12-13 BOUGEROL, J.-G. - La théologie de l'espérance aux XII^e et XIII^e siècles (1985)

Hors série

COLLECTION DES ÉTUDES AUGUSTINIENNES

CLASSIFICATION PAR ORDRE ALPHABÉTIQUE D'AUTEURS

(SA = Série Antiquité; SMA = Série Moyen Âge; HS = Hors série)